HISTORICAL WESTERN MAP

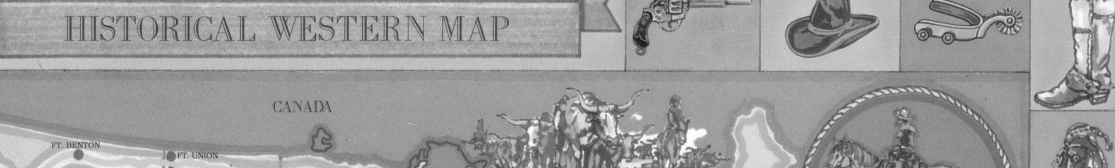

CANADA

FT. BENTON

FT. UNION

HELENA

⑤ ⑭ ⑩ ㉔
MILES CITY

BOZEMAN

DEADWOOD
RAPID CITY

FT. LARAMIE
CHEYENNE OGALLALA
FT. BRIDGER

SALT LAKE

㉘ ㉒ ❼

DENVER
㉕ ⑪ ⑯

TRAIL CITY ELLSWORTH

OMAHA

㉞ ㉛
ABILENE KANSAS CITY
SEDALIA

㉜

❽ ❾
PUEBLO
⑫

DODGE CITY

BAXTER SPRINGS

ST. LOUIS

CHICAGO

㉗
NEW YORK

④
NEW JERSEY

BALTIMORE

CINCINNATI

* The first
herefords are
sent to Texas
in the 1860s.

ATLANTIC OCEAN

* The first herefords to
reach the new world
were imported from
England, and land at
the new colonies in
1745.

CONQUISTADOR

SANTA FE

❶

❸

㉚
CITY

㉑

* SPANISH HORSES ARE SET
FREE DURING THE 1500s.

N

W E

S

NORTHERN COWHAND

EL PASO ❻

⑰ ㉖

FORT WORTH

㉙

SAN ANTONIO

❷

GULF OF MEXICO

* CORTEZ BROUGHT THE
FIRST SPANISH HORSES
INTO MEXICO FROM
VERA CRUZ IN 1519.
(16 STALLIONS AND 5
MARES).

MEXICO

* DE SOTO BROUGHT
HORSES TO WESTERN
FLORIDA (TAMPA BAY)
IN 1538.

* COLUMBUS LANDS AT
CAPE HAITIEN,
HISPANIOLA IN 1494 WITH
THE FIRST COWS AND
HORSES IN THE WESTERN
HEMISPHERE.

Dave at age 3

Dedication

I would like to dedicate this book to my brothers, Buzzie and Walter, who played cowboys and Indians with me when I was young, and who continued to support and understand my deep desire and passion to keep on playing cowboys and Indians after all these years.

I can't go without mentioning my three sons, who have taken the place of Buzzie and Walter and are now playing cowboys and Indians with me, whether they like it or not: Drew, Taylor, and Colby.

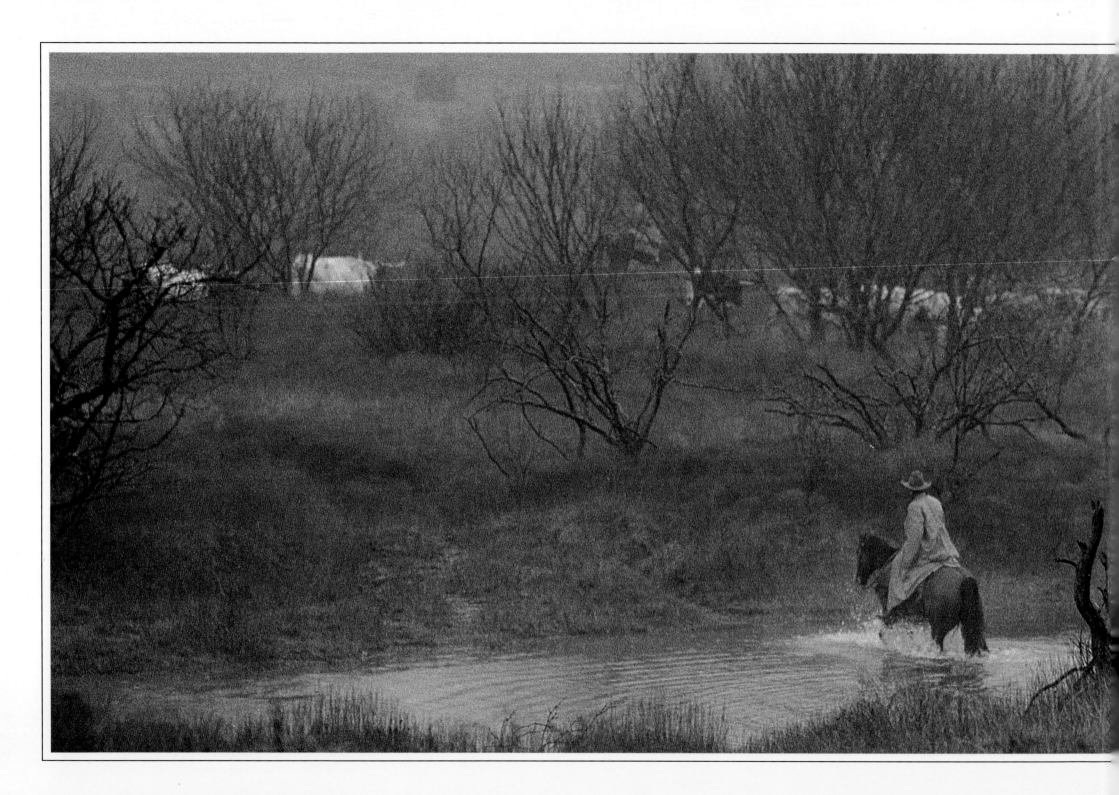

The longhorn cattle were as wild as elk and as smart as foxes,
and so too were the men who rounded them up and drove them home.

COWBOY GEAR

A photographic portrayal of the
Early Cowboys and their Equipment

Photography by David R. Stoecklein

Dober Hill Ltd.

All photos in this book are available upon request:

David R. Stoecklein Photography
P.O. Box 856
Ketchum, Idaho 83340
800/727-5191 208/726-5191

1/2011

Publisher: *Dober Hill Ltd.*
A Division of Stoecklein Publishing
David R. Stoecklein Photography
P.O. Box #856
Ketchum, Idaho 83340

Printed in Hong Kong through Palace Press International

Photographer and Creative Director: *David R. Stoecklein*
Assistant Photographers: *Bruce Kendall, Jim Volkert & Paul Stover*
Special Studio Photography: *Jim Volkert & Bruce Kendall*
Consultant on authenticity of gear and text: *Charlie Smith*
Consultants on bits & spurs: *Danny Neill, Ron Gillett, Roger Baker*
Consultants on horsehair: *Linda Kohn & Joseph Sherwood at High Noon*
Text Researchers: *Danielle Buonincontri, Julie Fanselow, John Kubiak, Phil
Livingston, Brad Popham*
Special Consultant on cowboy songs and poems: *Scott Preston*
Text Editor: *Dan Streeter, Associate Editor of the Painthorse Journal*
Copy Editor: *Premi Pearson*
From Western Words: A Dictionary of the American West by Ramon F. Adams.
Copyright © 1968 by the *University of Oklahoma Press*
Cover stamp by Jo Mora and Jo Mora illustrations on pages 13, 67, 76, 92,
111, & 129: *Reprinted by permission of Jo Mora Jr.*
Designers/Typographers: *Ernest R. Matthes and Kimberly D. Woodland*
Publicist: *Wendy S. Carter*
"Anatomy of a Chuckwagon," page 52, *John McClusky, WILDHORSE Studio*

Jacket: *Cowboys of the high mountains pose in the finest of Western gear*

End papers: "Atlas of the Historical West", *John McClusky, WILDHORSE Studio*

Acknowledgments

I would like to thank all those great men and boys who rode the dusty trails so many years ago—the cowboys who became legends, living a life I can only dream of. I truly admire the men who made the saddles, spurs, boots, hats, headstalls, and bits. These tools have become American Art: treasures that are an important part of our culture and symbols of an American passion.

These collectibles are special because of their beauty and craftsmanship, and because they were used by real cowboys. When you look at or hold a saddle, you can feel the spirit of the man who, one hundred years ago, made his living riding in this saddle, and laid his head on it at night while sleeping under the stars. You cannot help but feel the hand of a gunfighter as you grip his Peacemaker Colt 45.

I do not pretend to be an authority on the subject of cowboys or their gear—just a very big fan. I did this book for my own education as much as for yours. I am not an authority and neither is this book—it is a collection of thoughts, words, and pictures. I only hope that you will learn something from this journey, and enjoy the photographs as much as I enjoyed taking them.

So many people have helped me with this book: supplying information; sharing tack and clothes from their personal collections; offering their ranches to work on, their horses to ride,

and their longhorn cattle to rope; performing their daily tasks for me while I photographed them at work; acting as models, dressed in the original gear that has been preserved.

I could not possibly list all of the colleagues—researchers, collectors and cowboys—who helped me with this project, but I would like to try: Jay & Nancy Hoggan, Monte Funkhouser, Paul Stover, Lyle Albertson, Lori Aslet, Steve Aslet, Bobby Marriott, Shane Hoopes, Monte Newman, Lynn Tomlinson, Tony McLaughlin, Pete McGarry, Pat McGarry, Ray Seal, Mike & Kathy Seal, LeRoy Swanson, John Kubiak, Charlie Smith, Ron Gillett, Elmer Diederich, Julie Fanselow, Roger & Marcia Baker, Ed Roberts, Danny Neill, Dick Engle, Phil Livingston, Bruce Kendall, Jim Volkert, Tom Saunders Sr., Thomas Saunders V, Brett Reeder, Mike Johnson, Randy Dains, Raymond Jayo, Darrell Dodds, Darrell Byerly, Tub Blanthorn, Tina Amy, Calvin Amy, Delwin Amy, Guy Twitchell, Zane Wines, Vaughn Wood, Nord Hill, Lynn Spiller, Premi Pearson, Jo Mora, Chester Stidhorn, Derry Williams, Gary Henry, George Slaughter IV, James Crow, John Chapman, Lee Hay, Michael Body, Rick Wilson, Terry Moore, Ace Tague, Larry Robinson, Dave Zarneski, Penny Zarneski, Dale McNee, Linda Kohn and Joseph Sherwood at High Noon, and Paul Snider.
Thanks to all. ENJOY!!

The American Cowboy

"Ma," says the Eastern girl, "do cowboys eat grass?"
"No, dear," says the old lady, "they're part human."

Trails Plowed Under: "The Story of the Cowpuncher"
Charles M. Russell; Doubleday & Co., 1927

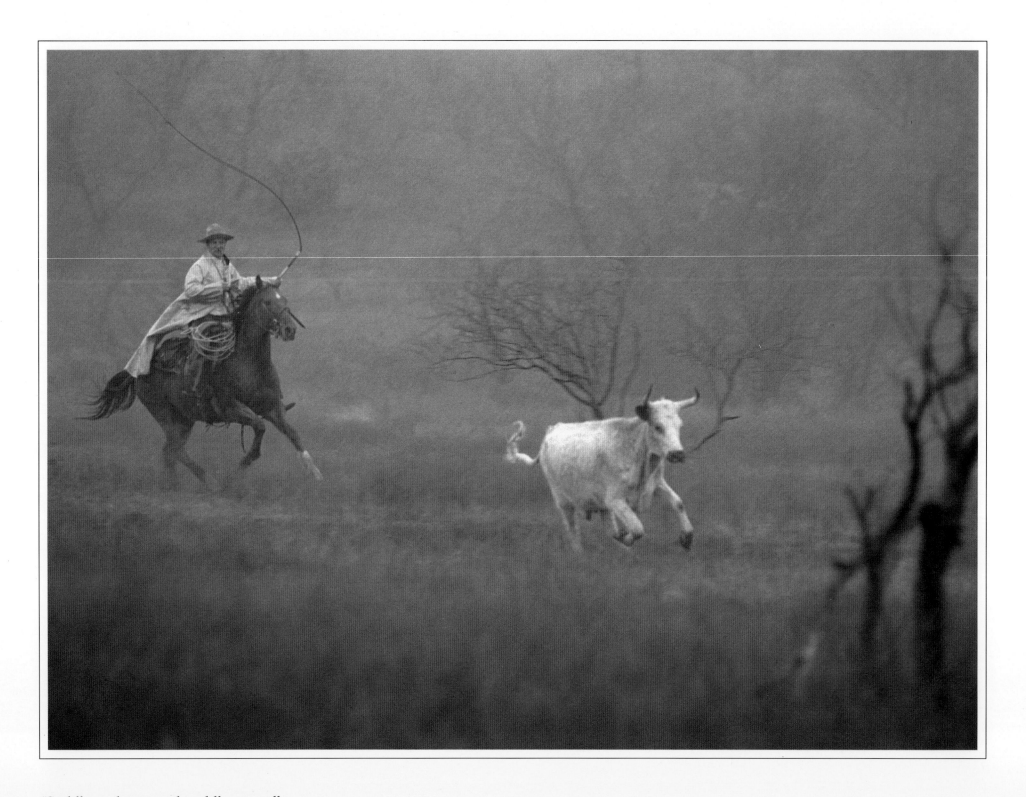

"Saddle up boys, and saddle up well

for I think these cattle have scattered to hell."

—The Old Chisholm Trail

Foreward

Like many who grew up in this great country, I have always been intrigued by cowboys. The way they walked, talked, and lived always captured my imagination, and I knew very early on that my life would be lived in close association with their lifestyles. Although my business is photography, I have managed to interject both my life and work with a Western flair. When not on assignment or in my studio combing through photographs of the West and its people, I can usually be found relaxing with my family or working on my Idaho ranch.

In 1991, I published "*The Idaho Cowboy*," a photographic essay depicting a way of life that many people assumed had disappeared from the American landscape. In that book, I hoped to portray the Idaho cowboy as he really is. In this book, I have turned my attention to the other stuff of cowboy legend — his gear. What would a cowboy be without his saddle, spurs, hat, chaps, and boots?

The following pages display and discuss gear used by the cowboy in the years 1860 through the 1920s. The reader will find photographs and illustrations of some of the finest cowboy gear ever made, along with examples of the tools used in everyday cowboy work and life. I could not even attempt to include all of the gear produced by the makers, but have tried to show a good cross-section.

Much of this gear is basically the same today as it was 130 years ago, when the American cowboy, as we know him today, first came into existence. Most early cowboy gear and equipment was used sunup to sundown, seven days a week. Most pieces have undergone numerous repairs to their leather and silver. Yet the design of this gear has withstood the test of time, and remains much the same today as in the early days of the Spanish vaquero.

Each year, cowboy and Western memorabilia grow in popularity and become harder to find. Many books have been published about cowboy collectibles and the like, but to date nobody has ever shown the gear as it actually looked on the cowboys, how it was used in their everyday work, and why certain craftsmen's work was favored over others. I first gained this perspective during my work on *The Idaho Cowboy*, and it is a perspective I hope you will share once you have read this book.

Like many of today's cowboys, I was accustomed to seeing early gear displayed in old, poorly reproduced black-and-white photographs.

While working on *The Idaho Cowboy*, I began using items from my personal collection of Western memorabilia on the photo shoots. It was then that I realized I had never seen color photographs of actual cowboys using authentic old gear. Seeing these dusty artifacts worn by real cowboys in real cowboy situations was such an eye-opening experience for me that I wanted to photograph an entire book featuring authentic old gear.

Though I am a rancher and collector of cowboy gear, I, like many modern-day cattlemen, did not know much about the origin of these pieces. I wanted to know the history of the early cowboy gear and how it looked when being used by the first cowboys. With this seed of curiosity and wonder planted, I called my good friend and fellow collector Charlie Smith and asked him if he would like to join me in producing a book on cowboy gear — a book that would show the gear in color photographs, as worn by the original cowboys, and explain the origins of the gear as well.

Charlie shares my enthusiasm and love for the Old West and has been collecting Western antiques for more than two decades. He runs a business in Milton-Freewater, Oregon, called Western Americana, where he deals in antique cowboy gear. Needless to say, he jumped at the opportunity to do a book on old cowboy gear. A year and a half later, here we are.

After many great times making photographs of some of the best cowboys in the West, and many wonderful evenings sitting around the table talking about how work was done, who invented the incredible variety of tools and clothing, and why they did so, we are finished writing and photographing the first of two books. This first volume covers the years spanning 1860-1920s, the era of both the open range and the fencing of the West. The next book will start where this one ends — describing the recent history of authentic cowboy gear from 1920s to the present. There is alot of overlap, no definite distinction in line or function, so anything left out in this volume will be included in the next.

Happy trails!

David R. Stoecklein
Publisher and Photographer
Ketchum, Idaho, 1993

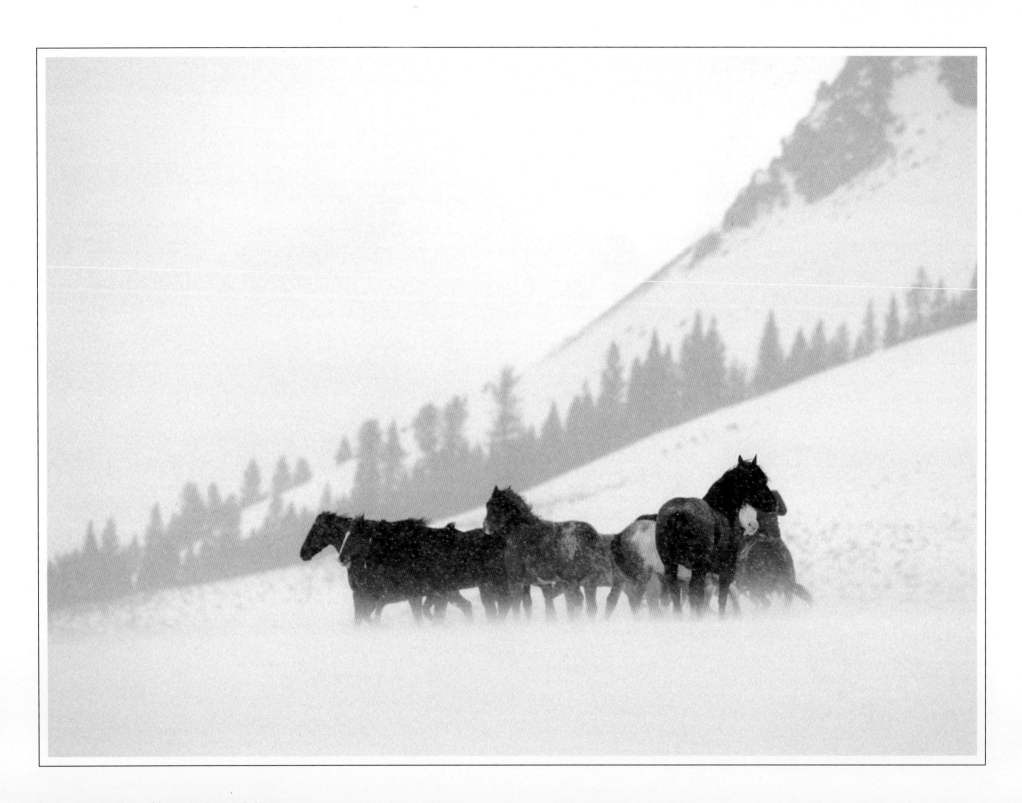

In the winter the horses' hair grew long and shaggy—
they adapted well to the wind and snow of the high country.

Contents

	Introduction	10
One	The Cattle Drives	13
Two	Longhorns	19
	Branding	22
Three	The Horse	31
	Breaking a Horse	43
	Hobbles	50
Four	The Chuck Wagon	53
Five	Catalogs, Merchants & Fobs	59
	Great Gear Makers	60
Six	The Saddle	67
	Stirrups	83
	Tapaderos	87
	Saddle Pockets	89
Seven	Bridles & Headstalls	93
	Bits	97
	Horsehair	105
Eight	Ropes & Roping	111
	Whips & Quirts	123
Nine	Cowboy Clothing	127
	The Hat	129
	Scarves	139
	Chaps	145
	Coats, Vests & Jackets	157
	Cuffs, Gloves, Gauntlets & Kidney Belts	165
	Cowboy Boots	173
	Boot Jacks	187
	Spurs	189
Ten	Guns & Knives	207
Eleven	The End of the Trail	219
	Cowboy Talk (A Dictionary)	220
	Bibliography	227
	Technical Notes	228

Introduction

The cool breeze of late spring softly rustled the sagebrush, wildflowers, and scrub cedar of the northern Utah mountains. At 5,000 feet above sea level, the morning of May 10, 1869, had dawned clear, and cold enough to freeze the water in scattered ponds. Now, by midafternoon, the sun had warmed the desolate valley floor and the bleak tent-and-shack shantytown crossroads of Promontory to nearly 70 degrees.

To the south, behind the nearby cedar-covered hills, loomed the Wasatch rampart. Invisible to the east and west lay the recently conquered Sierra Nevada and Rocky Mountains.

It was in this setting, under the anxious gaze of 1,500 tired and dusty laborers from three continents, top-hatted empire builders, and a few curious jackrabbits and buzzards, that Leland Stanford, president of the Central Pacific Railroad, swung an unwieldy silver-headed sledge-hammer toward a shiny golden spike.

As Stanford's shiny maul awkwardly clanged down (he missed on the first swing, hitting a steel rail instead), telegraphs simultaneously signaled "Done" to both East and West. A band played. Cheers of "til we bust" erupted and the steam whistles of the Central Pacific's locomotive Jupiter and the Union Pacific's famous No. 119 shrieked in celebration of Stanford's blows—blows that marked the completion of America's first transcontinental railroad and the end of a mammoth seven-year undertaking initiated by Congressional passage of the Pacific Railroad Act.

The "iron horse" had spanned the continent, and, in so doing, opened huge Eastern markets to the heretofore isolated Western cattle-men. Easy and economical rail access to market sparked the glory days of Western cattlemen and the hero of the West, the cowboy. Unbe-knownst to either, it also marked the beginning of the end of the famed Open Range of the American West.

During the next few decades, millions of cattle were driven to rail-heads throughout the West by an eclectic group of men. The riders ranged from wagon train pioneers to burned-out Eastern farmers, from disen-chanted Civil War veterans to exiled European royalty. The heyday of the American cowboy—man, myth, and legend—was running at full flood.

Before the railroad's penetration of the West, the region's vast herds of both wild and domestic animals were of little economic conse-quence. It was virtually impossible to get large numbers of animals to market efficiently. In his book *The Cowboy*, written in 1922, Philip Ashton Rollins remarked on the ranchers' circumstances before the advent of the railroads:

"The owners of these ranches obtained from them no commercial profit, for the reason that there was no available selling market for their animals. These owners could make of their livestock no disposition beyond satisfying the scant requirements of the hacienda's dinner table, or the need for leather by the local cobbler and neighboring saddlemaker."

Cattle and cowmen were nothing new to the American West in the late 1800s. By 1774, 25,000 cattle, descendants of the beasts that had landed with the Conquistadors more than 250 years earlier, filled the Nueces Valley in Texas. In 1842, when Mexico abandoned the Texas grasslands, the herds numbered in the hundreds of thou-sands. By 1860, there were more than three million cattle on the Texas range alone.

In the late 1840s, some Texas cattle were driven to points in Ohio and Louisiana, and even as far away as Chicago. Others were driven to ports for shipment to Cuba. But the numbers of these cattle were an insignificant part of the total longhorn population. It was the surging demand of booming Northern industrial cities following the Civil War, and the advent of rail transportation, that set the stage for the monu-mental cattle drives and created the new icon of the West, the cowboy. By 1865, cattle that sold for $4 a head in Texas brought $35 to $40 in the North. Economics sparked the cattle drives.

The men who herded, cared for and sold these cattle numbered in

the thousands. They rode the windswept, largely vacant territory bounded by the Missouri, Rio Grande, and Columbia rivers.

The cowboy's craft descended, essentially unchanged, from that of the Mexican vaquero (from "vaca," or cow). Clad in boots, chaps, wide-brimmed hats, and kerchiefs, they plied their difficult trade on lonely ranges and over trails with names like Texas, Chisholm, Northern, Fort Griffin, and Dodge City. Their work was dirty, difficult, poorly paid, and sometimes brutal. The cowboy earned about $30 a month for roping, herding, and branding cattle; breaking horses; shooting an occasional varmint; and protecting himself and his boss's livestock from the ravages of weather, disease, and rustlers.

The cowboys' heyday on the open range was brief, lasting only a few decades. The lifestyle was doomed from the beginning by the same railroad that had created it. In only 40 years, the open range and the huge herds had fallen victim to fenced waterholes, established ranches, barbed wire, windmills, farmers, and the growth of towns and cities along the rail lines.

Yet the men of this land, the cowboys, made an indelible mark on American history—in both fact and mythology. Their work, customs, culture, and tools are the stuff legends are made of. Books, poems, paintings, sculpture, radio, and motion picture dramas all strive to capture either the truth or the romance of these men, their times, and their deeds. The legendary cowboy ethic of strength, honesty, and integrity remains the model for the American folk hero.

The work of cattlemen continues today, in many ways unchanged and faithful to tradition. Men still ride and rope, break horses, and brand cattle in all kinds of weather. Often they are far from home, across plains and under skies that still seem nearly endless when compared to modern urban standards.

This book is a photographic essay of the early cowboy's tools and possessions. It attempts to highlight the most significant and important items in the kit of a typical hardworking cowhand who rode the range between the 1860s and the 1920s.

The cowman's gear evolved from that used centuries earlier by the vaqueros. The early Spanish and Mexican cowboys did such an effective job of engineering that their American counterparts adopted the early tools wholesale.

Author Rollins noted, "The methods and implements employed at these early establishments (Mexican ranches) were so fully developed that, when, years afterward, America's West came into existence, it at first adopted these methods and implements in their entirety, and subsequently modified them only insofar as to brand more industriously, break and ride less cruelly, shepherd more carefully. . . ."

This book catalogs many of those early tools, their evolution, and their variations on the Western range. All of the gear illustrated in this book is authentic, much of it of museum quality. These items reside in several private collections, and many have been passed down through generations of ranching families.

The intent of this volume is to exhibit traditional cowboy gear in its natural environment—outdoors, on horseback, in the face of bitter winter wind and cold, or under searing summer sun. It shows the reader the applications of cowboy gear, the difficulties and challenges of range work, and the wild, raw beauty of the cowboy's workplace. The gear and people photographed seem to take on added dimension, color, and texture when shown in their natural context.

This book offers a general explanation of the heritage and use of the items shown. It describes which items and makers were favored over others, and how the isolated cowhand came to procure the goods he required.

While this book is by no means intended as a historical resource on the American cowboy, it does endeavor to explain the development and evolution of the cowboy and his culture through these pages of photography, illustration and text.

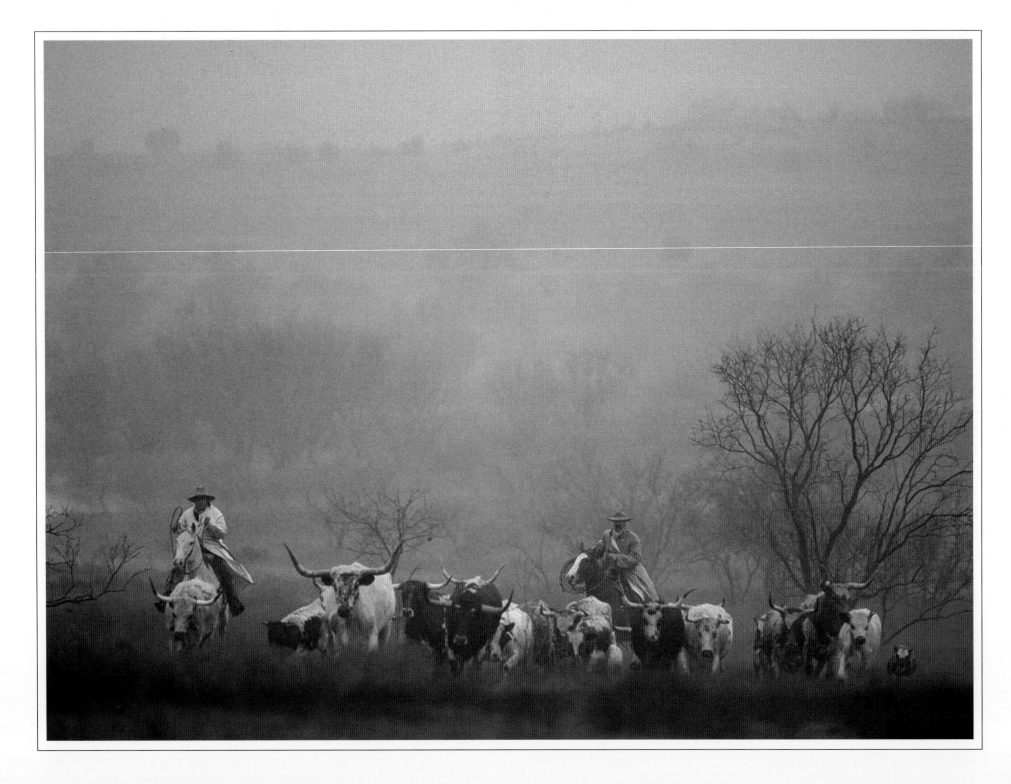

The mesquite brush in Texas had thorns an inch long and was thick as a brick wall.
In this mesquite hid the wild longhorns.

The Cattle Drives

Chapter 1

"As I walked out one morning for pleasure,

I spied a cow-puncher all riding alone;

His hat was throwed back and his spurs were a-jingling,

As he approached me a-singin' this song:

Whoopee ti yi yo, git along, little dogies,

It's your misfortune and none of my own.

Whoopee ti yi yo, git along, little dogies,

For you know Wyoming will be your new home.

Your mother she was raised way down in Texas,

Where the Jimson weed and the sand burrs grow;

Now we'll fill you up on prickly pear and cholla

Till you are ready for the trail to Idaho. . . ."

—Cowboy folk song

A man is not a cowboy if he's never pushed a cattle herd across the prairie. A ranch without cattle, in the eyes of a cowboy, is no ranch at all.

While the completion of the transcontinental rail line in 1869 helped expedite the transportation of beef from coast to coast, most herds still had to be driven from Texas or other range and roundup areas to the nearest rail towns. Kansas City and Sadalia, Missouri, and Abilene, Ellsworth and Dodge City, Kansas, were destinations of drovers with herds bound for the slaughterhouses of Omaha or Chicago. In the 20 years between 1867 and 1887, an estimated 5.5 million cattle were driven over thousands of miles of trails to railway cowtowns. More than 300,000 head were driven to various railheads in 1866, a number that swelled annually, cresting at nearly 600,000 in 1871. The lowing, dusty tide subsided quickly after 1885, falling victim to fence and farm.

Prior to final shipment to the Eastern stockyards, some of the massive herds were driven northward to Montana, Wyoming, Idaho, and Colorado, where the cattle would fatten on the grass that was plentiful there.

Depending on their destination, early cattlemen used a number of trails for this annual pilgrimage. The California Trail was more than 1,500 miles long. Texans first used it in 1848, when they realized their cattle would command good prices in California. The trail headed west out of Texas, along the Mexican border. It skirted El Paso and Tucson, Arizona, then branched out in various directions for San Francisco, Los Angeles, or San Diego. The Shawnee Trail followed old buffalo and Indian paths, running north from south Texas, past Austin and Dallas, through Oklahoma, and into Missouri.

The Goodnight-Loving trail, probably the West's most heavily used, was pioneered in 1866 by Texas ranchers Charles Goodnight and Oliver Loving. The trail ran from west Texas, along the Pecos, into what is now New Mexico. From there it turned north, passing through Colorado and Wyoming, and ending in Montana.

However, the longest ambling route was the Western Trail. First used in 1876 and requiring a journey of up to five months, it was also known as the Chisholm, Fort Griffin, and Dodge City Trail. Named for a Cherokee Indian, Jesse Chisholm, it was popularized in 1867 by Joseph McCoy, who established Abilene, Kansas. The trail was really a collection of more or less parallel paths leading to water, forage, and relative safety from the elements or hostile humans. Beginning in central Texas, the track crossed the Red River and then flowed north across Oklahoma, Kansas, and the Dakotas. In the Northwest, the same route was known simply as the Texas Trail.

The Chisholm Trail was used by many, transporting an estimated four million cattle north. It was popular with cowboys for a number of reasons: It was shorter than some other trails to Abilene, it had relatively easy river fords, and along its route there were ample supplies of water and grazing pastures for the cattle.

Manpower on the typical cattle drive consisted of one cowboy for every 175 to 300 head of cattle—depending on the generosity of the owner and the danger of the territory to be traversed. A typical herd ranged from 1,500 to 3,000 head, often stringing out more than a mile from van to "drag," the tail end of the herd. Ultimate herd size was largely determined by the number of animals that could drink simultaneously, since the impatience of thirsty bovines denied immediate access to a water hole could result in fights, injuries, or fatalities to the stock. Three thousand thirsty longhorns required nearly a mile of stream frontage in order to wet their collective whistle.

Cowboys often worked 18-hour days, seven days a week. The pay each hand received depended on his duties. The trail boss was paid approximately $100 a month, while the cook might receive $50 and all he could eat. The cowpunchers were paid about $30 a month for driving the herd and suffering all manner of trials—heat, cold, rain, mud, thirst, loneliness, and the ever-present threat of stampede.

Stampedes were liable to be caused at any instant by something as unpredictable as the sight or smell of buffalo. The entire herd might "hightail it" across miles of prairie because of a loud sneeze, the clatter of a tin cup, an abruptly tossed hat, a hailstorm, a lightning flash, or even a rapid moonrise. One drover confessed to having his herd stampede 18 times in one night. Another said his herd ran 40 miles before coming to a stop.

A stampede sent all hands flying to reach the perimeter of the scattering herd, turning the surging beasts into a U-shaped, circulating mass that milled about until the animals became exhausted or exorcised whatever demon had precipitated their flight.

At sunup each morning of a normal day on the trail, the cowboys spread out around the dusty column of beef, each man riding at the position his job required to keep the herd moving. Slightly behind and some distance from the lead cattle rode the "point" or "lead" men. Their job was to gently guide the herd's direction of travel. The herd was turned by the point men riding to a position in front of the leading cattle, then arcing their path in the desired direction. Because the lead cattle shied from the approaching human on the one side, and moved toward the receding cowpoke on the other, they soon found themselves following a new route.

Following the point riders by several hundred yards were the "swing" or "flank" riders. The flank riders contained the column's sides and discouraged local stock from joining the driven herd. In the choking dust cloud following the herd rode the "tail" or "drag" men, whose unfortunate task it was to urge along the lazy, tired, or weak stragglers at the rear of the herd. Following the drag came the remuda and its "wrangler" or "remuda man." The remuda contained extra mounts for all hands. It usually consisted of nearly 100 horses, an average of seven mounts for each cowhand on the drive. In the vicinity of the remuda rolled the ubiquitous chuck wagon, occasionally in the company of a "hooligan wagon," which carried fuel and water in treeless and arid country.

On the long drives of later years, a "calf wagon" or "nursery" joined the parade, carrying trail-born calves until they were strong enough to join the drive. This ended the earlier practice of killing the calves because they were too weak to keep up.

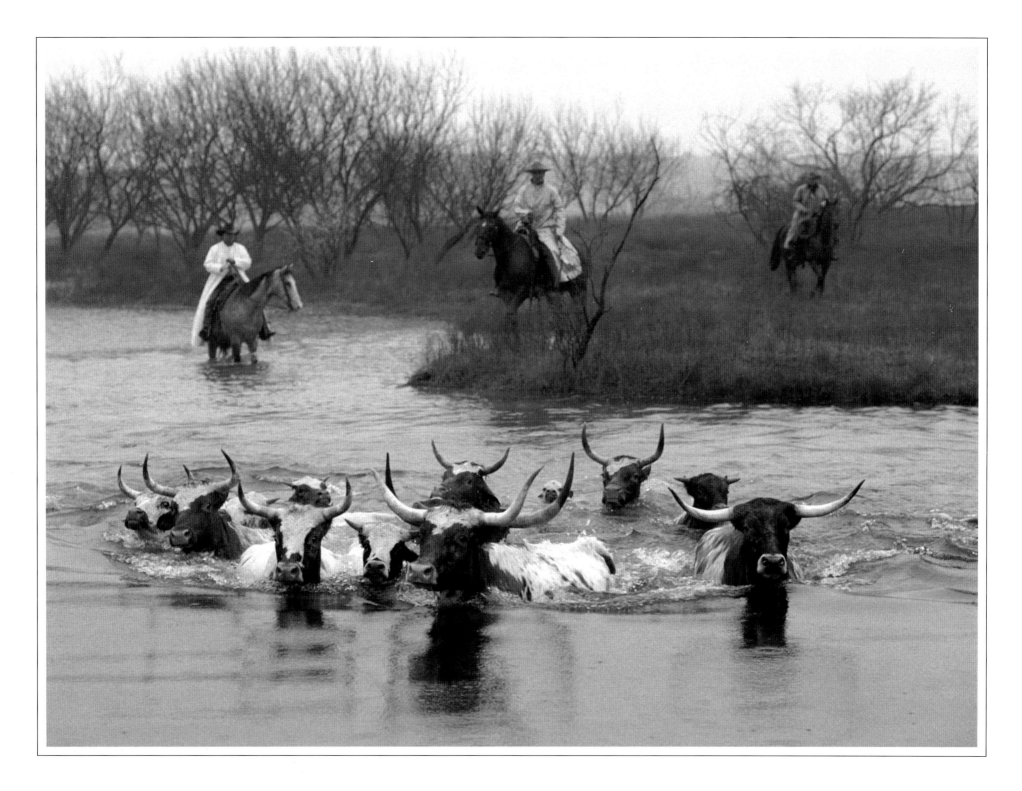

"Swimming the rivers across our way,
We fight on forward day to day."

—Doney Gal

Traveling ahead of the herd by a day's journey —usually 10 to 15 miles—was the scout. This cowboy searched out the safest route and river crossings, available water sources, and grass.

Late each afternoon, the cowboys "rode down," or gathered the herd into a reasonably concentrated mass. Three thousand cattle could be compressed onto five or six acres. The gathered herd was then moved, or "thrown off" the principal trail, about half a mile. This was done to avoid confusion with other bovine caravans that might be coming along the same track. The cattle were allowed to graze before being "bedded down" by the hands who drew night watch duty. This consisted of slowly riding in opposing circles around the cattle, singing whatever gentle tunes came to mind. Hymns were often selected for their calming tones, but the lyrics were altered extensively to suit the cowpuncher's mood or vocabulary. The vocalizing of these night watchmen was done in the hope of keeping the cattle calm and averting a dreaded night stampede.

Finally, following months of drought, dust, violence, and boredom, the herd reached its trailhead destination in cowtowns such as Abilene, Dodge City, and Newton. When the cattle were loaded onto eastbound trains, and the cowboys indulged in their famous post-trail exuberance in the readily available saloons, before returning to whatever range or ranch they called home.

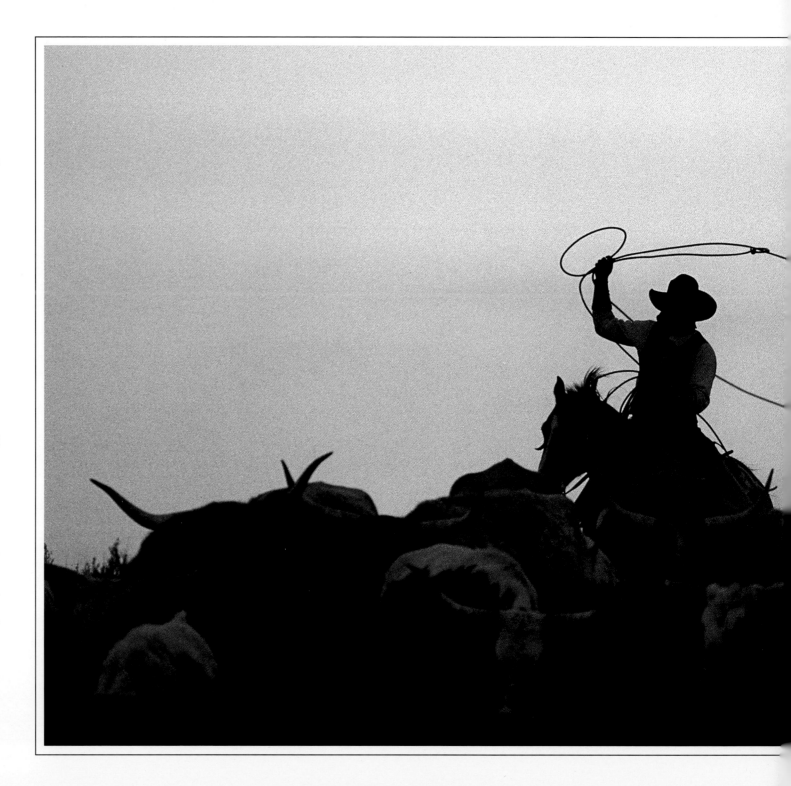

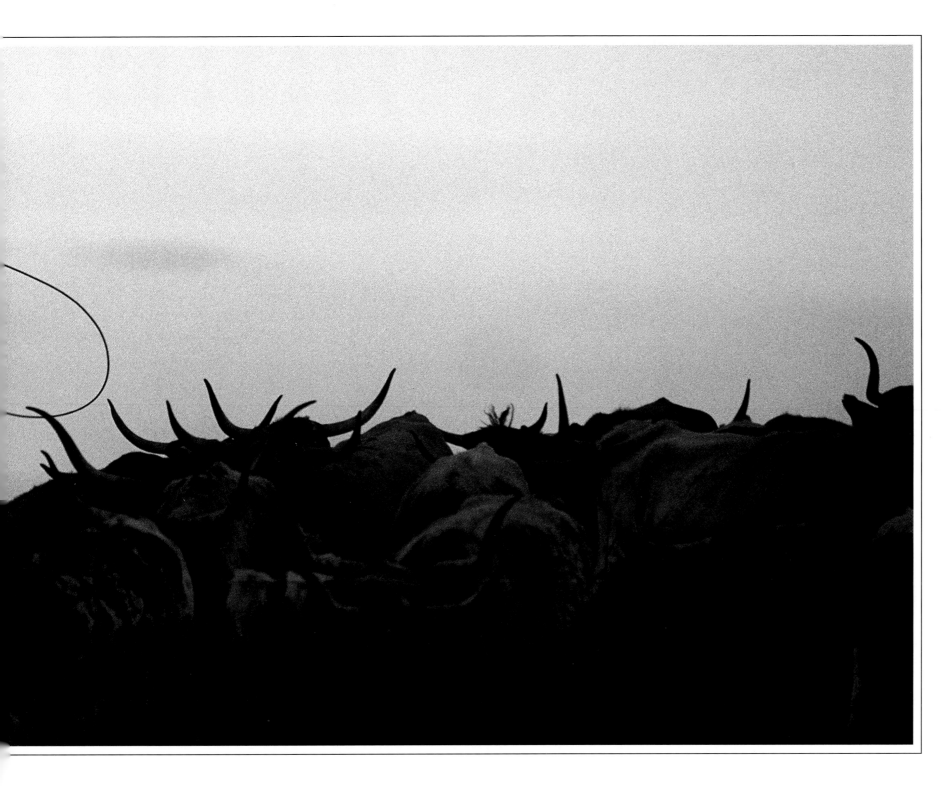

"I'm bound to follow the longhorn cows until I'm too old;
It's well I work for wages, boys, I get my pay in gold."

—The Lone Star Trail

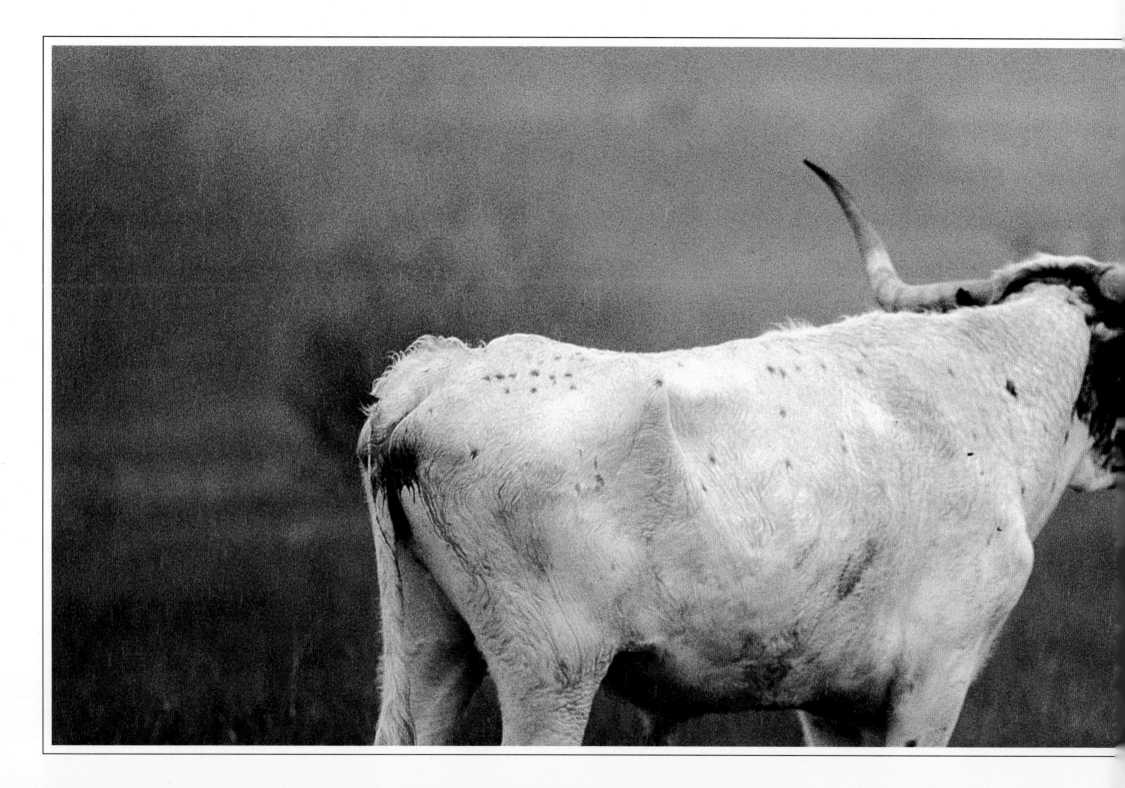

The lead steer was a tame longhorn that was easily guided by the cowboys and was followed by the rest of the herd. These special and valued animals were brought back to the ranch with the horses at the end of the cattle drive. There are many legends about these steers in Texas history. Longhorns came in all colors and combinations of colors, and their horns varied widely in length and shape. The biggest horns could reach eight feet from tip to tip.

Longhorns

Chapter 2

"*Cowboys familiar with the breed so described the Texas longhorn steer as 'tall bony coarse-headed, coarse-haired, flat-sided, thin-flanked . . . three-fifths horn and hooves and the rest hair.'*"

The Old West Quiz & Fact Book
Rod Gragg; Harper & Row, 1986

The herds that comprised the early cattle drives were populated almost exclusively by the Texas longhorn, a descendant of early Spanish renegade cattle. Named for their horns, which could easily measure 6 to 8 feet across, the irascible beasts were also known as "coasters," "sea-lions," "cactus boomers" and "mossy horns."

In his 1903 account of a Texas cattle drive, writer Andy Adams characterized a herd of Mexican longhorns: "They were the long-legged, long-horned Southern cattle, pale colored as a rule, possessed the running powers of a deer, and in ordinary walk could travel with a horse."

To gather a herd of wild cattle literally required hunting them in their brushy stomping grounds, then rousting them with all manner of violent intimidation, including, as cowboy historian Jo Mora detailed, "Tail twistings, six-shooter shots close to the tender parts, dirt in the eyes, hard spurrings, lashings with the quirt or coiled lariat, draggings with a rope and horse, in fact everything a desperate cowboy could think of. . . ."

Once gathered into a herd, the independent longhorn still had a tendency to bolt for the familiar brush. To halt this behavior, the cowboy used the "coleo," or tailing. Tailing was the practice of grabbing the errant beast by the tail and standing it upon its head, often breaking a horn or a rib. But even this violent treatment was only modestly effective.

Cowhands would often use oxen or domesticated cattle to decoy the wild longhorn into joining the bovine parade. Each herd had a "lead" animal that broke the trail each day under the point men's guidance. Fortunately for the cowhand, the longhorn drives lasted a mere two decades before the independent beasts were replaced by more docile, shorter-horned breeds.

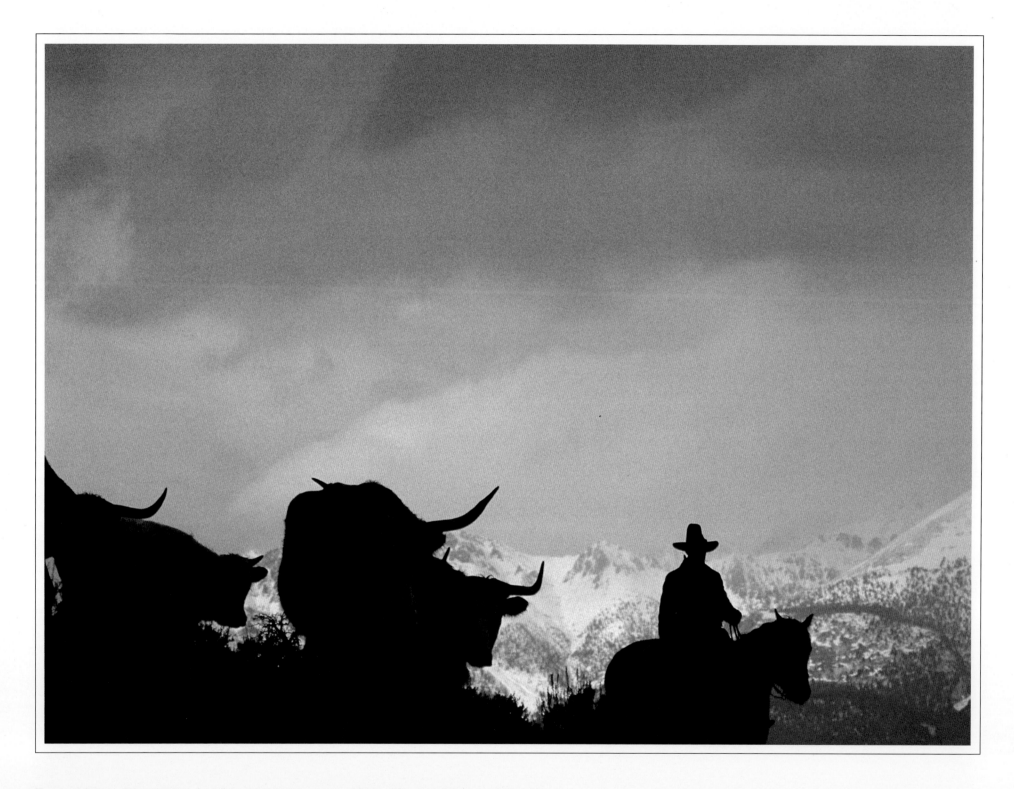

Texas cattle were driven north to feed the gold and silver miners of Idaho, Montana, Oregon, and Nevada.
Ranches were built in the deep grass of the high mountain valleys to house them upon their arrival.

Brand Marks of the Early Trail Drivers

(O Six) H.L. Kokernot Ranch, Alpine, Texas. The O6 brand was registered in Calhoun County as early as 1837. In the 1850s Capt. W.E. Jones registered the brand, and it was bought by J.W. Kokernot in 1872. Today the O6 holdings lie between Alpine and Fort Davis, Texas, and are managed by Chris Lacy Jr.

(Pitchfork) Pitchfork Land and Cattle Co., Guthrie, Texas. First registered in 1843, the Pitchfork brand was used upside down and did not have a middle prong. In 1879, a man named Jerry Savage ran cattle near the headwaters of the Wichita River using the Pitchfork brand upright and with a middle prong. Today the Pitchfork brand is used on cattle on 165,000 acres in Texas, on 32,000 acres in Wyoming, and on 4000 acres in Kansas. Jim Humphreys is presently the vice president of Pitchfork Land and Cattle Co.

(Rocking Chair) Rocking Chair Co., Ltd., Collingsworth, Wheeler, Donley, Gray, Childress and Hall counties, Texas. The Rocking Chair brand came to Collingsworth County from the area around the Llano River about 1879. Today, Bill and George Arrington use the brand and another version of it is used by L.C. Whitehead, whose ranch is in Fort McKavett, Texas.

(Running W) King Ranch, Inc., Kingsville, Texas. The running W brand, which appeared as the official brand of the King Ranch in the 1860s, may have originated by turning over an "M" brand that King acquired when he bought the land and livestock from William Mann in 1862. The brand has been burned onto the hides of thousands of cattle through the years, but since about 1950, the main breed of cattle to wear the Running W has been the Santa Gertrudis breed, which was developed on the ranch by then-ranch manager R.J. Kleberg Jr.

(Mill Iron) Mill Iron Ranches, Texas Panhandle. Col. Wm. E. Hughes, a Civil War veteran, organized the Continental Land and Cattle Co. In 1870, the company registered the Mill Iron brand. For many years the ranch was one of the best-known registered Hereford operations in the country.

(Turkey Track) Oliver Loving and Son, Jermyn, Texas. The Turkey Track brand, which is made with two irons, a half-circle and a bar, is still used today by Oliver Loving III.

(XIT) XIT Ranch, Texas Panhandle. Abner Blocker is generally credited with having devised the XIT brand, which is known throughout cattle country as one of the hardest brands for a thief to alter. In the early years, the brand was carried by as many as 150,000 longhorn cattle. The ranch began to slowly improve the native cattle by infusing blood of Hereford, Shorthorn, and Angus breeds. In 1901, the ranch began selling some of its land, and by 1912 the last of the XIT cattle were sold.

(Long S) C.C. Slaughter, Dallas, Texas. Rancher Slaughter is famous in Texas as one of the first cattlemen to use English bulls to upgrade Texas longhorn cattle. He started the Long S brand in 1879.

(Long X)) Reynolds Cattle Co., Fort Worth, Kent, and Dalhart, Texas. The Reynoldses were an early Texas ranching family. The Long X brand originated about 1882, and gave the 225,000-acre ranch in Jeff Davis County its name.

(Matador V) Matador Land and Cattle Company, Motley County, Texas. In 1879, John Dawson sold a herd of cattle wearing the "V" brand to Matador Ranch, and the ranch adopted the brand as its own. Today the ranch is run by Matador Cattle Co. out of Wichita, Kansas.

(Circle) Charles Goodnight and Oliver Loving, both trail drivers. In 1866, Goodnight and Loving established a cattle trail from Fort Belknap, Texas, to Fort Sumner, New Mexico. On the third trip, Loving was attacked and wounded by Indians. He sought cover near the Pecos River, and his repeating Henry rifle was buried in the mud. Loving later died, but the Henry, although wet, still worked. That incident brought credibility to repeating rifles and led to the development of the Winchester. The circle brand was Goodnight and Loving's road brand, and was only burned on cattle destined for the trail.

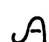

(Half Circle 10) George Saunders, San Antonio, Texas, cattleman, trail driver, and founder of the Trail Drivers Association. Saunders first started ranching as a teen when his father and brothers left the family operation to fight the Civil War. In 1871, Saunders made the first of his nine trips in 15 years, trailing cattle from Texas to Kansas. In 1888, he started the George Saunders Commission Co., and later established Union Stockyards, both in San Antonio. His father, Thomas Bailey Saunders, gave him his brand on his tenth birthday.

(SMS) SMS Ranches, Stamford, Texas. Svante Mangus Swenson, an immigrant Swede, came to Texas in 1836 and prospered in the mercantile business and banking. His wealth enabled him to acquire vast acreage in the Texas Rolling Plains. His sons, Eric and S.A. Swenson, developed this land for ranching and selected their father's initials as the ranch's brand. Legend says that the S's were branded backwards after a blacksmith mistakenly forged an iron that way.

(Four Sixes) Burnett Ranches, Inc., Fort Worth and Guthrie, Texas. Samuel Burk Burnett bought the brand in 1871, along with 100 cattle. A popular but untrue story is that Burnett's brand represented a winning hand he once had while playing poker for large stakes.

(Frying Pan) Glidden and Sanborn, Texas Panhandle. The Glidden and Sanborn 300,000-acre ranch was located on an old Indian camping grounds next to the XIT ranch. The operation began running the Frying Pan Brand, also called the Skillet and the Panhandle, in 1885, and it is currently recorded in a number of Texas counties by various cattlemen.

(JA) M.H.W. Ritchie, Clarendon, Texas. Col. Charles Goodnight selected the JA brand in 1876 to honor his partner, John Adair. The two men ran cattle in six panhandle counties. When Adair died in 1885, his widow continued the partnership until 1887, when the property was divided and she retained the JA brand and ranch.

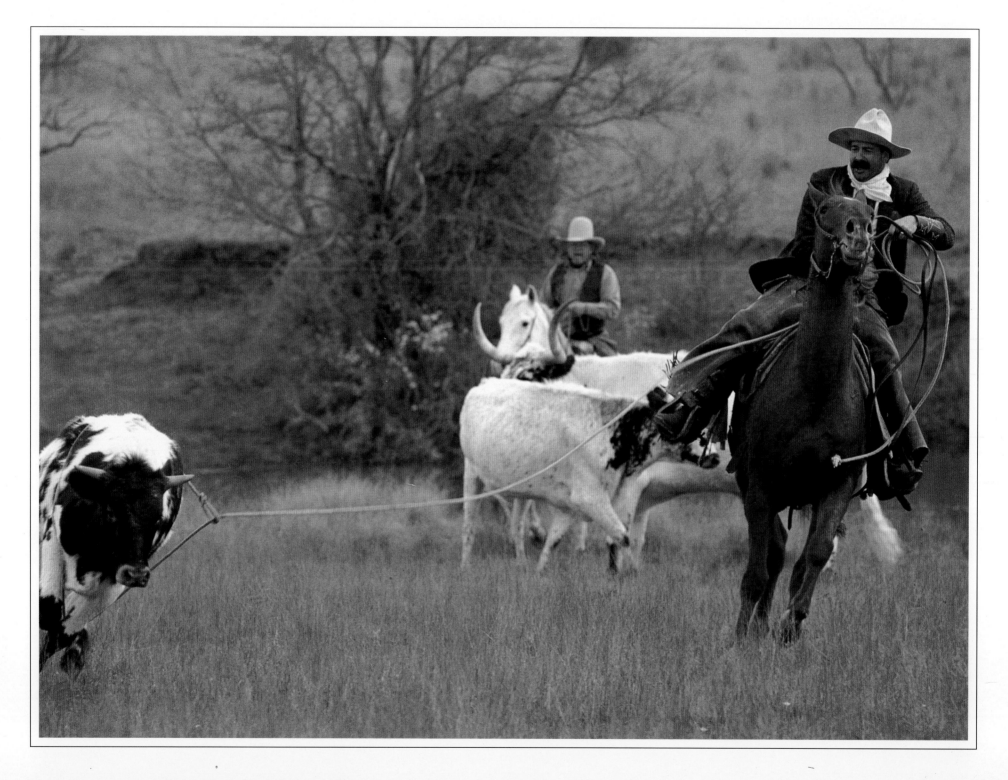

"Your foot in the stirrup and your hand on the horn,

you're the best durned cowboy that ever was born."

—The Old Chisholm Trail

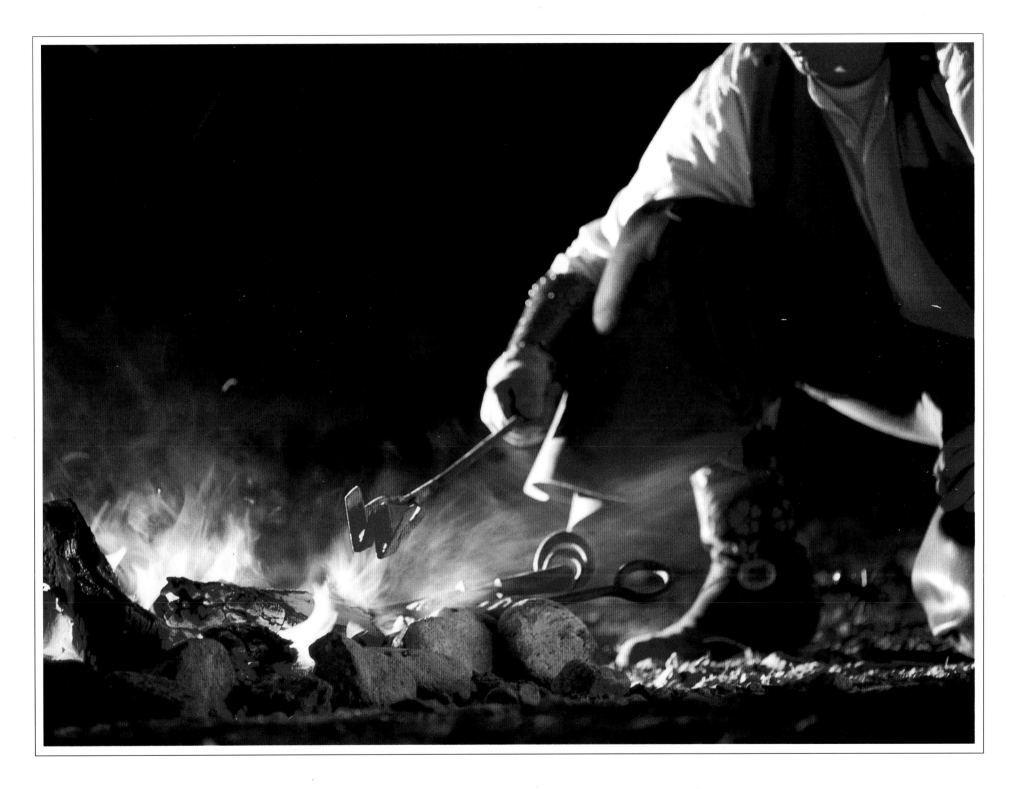

A cowboy learned to brand through experience. He gauged the temperature of an iron in the campfire, knowing that too hot an iron would blotch the hide, and too "cold" an iron would render a brand that would rub off down the trail.

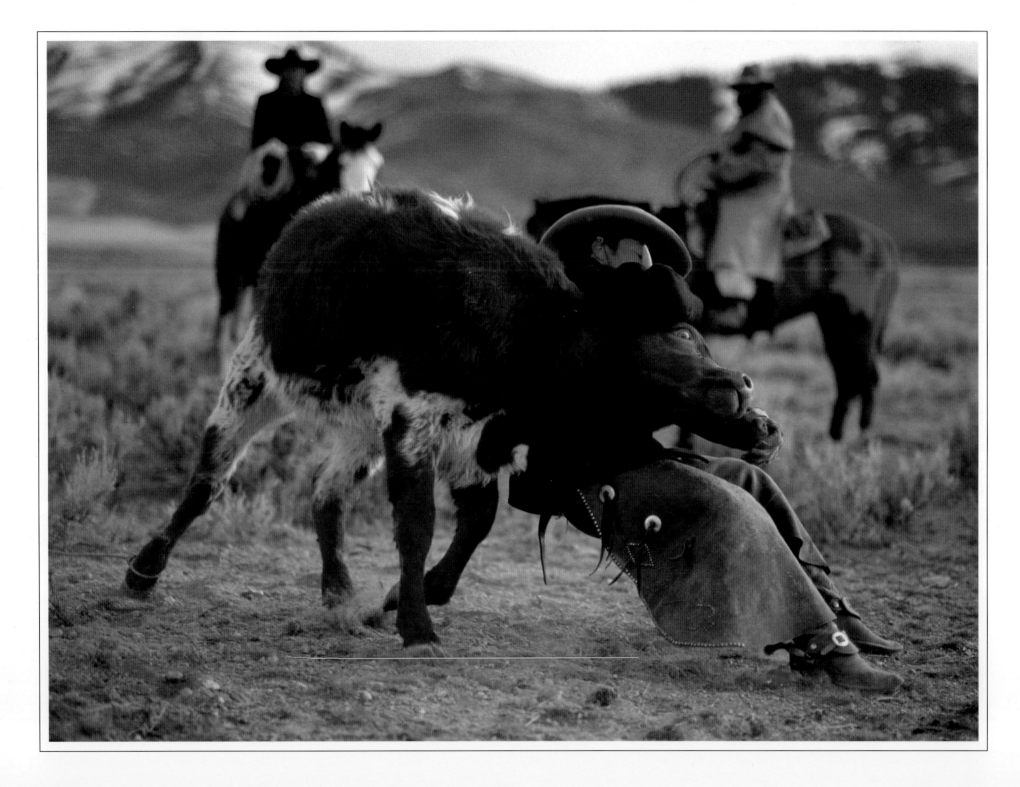

Bulldogging a steer: Steers of this size sometimes had to be wrestled to the ground before branding;
other times, bulldogging a steer was done for sport.

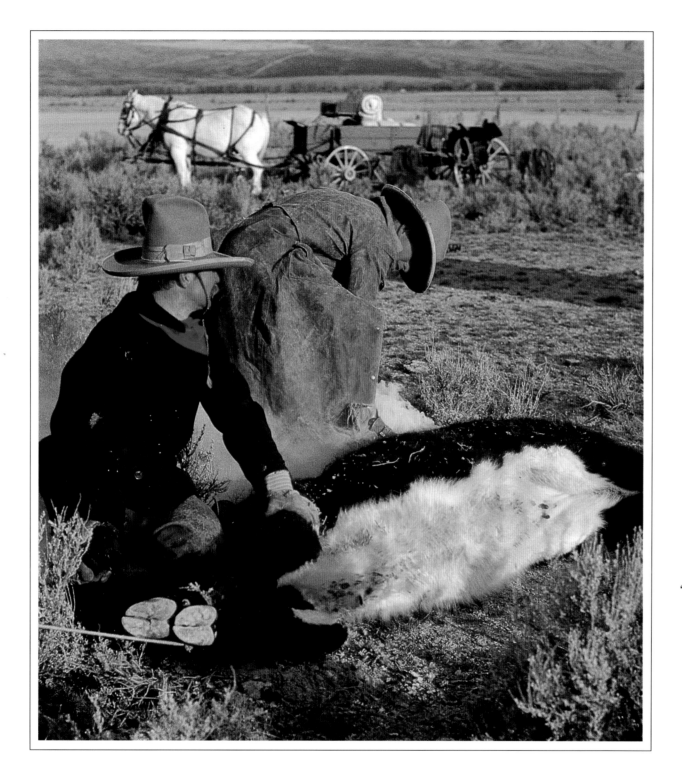

"*We fellows don't know how to plow*
Nor reap the golden grain,
But to round up steers
And brand the cows
To us was always plain."

—Bronc Peeler's Song

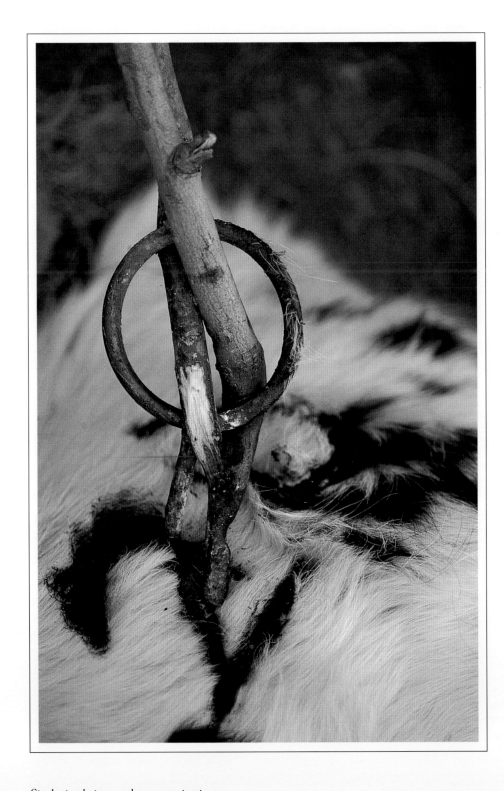

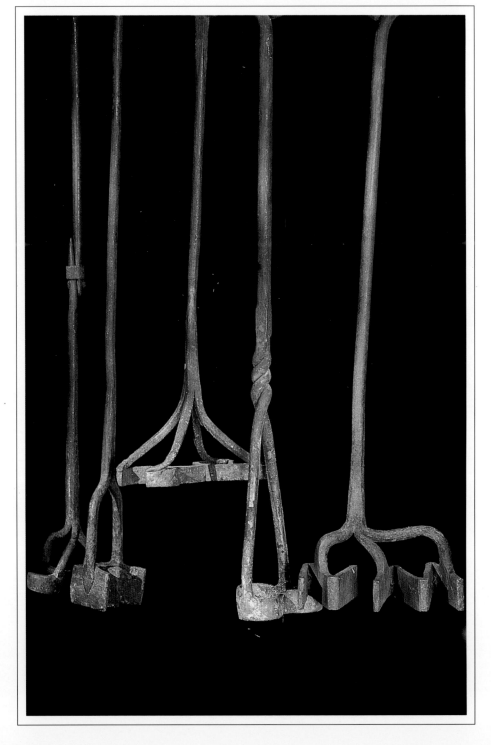

Cinch ring being used as a running iron.
Running irons were an important tool for the early branding
teams and, later, for cattle thieves.

A variety of branding irons. Well into the 20th century, all branding irons were made of
malleable iron, hammered into shape wholly by hand. A shorter handle made an iron
harder to handle, yet easier to pack in the field. The iron on the far left folds in the middle,
perfect for working mavericks in the brush and packing in a saddlebag.

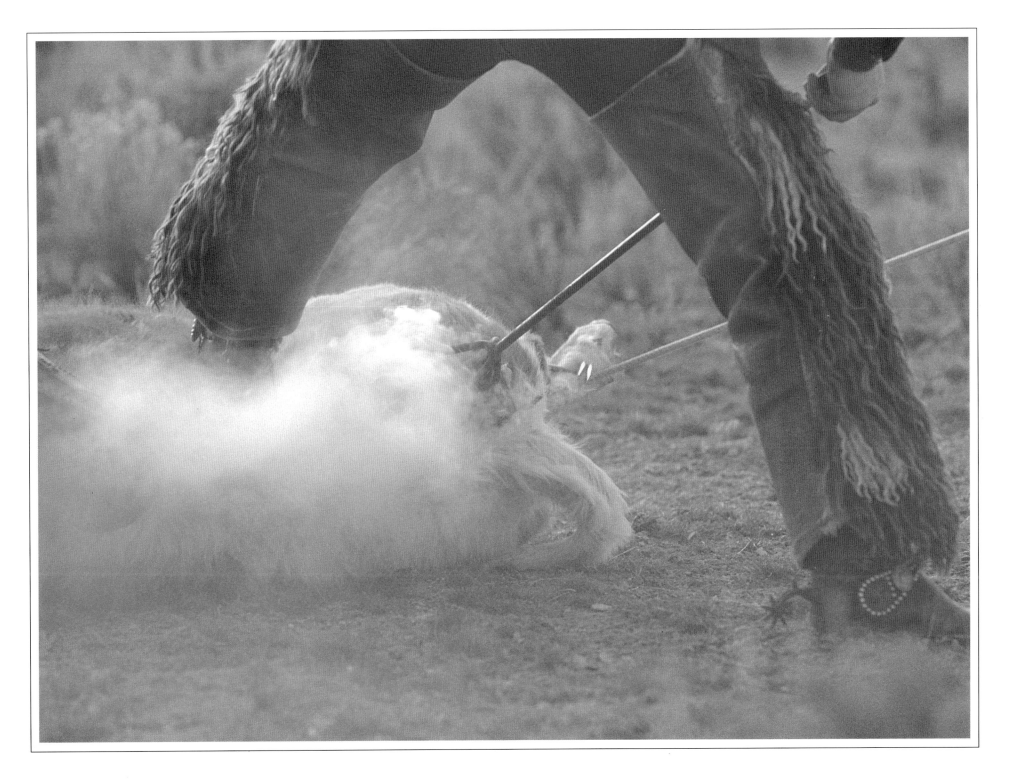

"Next morning at daybreak in a circle we ride, we round up the dogies, take down the rawhide,
we rope them and brand them like in days of old, upon the left shoulder we stamp the 8-0."

—The Pecos Puncher

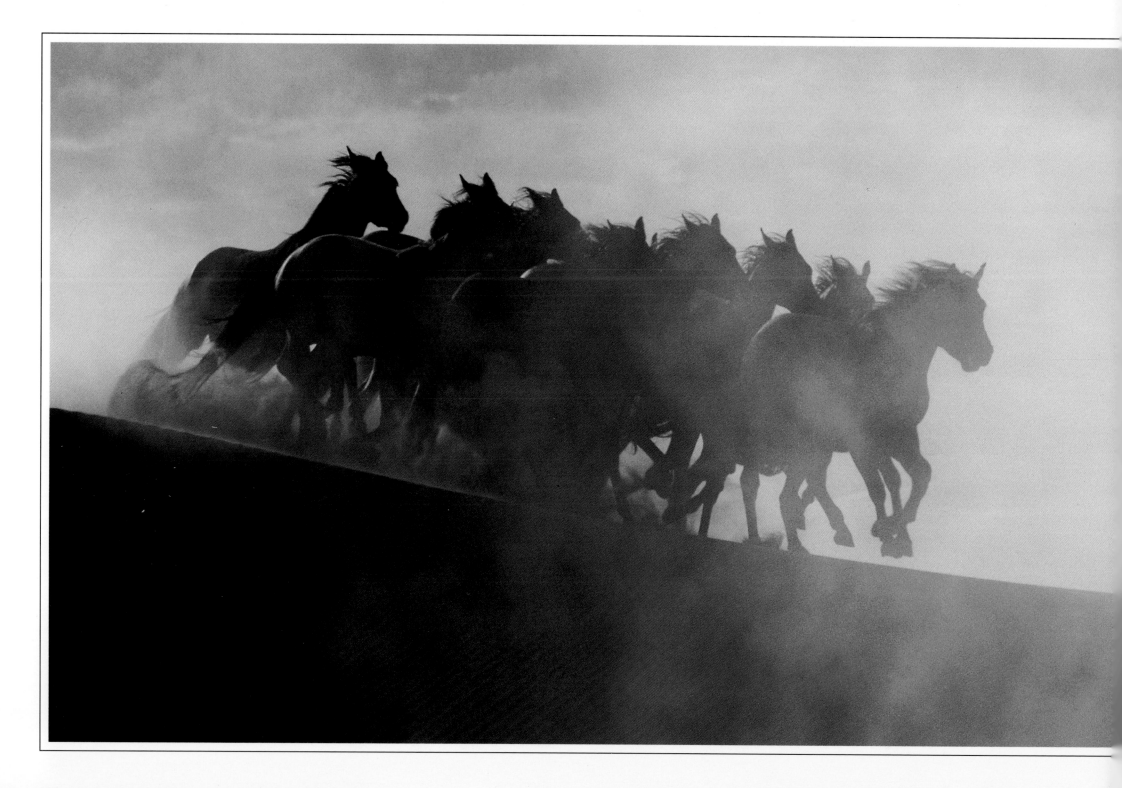

"I've roped the wild horse and tied him down quick,

did the saddle act and forked him plumb quick."

—Wild Bronc Peeler

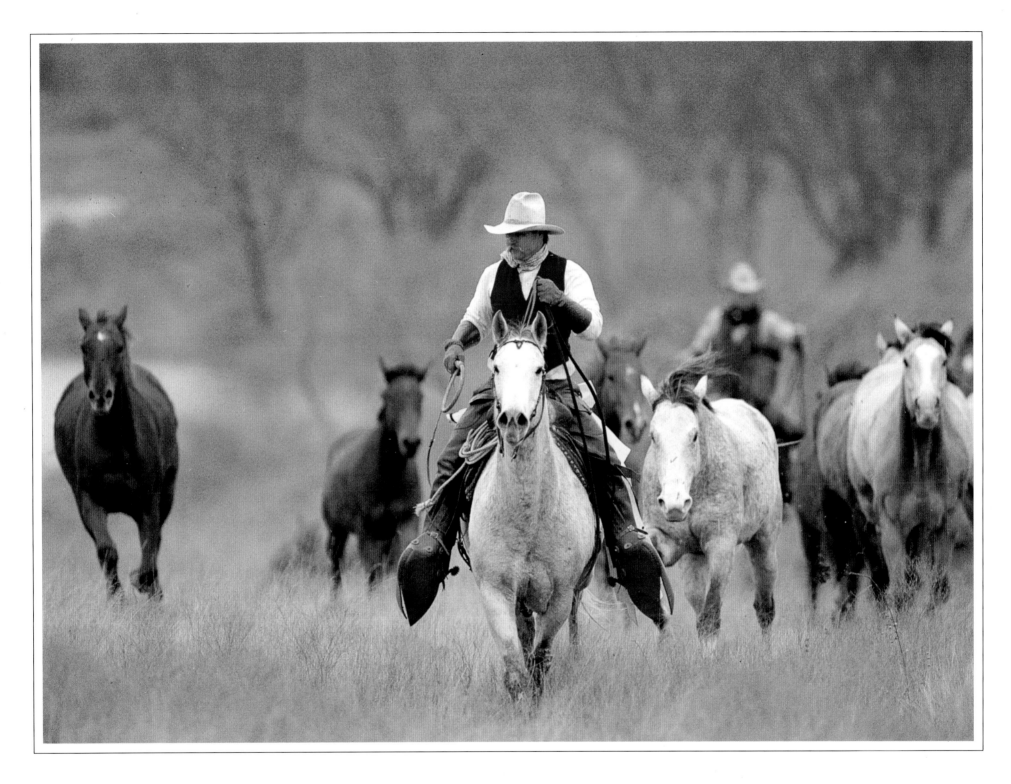

"He put me in charge of a cavyard, and told me not to work too hard—
that all I had to do was guard the horses from getting away."

—The Horse Wrangler

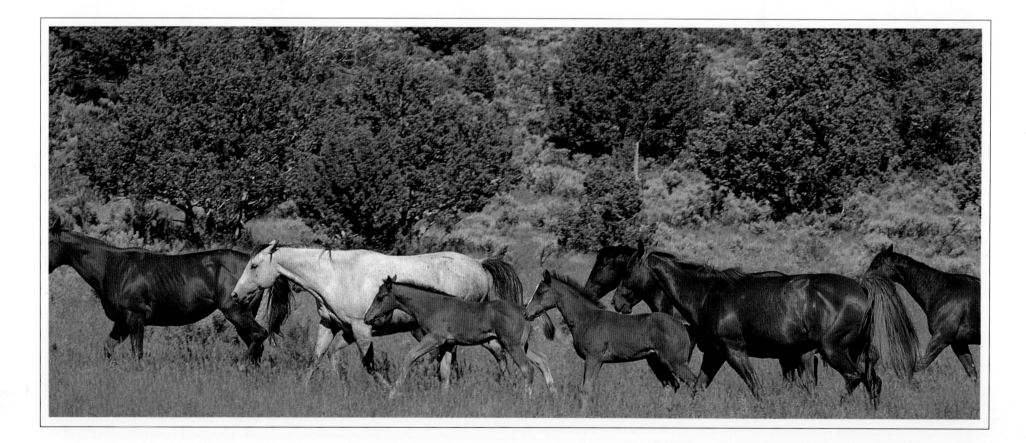

The Horse

Chapter 3

"*Since that old bug-eater (Mister Cave Man) snared that first cayuse, his descendants have been climbin', an' the hoss has been with 'em. It was this animal that took 'em from the cave. For thousands of years the hoss an' his long-eared cousins furnished all transportation on land for man an' broke all the ground for their farmin'. He has helped build every railroad in the world. Even now he builds the roads for the automobile that has made him nearly useless, an' I'm here to tell these machine-lovers that it will take a million years for the gas wagon to catch up with the hoss in what he's done for man. Today some of these auto drivers want to kill him off to make fertilizer out of his body. Mebby I'm sentimental, but I think it's a damned hard finish for one that has been as good a friend to man as the hoss.*"

Trails Plowed Under: "The Horse"
Charles M. Russell; Doubleday & Co., 1927

The horse was the cowboy's principal tool and, often, his best friend. An early cowboy could easily be lost or even killed if separated from his horse. An indication of the value placed on horses can be taken from the early Texas courtroom practice of sometimes wink-ing at cattle rustling, but sentencing horse thieves to hang.

Sixteenth-century Spanish explorers brought with them the first horses to roam the North American continent since the extinction of native prehistoric animals caused by the Ice Age thousands of years earlier. The Spaniards' beautiful animals, of Arabian breeding, were set free to graze the endless pasture of the New World. During the next three centuries, strays from these colo-nial herds migrated to the north, both along a coastal route and by an interior trail on the eastern slopes of the Continental Divide.

Horses carried names that varied with the geography they inhabited. These names included fuzzies, broncos, broncs, ponies, broomies, broomtails, cayuses, and mustangs. To the far north, equine descendants of followers of the coastal trail became known as the Oregon cayuse (sometimes spelled kiuse), deriving their name from the horse-riding Cayuse Indians. Coloration of horseflesh was another area with great variety, and included shades of white, black, piebald, roan, pinto, paint, and gray. Local to the Southern Califor-nia region was the California palomino, with its cream-colored tail and mane, and white stockings.

Heading north from Mexico along the eastern trail were the predecessors of the prized Western mustang. If ever there was a horse made for the cowboy and his work, it was this one. The mustang, having adapted to the wild desert conditions of the Old West, was a small, wiry, and sure-footed animal with great stamina. Traveling in "menadas," or bands, these horses were originally cap-tured in the wild by mustangers, men who tracked and tamed the elusive wild horses.

Mustangers often achieved quite a local reputation for their ability to think like the horses they worked with. Some-times catching these spirited animals was accomplished by simply walking quietly after the horse on the prarie, usually for several days. This was the origin of the term "walking down" a horse.

On early cattle ranches, cowboys would be assigned seven to ten horses each. This collection of animals was called their remuda, a Mexican-Spanish term meaning re-change or remount. Because of their reputation for being the best cowhorses, castrated stallions known as geldings made up most remudas. Stallions were considered too aggressive and apt to fight, and mares were thought to be too temperamental.

Each hand was responsible for his remuda, and a cowboy looking for work usually judged a ranch by the quality of its horses. If he didn't think the mounts were up to snuff, he would most likely stay only a few days before moving on in search of a

ranch with better stock. On the other hand, if a cowboy didn't tend his remuda properly, the ranch foreman might confine him to one horse, or perhaps banish him from the ranch altogether.

Cowboys weren't the only horsemen breeding horses. Indians, most notably the Comanches, bred the two-toned pinto. The Nez Perce of the Northwest preferred the spotted Appaloosa. Most cowboys seemed to prefer the solid browns, bays (a deep chest-nut red-brown color, with a black mane and tail), and sorrels (a light red with a golden tinge).

Regardless of coloration, the most prized horse in any remuda was the cutting horse, named for its ability to "cut out," or separate, a single cow from the herd. A good cutting horse is born with a "sense of the herd," a talent virtually impossible to teach. Much as a cowboy may have wanted a particular horse as his cutting horse, the animal either had the innate cutting ability or not.

Cutting horses were bred for size as well as know-how. Most cowboys agreed the best size for a cutting horse was between 14 and 15 hands high. (Horses are measured from the ground to the top of their withers, with a "hand" equal to four inches.)

While slowly maneuvering its way through a herd, separating the desired cow or calf, a cutting horse anticipates a resisting cow's every move—oftentimes spinning and turning to keep the beef on course. During a cattle drive, if a particular cow was persis-

tently too slow or too fast, or just plain ornery with the rest of the herd, a cowboy might use his cutting horse to separate the beast from the rest of the cattle. Often these renegade steers were traded for grazing or water usage along the drive's path.

Depending on the situation, a cow-puncher might go so far as to slip the bovine troublemaker a quick dose of lead poisoning, then turn it over to "Cookie" for that night's grub. Cowboys weren't known for their patience with stubborn longhorns, and no drive ever ran out of fresh beef.

A cowboy's remuda had a horse for just about every task. Along with the cutting horse, there was a rope horse that aided the cowboy when he was lassoing cattle, a night horse trained to work in the dark, and running and branding horses. There were even some horses trained to herd cattle across rivers and other bodies of water.

The horse did for transportation in the Old West what airplanes did for travel in the 20th century, and made the ranching and cattle culture possible.

The bond between cowboys and their horses is legendary. Often, a man's horse is as famous as he. In some cases, cowboys even asked to be buried with their mounts, provided, of course, that the horse expired more or less simultaneously with his rider. A cowboy once said to another as they turned their horses loose to graze after ten hours in the saddle, "You know, by God, Walt, I love that damn horse so much I like him."

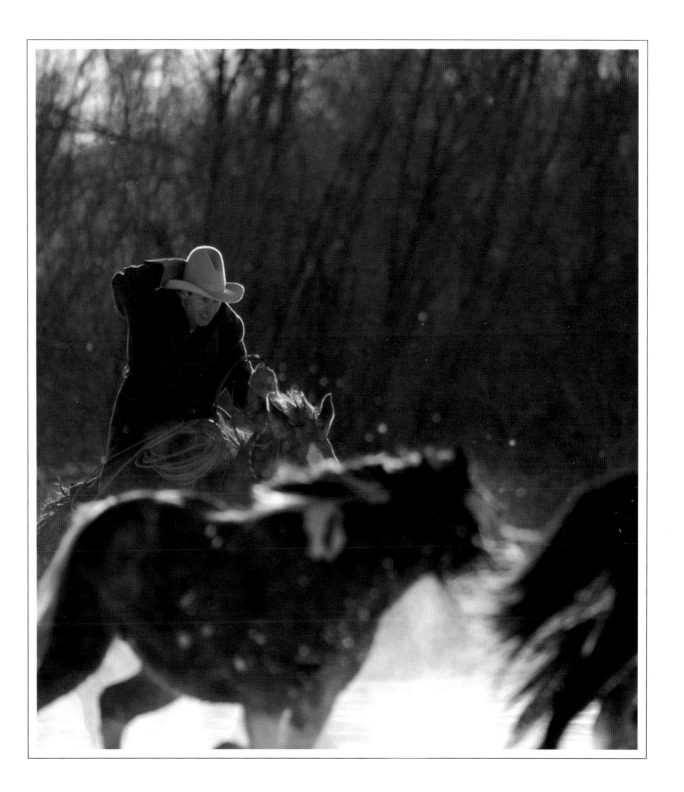

They rode as fast as the wind.

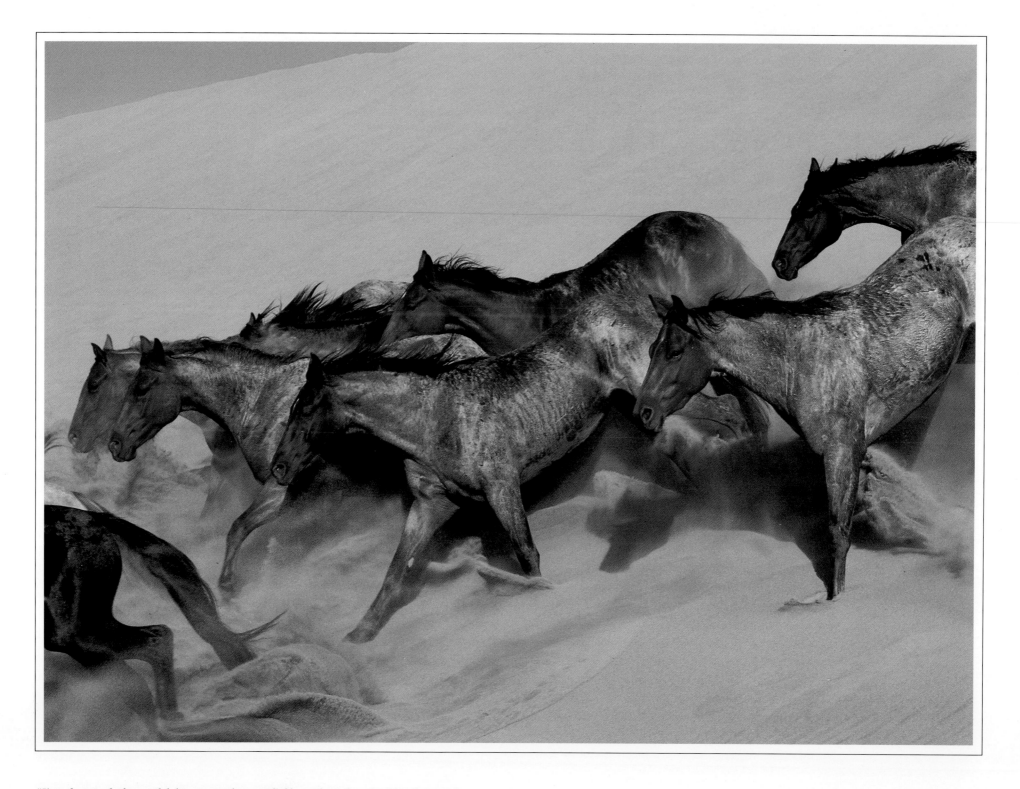

"I've busted the wild broomtails, with their heads plumb skinned,

And rode a slick saddle from beginning to end."

—Wild Bronc Peeler

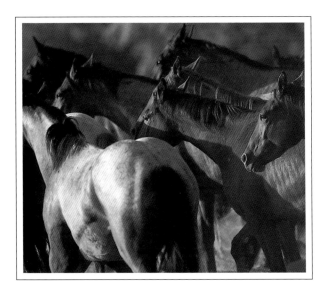

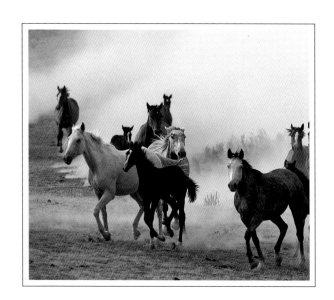

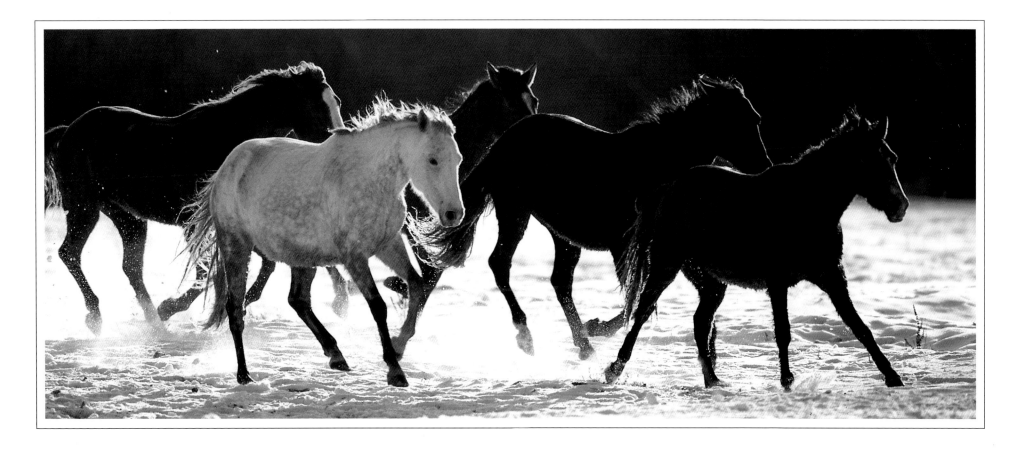

"But the cattle now are shipped and homeward are we bound
with a lot of tired horses as ever could be found."

—The Crooked Trail to Holbrook

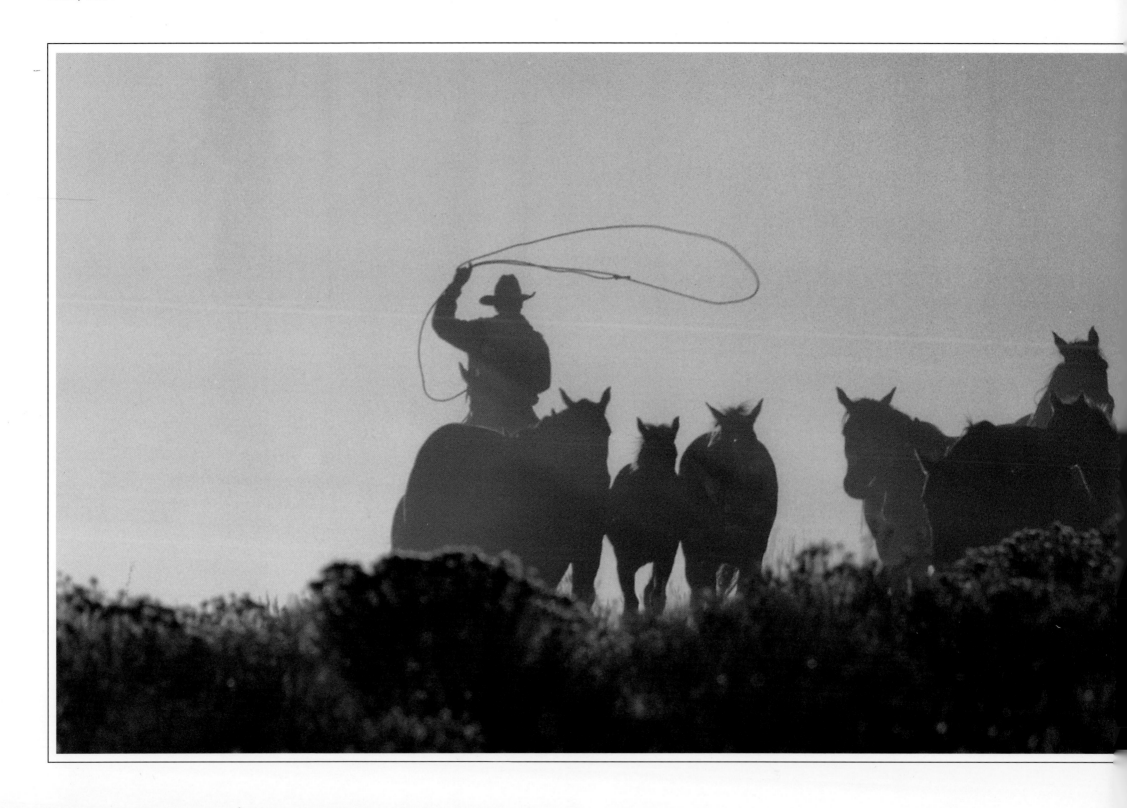

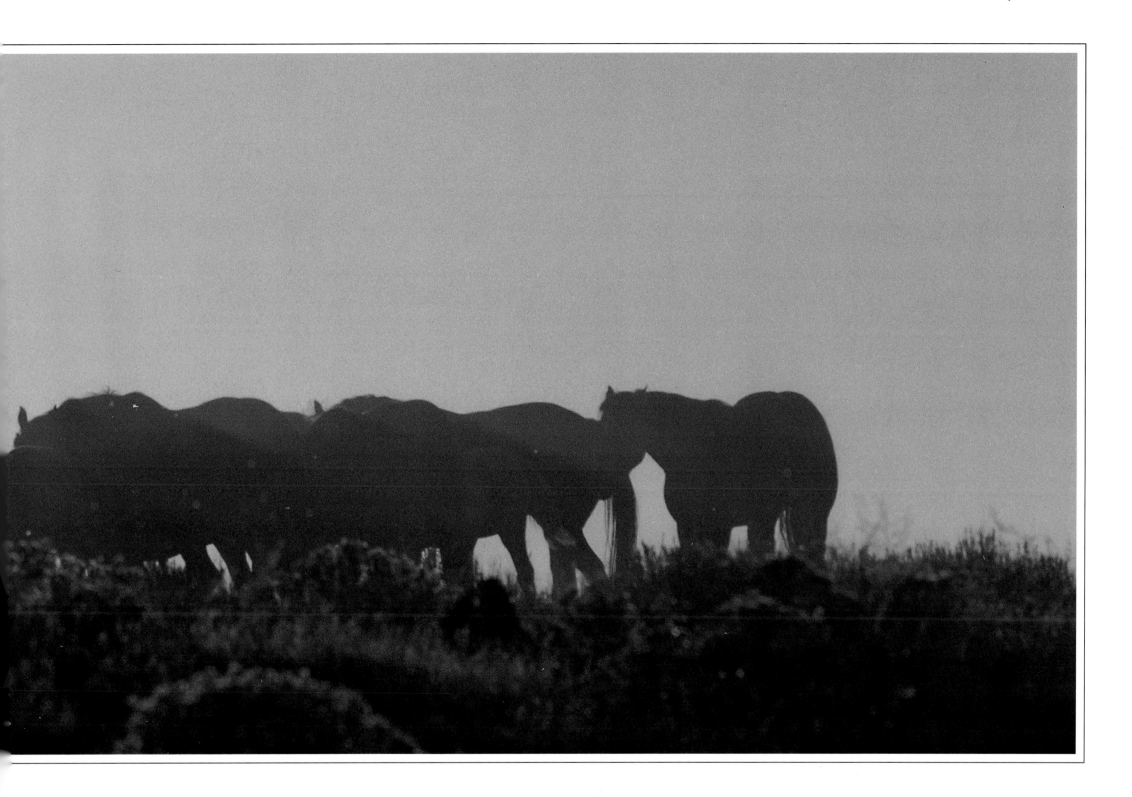

"When you fail to find a pony or a cow that's gone astray / Be that cow or pony wild or be it tame,
The cowboy, like the drummer, and the bedbug too, they say / Brings him to you, he gets there just the same."

—The Cowboy and His Work

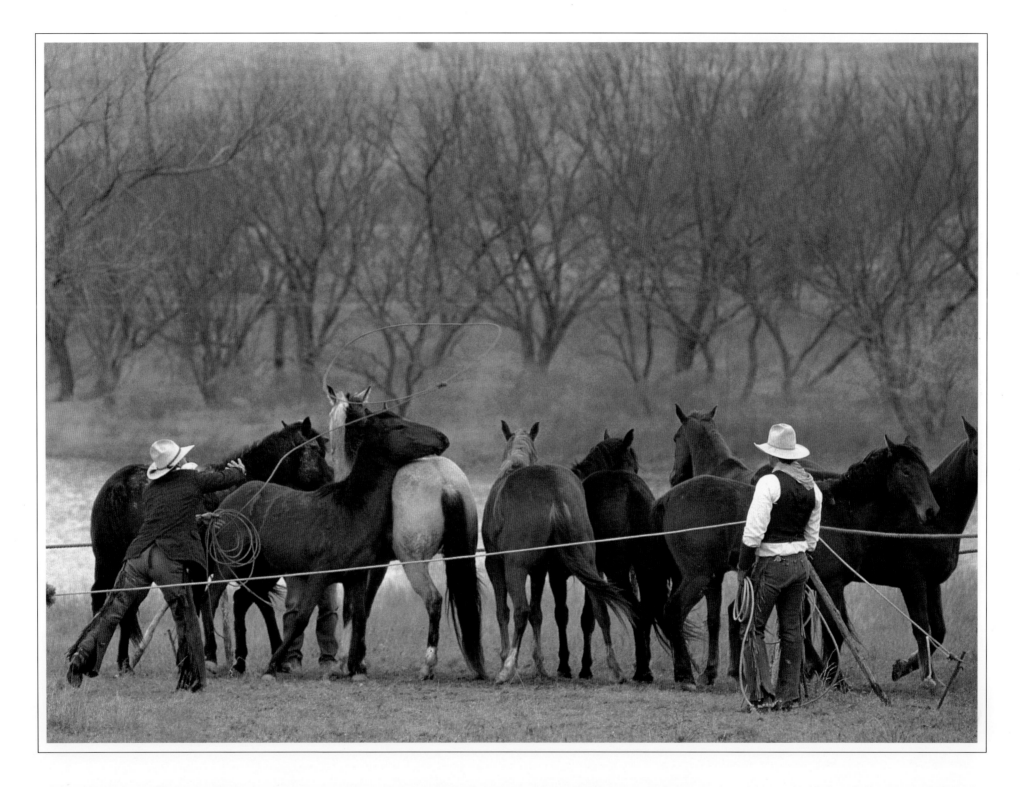

"Come shake out your rawhide and shake it up fair—come break your old bronco to take in his share,

come from your steers in the long chaparral, for it's all in the drive to the railroad corral."

—The Railroad Corral

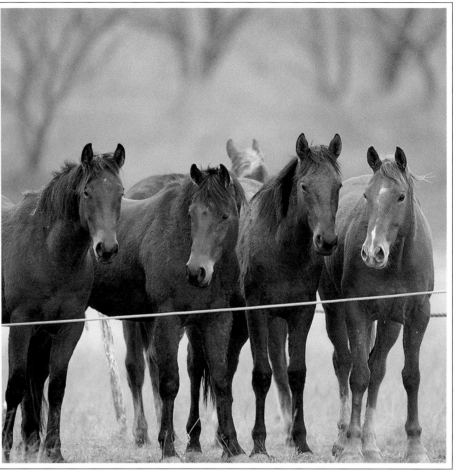

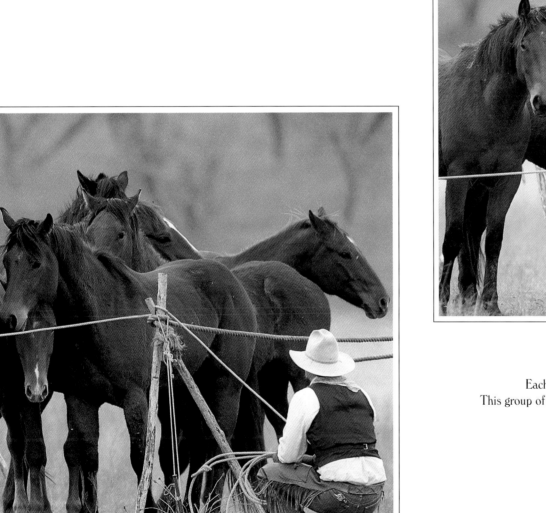

The Remuda
Each cowboy on the trail used a variety of horses during the course of a day.
This group of horses was called a remuda. It was the wrangler's job to cut a horse out
for the cowboy when he needed one.

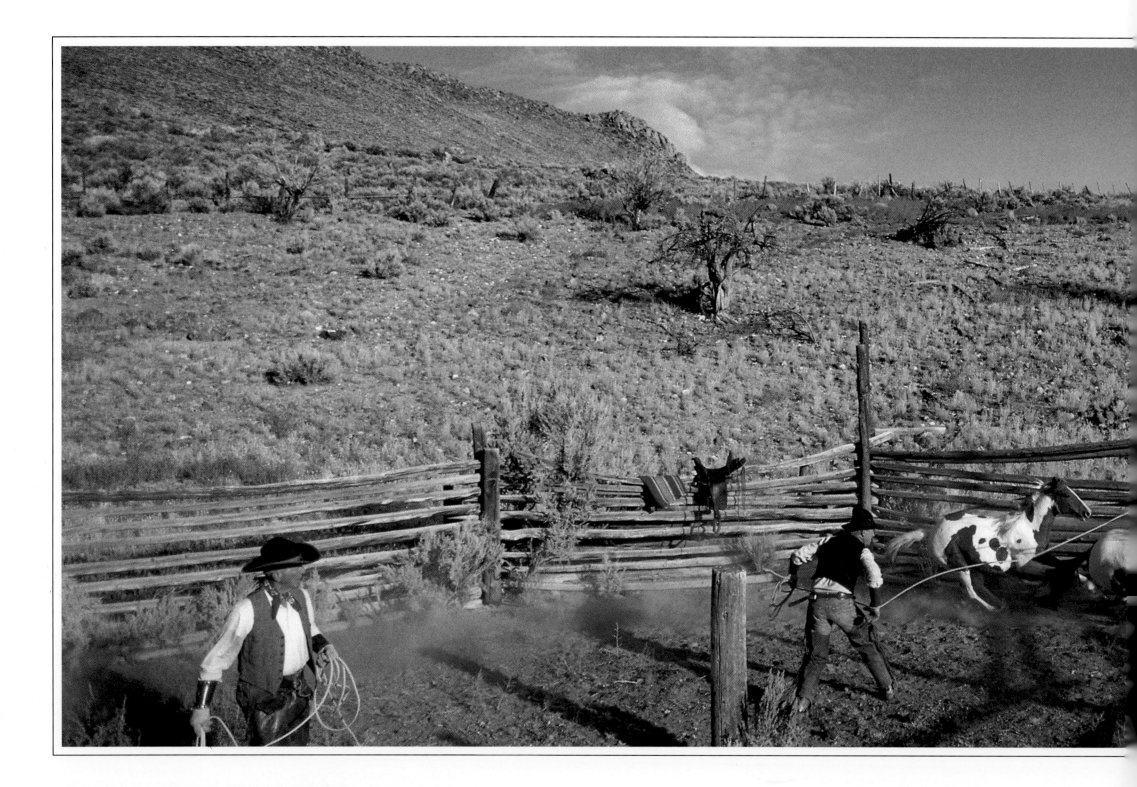

"We could see the tops of mountains under dunny every lump,

but the stranger he was growed there just like a camel's hump."

—The Zebra Dun

Breaking a Horse

Before a cowboy could do his work, he needed to train his most important tool—his horse. The objective of "breaking" or gentling a wild horse was to break the animal's free spirit and make it follow the cowpoke's commands.

Horsebreaking was often the work of a specialist who traveled from ranch to ranch taming horses. In the Old West, four-year-old mustangs were herded off the plains into a corral where the mustanger, or bronco-buster, earned his keep.

First, the bronco-buster roped the animal. A partner then held the horse while the trainer slipped a bridle or hackamore onto its muzzle and hobbled its forelegs. Next, the trainer swung a blanket and saddle onto the animal. Finally, the trainer mounted the beast and used his rope, quirt, and spurs to subdue it. Some trainers accomplished all this in a day's work. Others took days or weeks, pausing between each step to allow the animal to accept every new restriction.

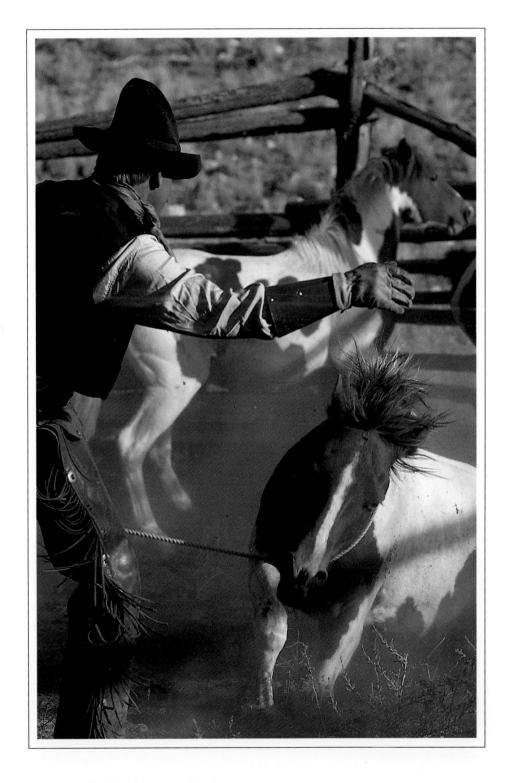

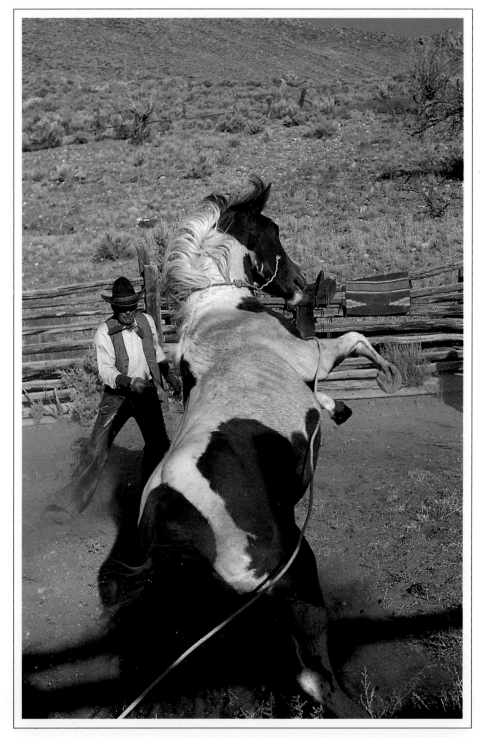

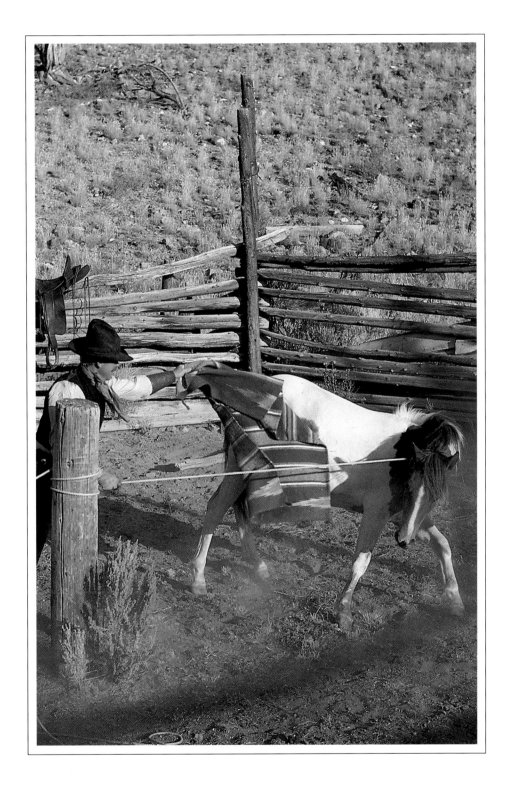

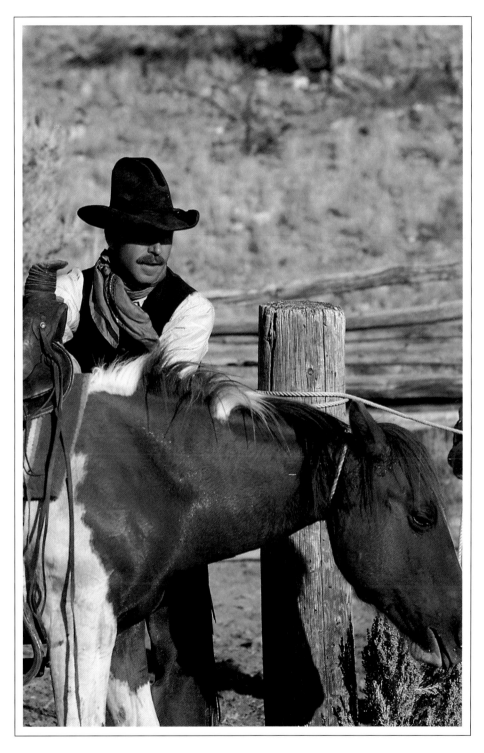

Breaking young horses could be dangerous work, and the men who did it were a tough breed.

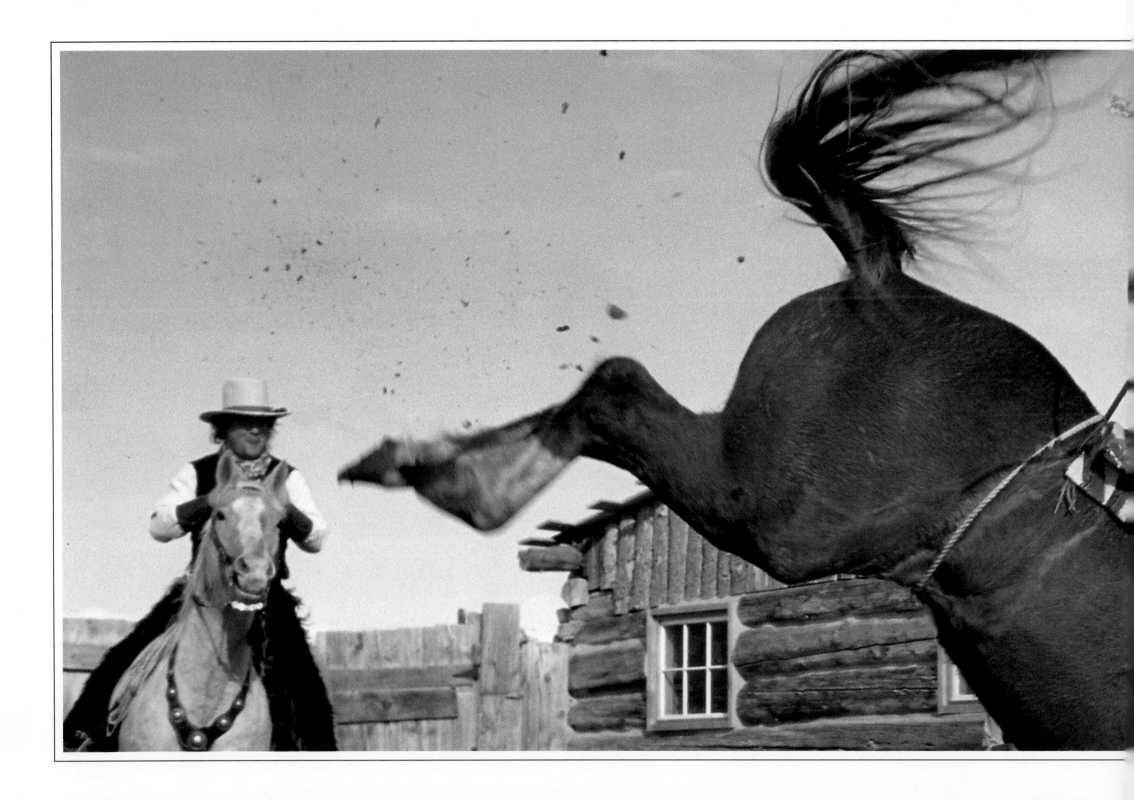

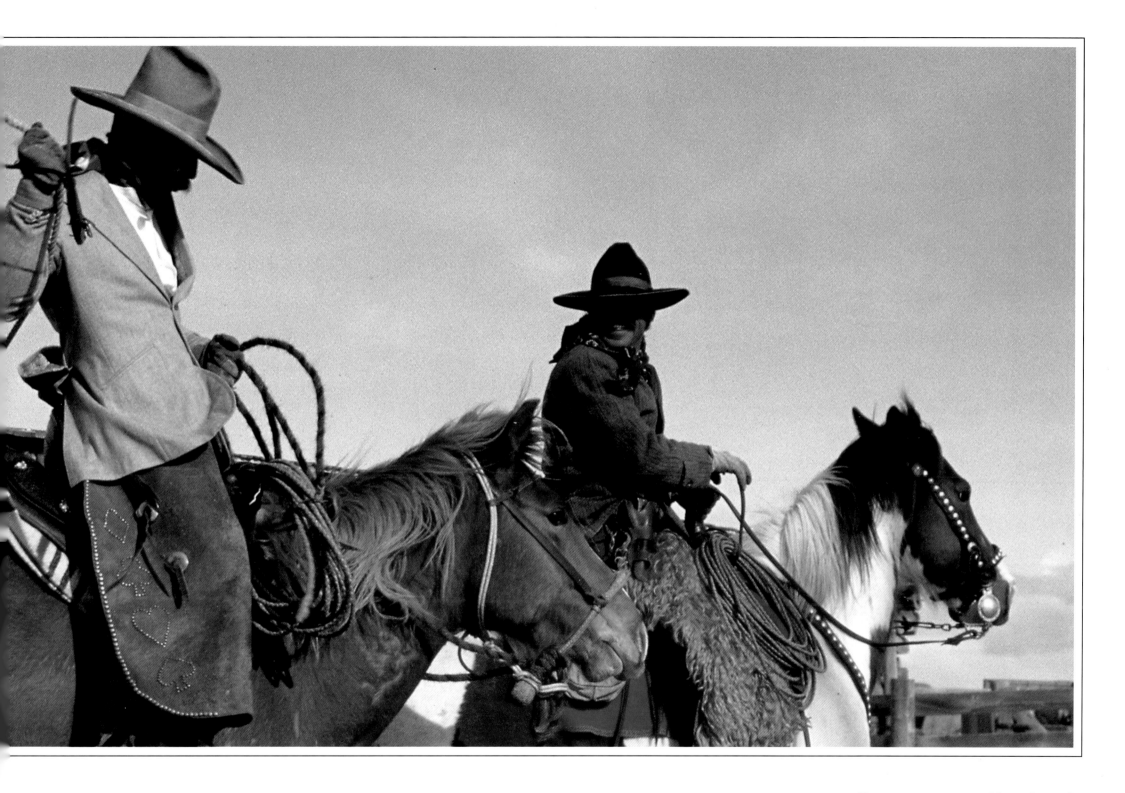

"I am a vaquero, and here I reside;
Show me the bronco I cannot ride."

—Pinto

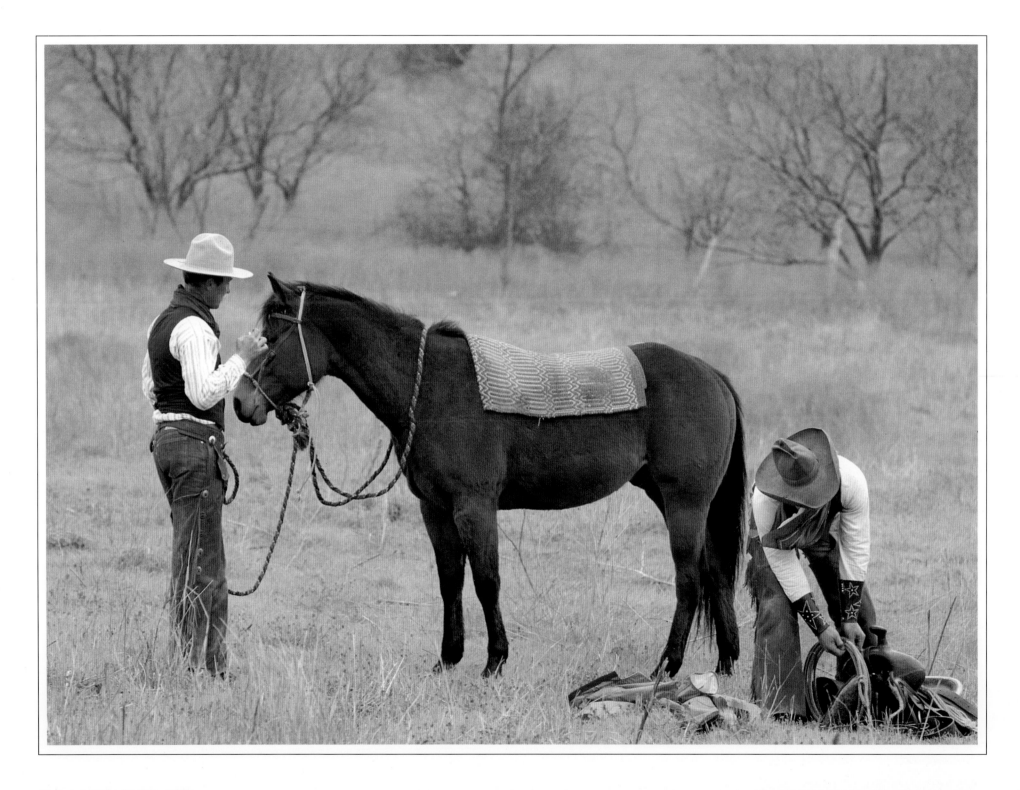

Getting ready for his first saddle

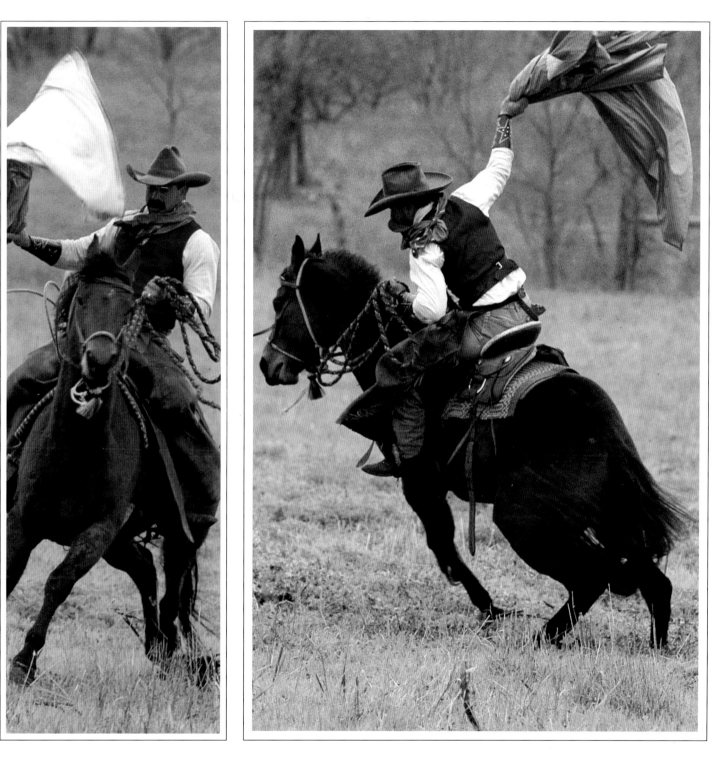

Putting the fish to 'em—
often a cowboy used his "Fish brand" rain slicker to haze
the horse and help get the fear out of him.

Hobbles

At day's end on the range, a cowboy unsaddled his horse and turned it loose on the prairie to graze and rest. In order to allow grazing, but discourage wandering, the cowpuncher typically hobbled his animal by tying its forelegs a few inches apart. While some punchers used the leather cuff and chain hobble issued by the U.S. government, most preferred more creative mechanisms made of rope, buckskin, or even a burlap sack.

The standard practice was to hobble only the horse's front legs. This still allowed an acrobatic animal to hop from place to place, however and an errant horse could sometimes hop several miles in a night's time. Such getaways were forestalled by attaching one of the horse's forelegs to an opposite hind leg, a practice known as "cross-hobbling."

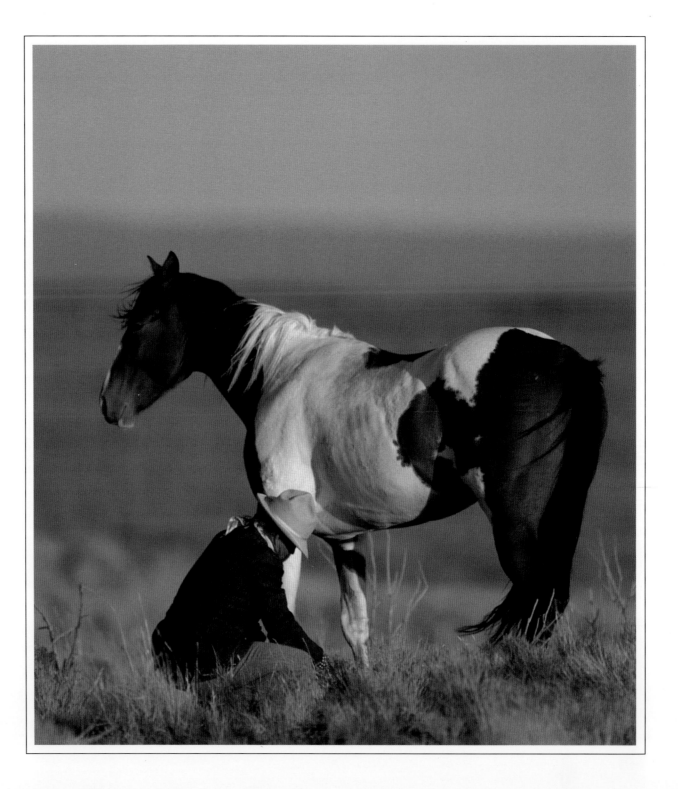

Putting on hobbles

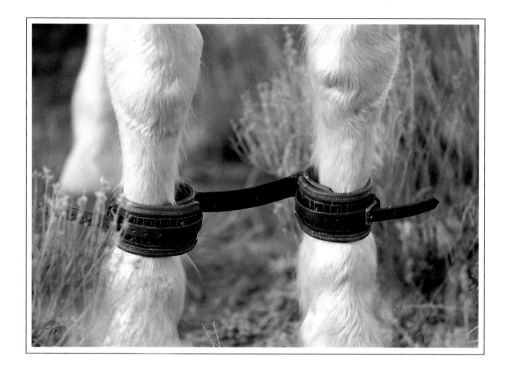

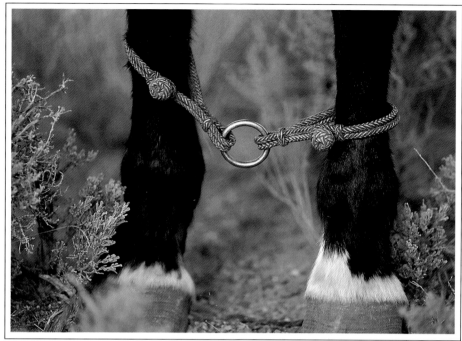

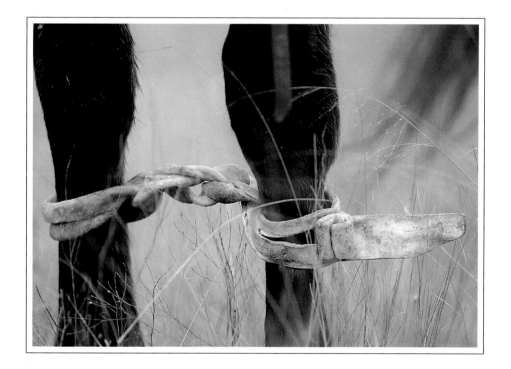

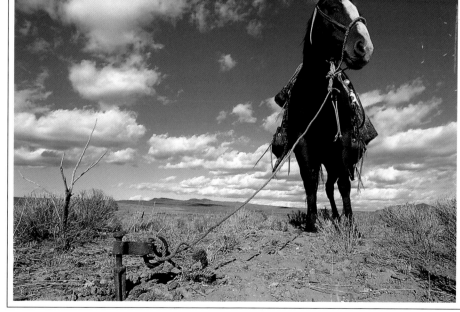

Top: Leather store-bought hobbles
Bottom: Rawhide hobbles

Top: Braided rawhide hobbles
Bottom: Picket pin

ANATOMY OF A CHUCKWAGON

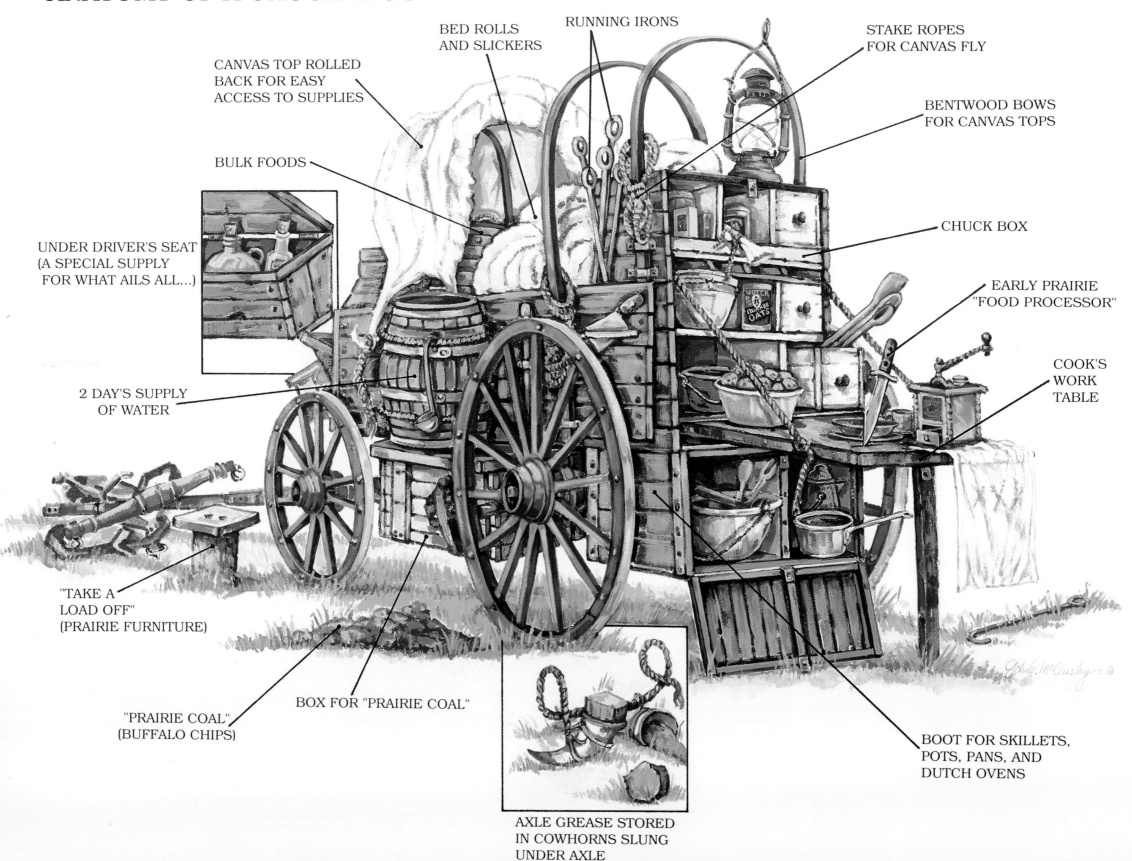

CANVAS TOP ROLLED BACK FOR EASY ACCESS TO SUPPLIES

BED ROLLS AND SLICKERS

RUNNING IRONS

STAKE ROPES FOR CANVAS FLY

BENTWOOD BOWS FOR CANVAS TOPS

BULK FOODS

UNDER DRIVER'S SEAT (A SPECIAL SUPPLY FOR WHAT AILS ALL...)

CHUCK BOX

EARLY PRAIRIE "FOOD PROCESSOR"

COOK'S WORK TABLE

2 DAY'S SUPPLY OF WATER

"TAKE A LOAD OFF" (PRAIRIE FURNITURE)

BOX FOR "PRAIRIE COAL"

"PRAIRIE COAL" (BUFFALO CHIPS)

BOOT FOR SKILLETS, POTS, PANS, AND DUTCH OVENS

AXLE GREASE STORED IN COWHORNS SLUNG UNDER AXLE

The Chuck Wagon

Chapter 4

"The cook, or 'cookie,' sometimes referred to as the 'Old Lady, or 'Cossie' (other names fit to print were 'Gut Robber,' 'Dough-Boxer,' 'Sallie,' 'Greasy Belly,' 'Bean-Master,' 'Belly-Cheater,' and 'Biscuit Shooter'), would prepare the meal of baked beans, bacon, hard biscuits and rank coffee from the back of the chuck wagon. He had been hired solely for his ability to drive a team of horses, not for his culinary accomplishments. . . . In addition to his pots and pans, his equipment included one shovel, for his responsibilities included not only feeding the men, but burying the dead. The one attribute that 'cookie' did not possess, according to any cowboy ever questioned about the matter, was an ability to cook. . . . One cowboy, so upset at the rotten quality of the mess, in a fit of rage, shot dead the cook. The other cowboys, realizing they might starve as a result of his rashness, planned to lynch the murderer. But the drover intervened, and with a Solomon-like decision ordered that the killer should forthwith become 'cookie' for the remainder of the drive. The meals were even worse than before."

Cowboys: The Real Story of Cowboys and Cattlemen
Royal B. Hassrick; Octopus Books, 1975

The chuck wagon was a welcome sight to any cowboy after a day on the range. Though not always serving the best grub a hand ever had, a chuck wagon, sometimes called trail wagon or commissary, was always sure to fill his belly at day's end.

The chuck wagon served many purposes. Besides being the place where "Cookie" mixed up the stew, it served as the camp's hospital and social center, as well as a place where hands could store their bedrolls and dry clothes. On any given night around the chuck wagon, a cowboy could count on a warm fire, some conversation, and a place to sit down and roll a smoke.

Many attribute the invention of the chuck wagon to Charles Goodnight in 1866. However, in his book, "Trail Dust and Saddle Leather," historian Jo Mora offers two accounts of chuck wagon use before Goodnight's. One story claims a man named McCutcheon assembled and used a "camp cart" in 1857. Another account describes a man, identified only as Reed, trailing a wagon on a drive to Louisiana at the outbreak of the Civil War in 1861. Regardless of its inventor, cowboys were clearly better off once the chuck wagon became standard equipment on cattle drives. Before Goodnight customized and popularized the chuck wagon, cowpunchers were responsible for their own grub. This meant they ate and wore whatever they could stuff into their saddle bags.

The chuck wagon itself was most often a converted Army surplus or conventional springless farm wagon. It was pulled by four oxen in the earliest years, and later by mules or horses. It was usually fitted with a large "chuck box" in the rear, which held the cook's tools in several drawers and shelves. The lid of the box, when lowered, could be used as a work table.

On long drives, the underside of the chuck wagon might be fitted with a rawhide apron called the "possum belly," or the "coonie." The coonie was used to store dried buffalo chips—cow chips in later years—or wood for use as emergency fuel. Inside the wagon was lashed a water barrel with a faucet that protruded through the side of the wagon box. At the front of the wagon rested the "jewelry box," holding a range of miscellaneous tools, bullets, and other occasionally used items.

When cattle drives first began making use of a chuck wagon, the camp cook was hired primarily for his ability to drive a team of oxen or horses. The cook was, often as not, a terrible chef. In *Cowboy*, author Philip Ashton Rollins furnished a definition of the early trail cook as ". . . a man who had a fire; who drew the same wages that he would have earned if he had known how to cook." Along with cooking and maintaining the working condition of the chuck wagon, the cook was also the camp doctor, and was in charge of repairing leather harnesses and other gear.

On a cattle drive, a poor rider was often called "Cookie." Still, overt criticism of the cook was rare, since a cowpuncher complaining unduly about the cook could, by custom, be pressed into service as the cook's helper or replacement for a day's time. Rollins related the anecdote of the quick-thinking puncher who blurted, "This bread is all burned, but gosh, that's the way I like it."

The camp cook was always up before the crack of dawn, preparing the first of three hearty meals he would cook throughout the day. Cowboys were accustomed to eating at what they called "The 6's"—a meal at 6 a.m., another at noon, and one more at 6 p.m.

A good cook was a priceless asset to any outfit. He was a magician with beans, bacon (or "sowbelly"), and coffee. A good camp cook would do his best to keep variety in his meals, although most included beans, bread, and steak. On the Northern range, bread was usually made from wheat flour. In the South, Texans preferred cornmeal.

Whatever the grub, a cowboy could count on a thick cup of coffee to wash it down. Many cowboys commonly referred to coffee as "Arbuckles," after the popular Arbuckles brand of pre-roasted coffee. Sometimes a less financially fortunate crew resorted to a substitute coffee brewed of parched maize, sweet potatoes, or meal bran. A colloquial cow country recipe for coffee was: Add 2 pounds of coffee to 2 gallons of boiling water. Boil two hours, then throw a horseshoe into the pot. If the shoe sinks, the coffee isn't done yet.

As they did with most everything else associated with their work, cowboys attached colorful descriptions to their food. For instance, "whistle berries" was the nickname for beans, eggs were called "crackle berries," canned milk was "canned cow," onions were "skunk eggs," and kidney stew was known as "son-of-a-gun" stew. If the cookie was feeling good-hearted, he might whip up some "spotted pup"—rice and raisins—or some "plain pup"—rice and spices—for dessert.

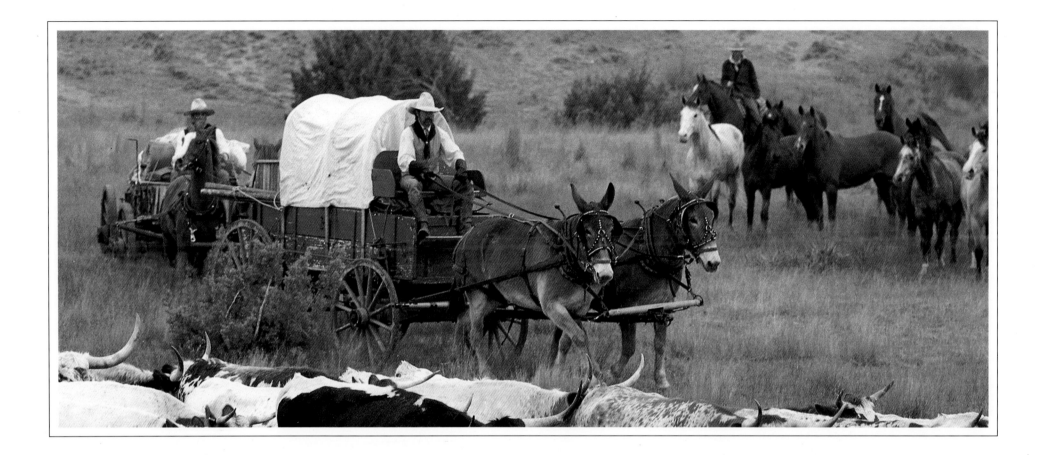

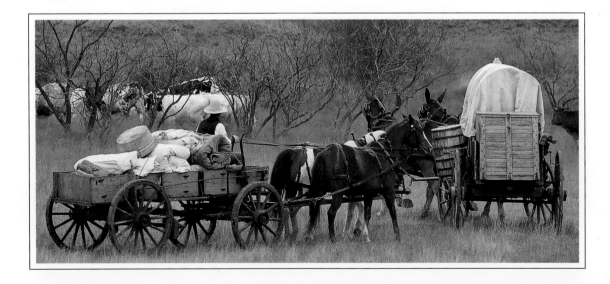

Moving down the trail

Mules were the beasts of preference for pulling chuck wagons.

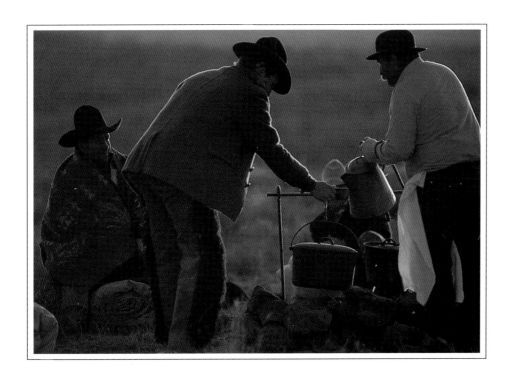

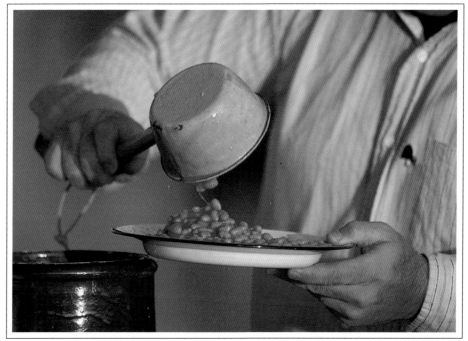

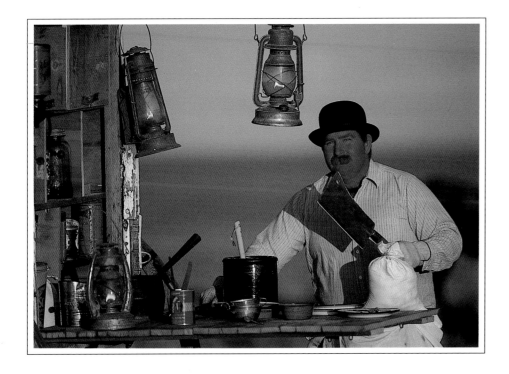

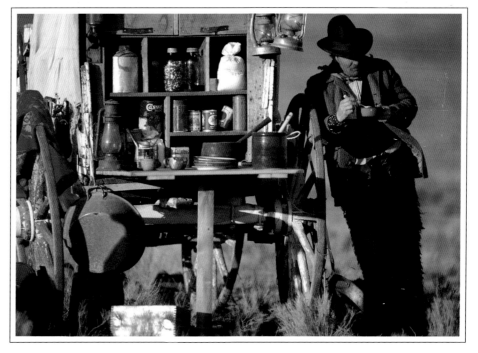

"The Cook is at the chuck box / Whistlin' "Heifers in the Green,"
Making baking powder biscuits / While the pot is boiling beans."

—A Cowcamp on the Range

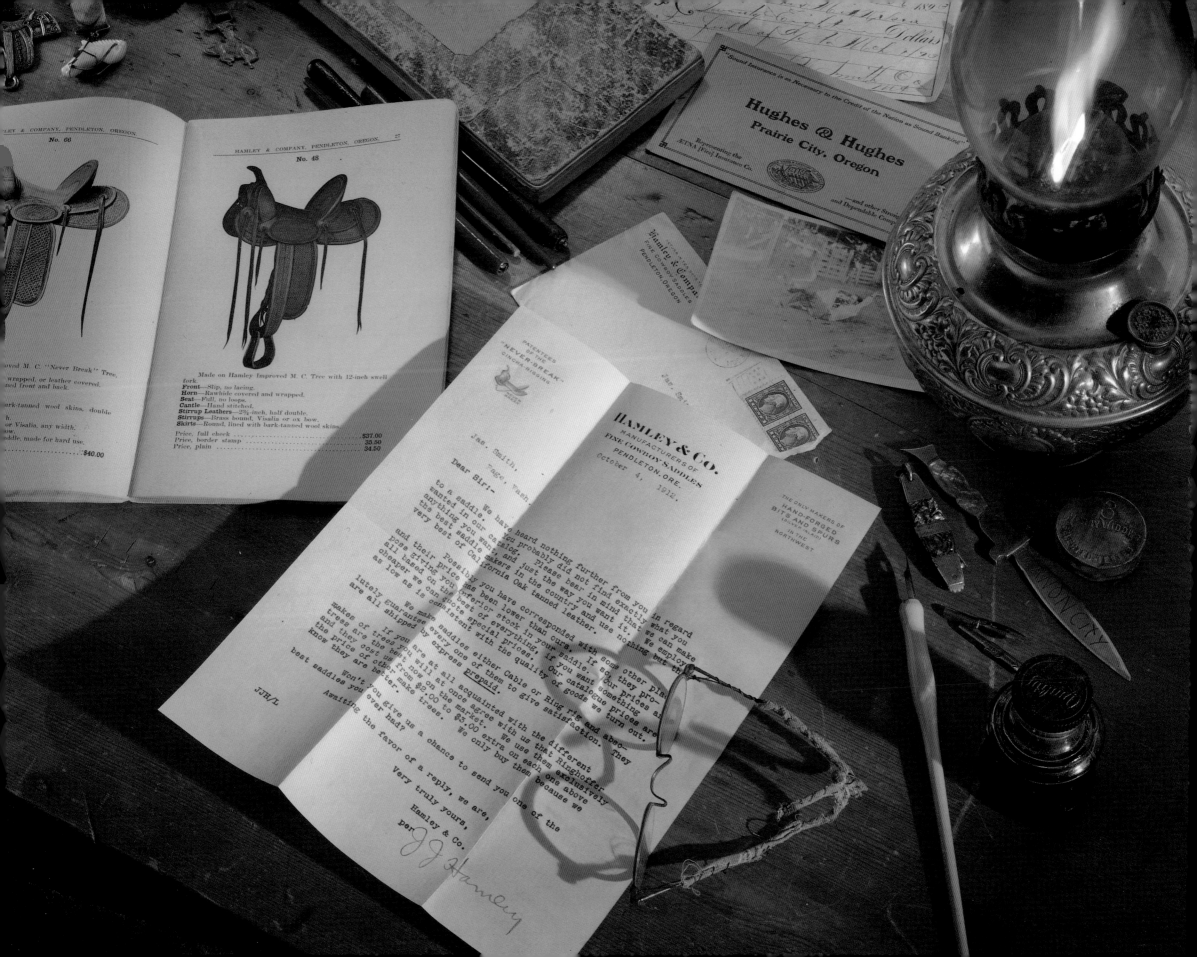

Catalogs, Merchants & Fobs

Chapter 5

Although trading posts and bartering were popular, cowboys purchased most of their gear by mail. Trips to town were few, so cowboys browsed through catalogs to see the latest in boots, spurs, bridles, and chaps.

Profusely illustrated and full of chatty advice and slogans, catalogs from Hamley & Co. of Pendleton, Oregon; H.H. Heiser of Denver, Colorado; Shipley of Kansas City, Missouri; or other great Western merchants were as eagerly awaited in cattle country as visits from seldom-seen friends. Catalogs included detailed instructions for measuring and determining the correct size a cowboy needed, and often included a tape measure. Once a cowboy located the items he wanted, he sent in his order and waited. It could take weeks to receive the merchandise, but quality gear that would last for years was worth the wait. The cowboy demanded the best and usually got it, even if it came at the cost of several months' wages.

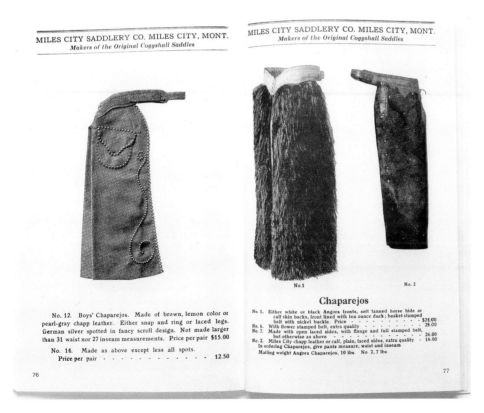

Too many hours spent with cowboys' wishbooks like these could stretch a working hand far beyond his financial means.
The Edward H. Bohlin Catalog is a repoduction by Pittman Treasures.

1925 CATALOG

MILES CITY SADDLERY CO.
Successors to C.E. Coggshall
17-19 S. SIXTH STREET MILES CITY, MONT.

Manufacturers of the Original
COGGSHALL SADDLES
No. 26

Great Gear Makers

A select list of master craftsmen

ALLEN, BONA

Established in 1873 in Buford, Georgia. Allen made a wide range of horse gear. Many saddles made by Allen were marked "J. C. Higgins." The company is now owned by the Tandy Corporation.

BASS, J. O.

James Oscar Bass was born in Atlanta, Georgia, in 1880. He opened his first shop in Quitaque, Texas, in 1897. He moved to Tulia, Texas, in 1905, and made spurs to order until 1924. Bass's spurs had swinging buttons and copper/silver overlays, often shaped like a heart. He usually marked his spurs clearly "J. O. Bass, Tulia, TX.'

BIANCHI, JOE

Bianchi was born in Italy in 1871. He moved with his family to Victoria, Texas, in 1885. He went to work in the late 1890s. at the Bianchi Brothers' Blacksmith Shop in Victoria. Bianchi spurs are easily recognized by their bottle-opener shanks and use of Mexican silver coins. Bianchi made bits and spurs until his death in 1949. He marked his spurs "Bianchi" inside one heelband and "Victoria, TX." inside the other.

BUERMANN, AUGUST

Buermann was born in Germany in 1842. He sailed for New York in 1863 and started up his company in 1866 in Newark, New Jersey. By 1896 the Buermann Company had 100 employees. Buermann sold a wide array of bits, spurs, and stirrups to jobbers and wholesalers. At its peak, his company offered nearly 450 different spur designs. Buermann had a creative mind and patented many designs and modifications. The company was acquired by North & Judd in 1926.

CAUSEY, BOB

Established in 1880 in New Mexico. As an expert bit and spur maker, Causey traveled around the country. He worked in Safford, Arizona; Pendleton, Oregon; Rupert, Idaho; Artesia, New Mexico; and Odessa, Texas. Causey is noted for creating. The Gal-leg spur is attributed to Causey.

COGGSHELL, C. E.

Coggshell made saddles in Miles City, Montana, in the early 1880s. He bought the Hugh Moran Shop in 1895. In 1897 Coggshell formed a partnership with Al Furstnow. Coggshell sold out to Miles City Saddlery in 1909.

This Miles City Catalog is a reproduction by Pittman Treasures.

COLLINS, J. S. and G. H.

In 1864 John Collins started his business in Omaha, Nebraska. With the help of brother Gilbert, he opened another shop in Cheyenne, Wyoming, in the 1870s. Gilbert died in 1880. Collins returned to Omaha and took in a partner, John Morrison, in 1886. The company name changed to Collins & Morrison. In 1896 Collins and Morrison was sold to Alfred, Cornish.

FLYNN, TOM

Flynn opened his first saddle shop in Silver Cliff, Colorado, in 1880. He lived in Trinidad, Colorado, until 1893, when he moved to Pueblo, Colorado. His business prospered in Pueblo until 1921, when he was wiped out by the great flood of that year.

FRAZIER, R. T.

Frazier was born in 1850 in New Philadelphia, Ohio. After the Civil War, he followed the gold rush to Leadville, Colorado. In the 1870s Frazier worked for Pete Becker Saddlery in Leadville. In 1880 he joined with S.C. Gallup in Pueblo and eventually became a partner in Gallup & Frazier. In 1890 Frazier opened his own shop. Frazier believed in advertising, and his catalog became a "cowboy bible." By the turn of the century, Frazier had become a famous saddle maker, claiming to be the world's largest maker of high-grade saddles. The company survived into the 1940s.

FURSTNOW, AL

Furstnow made saddles as early as 1884 in Miles City, Montana. He opened his own shop there in 1894. He went into partnership with C. E. Coggshell in the late 1890s and offered a full line of tack. Furstnow died in 1923, but the shop continued to operate under Joseph Moreno.

GALLATIN, E. L.

Gallatin was born in Missouri in 1828. He worked for Israel Landis, legendary maker of the 1860 Pony Express saddle. In 1863 he founded a saddle shop in Denver, Colorado. He became partners with Francis Gallup and operated as E. L. Gallatin and Company, and then, in 1865, as Gallup & Gallatin . In 1868 Gallatin moved to Cheyenne, Wyoming, and opened a new shop, hiring his nephew, Frank Meanea. A branch was opened in 1867 in Nebraska City, Nebraska. In 1873 Gallatin sold his interest in the Denver operation to Gallup, and the Cheyenne shop to Frank Meanea. Gallatin's Cheyenne and Pueblo rigs were known from Texas to Canada and were the standard of excellence for many cowboys.

GALLUP, S. C.

Gallup started his saddle shop in Pueblo, Colorado, in 1870. He was the brother of Francis Gallup, a saddle maker in Denver, Colorado. S.C. Gallup took in R. T. Frazier as a partner, sold out to him in 1897, then quickly opened the S.C. Gallup Saddle Company in 1898. This business lasted into the 1930s.

GARCIA, GUADALUPE S.

G. S. Garcia was born in 1864 in Sonora, Mexico. He moved to Santa Marguerite, California, and opened his first shop in 1882. He then moved to Elko, Nevada, in 1894, selling a complete line of cowboy gear. Garcia was best known for his bits and spurs, and employed some of the best makers of the day, including Estrada, Goldberg, Herrera, Gutierrez, and Morales. Guadalupe's sons, Les and Henry, took over the business in 1932, and Garcia died in 1933. The business moved to Salinas, California, in 1936 and the name was changed to The Garcia Saddlery. His early mark was usually "G. S. Garcia, Elko, Nev."

GOETTLICH, E.

Goettlich operated his shop in Miles City, Montana Territory, in the 1880s. He took Al Furstnow into his business in 1884, and sold Furstnow the company in 1888.

GUTIERREZ, RAPHAEL P.

Gutierrez was born in California in 1889. He started making bits and spurs at the age of 16 in Sacramento, before joining G.S. Garcia in Elko, Nevada. In 1917 he joined with Bill Phillips in Cheyenne, Wyoming. The Phillips & Gutierrez partnership made beautiful Northern Plains style spurs until he returned to California in 1920. There he continued his work until his death in 1958.

HAMLEY AND COMPANY

John and Henry Hamley opened their saddle

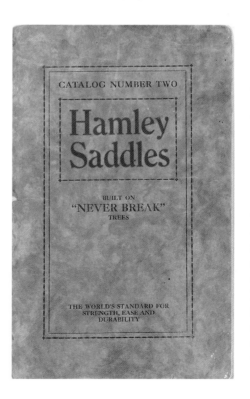

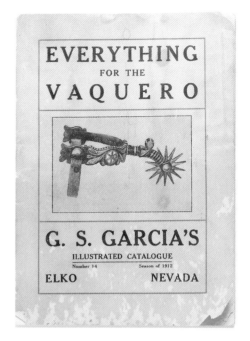

shop in Ashton, South Dakota, in 1884. They moved their business to Kendrick, Idaho, in 1890, and then to Pendleton, Oregon, in 1905. In Pendleton the product line was expanded by John's two sons, Lester H. and John M. They produced the first of many catalogs in 1909. One of the Hamley marks was an "H" in a circle. Hamley and Company is still in business.

HEISER, HERMANN H.

Heiser started his saddlery in 1858 in Denver, Colorado, and became one of the West's largest saddle makers. Among other projects, Heiser made saddles for the Rocky Mountain Division of the Pony Express. In 1878 he bought Gallup & Gallatin in Denver. Heiser died in 1904 and his three sons took over the business. The shop evolved to specialize in belts and holsters. Later catalogs show no saddles. The business was sold in 1945 to the Denver Drygoods. The trademark often used by Heiser was a triple "H."

KELLY, PASCALL MORELAND

Kelly was born in 1886 in Van Zandt County, Texas. He made his first spurs in 1903 in Childress, Texas. In 1911 Kelly went into partnership with Clyde Parker, making bits and spurs marked "KB & P" or "Kelly Bros. & Parker." The partnership ended in 1919, with the Kelly Bros. Co. continuing to operate. The business moved to El Paso, Texas, in 1925, and was sold to Renalde of Denver in 1965.

KEYSTON BROS.

In 1867 James and William Keyston founded a company that became one of the largest outfitters in the country. They began buying up companies with J. C. Johnson Co. of San Francisco in 1905. They bought Main, Winchester & Stone,

and F. S. Johnson in 1912; Harpham & Jensen of San Francisco in 1914; W. David & Sons Saddlery in 1917; and finally, H. H. Heiser in the 1950s.

LAWRENCE, GEORGE

In 1874 Lawrence joined the firm founded in 1857 by Samuel Sherlock in Portland, Oregon, and assumed control after Sherlock's death two years later. He renamed it the George Lawrence Co. in 1893. Lawrence was Sherlock's brother-in-law, and a relative of August Buermann. The business was operated by the Lawrence family for more than a century. The George Lawrence Company produced many angora chaps, as well as saddles, cuffs, harnesses, and a variety of leather goods. One mark used was "G.L.C. Co." in a diamond.

MAIN & WINCHESTER

In 1849, during the California gold rush, Charley Main and E. H. Winchester established a saddle and tack shop. They sold top quality merchandise to gold-flush 49ers. M&W contracted with other famous businesses of the time, such as Russell & Majors Pony Express Line. Main & Winchester consolidated with L.D. Stone in 1905, before selling out in 1912 to Keyston Brothers.

MC CHESNEY, J. R.

McChesney was born in 1867 in South Bend, Indiana. He began making spurs about 1887 in Broken Arrow, Oklahoma, after buying a bankrupt shop in Tulsa. McChesney moved in 1890 to Gainesville, Texas, and again in 1907 to Pauls Valley, Oklahoma, where his factory became the biggest bit and spur manufacturer in the world, employing as many as 50 men. The business was acquired by the Nocona Boot Company on his death in 1928. McChesney never marked his spurs, but the Nocona Boot Company began putting his name on them after acquiring the firm. McChesney is best known for his gal-leg and gooseneck spurs and bits. At his peak, he produced a catalog listing 120 patterns of spurs and 64 patterns of bits.

MEANEA, F. A.

Frank Meanea joined the saddle shop of Gallup and Gallatin in 1868, and purchased it in the late 1870s. He continued to run his Cheyenne, Wyoming, shop until his death in 1928. Meanea is widely credited with originating the Cheyenne style saddle. His use of quality materials and attention to details makes his leather highly desirable to collectors today.

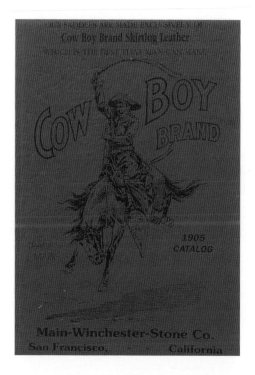

This Main & Winchester Catalog is a reproduction by Pittman Treasures

MORALES, MIKE

Morales began his career making bits and spurs for G.S. Garcia in the early 1900s. He moved to Pendleton, Oregon, in 1910 and went to work for Hamley and Company. In 1920 he moved to Portland, opening his own shop. Morales primarily made California-style silver inlaid bits and spurs marked with a stylized "M." He moved to Los Angeles in 1927 and continued his work until his death in 1935.

MORAN, HUGH

Moran was probably the first saddle maker in Miles City, Montana Territory. He remained in business until bought out by Coggshell in 1875.

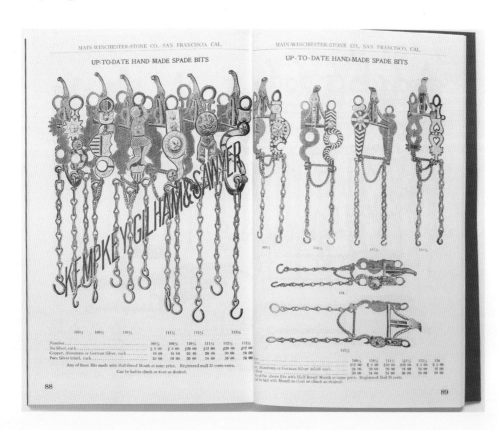

MILES CITY SADDLERY CO. MILES CITY, MONT.
Makers of the Original Coggshall Saddles

No. 95

MILES CITY SADDLERY CO. MILES CITY, MONT.
Makers of the Original Coggshall Saddles

No. 95

PRICE $85.00

COGGSHALL'S IMPROVED PORTLAND TREE. High, medium or low horn as preferred; seat, side jockeys and cantle one piece; cantle bound with fancy turned binding; 3-inch stirrup leathers; small round skirts lined with back tanned wool skins; Spanish rig, made three-quarter or double rig if preferred; hard cord or fish cord cinch; rope strap on off side; weight about 32 pounds. Made with square skirts at same price; pockets to match, $8.50 extra. Made on any of the following Improved Trees: Taylor, Visalia, Montana, Imperial, Ladesma Nelson or Powder River.

"Common Sense" Rigging Rings, shown on page 101, used when ordered with Spanish, three-quarter or center fire rig.

This is a neat flower stamped saddle and a favorite with those who prefer this style.

Those who are familiar with the history and growth of the saddle business recognize the fact that our saddles are superior in workmanship, style and quality to any on the market.

PORTER, NEWTON
Porter started his business around 1875 in Taylor, Texas, making leather goods. He worked in Abilene, Texas, and Everett, Washington, in the 1890s before settling in Phoenix, Arizona, in 1895. He died in 1906 and the business was taken over by his son, Earl Porter.

SHIPLEY, CHARLES P.
In 1885 Shipley began producing horse and Western gear in Kansas City, Missouri. He was in business for 87 years. Shipley's was a large operation, making a wide assortment of cowboy and horse gear.

SICKLE, J. B.
J.B. Sickle Saddlery was established in 1834 in St. Louis, Missouri. Sickle's saddle shop was sold in 1972, and is known for being the longest-running saddle shop in the West. Sickle made Texas-style saddles, using the Morgan Saddletree.

MUELLER, FRED
Mueller established his leather shop in Denver, Colorado, in 1883. He retired in 1917, selling the establishment to his employees, who continued to operate well into this century.

MYERS, S. D.
Samuel Dale Myers opened his first saddle shop in Sweetwater, Texas. He soon became one of the best-known makers in the trade. He moved to El Paso, Texas, where his shop survived into the early 1900s.

NORTH & JUDD
North & Judd was incorporated in 1863 in New Britain, Connecticut. By 1925 the company employed 1200 workers, making saddle hardware, bits, and spurs. Their famous mark, "The Anchor Brand," was registered in 1879 and is still used today. North & Judd absorbed the August Buermann Company in 1926. They continued to use the star mark, but with the A.B. filed out.

PETMECKY, JOSEPH CARL
Petmecky apprenticed to an Austin, Texas, gunsmith named Owens in 1851. He soon became a noted gunsmith and spur maker. Petmecky made spring-tempered steel spurs. His precision spurs were prized from the early trail driving days well into the 20th century. Petmecky is credited with designing the O.K. style spur. He died in 1929.

VISALIA STOCK SADDLE COMPANY
The company was founded in 1863 by Juan Martarel in Visalia, California. It was purchased by Henry Shuham and David Walker in 1870. In 1899 the company was acquired by Edmond Weaks and moved to San Francisco, California. In 1906, after the San Francisco earthquake, it was moved to Castro Valley, California. Visalia produced mostly saddles in the 1800s, and added a line of silver mounted tack early in the twentieth century.

WYETH SADDLERY & HARDWARE MANUFACTURING COMPANY
The company began operating in 1859 in St. Joseph, Missouri, and operated until 1954. In 1859 Wyeth made Pony Express saddle Mochilas for Landis. Over the years, Wyeth made thousands of scabbards and holsters.

This Morales Catalog and the Vislia Catalog above are both reproductions by Pittman Treasures.

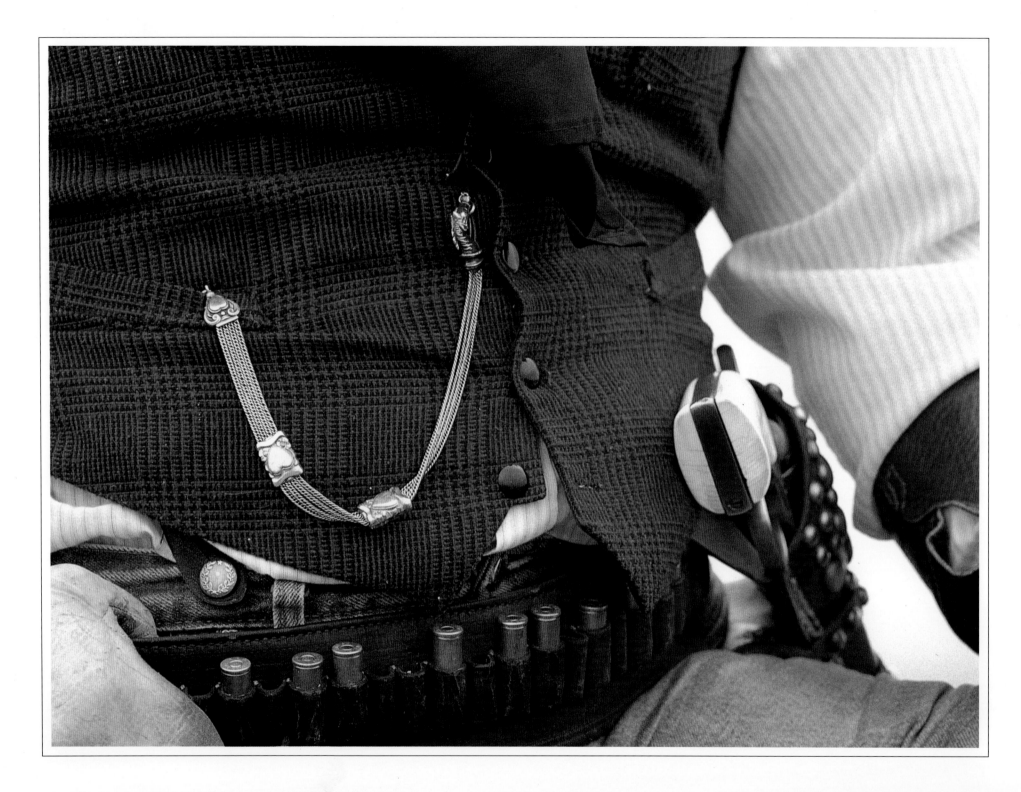

Watch inside vest pocket.
Watch fobs, some of which were produced by saddle companies for advertising
and promotion, would always be worn outside the clothing.

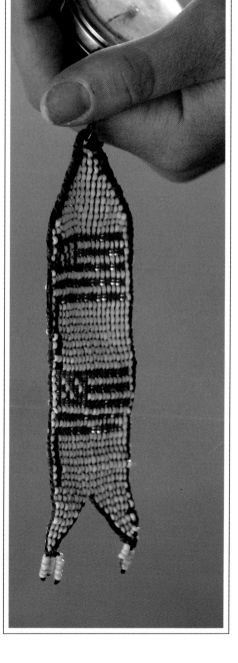

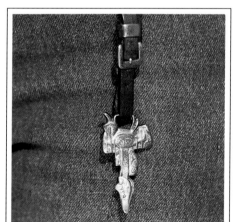

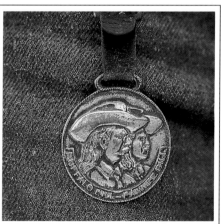

Indian-beaded watch fob

Watch fobs are highly sought after today as collectible cowboy gear.

Mother-of-pearl fob with gold fittings and seal-skin strap

Top: Celluloid fob

Middle: Nickel-plated brass saddle fob with original strap, Padgitt Bros., Dallas, TX

Bottom: Buffalo Bill and Pawnee Bill depicted on silver-plated brass fob with rope edge

Middle: Silver-plated brass fob depicting a bucking horse and rider, Western Ranchman Outfitters, Cheyenne, WY

Bottom: Nickel-plated brass saddle fob, Robbins Co., Attleboro, MA

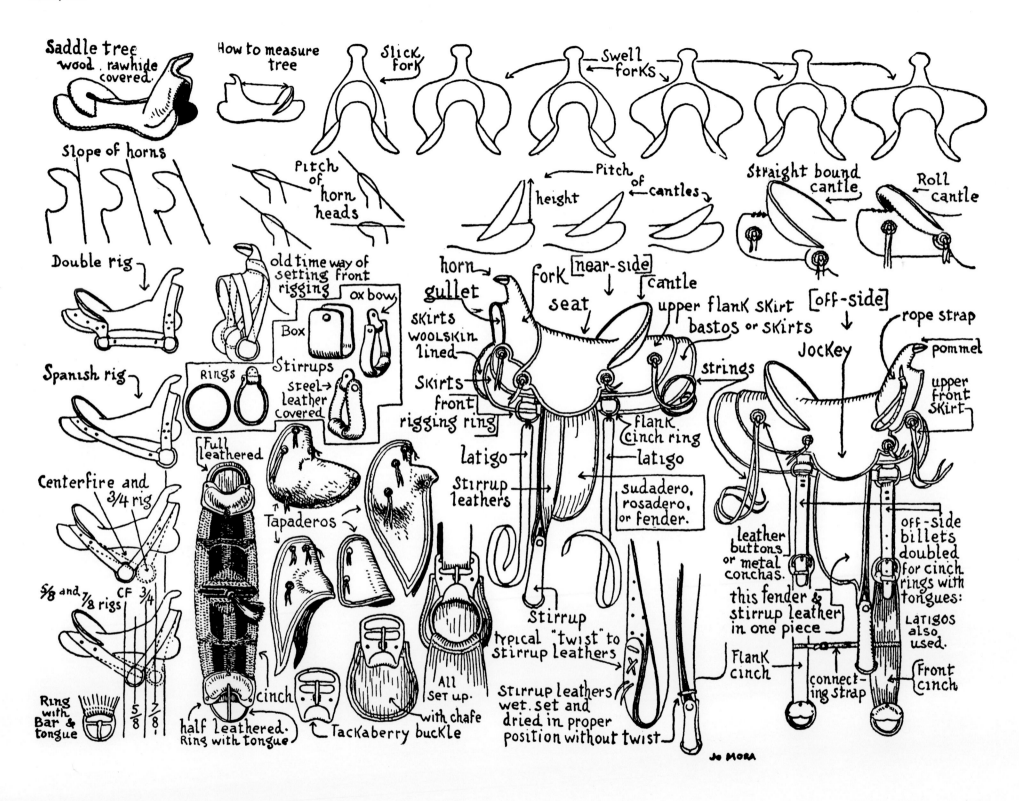

Saddle tree wood. rawhide covered.

Slope of horns

How to measure tree

Slick fork

Swell forks

Pitch of horn heads

Pitch of cantles

height

Straight bound cantle

Roll cantle

Double rig

old time way of setting front rigging

Box

ox bow

Rings

Stirrups

steel leather covered

Spanish rig

Full leathered

Tapaderos

Centerfire and 3/4 rig

5/8 and 7/8 rigs CF 3/4

cinch

half leathered. Ring with tongue

Ring with Bar & tongue

5/8 7/8

Tackaberry buckle

All set up. with chafe

horn

gullet

fork

seat

[near-side]

cantle

[off-side]

upper flank skirt bastos or skirts

skirts woolskin lined

skirts

front rigging ring

latigo

strings

flank cinch ring

latigo

stirrup leathers

sudadero, rosadero, or fender.

Stirrup

typical "twist" to stirrup leathers

Stirrup leathers wet. set and dried in proper position without twist

Jockey

rope strap

pommel

upper front skirt

leather buttons or metal conchas.

this fender & stirrup leather in one piece

Flank cinch

connecting strap

off-side billets doubled for cinch rings with tongues:

latigos also used.

Front cinch

Jo MORA

The Saddle

Chapter 6

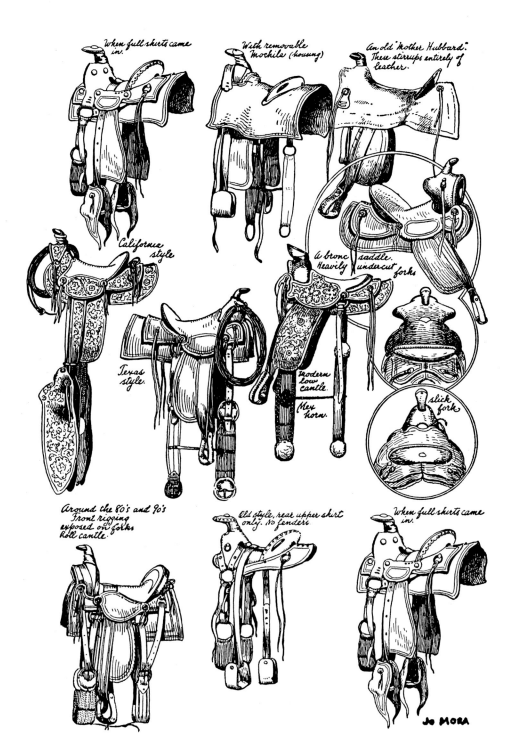

When full shirts came in.

With removable Mochila (housing)

An old "Mother Hubbard". These stirrups entirely of leather.

California style

A bronc saddle. Heavily undercut forks

modern low cantle

Mex horn.

slick fork

Texas style.

Around the 80's and 90's front rigging exposed on forks. Roll cantle.

Old style, rear upper shirt only. No fenders.

When full shirts came in.

JO MORA

"For the cowboy, his saddle was a most cherished possession. Everyone in the West knew it, and as one cowpoke expressed it, "There goes Buck with his $100 saddle on his $10 horse."

Cowboys: The Real Story of Cowboys and Cattlemen
Royal B. Hassrick; Octopus Books, 1975

The saddle was by far the cowboy's single most important asset. It was both his prized possession and his livelihood. A cowman might not have always owned a horse, but a hand looking for work on a ranch had better be packing a saddle. If not, he would be assigned to "ground chores," an undesirable circumstance for any self-respecting puncher. A desperate cowboy in a barroom poker game would lose the shirt off his back and walk away before he gambled his saddle. There was no sorrier sight on the range than a naked cowboy totin' a saddle.

In the latter years of the 19th century, a saddle could cost a cowboy a month's pay, $30—but a well-maintained saddle could last him 30 years or longer. A cowboy often spent 10 to 12 hours a day in his saddle. At day's end, after supper had been eaten, a hand's saddle often doubled as his pillow. Some said a man could, in a pinch, sleep in a well-broken saddle.

The tailoring and upkeep of a man's saddle was as important to his

horse as it was to the rider. As one cowboy said, "A rider with a gentle hand and a good rig (saddle) could travel 70 miles in one day and still have a healthy horse. A thoughtless tyro in a poor saddle could make a horse's back sore in an hour's time."

The popular Western saddle evolved from the 16th-century Spanish war saddle, used by the conquistadors in Mexico. The Spanish saddle, in turn, was descended from the style used by the African Moors in the early 14th century.

The Western saddle, also known as "cow" or "range" saddle, weighed between 40 and 50 pounds, depending on the amount of gear a cowboy packed on. The foundation, or frame, of the saddle was a hardwood "tree." To the tree was bolted the metal horn, fashioned in various heights and angled to suit the rider's taste. The conquistadors' once-curved cantle, the upward-projecting rear part of the saddle, was tilted back and lowered for the Western rider's comfort and mounting ease. The wooden tree of the Western saddle was then covered entirely by rawhide, then placed upon a broad leather plate known as the "skirt," "basto," or "sudadero," which lay on the horse's back.

Under the basto was a pad called the "corona," or, more generally, a folded blanket known as the saddle blanket. Under all this, a gunny sack was often laid, providing some ventilation for the animal.

A cowpuncher's saddle was secured to the horse by a rigging consisting of a latigo, a cinch, and rigging rings. The cinch held the saddle in place. Sometimes known as the "cincha," or, in Texas, the girth, it was made of horsehair, cotton, wool, hemp, or canvas. It was wrapped under the horse's mid-section and secured to the rigging rings by long, thin leather straps called latigos. Latigos were the weakest part of any saddle. If not well-maintained, a latigo could break, quickly separating man and saddle from the horse.

If a saddle had two cinches, it was called a double rig, or double rigged. In gunslinger parlance, it was referred to as double barreled or double fire. Single-cinch rigs were known as single rig, single fire, centre fire, single barrel, or California rig.

The breast collar was another saddle accessory. Used to prevent the saddle from moving backward, it was most often employed when roping cows or climbing steep terrain. Other gear included a martingale, which kept the horse from rearing, and the breeching strip, which kept the saddle from moving forward.

Four sets of leather thongs hung from each cowboy's saddle. These were used to tie necessary gear to the saddle. The rear thongs typically held a "slicker" raincoat or a Mexican serape. In the absence of a chuck wagon, the cowboy wrapped food, a frying pan, and other travel essentials in his slicker. The thongs at the saddle's front secured whatever gear the day's tasks required.

Before the Civil War, the heavy, thick-horned Mexican saddle was the standard, but saddle makers soon developed stylistic variations with names such as Brazos, White River, Nelson, or Oregon. One popular variant was the double-rigged and square-skirted "Mother Hubbard." Another was the high-horned and short-skirted "California" style. There were other hybridized saddles used in parts of the Northwest and Rocky Mountain regions.

One popular saddle of the late 1800s was the Cheyenne saddle. It was designed in Wyoming and popularized by saddle makers Gallatin, F.A. Meanea, and the Collins brothers. Its invention was attributed to Meanea, while its name derived from the first place of manufacture. A favorite of Great Plains cowboys, the saddle's most distinguishing feature was its "Cheyenne roll," a cornice-like roll of leather on top of the cantle at the back of the saddle. This could be used as a hand-hold while riding a bucking horse.

Copyrights and patents did not exist for saddle-making styles, and many makers produced saddles of all types. In the days of the cattle drives, nearly every town had a saddle maker, who took about six weeks to construct a good custom saddle. If a cowboy found himself a considerable distance from the saddle maker, but still wanted to purchase a saddle, he might mail-order it from a catalog, picking it up on his next visit to town.

Although many saddle makers faded into time like so much trail dust, some, such as Gallatin and Meanea, still prosper. Other longtime makers include Heiser, Frazier, G.S. Garcia, Main and Winchester, L.D. Stone, and Visalia Stock Saddle Company.

Opposite page: Mother Hubbard saddle, circa 1870s

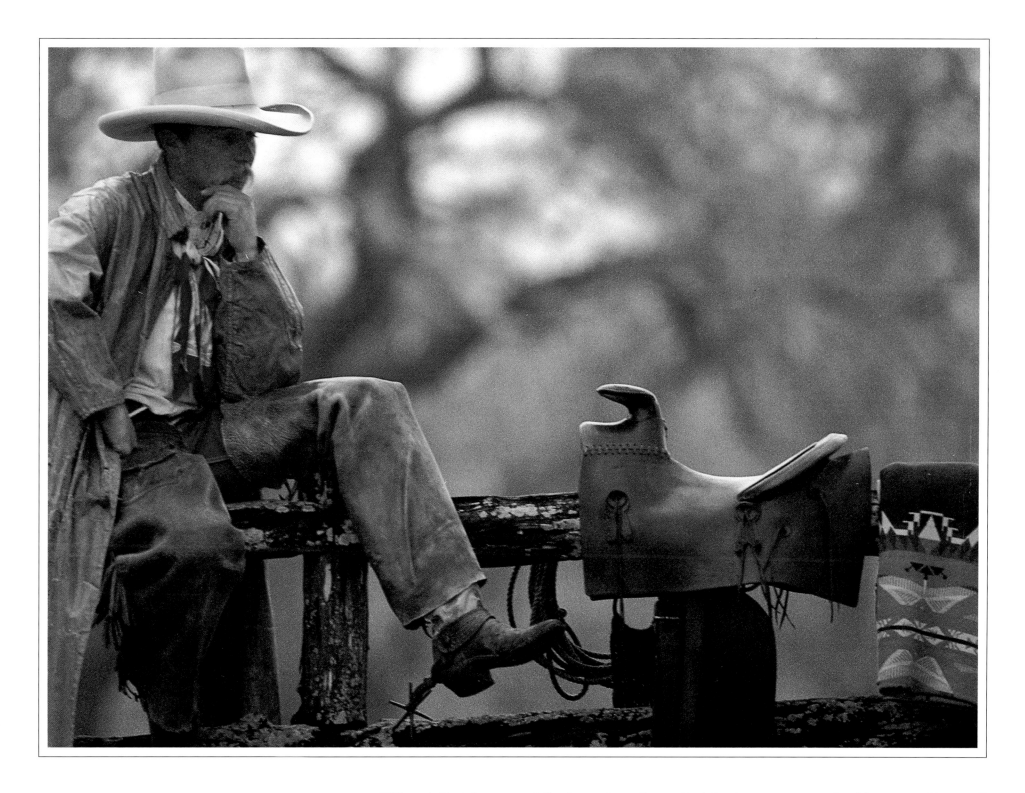

"When I die take my saddle down from the wall / Put it on my pony, lead him out of his stall,
Tie my bones to his back, turn our faces to the West / We'll ride the prairie that we love the best."

—Old Paint

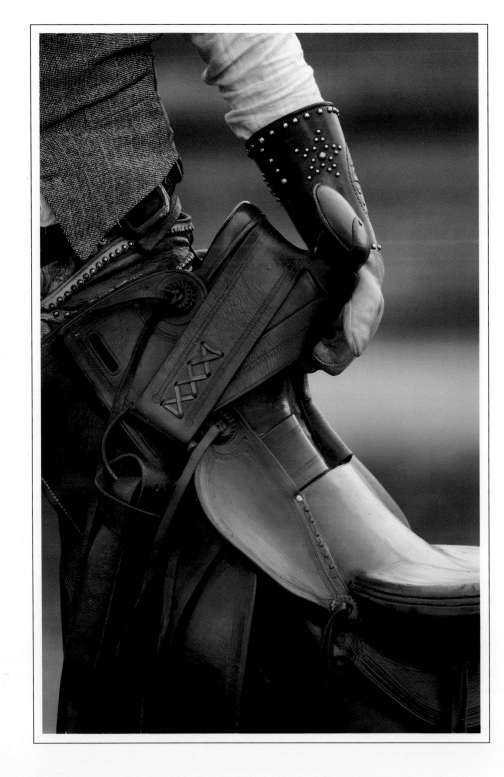

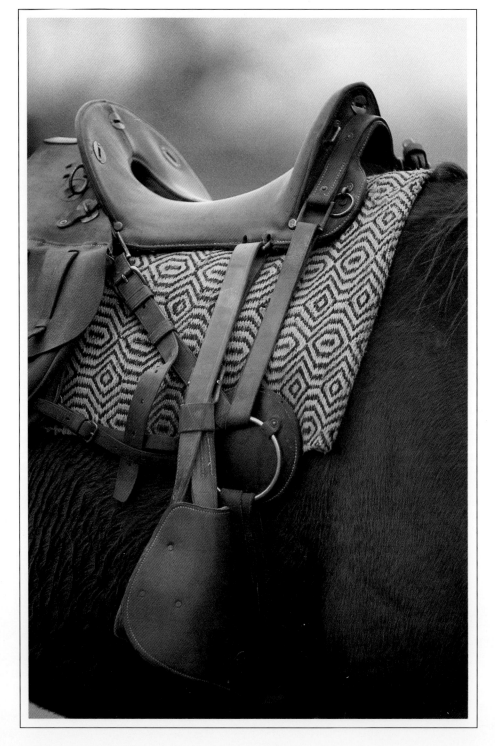

This great-plains saddle, built by A.J. Davidson of Helena, Montana Territory in 1885, could very well have seen action during the trouble between the cattlemen, homesteaders and sheepmen, in the Range Wars of the 1880s and early 1890s.

McClellan Cavalry saddles were all some cowboys could afford.

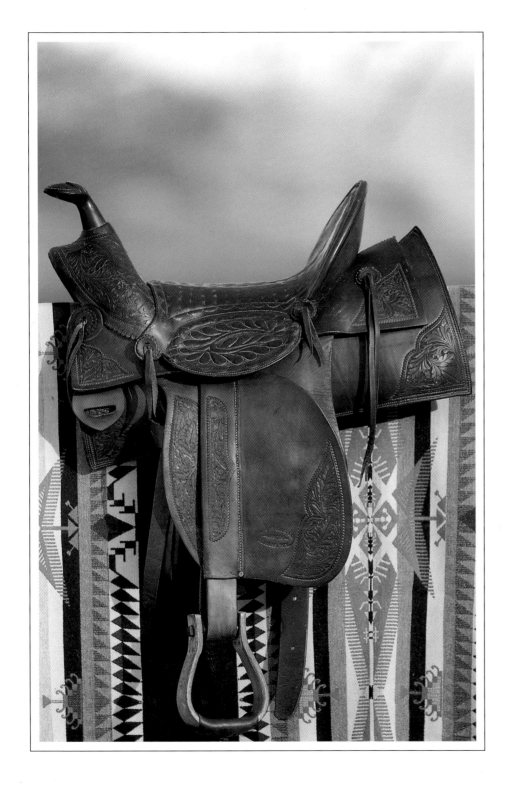

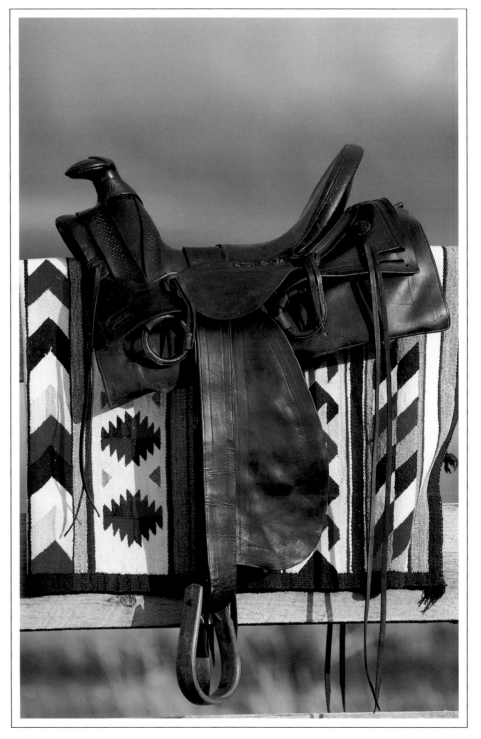

Ladies' astride saddle by Padgitt Bros., Dallas, Texas; circa 1910

Saddle by Heiser, Denver, Colorado; circa 1880

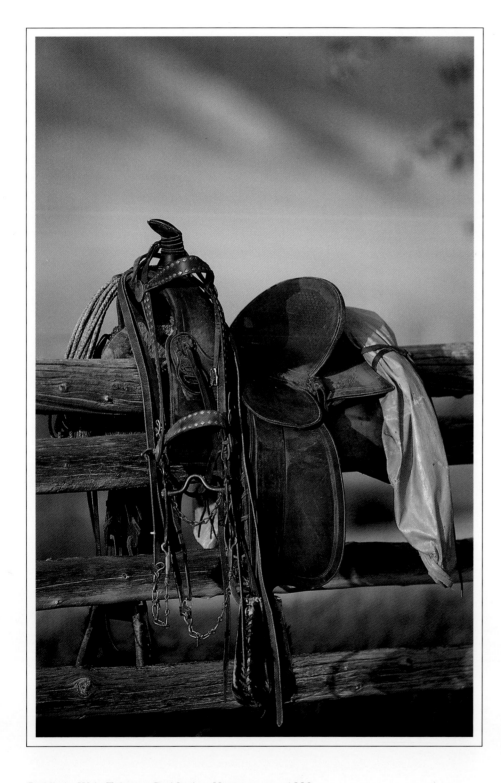

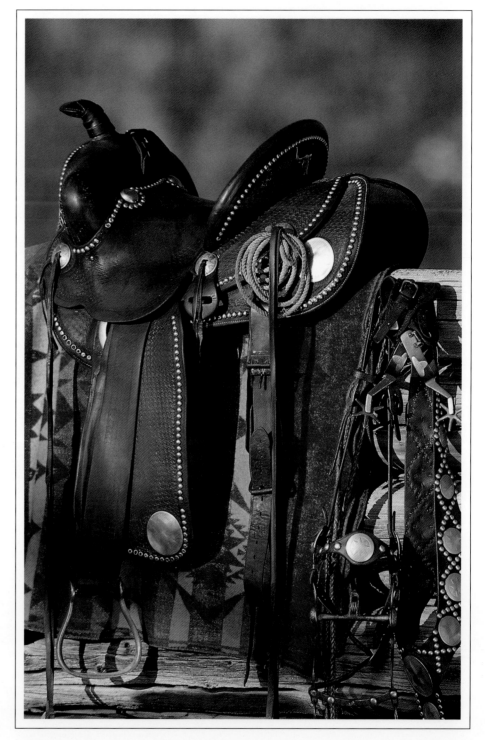

Saddle by W.A. Talmage, Red Lodge, Montana; circa 1890 Saddle by Blake Miller, Cheyenne, Wyoming; circa 1920

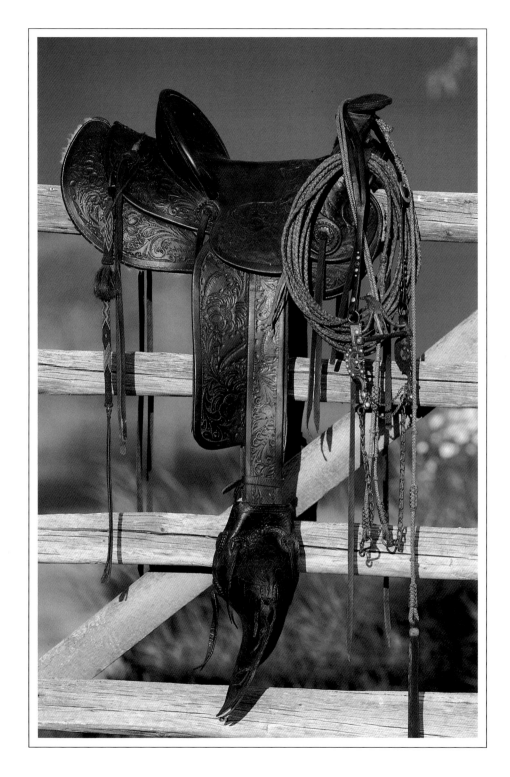

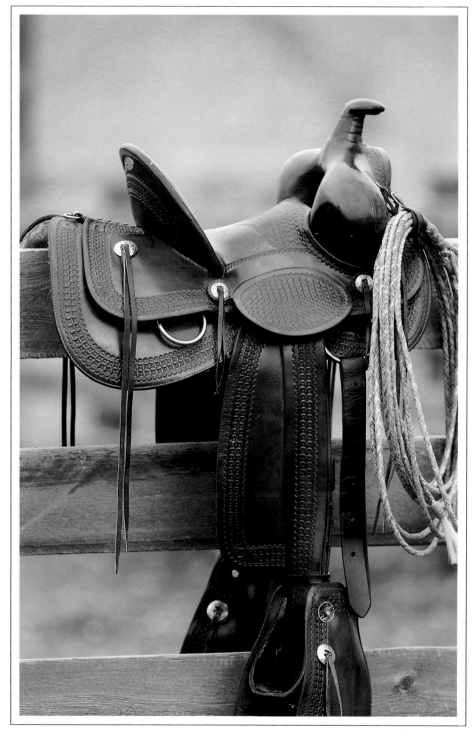

Saddle by John D. Buckley, Monterey, California; circa 1920
This saddle is a fantastic example of Californian leather carving.

Saddle by Knox & Tanner, California; circa 1920
This saddle is a great example of large bucking swells.

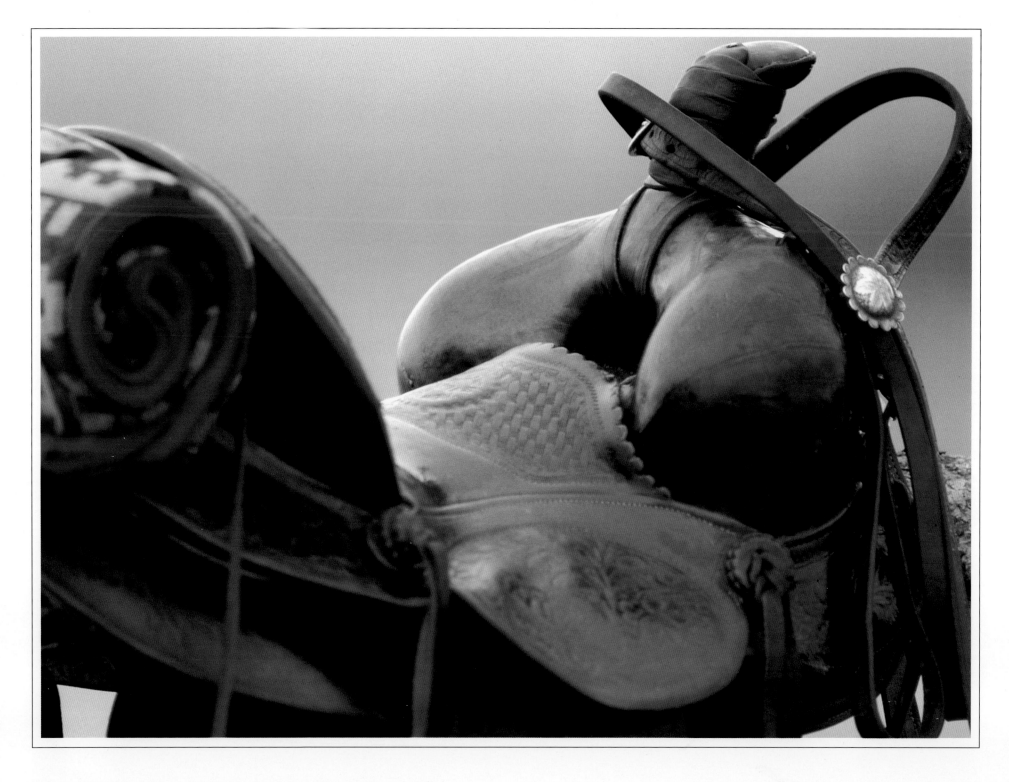

Full seat saddle with slightly swelled forks by G.S. Garcia, Elko, Nevada; circa 1925

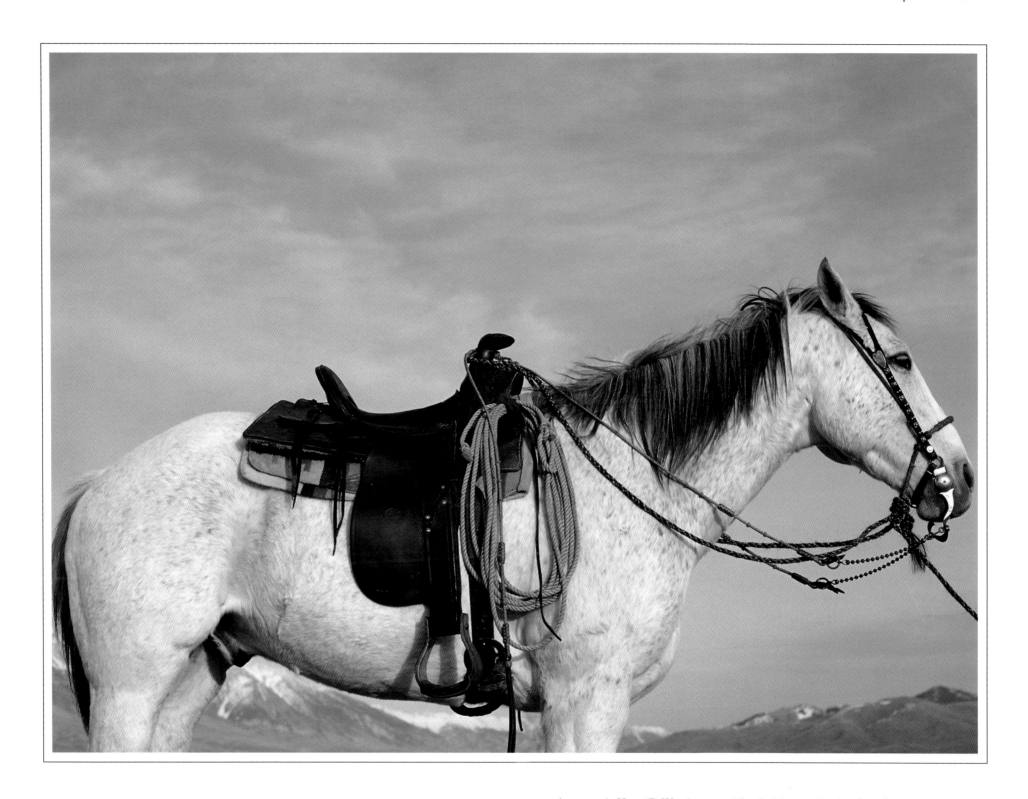

A very early Main & Winchester saddle, double rigged with a Sam Stagg rig; circa 1870s

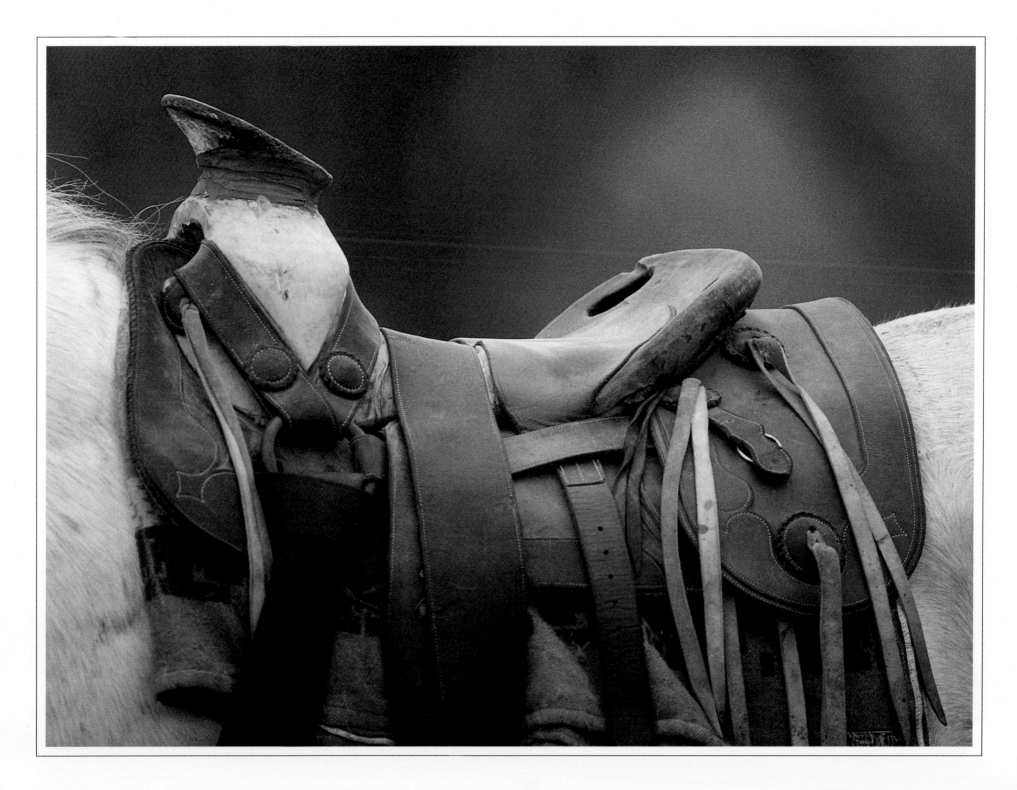

Early Mexican saddle, the forerunner of the American cowboy saddle

Fancy saddle ornament
This ornament and others were available from a number of gear catalogs and saddle makers.

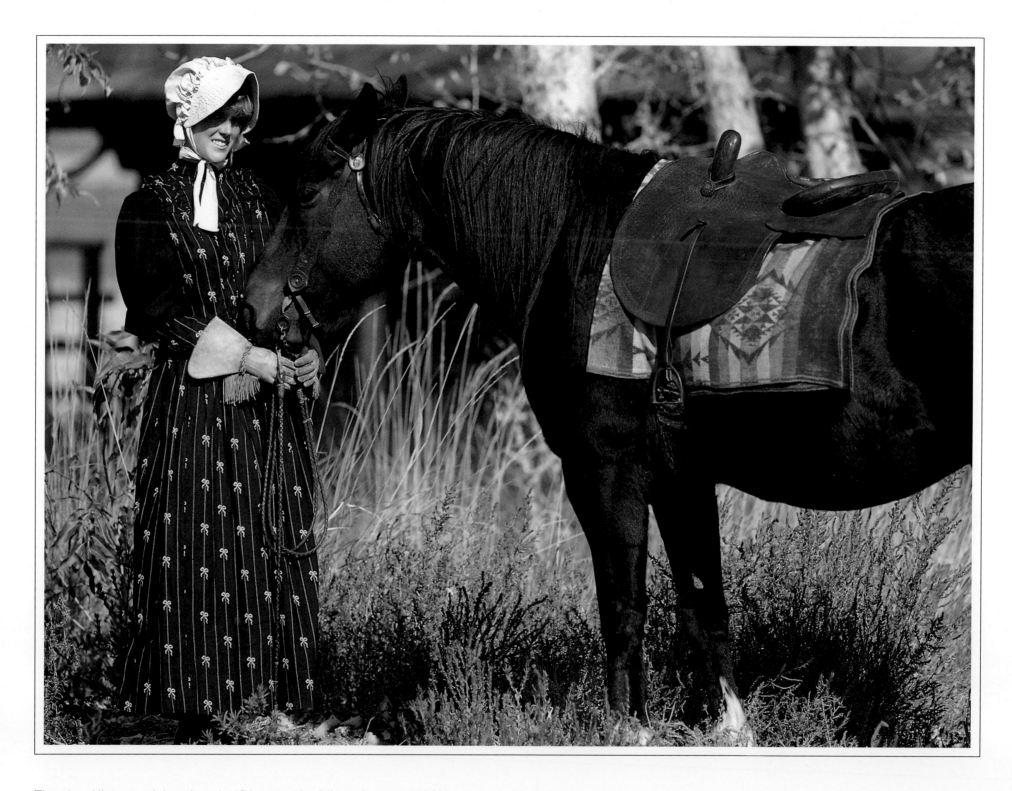

The side saddle was used throughout the 19th century, but fell out of use around 1900, when women began riding astride.

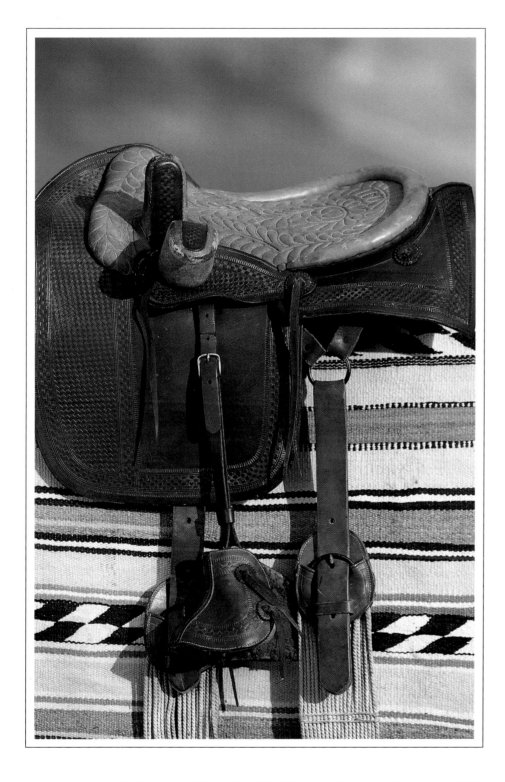

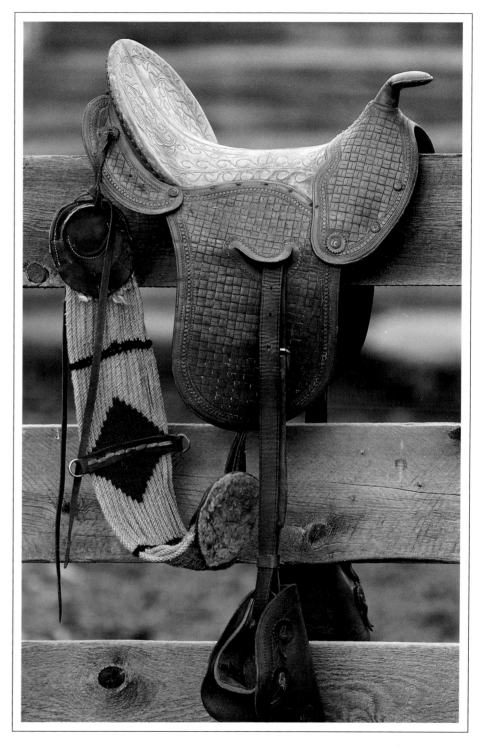

Ladies' side saddle made by Fred Mueller of Denver, Colorado; circa 1890

Ladies' astride saddle made by Charles Nye of Walla Walla, Washington
These women's saddles were popular from 1900 until the late teens,
when women started using men's saddles adjusted to their needs.

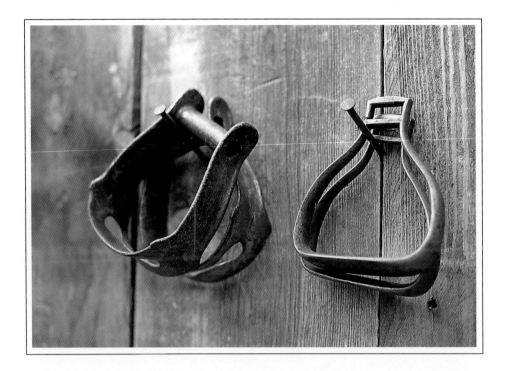

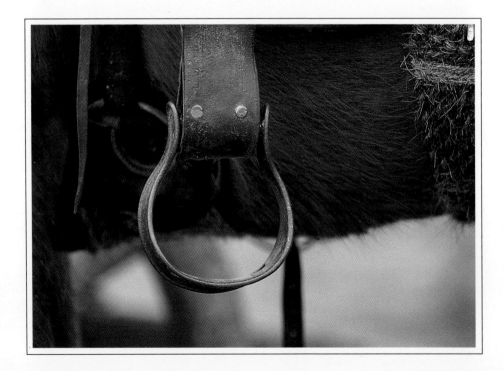

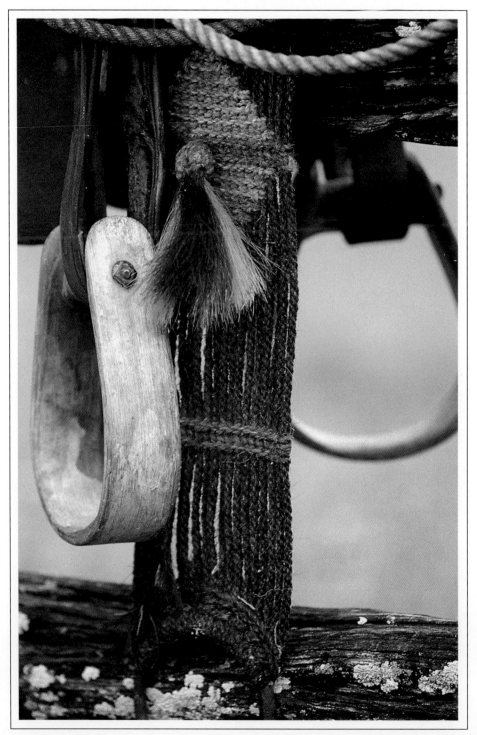

Top: Patented cast-iron stirrups

Bottom: Iron stirrups

Plain bentwood stirrups

Stirrups

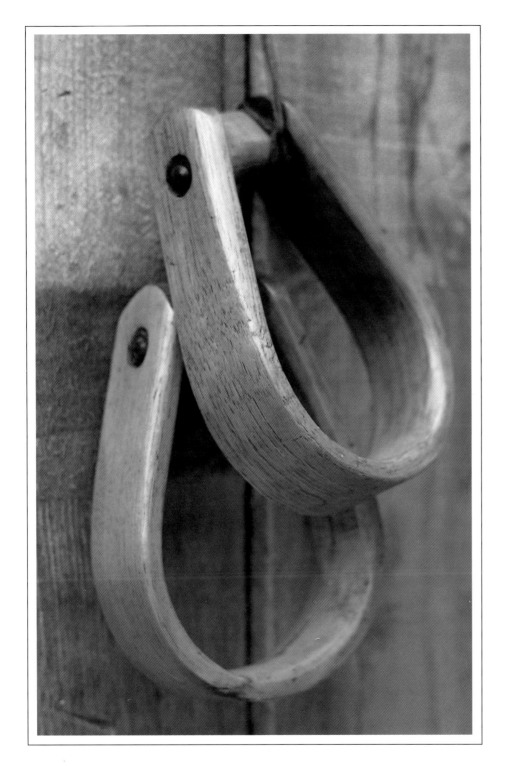

Stirrups kept a cowboy from falling off his horse by providing the solid footing that allowed him to balance and maneuver while in the saddle. This also provided a much more comfortable ride. Constructed of carved or bent wood, or even simple iron rings, stirrups had to provide a solid platform, while being capable of withstanding the crushing weight of a fallen horse.

Stirrups were affixed to the saddle by the stirrup leathers, two broad straps that at top were looped through the saddle tree. The bottom ends of the stirrup leathers passed through the top of the stirrups and were lashed together at a length that suited the rider.

The American cowboy preferred to ride with his whole foot on the stirrup, and early Texas cowpunchers were partial to bentwood "doghouse" stirrups, which were four to six inches wide. Over time, however, cowboys discovered the narrower Oxbow style stirrup, which allowed them to mount and dismount with greater ease. Made of a thin wooden board steamed into shape, the Oxbow let them bury their boots deeper in the stirrups, while allowing them to kick free easily in a pinch.

In the early 1890s, American entrepreneurs introduced steel stirrups, contending that steel was easier to shape and that steel stirrups could be made faster and constructed more sturdily than their wooden counterparts. They weren't in vogue long, however. They were bitterly cold in the winter and became dangerous if a rider found himself being thrown from a horse. Following World War I, steel stirrups were rarely used, and saddle makers reverted to leather-covered wooden models.

Good quality stirrups were covered with leather, both at the bottom and at the top, where the bolt and roller came together. Sometimes they were also trimmed with strips of zinc, iron, or brass.

Plain wooden Oxbow Stirrups

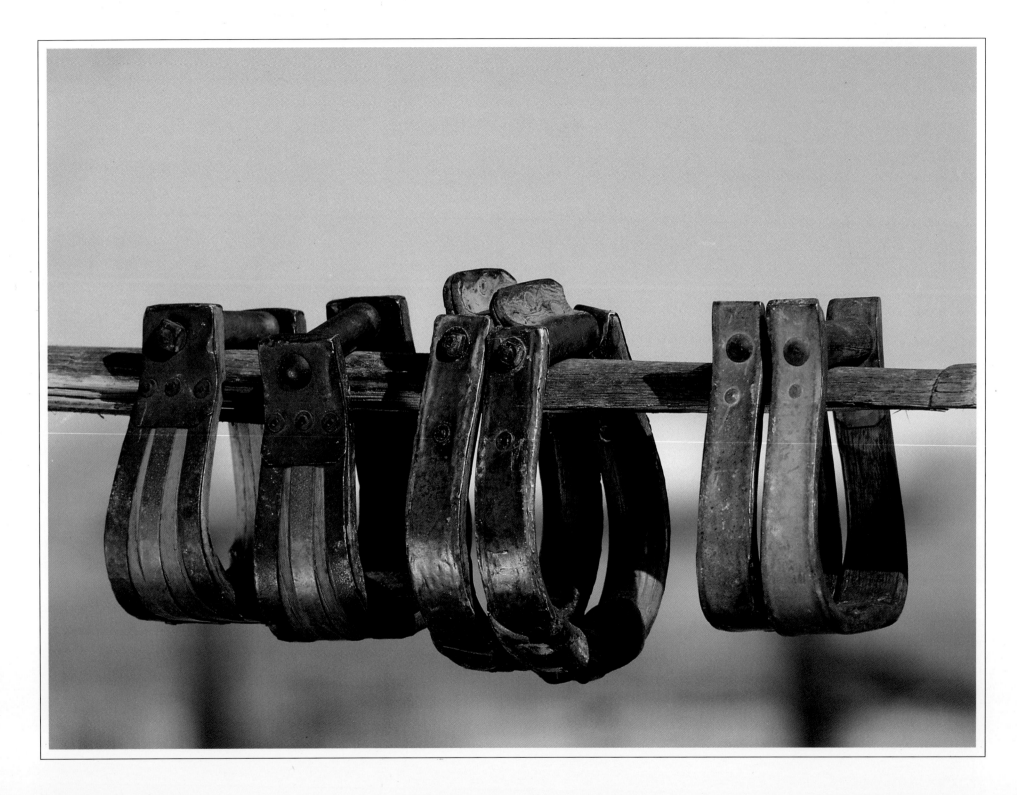

Bentwood metal-bound stirrups

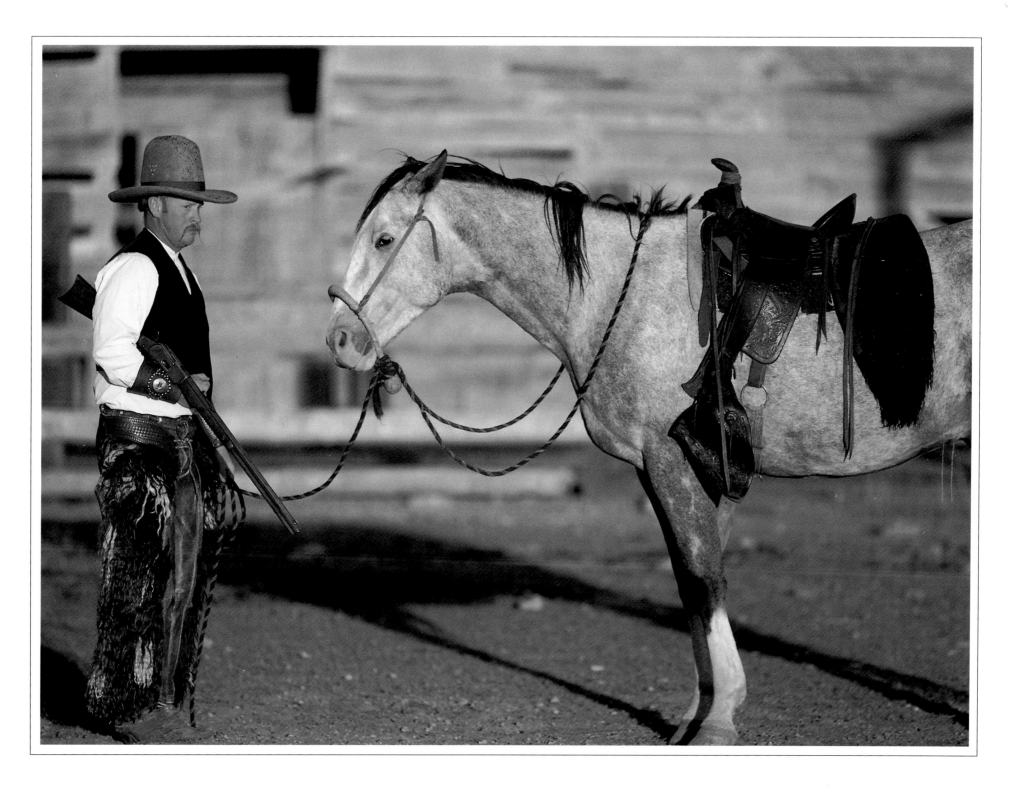

This beautiful saddle, made by John D. Buckley of Monterey Saddlery, Monterey, California, has eagle-billed tapaderos and angora saddle pockets made by Visalia Stock Saddle Co., Visalia, California.

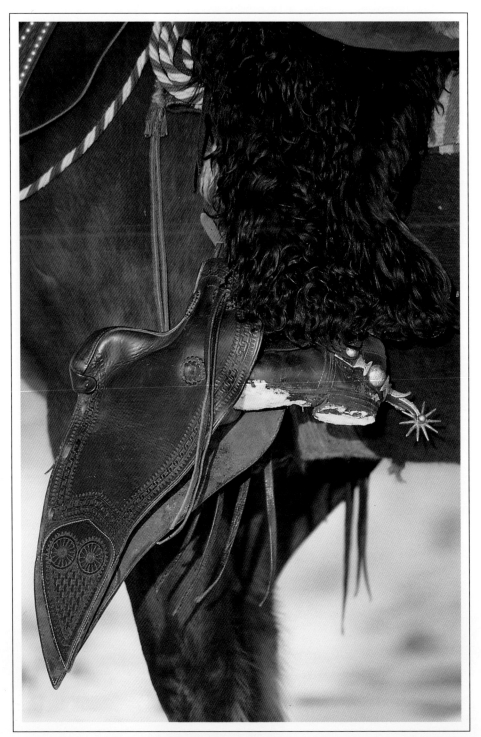

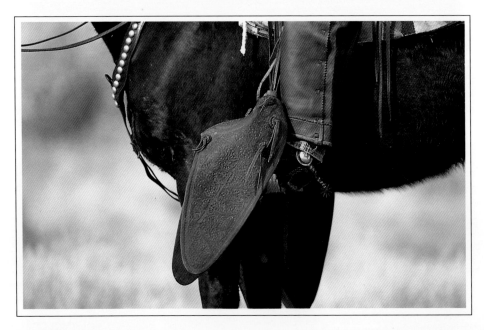

Top: Bulldog tapaderos

Bottom: G.S. Garcia eagle-billed tapaderos

Eagle-billed tapaderos

Tapaderos

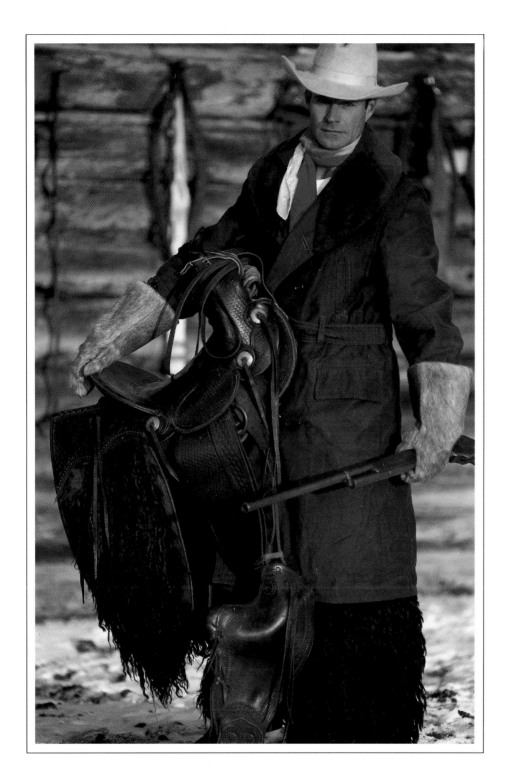

Saddle by L.D. Stone with eagle-billed tapaderos, circa 1880

Mexican vaqueros were, for the most part, known as "toe riders" because they used a stirrup that accommodated only the toe of their boot. These stirrups were often constructed of a solid piece of carved wood, with leather coverings called tapaderos.

Tapaderos, sometimes called "taps" or "toe fenders," were constructed of as many as three leather strips that were layered and placed on the stirrup leathers so that they hung down over the front of the stirrups. Their purpose was to keep the rider's stirrups from catching in the mesquite and chaparral of the Southwest, as well as to provide protection from biting horses. Northern cowpunchers used tapaderos lined with sheepskin to keep their feet warm in winter. Some makers decorated their tapaderos with gold and silver, intending them more for fiesta riding than range work.

"They go to the ballroom, and swing the pretty girls around—
they ride their bucking broncos, and wear their broad-brimmed
hats, their California saddles, their pants below their boots,
you can hear their spurs go ling-a-ling, or perhaps somebody shoots."

—The Melancholy Cowboy

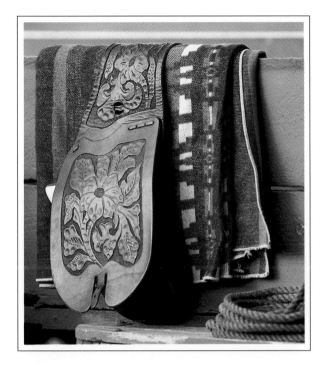

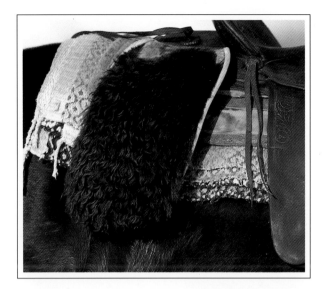

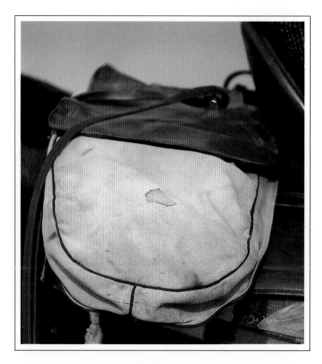

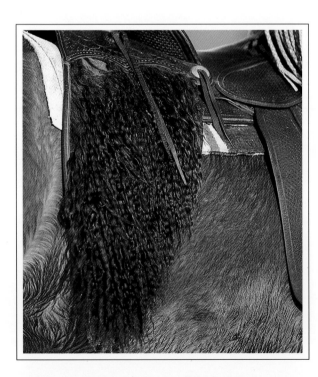

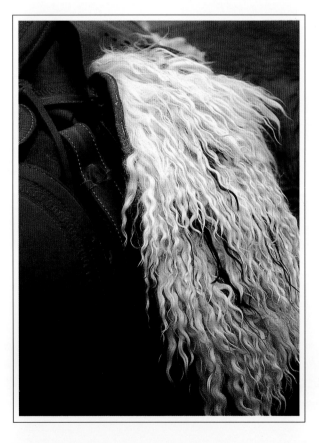

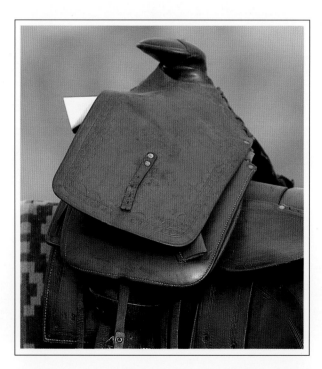

Top: Unmarked heavily tooled saddle bag with holster

Bottom: Visalia angora saddle bags

Top: Buffalo hide-covered saddle pockets

Bottom: Angora wool saddle pockets, white with black spots

Top: Canvas and leather bags

Bottom: Pommel bags showing pistol protruding from built-in holster made by Thomas McAllister of Sprague, Washington Territory, circa 1886.

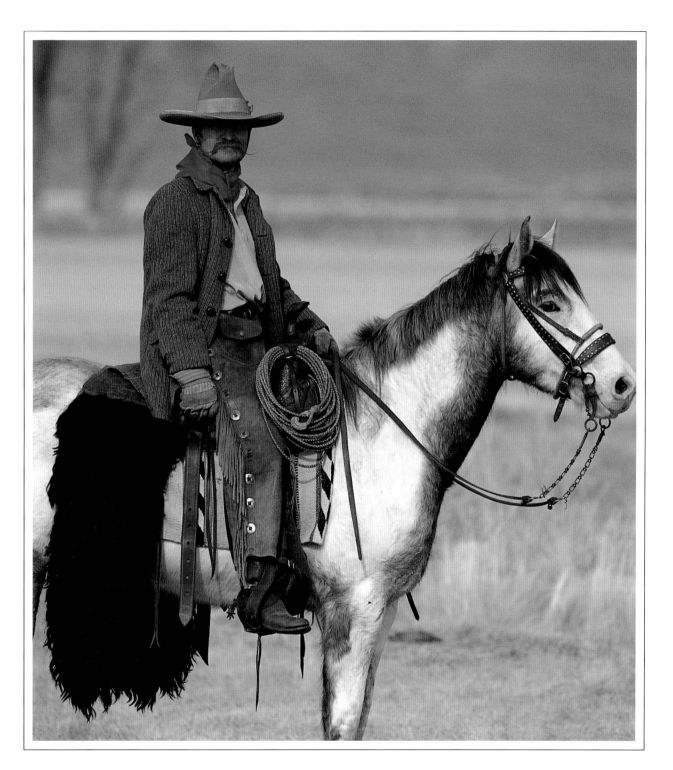

A very rare serape, from Sentinel Butte Saddlery, Montana; circa 1890
Serapes of this type had no functional purpose and were used solely for decoration.

Saddle Pockets

In the days before the chuck wagon, a cowboy carried only the gear and accessories he could pack into or onto his saddle and saddle pockets or bags. A cowboy's saddle bags served as his wallet, suitcase, and tool kit.

Before hitting the trail, a cowpuncher would always double-check his saddle bags to be certain he had everything he needed, especially tobacco and a picture or letter from his girlfriend. Saddlebags needed to be large enough to carry tools and personal possessions, but small and light enough not to interfere with a horse's movements. Before the use of packhorses and chuck wagons, a cowboy had to travel light.

Attached to the back of the saddle, behind the cantle and draped over the horse's flanks, saddle bags were usually covered with wool, angora, or other hide. Additional saddle bags, called "cantinas" or pommel bags, fit over the saddle horn. These were most often used on longer drives.

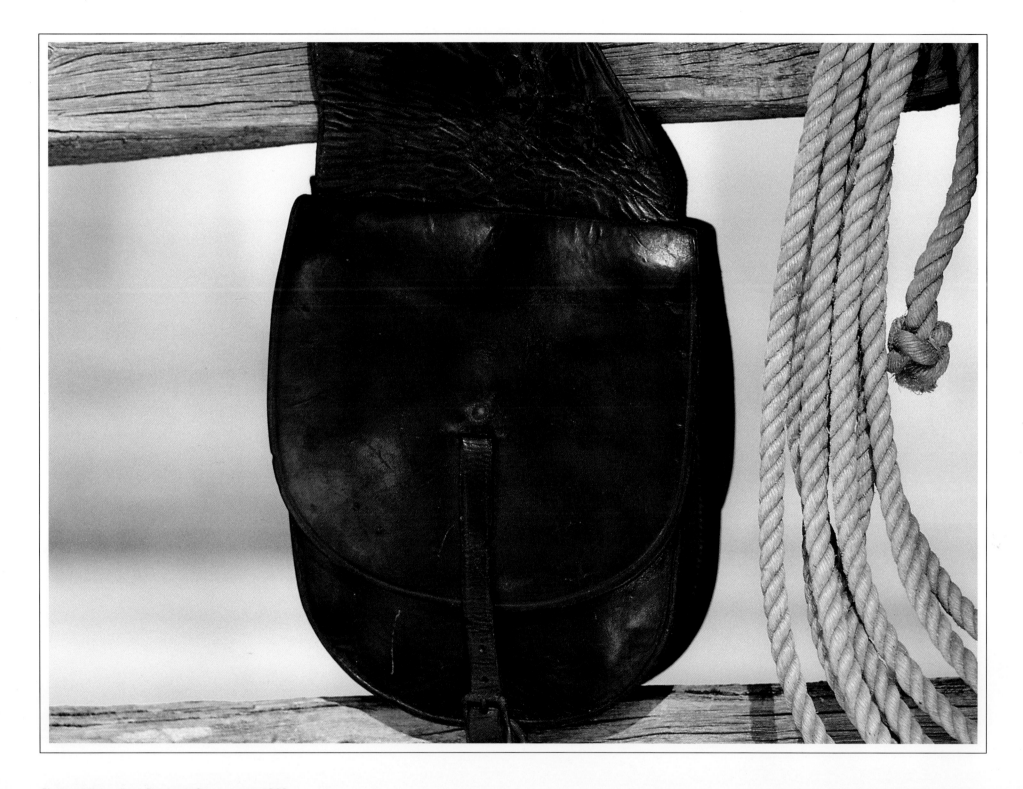

Clark saddle pockets, Portland, Oregon; circa 1900

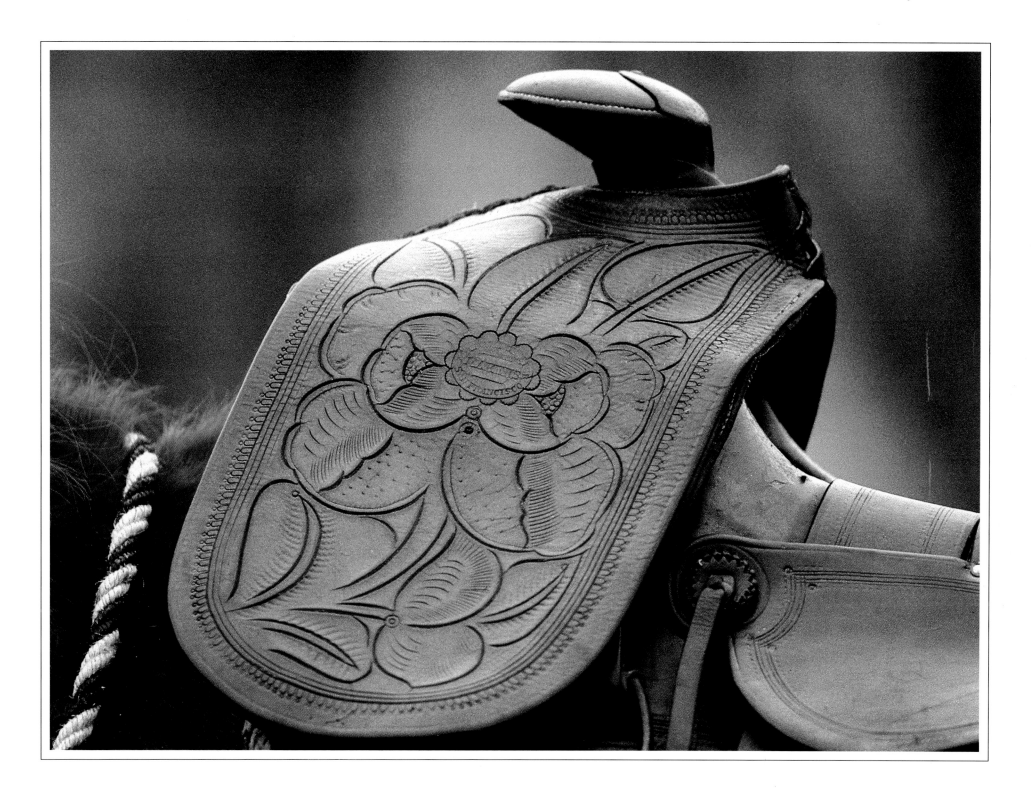

Main & Winchester pommel bags carved in the early Californian style, circa 1870s

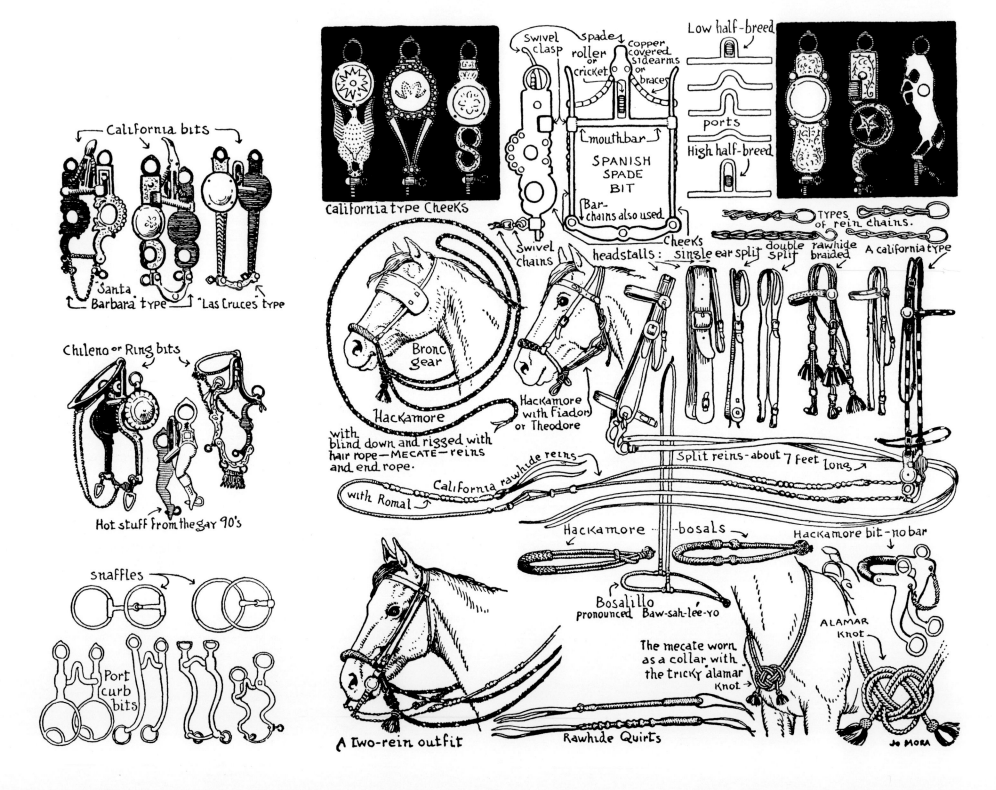

California bits

Santa Barbara type — "Las Cruces" type

Chileno or Ring bits

Hot stuff from the gay 90's

snaffles

Port curb bits

California type cheeks

swivel clasp — spade roller or cricket — copper covered sidearms or braces

Low half-breed

mouthbar

SPANISH SPADE BIT

Bar-chains also used

ports

High half-breed

swivel chains

headstalls: single ear split double split rawhide braided A california type

types of rein chains.

Cheeks

Bronc gear

Hackamore

Hackamore with Fiador or Theodore

with blind down and rigged with hair rope—MECATE—reins and end rope.

California rawhide reins

with Romal

Split reins - about 7 feet long

Hackamore bosals

Bosalillo
pronounced Baw-sah-lée-yo

Hackamore bit - no bar

ALAMAR Knot

The mecate worn as a collar with the tricky alamar knot

A Two-rein outfit

Rawhide Quirts

Jo Mora

Bridles & Headstalls

Chapter 7

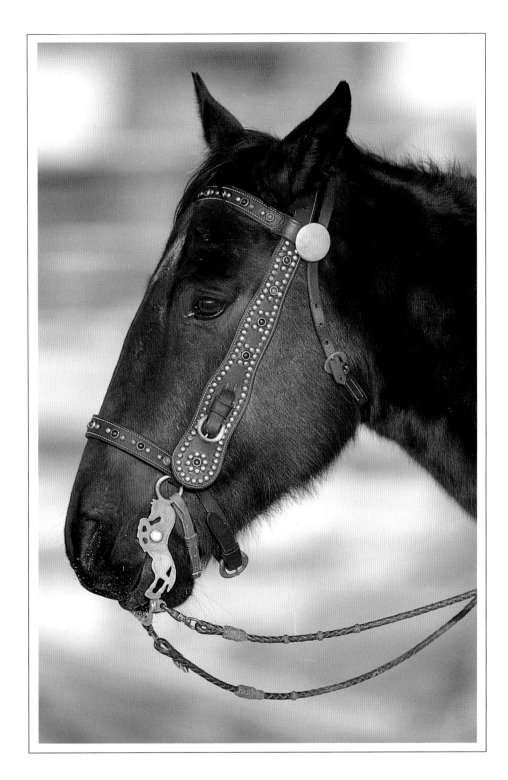

Heavily studded headstall with bronze horse bit, probably made by Buermann; circa 1900

In its simplest description, the bridle was a device that went over and around a horse's head, helping the cowboy control the animal. The bridle consisted of a headstall, bit, curb strap or chain, and reins. The headstall held the bit in the horse's mouth, and, when the reins were pulled, pressure was exerted on the bit. On the range, there were three popular styles of headstall: the California, the split-ear, and the hackamore.

The California headstall was generally made of horsehair or leather, and characteristically had a brow band across the horse's forehead. The split-ear style had a single or double split in the headstall leather to accommodate the horse's ears. This type could have either one split for both ears, or two splits, one for each ear.

The hackamore, or "jaquima," was a headstall without a bit. Western historian Jo Mora called the hackamore "the most misunderstood and seldom properly used implement." It consisted of a braided rawhide bosal (nose band), two strips of latigo hang bound to either side that acted as cheek pieces, and a tie to the poll to hold it in place. The cheek pieces were set close to the horse's eyes, and clamped high on the bosal to give more length and flexibility to the shanks when they were weighed down by the mecate knot and reins. "Mecate" is a Spanish term describing a horsehair rope, usually made of mane or tail hair. Sometimes called a McCarty rope, a mecate could also be made of mohair or cowtail.

The bosal had a nose button, extra braiding that passed over the horse's nose and tapered from the center to the sides. Hackamore reins were always made of mecate. The perfect hackamore fit was a bosal that fit the horse's nose, with a proper hang to the heel and rein knot so that they hung nicely when the reins were loose, clearing the under jaw at the

A fancy studded bridle with unmarked shield bit, circa 1900
Wide bridles such as this one were most popular on the plains; they could serve a
double purpose, both guiding the horse and covering the head of an ugly animal.

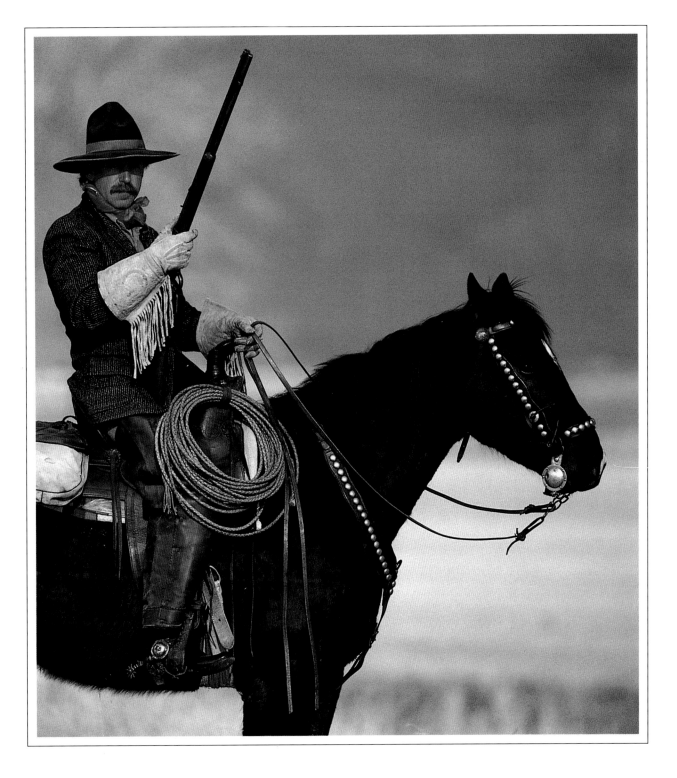

A fully outfitted horse with studded breast collar and
matching headstall with straight bar bit, circa 1920
Maker unknown

chin by about $1^1/_2$ inches.

The hackamore headstall system of breaking a bronc was widely known as the best way to break and train a horse. It was not unusual for a cowboy to take a year to break a horse using the hackamore system. Many punchers claimed a colt broken and trained with a hackamore to be the best, most responsive horse that could be ridden.

In Texas, they had a different system altogether. Texans of the Old West were inclined to break and train horses with a snaffle, or low curb bit. Using bits was a more aggressive and faster way of training a horse.

California vaqueros preferred bridles consisting of a lightweight, narrow-cheeked headstall with a Spanish spade bit. The spade bit was used after the hackamore was properly utilized. Many cowboys preferred braided rawhide reins that attached to the bit with chains, and formed a whip-like romal in the back. In Texas, cowboys used a smaller curb bit with a heavier, wider headstall. They used split-leather reins that attached directly to a low port curb bit, foregoing the chains.

With split reins, a Texas horse was trained to stay put when a cowboy dismounted. A Californian might tie his horse off with a mecate collar, while a Texan would "ground tie" his horse, meaning he let the animal's reins dangle to the ground. A horse that could do this was a well-heeled horse.

Bridles were a showcase where a maker could display his art. They were often decorated with beautiful designs and colors, and many were decorated with silver.

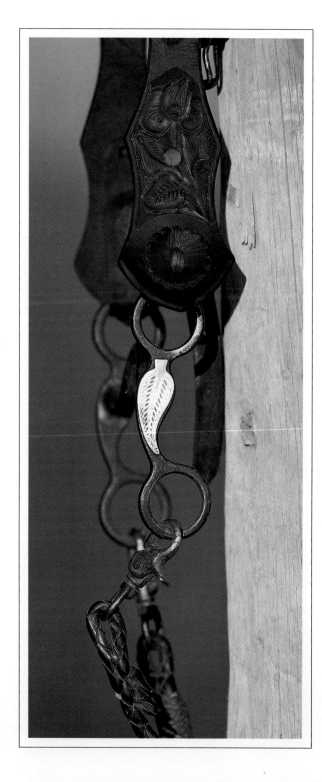

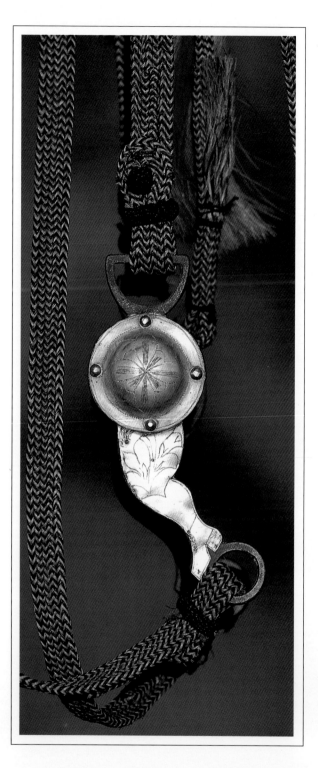

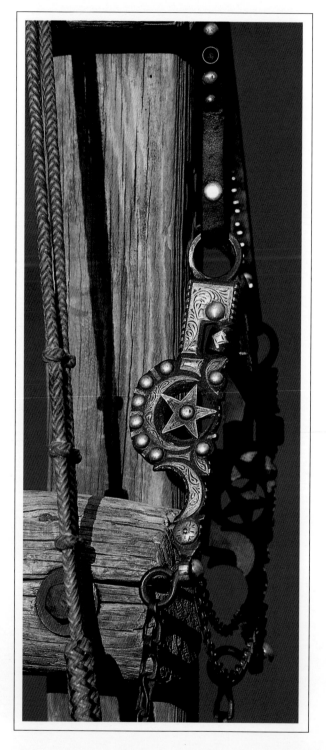

Kelly Bros. curb bit, circa 1930 Prison-made "gal-leg" curb bit, circa 1910 Elko star spade bit, circa 1900

Bits

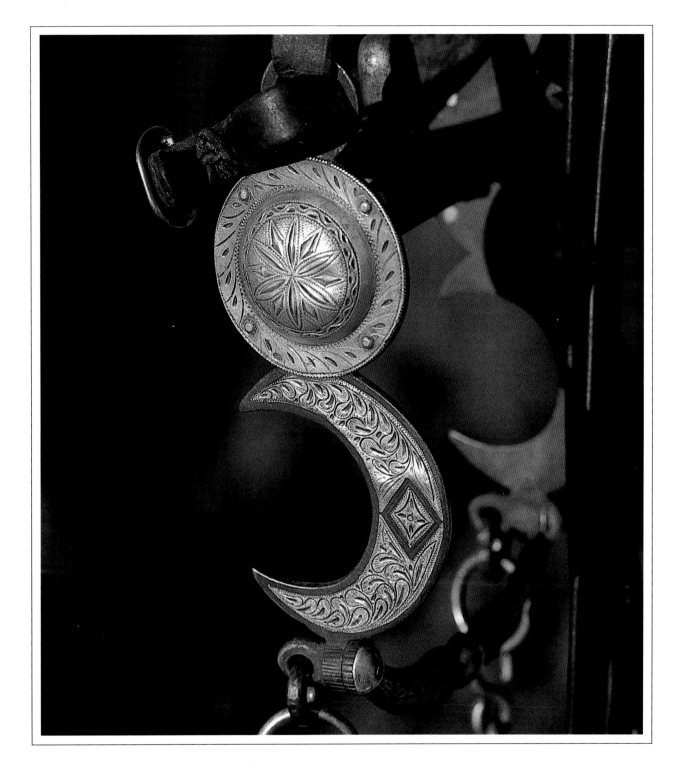

The bit was a metal bar placed inside the horse's mouth and attached to the headstall and reins. For the most part, cowboy bits developed from the big and slightly rough bits used by the Spanish. Cowboys used them to break, train, and guide their horses.

Bits suggested pain to the horse. During the first few days of training, the pain caused to the roof of the horse's mouth by the bit was enormous. After a while, the rider had merely to suggest that pain and the horse responded to the cowpuncher's commands. A well-trained horse answered to the snap of the reins to the side of the neck.

The "bar" bit, a straight bar, and the "snaffle" bit, a straight bar connected with a hinge in the center, were both straight bits. The snaffle, due to its configuration, was considered the least severe of all bits. Many bits used around the turn of the century had a curve, or "port," in the center of the bar. The port pushed on the roof of the horse's mouth. These bits came in various sizes and were called "curb" bits.

Other bits had a roller, or "cricket," in the mouthpiece. This roller made a whistling sound when spun by the horse's tongue. Depending on the curb in the mouthpiece, these bits were called "low half-breed" and "high half-breed" bits. There was the "spade"

G.S. Garcia half-breed-style bit, circa 1900
This bit is beautifully inlayed with silver and large, engraved conchos.

bit, which had a flat metal plate instead of a curve housing the cricket. The "chileno," or ring bit, was used by the Mexicans. Instead of a bar, it featured a ring that was placed under the horse's mouth.

One of the most complex bits was the Spanish spade bit. Joe Mora commented, "That mouth port looked plenty severe, sure enough! Yet, by the same token, I also commenced to ride some of the sweetest-mouthed, flash-reined ponies I had ever forked." This bit was fitted with a cricket in the center of a spade that sported a swivel clasp at the end. It also had copper-covered braces, or side-arms, stretching across from the cricket to the cheeks just below the mouth bar. It was an intimidating but effective tool.

Often, the bit a particular trainer used depended on where he lived. Each region had a unique way of doing things. Whatever style bit a man grew up with, he generally used throughout his life.

After the Civil War, the August Buermann Mfg. Co. of Newark, New Jersey, dominated the bit market with its Star Brand bit. Other popular bit makers of the time included G.S. Garcia of Elko, Nevada; A.J. Schell of Nevada; and Edwin Field of Santa Barbara, California.

Like a headstall maker, the bit maker was a master craftsman. The bits of the early makers were spectacular works of art. Many of the early bits sported beautiful silver inlays and designs, which, like the horsehair headstall, have become highly desirable to collectors.

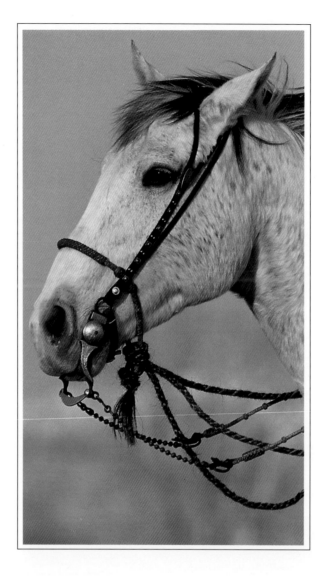

Two-rein outfit with unmarked spade bit, circa 1920
The two-rein outfit was used for training when the horse worked well in the hackamore but was just learning to respond to a bit.

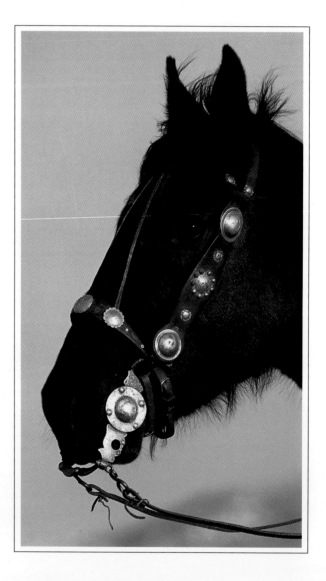

G.S. Garcia bit, circa 1900
The complete bridle with extensive silver work was popular in California.

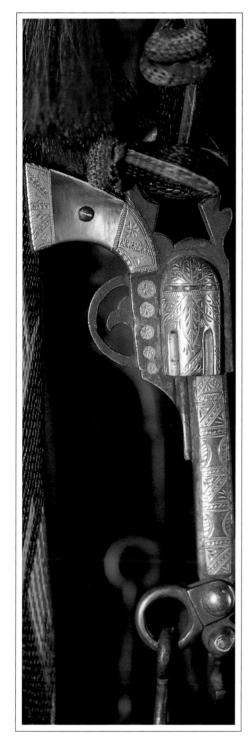

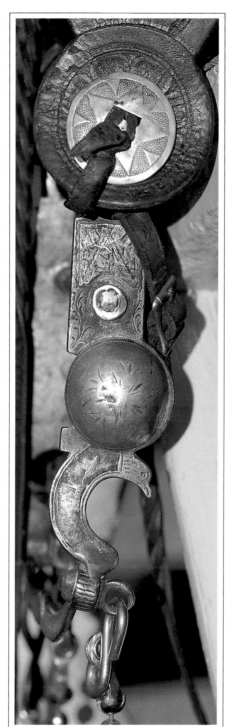

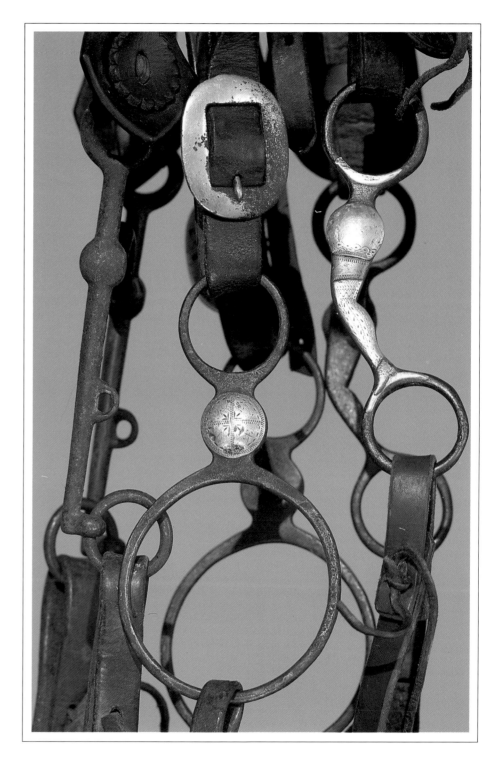

Canyon City Prison "Colt .45" bit, circa 1905

G.S. Garcia spade bit, circa 1900

Left to right: U.S. Cavalry curb bit, circa 1920; Qualey Bros. port bit, circa 1930; Texas-made McChesney "Ladies' leg" silver-overlay curb bit, circa 1910. (Matching spurs, page 199)

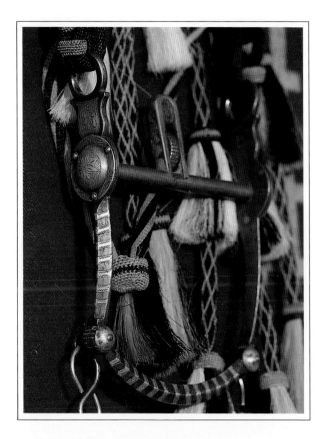

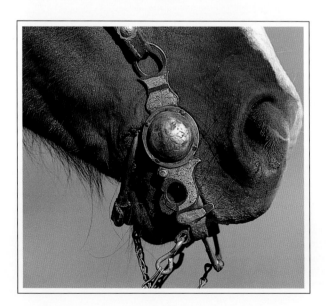

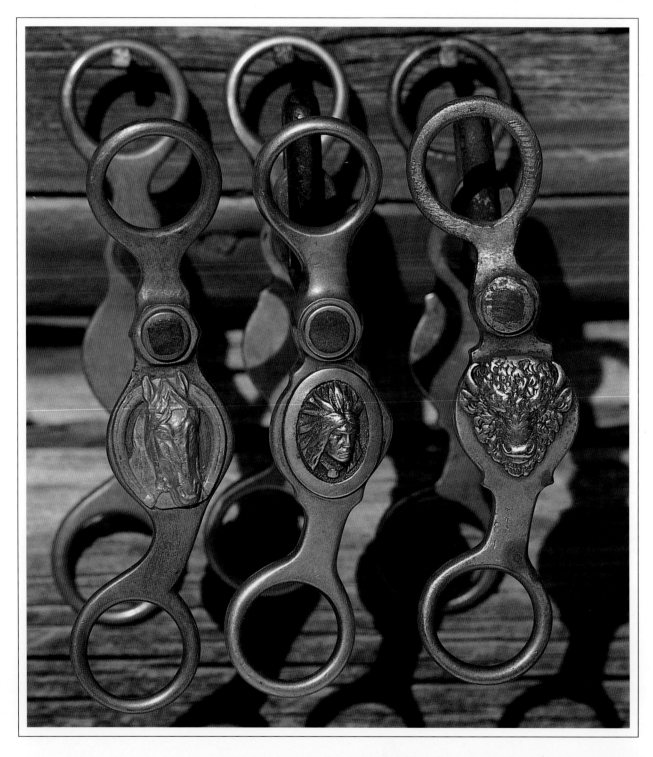

Top: G.S. Garcia bit with horsehair headstall, circa 1920
Bottom: Early unmarked ring bit, 1910

Buffalo, Indian and horsehead bits with nickel silver medallion figures, made by August Buermann; circa 1910

These "Hercules Bronze" bits were inexpensive to cast and proved to be quite popular early this century.
They could be purchased with matching spurs, as shown on page 202.

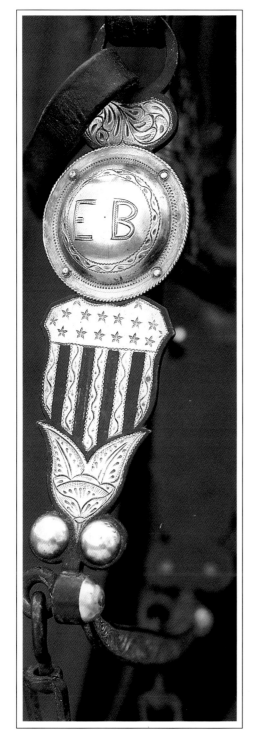

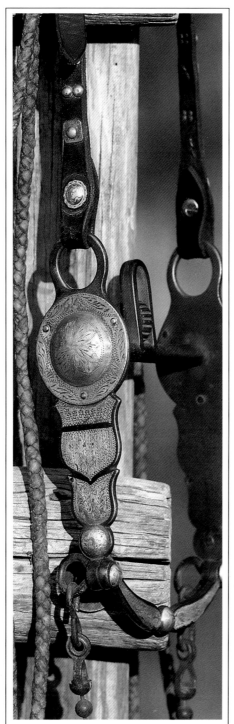

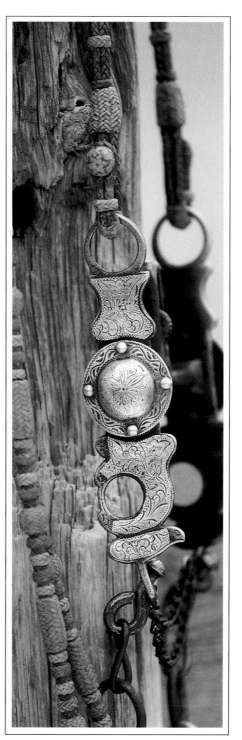

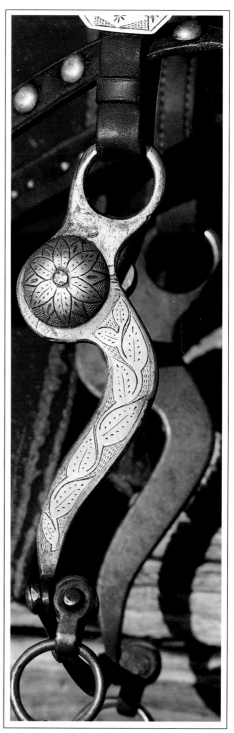

Marked "Goldberg, Staunton Saddlery Co."
Half-breed bit with initials J. E.
(Juan Estrada), circa 1920

Unmarked Morales half-breed bit,
circa 1900

Early Californian half-breed bit,
circa 1890

Canyon City Prison bit, very rare,
circa 1915

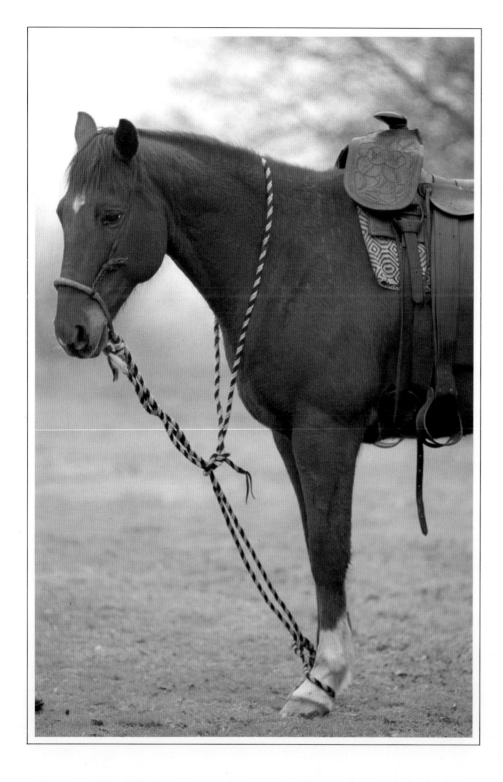

Hackamore used as a hobble

Giving him his first ride in a hackamore

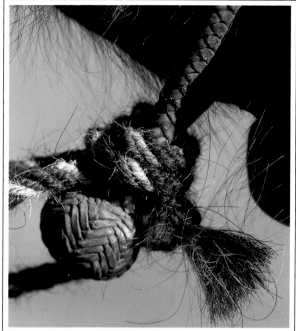

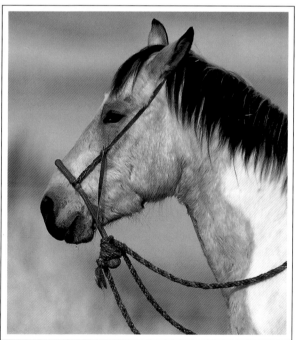

Bosal with McCarty: a complete hackamore outfit

Top: Detail of the bosal's heel knot and knot of the mecate

Bottom: This hackamore consists of a braided rawhide bosal around the muzzel and a piece of latigo for the headstall. A braided horsehair mecate makes up the reins and lead rope.

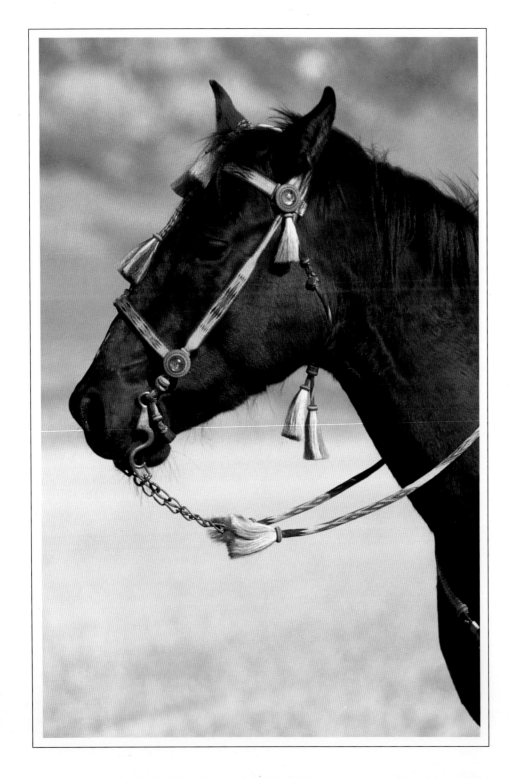

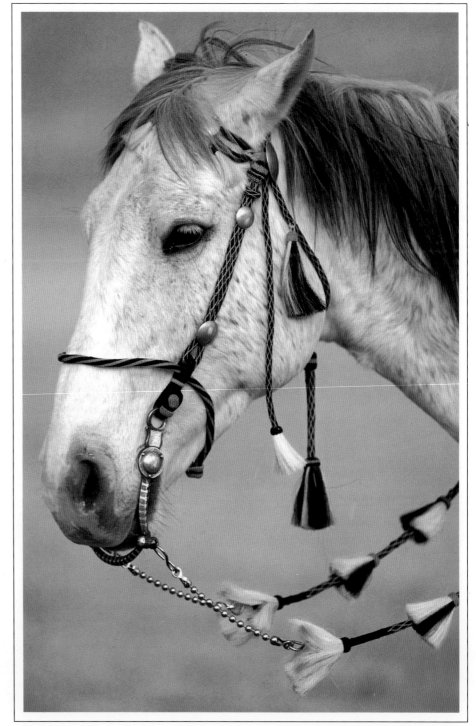

Walla Walla Prison-made horsehair headstall, circa 1910

Idaho Territory Prison-made horsehair headstall with G.S. Garcia bit, circa 1920

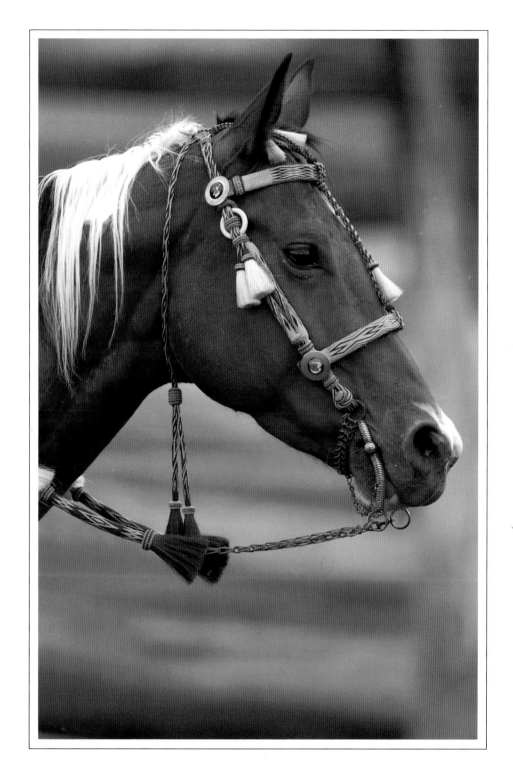

Deer Lodge Prison-made horsehair headstall, circa 1910

Horsehair

With a cup of coffee and a freshly rolled smoke, the old-time cowpuncher spent much of his free time dabbling in the art of weaving horsehair. Occasionally cowboys created something new, but most often they were simply repairing a small rope or headstall.

In the horse-and-buggy days, prison inmates made horsehair bridles, much as they make license plates today. When a man went to prison, folks would say, "Uncle Louie's weaving bridles." The practice of prisoners making bridles became so widespread that some prisons gained reputations as quality bridle makers. These included Walla Walla, Washington; Deer Lodge, Montana; Rawlins, Wyoming; Yuma, Arizona; and Canyon City, Colorado. Although the identity of the individual inmates was unknown, prison-made bridles of this era were among the most beautiful ever crafted.

To prepare horsehair for a project, a maker would usually color the lighter strands of hair with a series of aniline dyes and combine them with the natural browns, blacks and grays. The artist would then twist the hair into "pulls," or long strands, and fold them into shape. The weaving patterns were usually geometric and quite complicated, and the weaving process was long and tedious. It wasn't unusual for a custom-made bridle to require a year's work. Considered a work of art, these bridles almost never saw the wide-open spaces of the dusty range. Instead, they were reserved for special occasions.

As the demand for prison crafts escalated, horsehair belts, hat bands, purses, quirts, and ropes found their way onto the market.

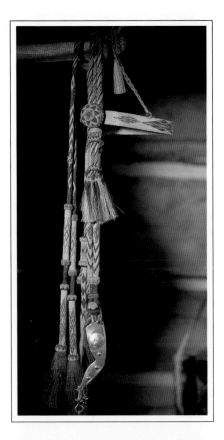

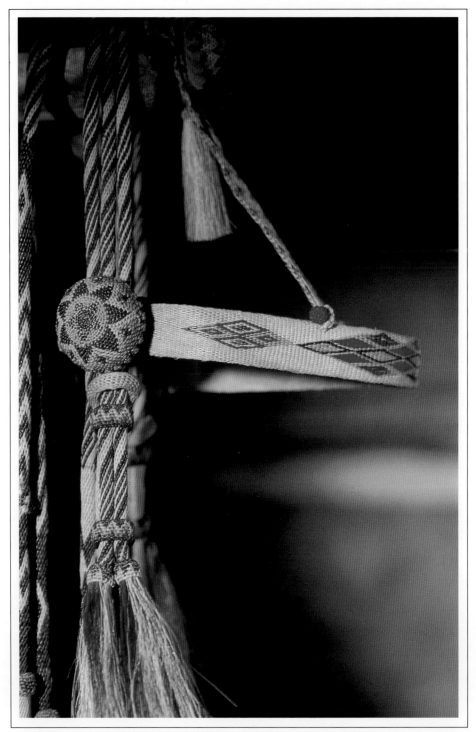

Yuma Prison horse-hair headstall with soft Southwest colors, circa 1900
The stars in the rosettes match the stars in the "Lady-leg" bit.

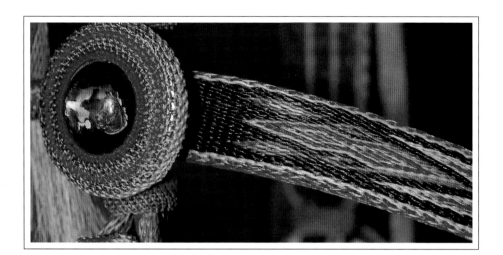

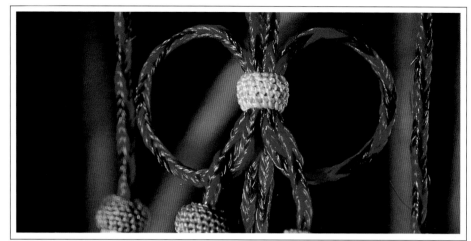

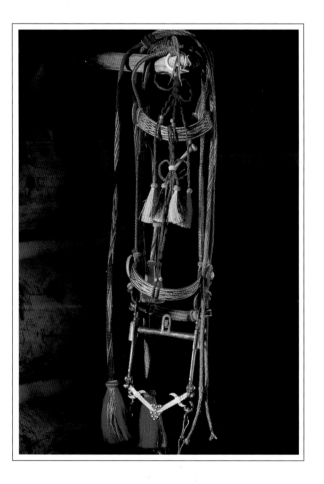

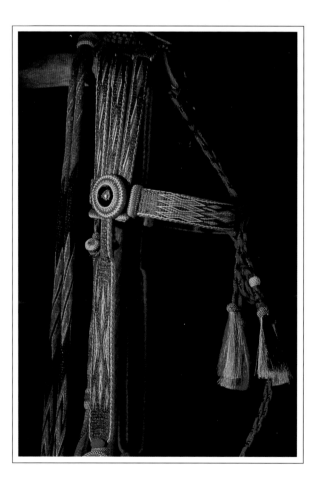

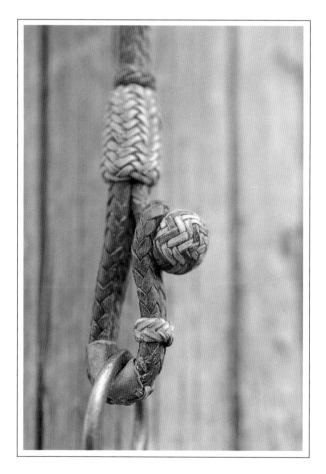

Multi-colored Deer Lodge hitched horsehair headstall with a "Colt .45" Canyon City Prison bit, showing bowie knives going into a heart on the slobber bar; circa 1910

Deer Lodge horsehair headstall has inticate hitched designs, colored tassels, and American flags on the reins

Top left: Glass bridle rosette hitched with horsehair, circa 1930
Top right: Horsehair headstall detail
Bottom: Ortega headstall detail of kangaroo leather button

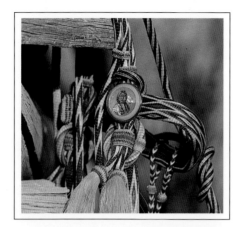

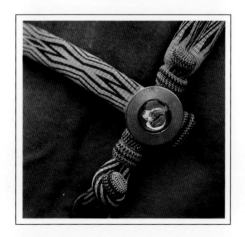

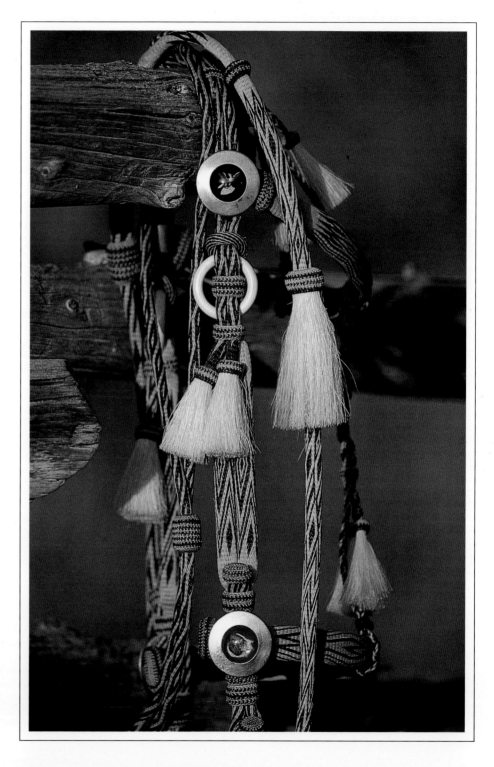

Deer Lodge Prison-made fancy
walking stick, circa 1910

Glass bridle rosettes, circa 1920

Deer Lodge, Montana horsehair headstall detail;
circa 1920

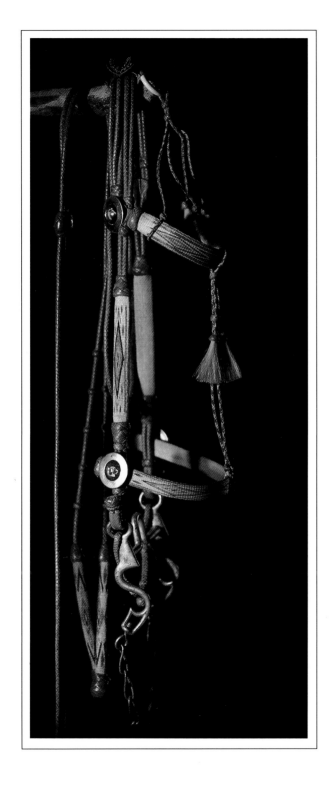

Deer Lodge Prison headstall of latigo
leather and hitched horsehair

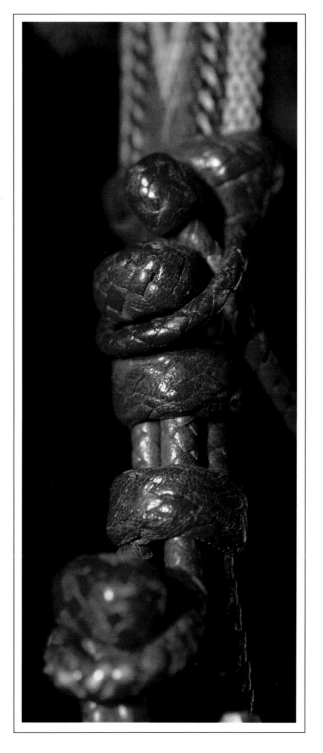

Intricate braided knots of latigo leather

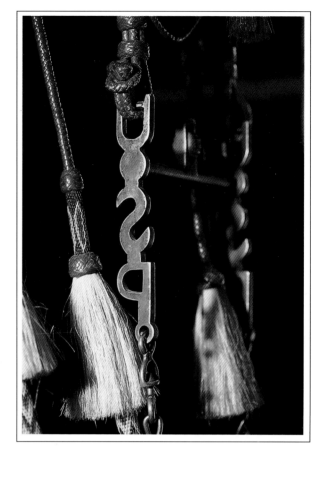

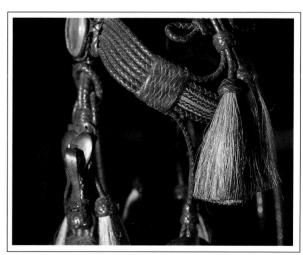

Top: Hand-forged Deer Lodge State Prison bit in latigo
leather and hitched horsehair headstall

Bottom: Latigo, or soft, oiled leather, is braided with sections of
hitched horsehair. Kangaroo leather is often used for this purpose.

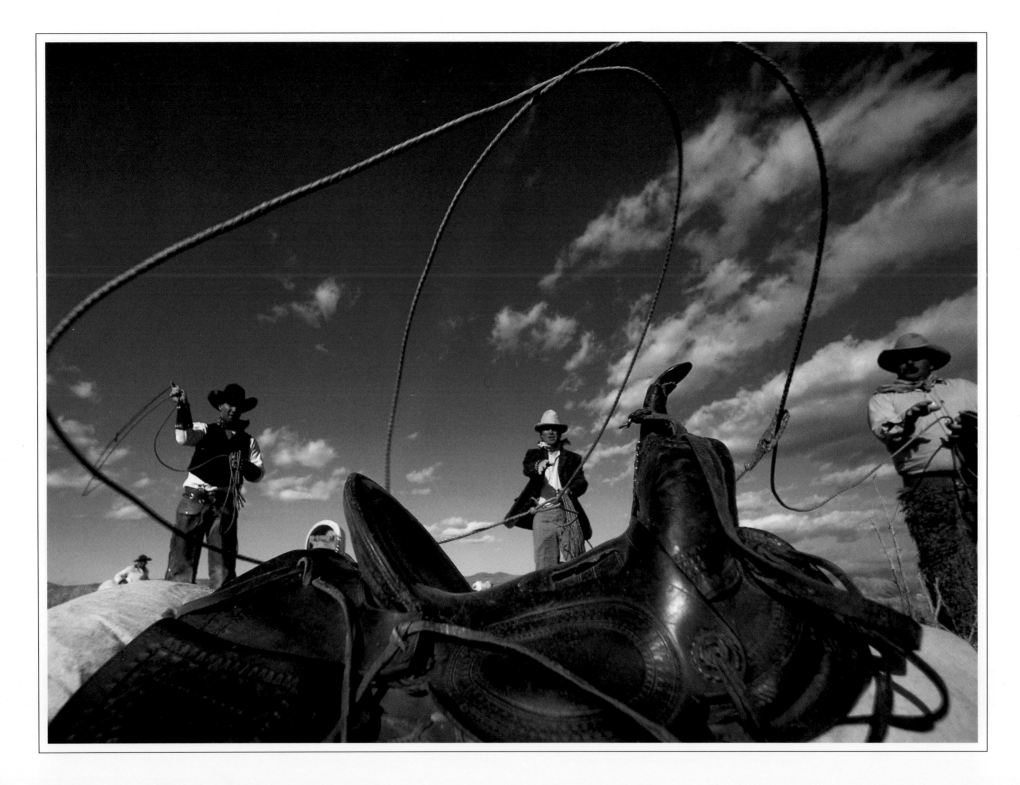

"When I was a cowboy / I could throw a lasso true,

I could rope a streak of lightning and ride / Coma ti yi yippy, ti yi yippy, yippy yea upon it too."

—Leadbelly's Chisholm Trail

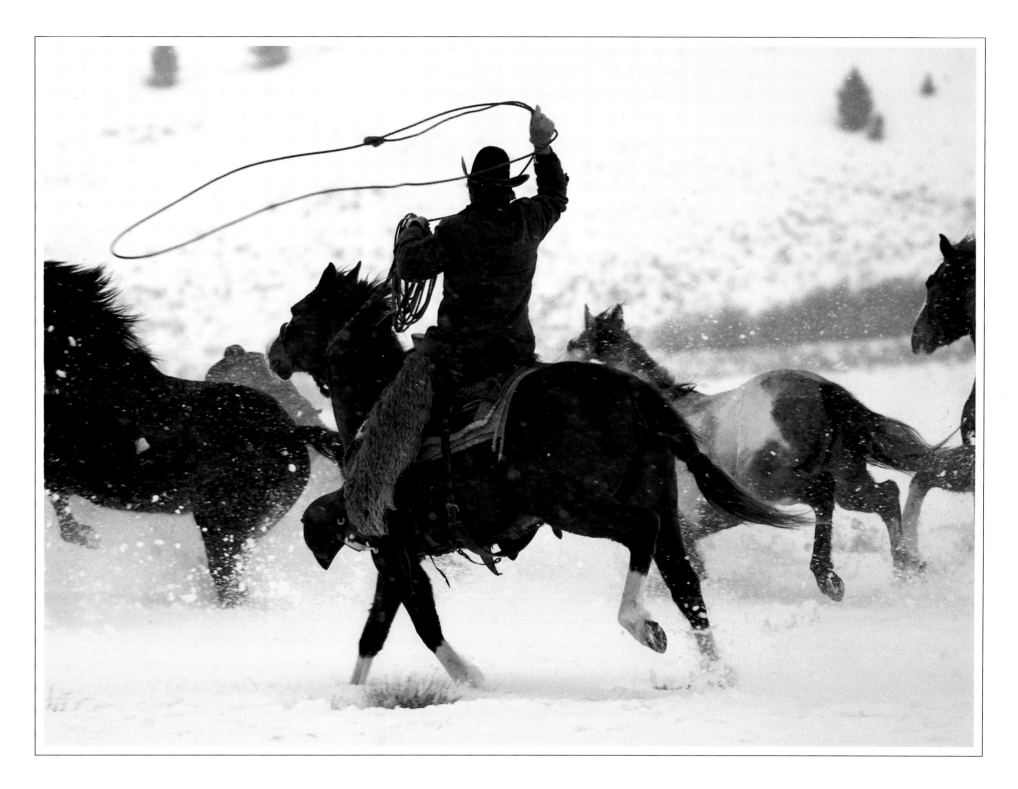

During the long winter months the cowboy would spend much of his
free time braiding rawhide reatas.

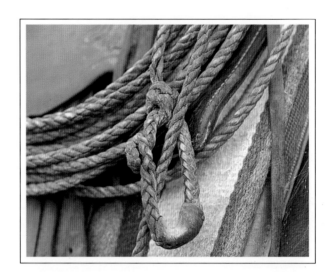
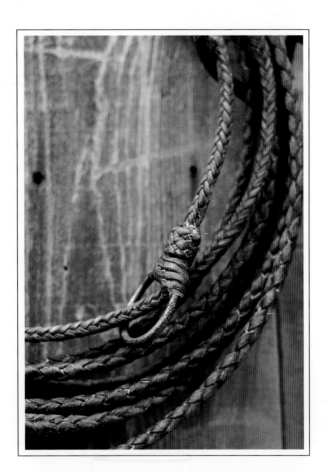
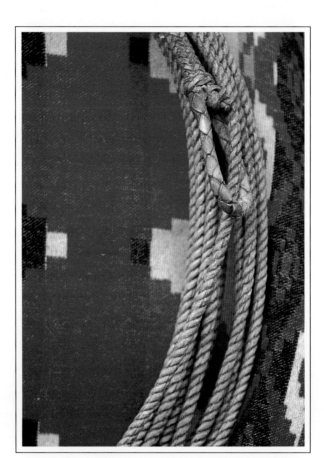

Rawhide reatas with different styles of hondos

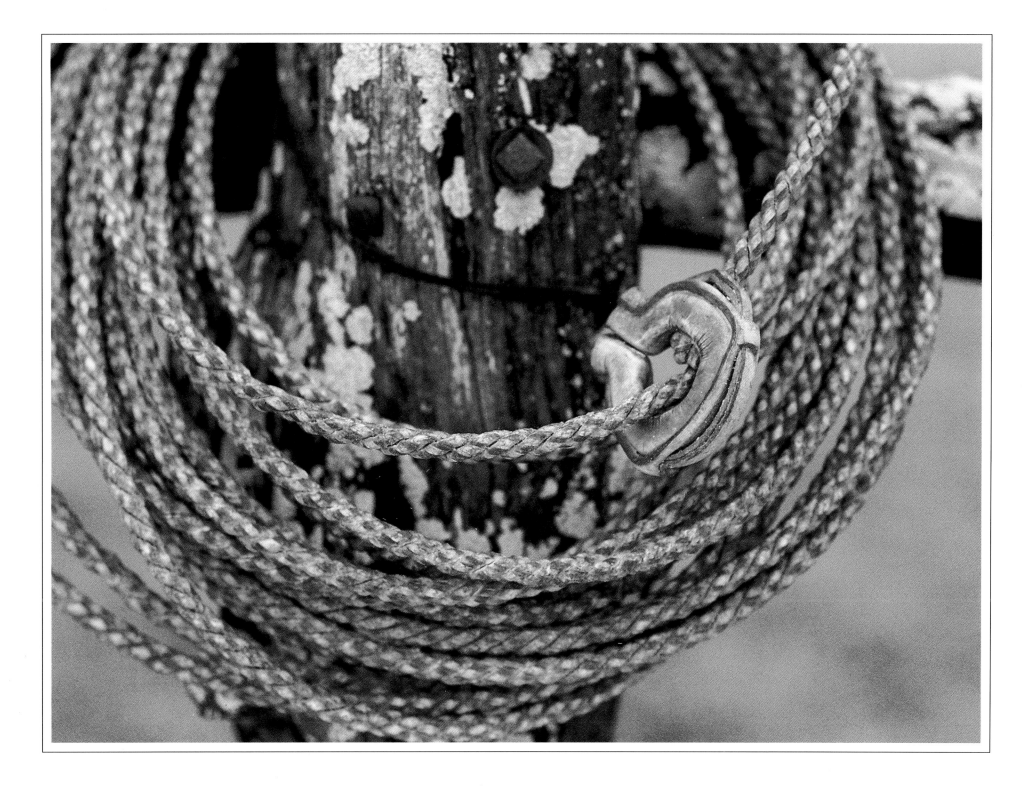

Twisted rawhide reata

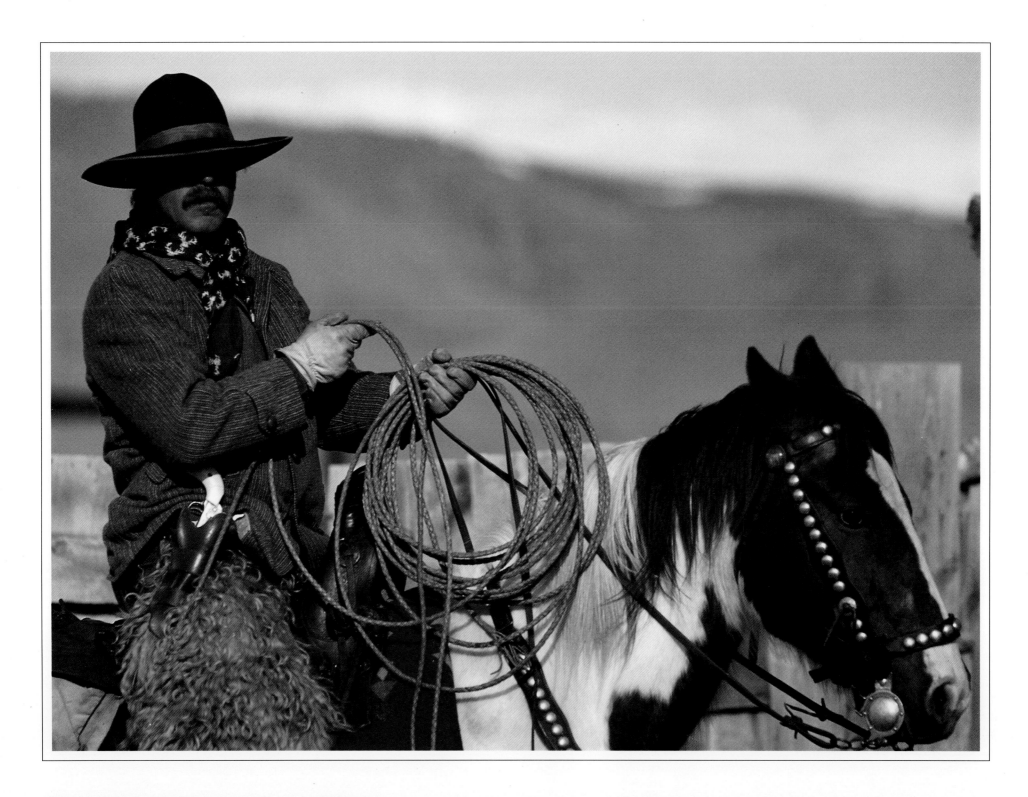

"With my blanket and my gun and my rawhide rope,

I'm a-sliding down the trail in a long, keen lope."

—The Old Chisholm Trail

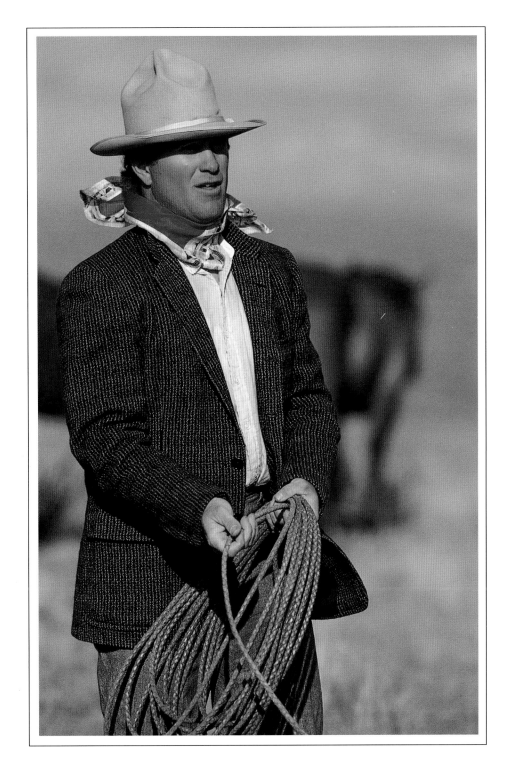

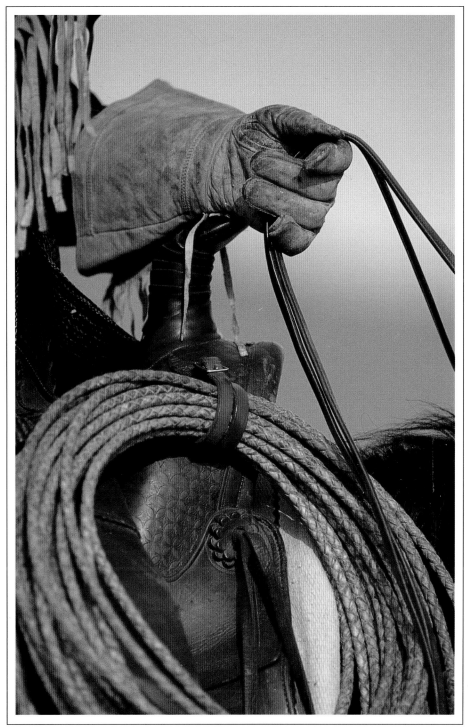

Rawhide reatas
A cowboy's reata was one of his most valuble tools.

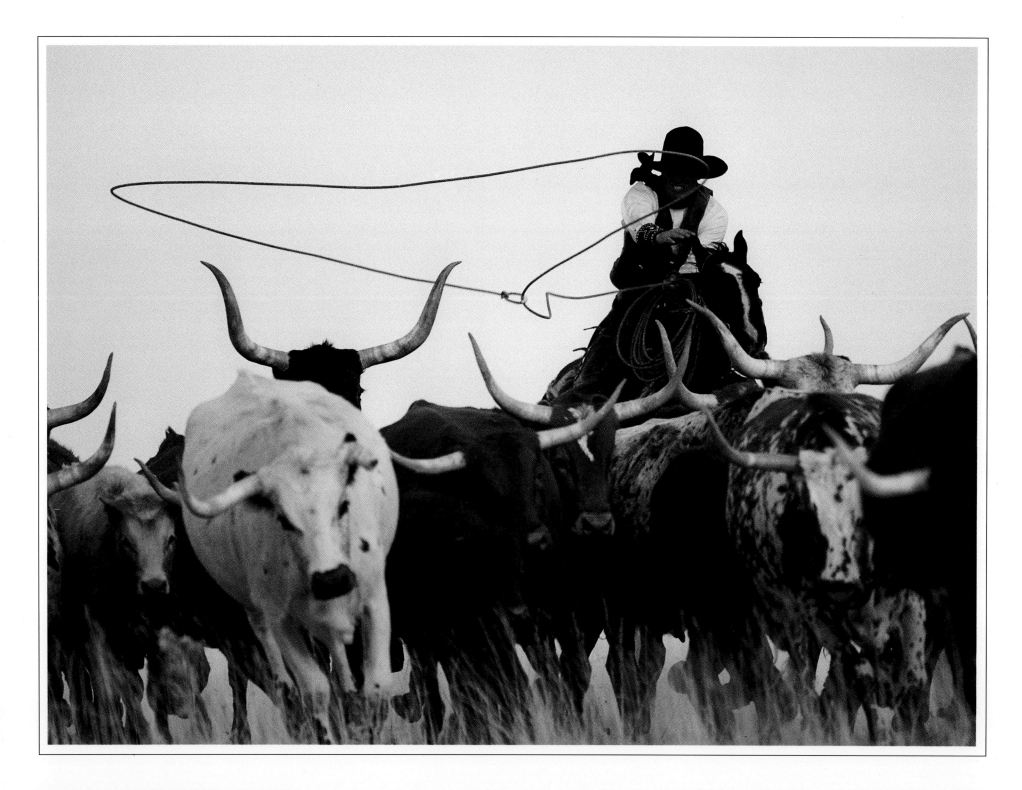

"I've turned the longhorn cow one way

and the other the buffalo."

—The Old Cowboy

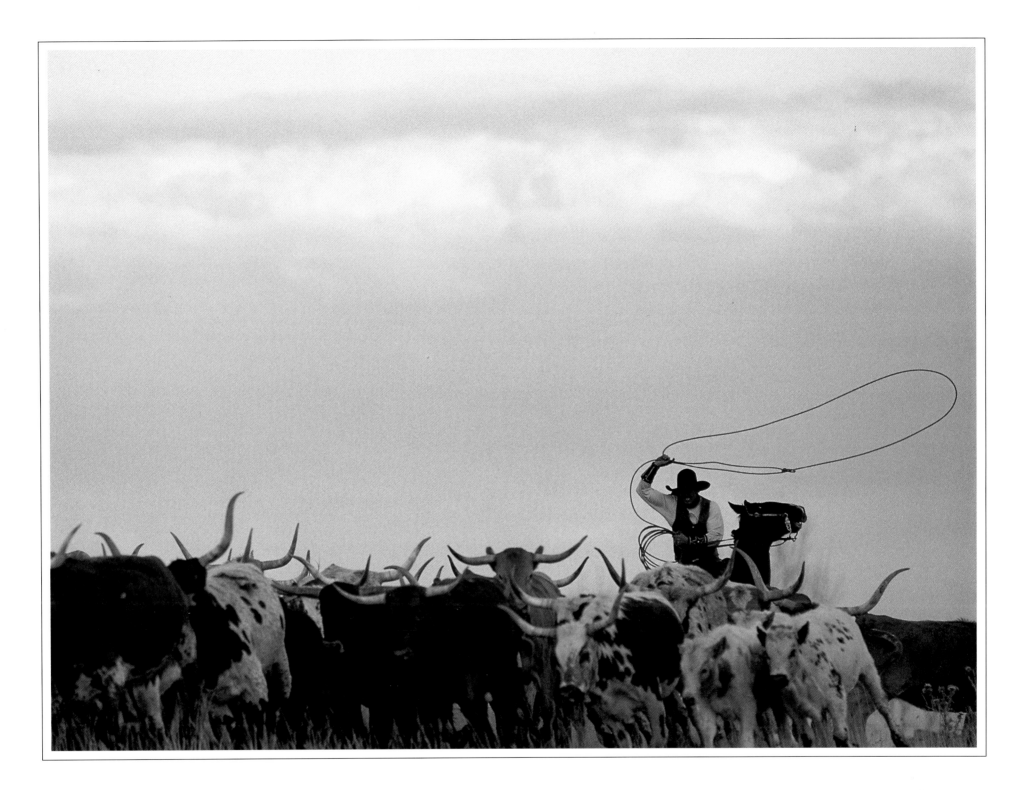

Pickin' the right one

"With his Brazos bit and his Sam Stack tree / His chaps and taps to boot,
And his old maguey tied hard and fast / Bill swore he'd tackle the brute."

—Windy Bill

Hard & Fast roping
The cowboy tossed the looped end of the rope to capture the animal. The other end of the rope was securely fastened around the horn. The line was then yanked tight, toppling the beast.

Dally roping
Once a catch was made the cowboy wrapped, or "dallied," the rope around his saddle horn, then tied it with a half-cinch knot before dismounting.

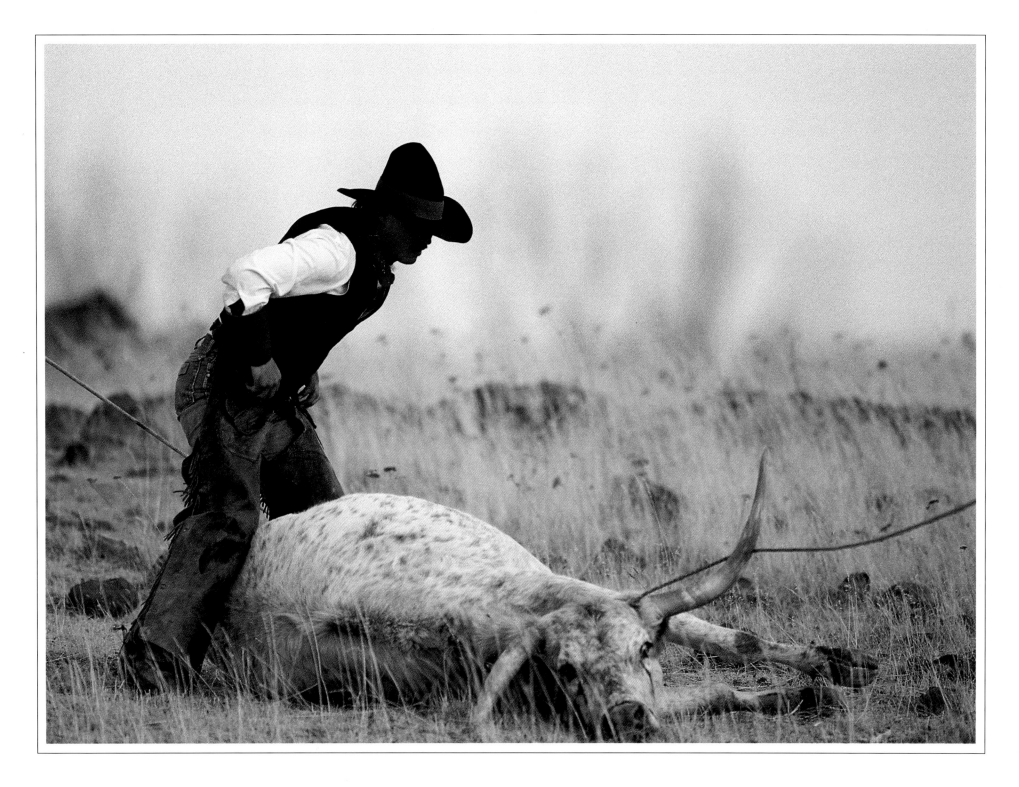

As a way to get them to behave as herd animals, the eyelids on some of the wildest longhorns would have to be sewn shut. Somewhere down the trail, the gut used for the sewing would rot away so they could see again, but by then the habits and rhythms of the trail would hopefully have worked a lesson on the miscreant, and it would be too late for misbehavior.

Quirts

Whips

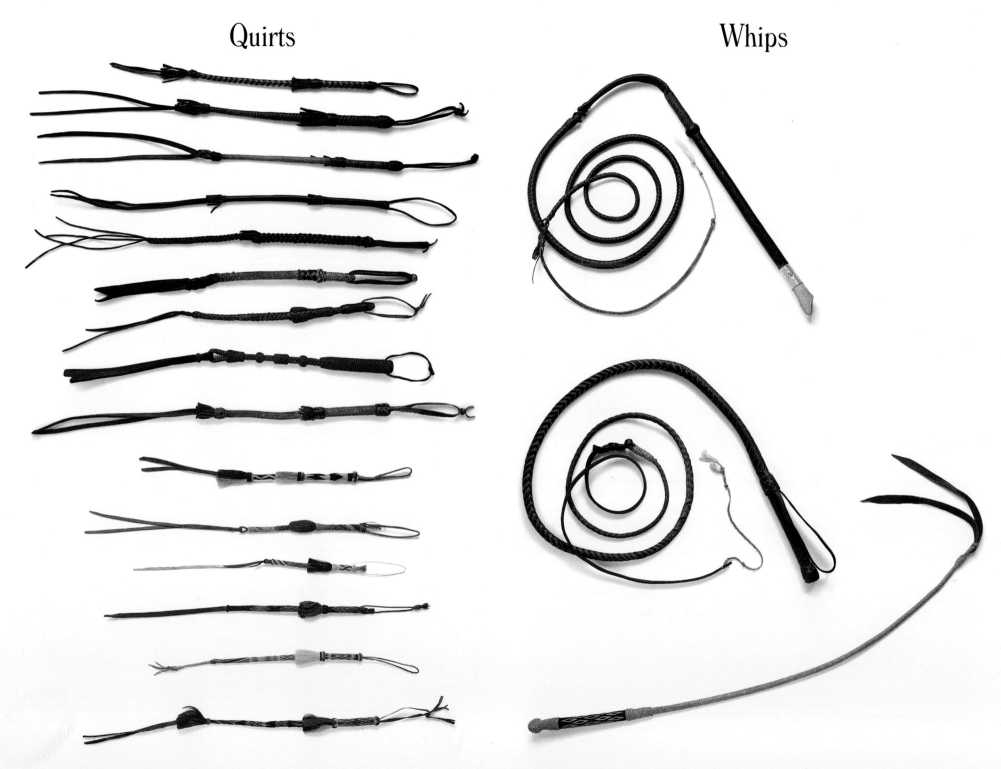

Top nine: Leather rawhide kangaroo quirts

Bottom six: Hitched horsehair quirts

Top: Drover's whip

Middle: Bullwhip

Bottom: Rawhide and hitched horsehair buggy whip

Whips & Quirts

The whip, or quirt, sometimes known as the "quisto," was used by early horsemen, both cowboys and Indians, in place of spurs. The word "quirt" comes from the Spanish phrase, "cuarta de cordon," meaning "whip of cord." Many cowhands called it a "cuerta." A rider sped up his horse by lightly striking the animal with the quirt just inside the hind leg.

Quirts were made of various combinations of horsehair, braided leather, or rawhide. The most commonly used quirt consisted of a braided rawhide stock or handle, a leather loop that fastened around the wrist and the handle, and a pair of dangling thongs called "lashes" or "poppers." Some quirts were fitted with decorative leather tasseling called "frills" or "skirts," or Spanish woven knots called "buttons." Although the thongs were usually the only part of the quirt that struck the horse, a cowboy might use the lead-filled handle on a rearing, out-of-control beast.

A cowboy who did not care to use a quirt would often arrange his bridle reins so that one or both reins extended well past the joining knot. This was called a "romal," a style popularized by the Mexican vaquero. The rider would use this excess leather as a whip.

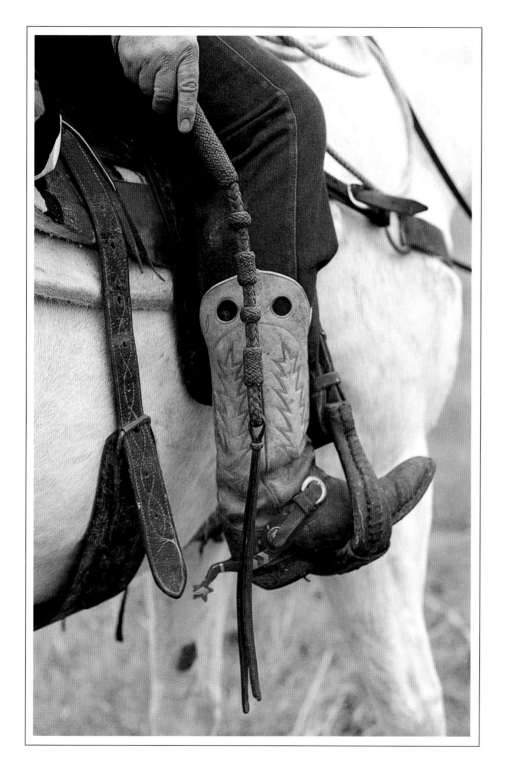

Rawhide braided quirt

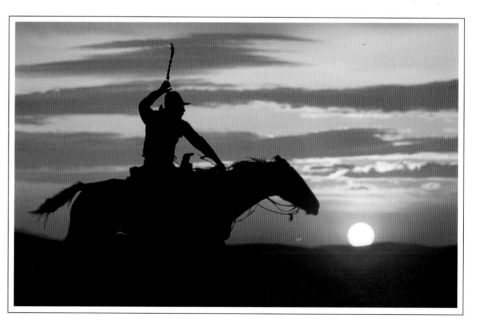

Riding into the sunset

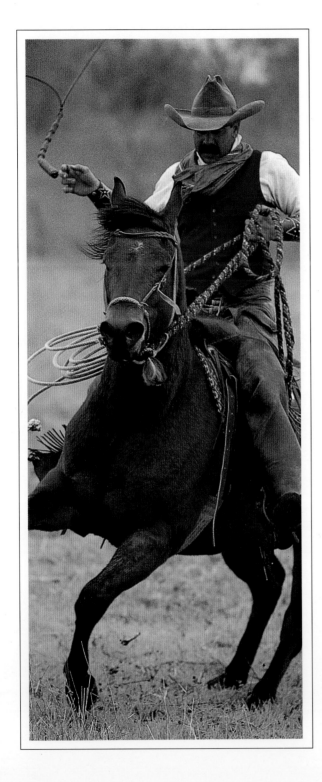 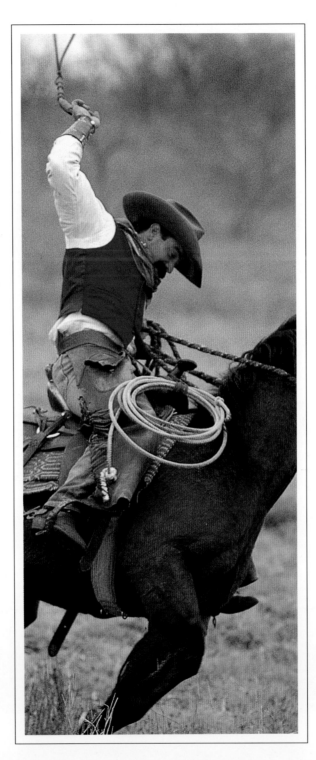 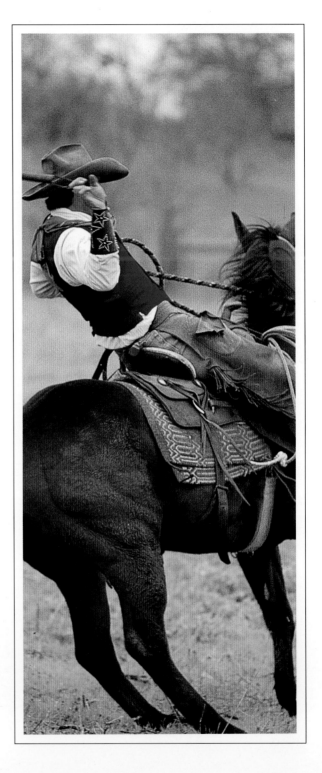

"Hike it, cowboys, for the range away / On the back of a bronc of steel,

With a careless flirt of the rawhide quirt / And a dig of a roweled heel."

—The Cowboy's Life

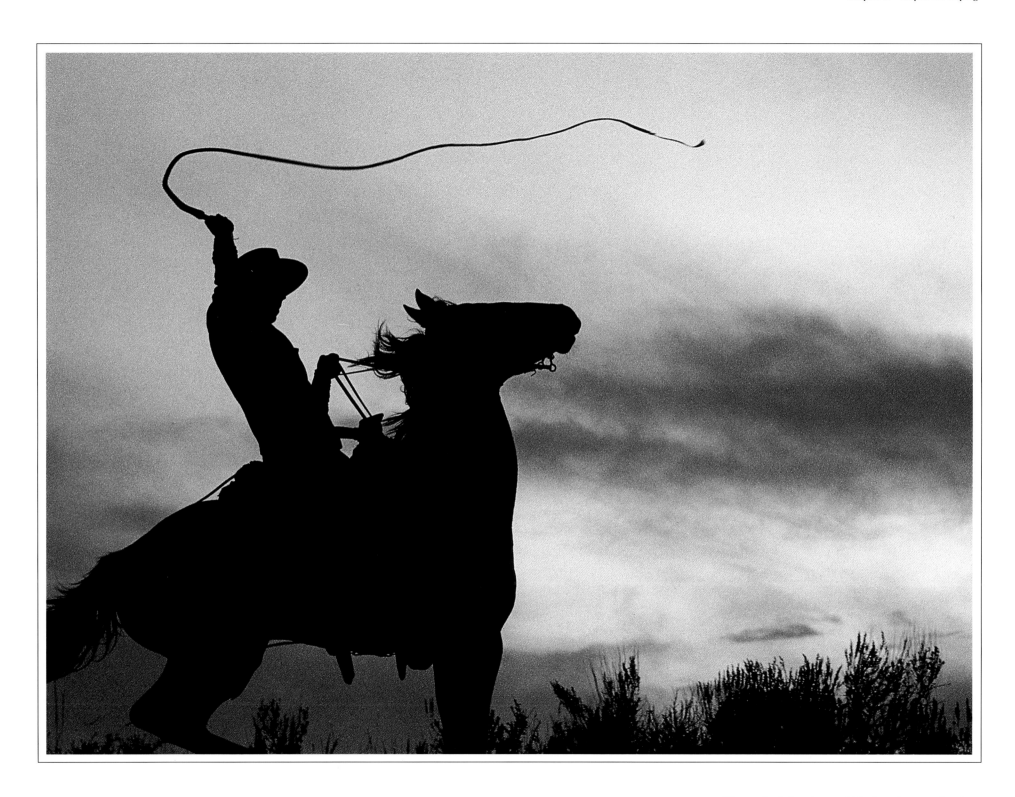

The crack of the whip could be heard across the plain.

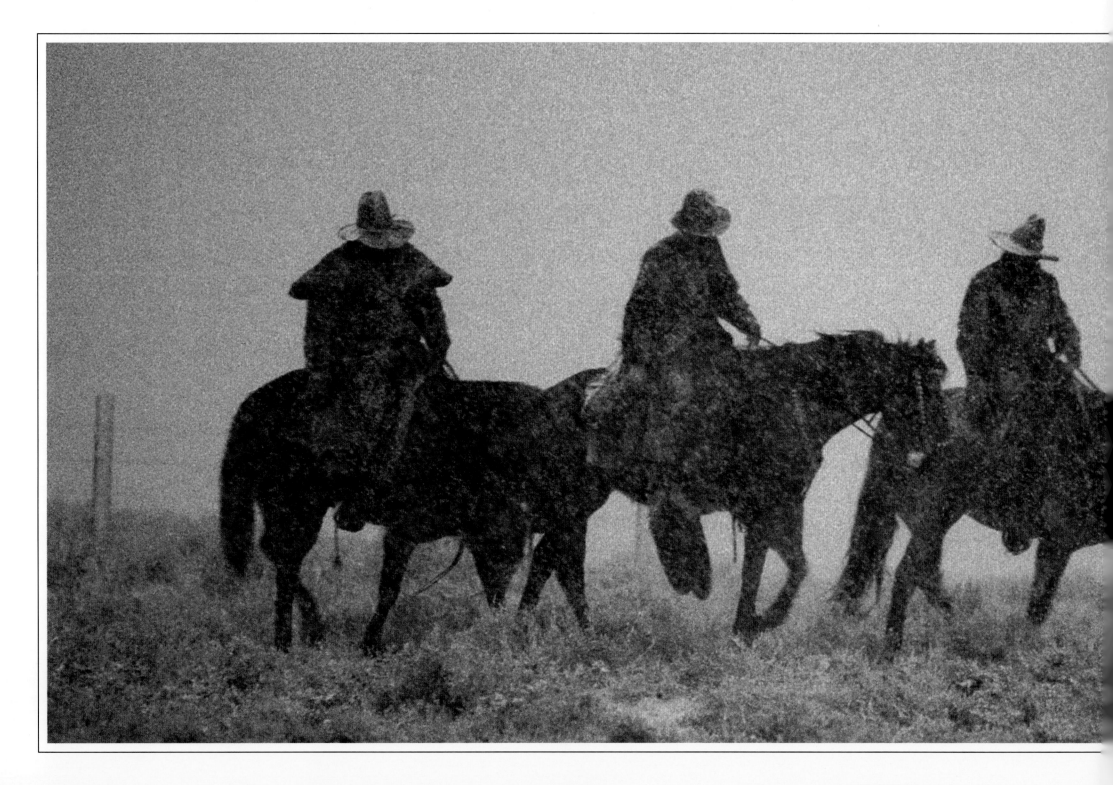

A cowboy's clothing had to be able to protect him in all types of weather. He purchased the best quality he could afford.

Cowboy Clothing

Chapter 9

The first cowboys, vaqueros, wore outfits that had evolved over a long period of Spanish history. Their clothing was both functional and ornate—not only an invaluable asset in his trade, but also an object of pride. Likewise, the cowboys working the ranges of the old West demanded as much of the clothing they wore as they did of the horses they rode and the tools they used.

The cattle drives passed through country with some of the most variable and unpredictable weather in the nation. One day a hand could be sweltering as he worked under the intense Texas sun, while the next day a "blue Norther" might have him shivering in the saddle. Regardless, his clothing had to protect him from the elements.

A cowboy's clothing also had to stand up to the rigors of the work he did. Chaps and a heavy jacket were a must for rousting wild longhorns from the thorny brush and cactus of south Texas. A substantial hat and a neckerchief were essential to withstand daily exposure to sun, wind and dust. And while everything he wore had to be sturdy, it also had to be comfortable enough to wear day in and day out, for however many hours were spent in the saddle.

For the most part, these work clothes were simple and functional. The fabric used to make them was that which had proven itself over the years. The colors were usually subdued and almost never red—a color thought to irritate the cowboy's bovine companions. However, the cowboy who found himself with some extra money at the end of the trail might indulge himself with fancier clothes for special occasions such as church, dances, and town meetings.

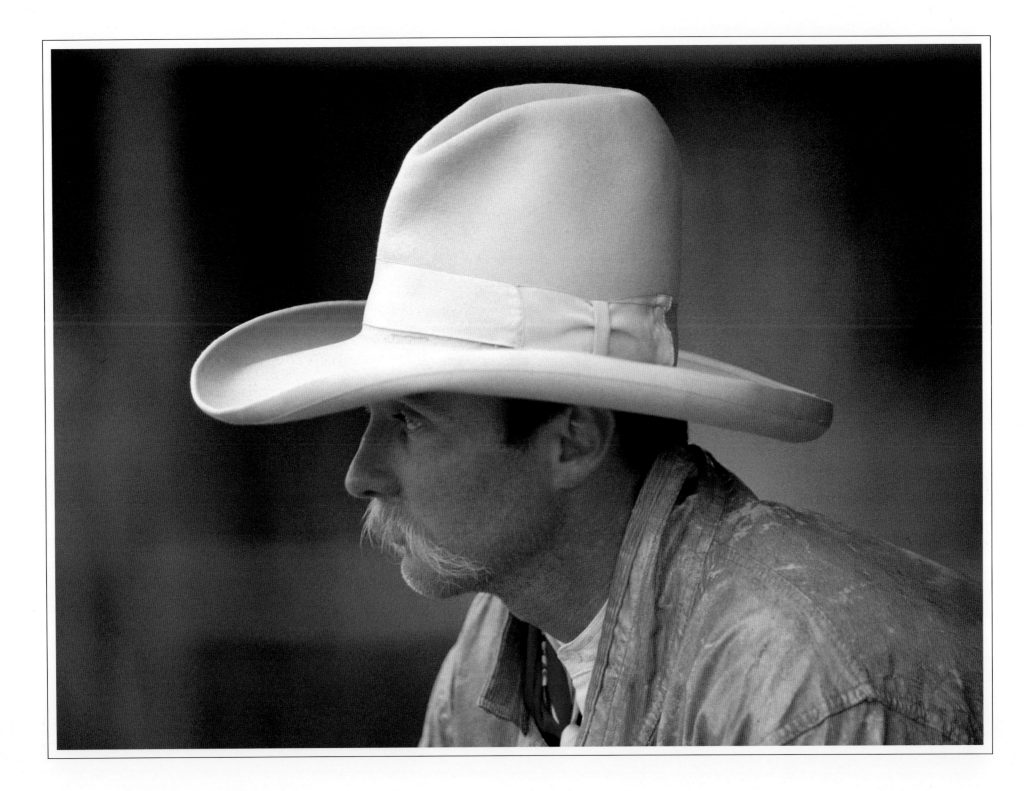

This hat style came to be known as the "Tom Mix."

The Hat

Legend maintains that a cowboy's hat was the last thing he took off at night and the first thing he put on in the morning.

Like the rest of a cowboy's getup, his hat had to be rugged and ready to serve a multitude of purposes. In addition to shielding the cowpoke's head, a hat could serve as a bucket for carrying drinking water or for dousing a campfire. A hat might plug a broken window pane at a line shack, be waved to signal other hands at a distance, or fan a campfire's embers.

The size, shape, and crease of a hat often identified a cowpoke's home territory. The high-crowned "10-gallon" style, for example, originated in the Southwest. If a hand in the Northwest wore that style, he might be accused of "chucking the Rio," or putting on airs. A cowboy creased his hat either to suit his own taste, or in the local style. Creasing styles included four dents that created a peak, two dents, a single center crease, two parallel side creases, or no crease at all. Over time, every hat took on a look unique to its owner.

Around the crown of the hat ran a ribbon; there also might be an adjustable band or belt. The belt was usually leather and could be decorated with silver conchos, gold nuggets, decorative rivets, nailheads, or rattles from a rattlesnake. Quality and style were paramount to cowmen. The most expensive hats were of a felt so soft and fine it was called "featherweight." A cowboy could spend four month's wages on a "lid" with a richly decorated belt.

Philadelphia's John B. Stetson was indisputably the most famous maker of cowboy hats. One story holds that Stetson got the idea for his invention while watching Westerners fashion a hat by pressing a wet hide into a hole with a post. Another version of the story maintains that Stetson fashioned his first cowboy hat while on a Pike's Peak expedition in 1863, in the hope of improving on the scant protection offered by the felt hats of the day. Although that first effort evoked laughter, he was able to sell it for $5. Upon returning to Philadelphia, he began manufacturing the "Boss of the Plains" hat, the success of which made the name Stetson synonymous with the cowboy hat.

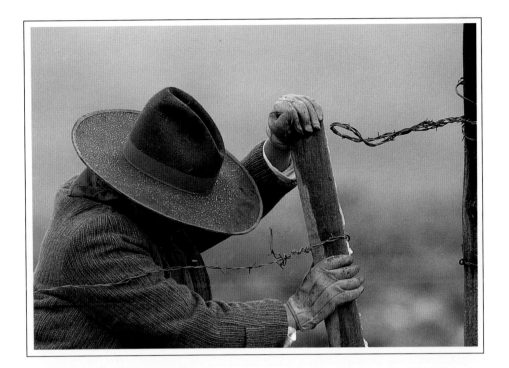

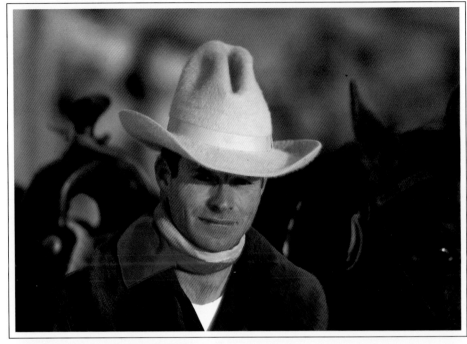

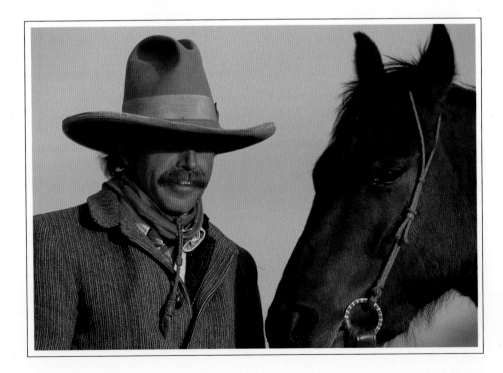

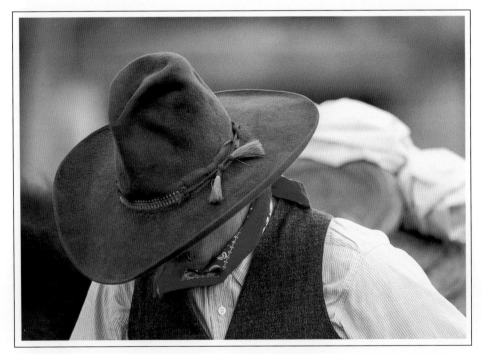

Top: Tom Mix hat

Bottom: Tom Mix-style hat

The Tom Mix style hat became popular with the coming of Western movies and Wild West shows.

Top: Carlsbad style-hat made of nutria fur

Bottom: Tom Mix-style hat made of nutria fur

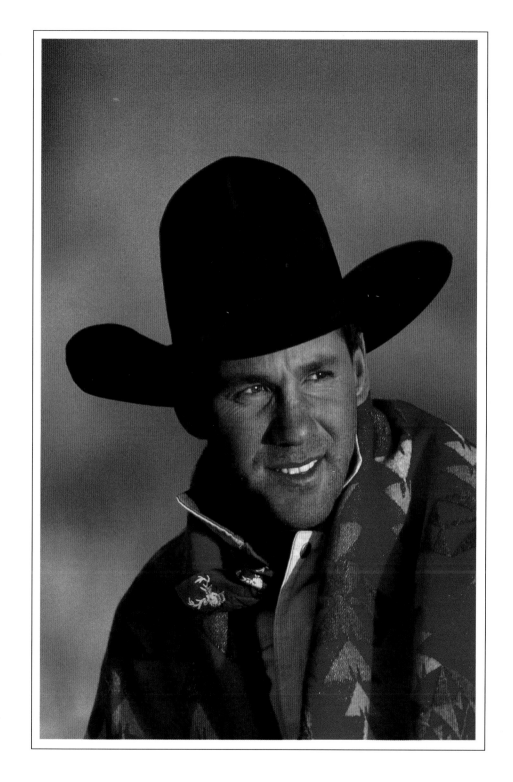

This hat is typical of later styles.

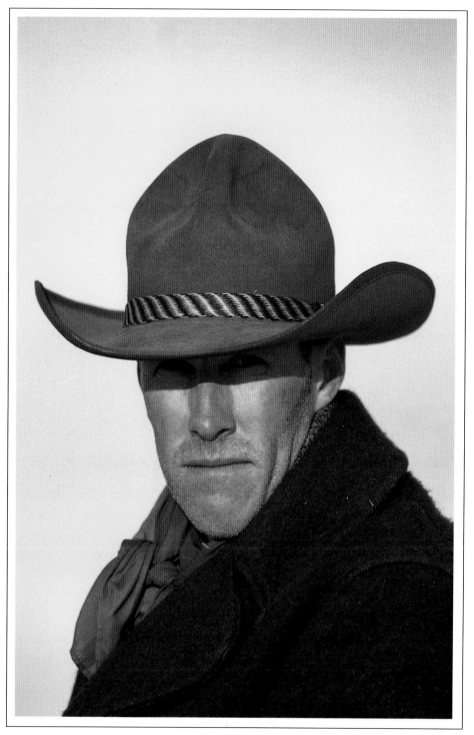

Montana Peak hat

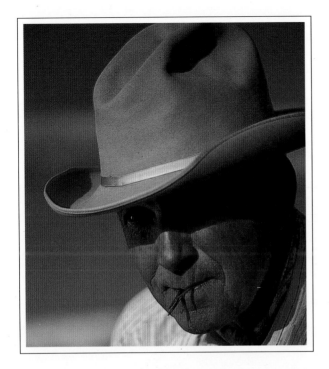

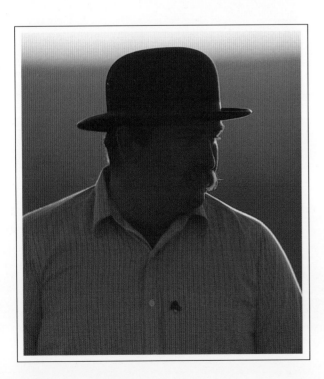

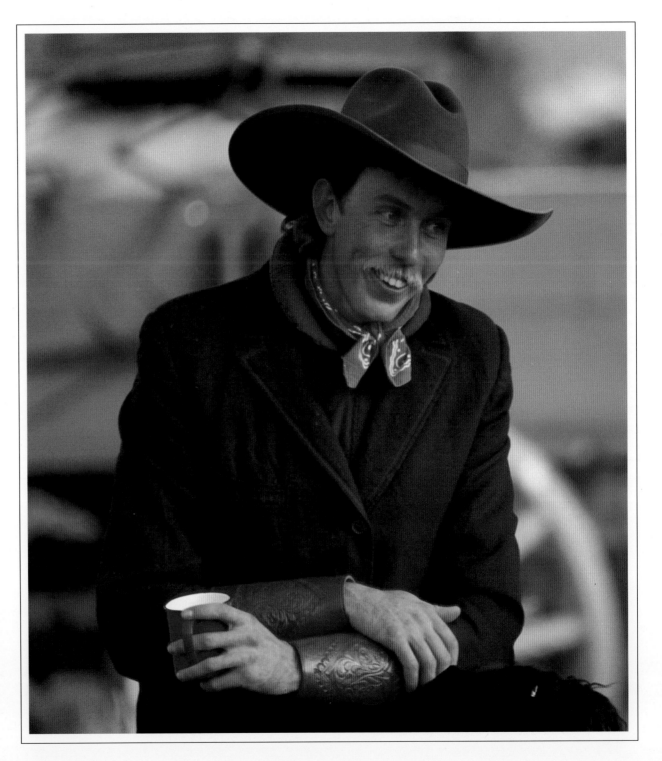

Top: Stetson's Open-Road hat

Bottom: Stetson derby or bowler
This style of hat was worn extensively in the West. It was not very popular with cowboys, although it looks great on a cook!

Montana-style hat

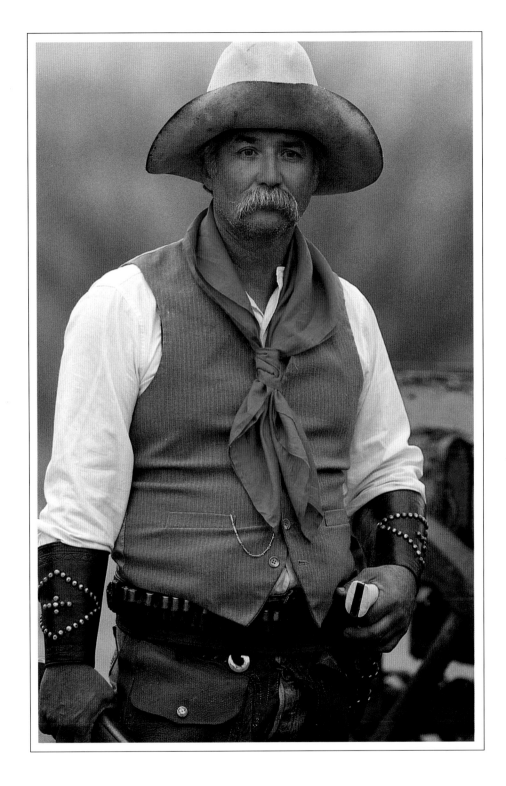

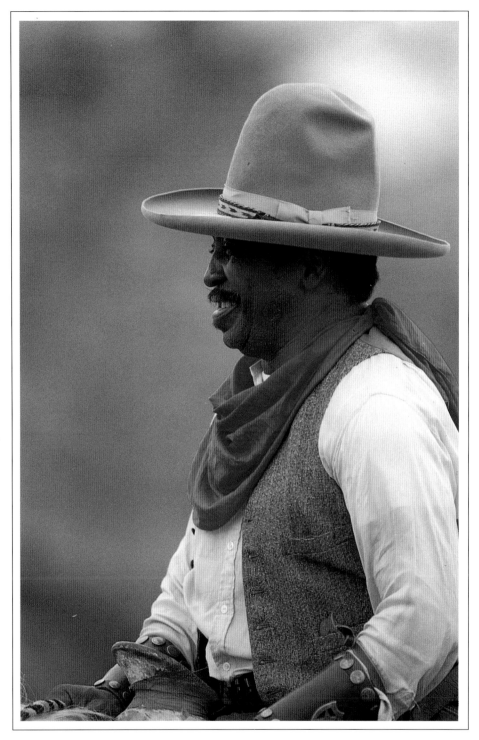

Hats were often rolled or bent up in front by early plains cowboys.

A very early Stetson style.

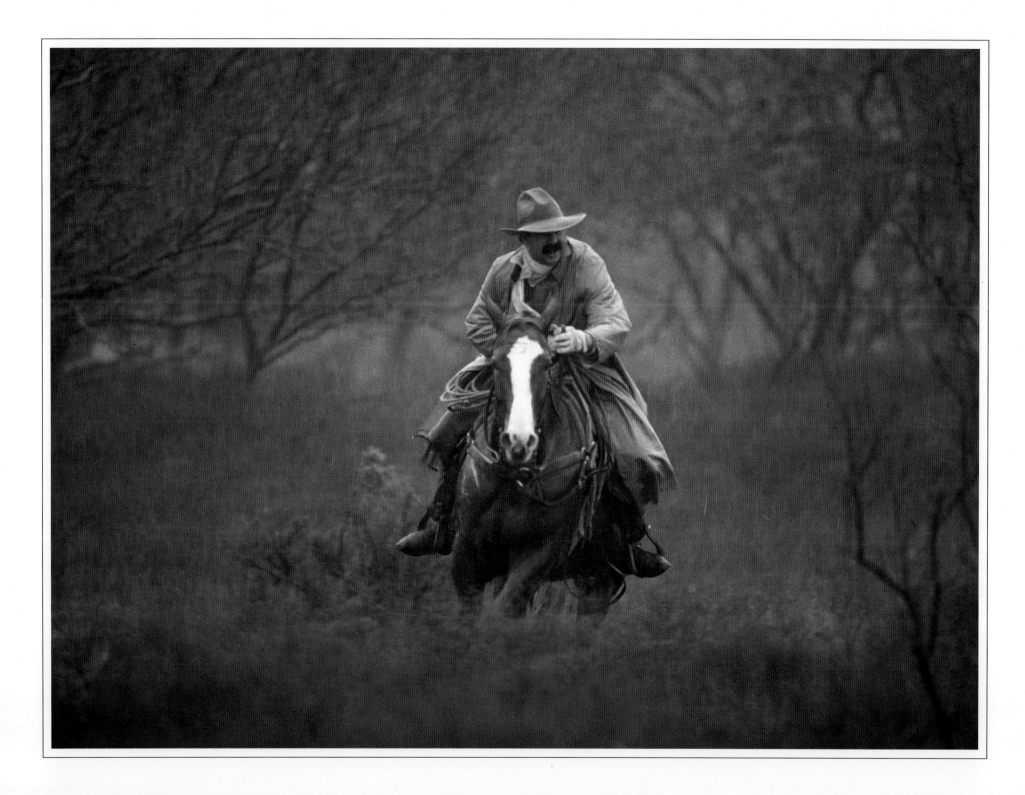

Riding in the rain—a good place for a good hat

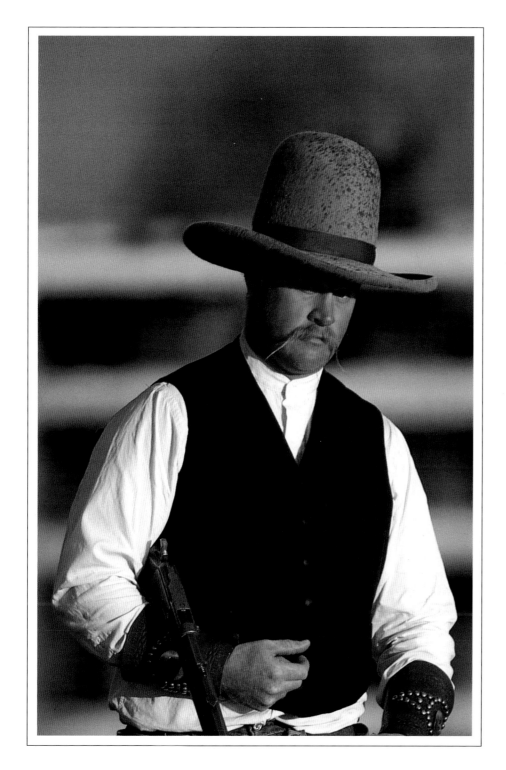

Early J.C. Penney hat

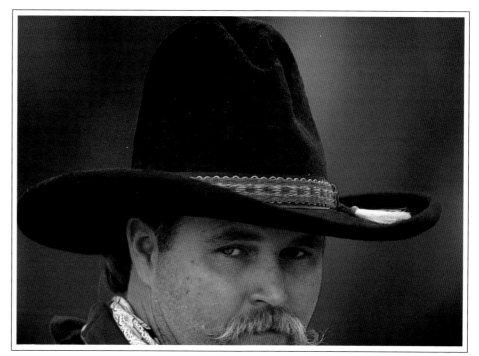

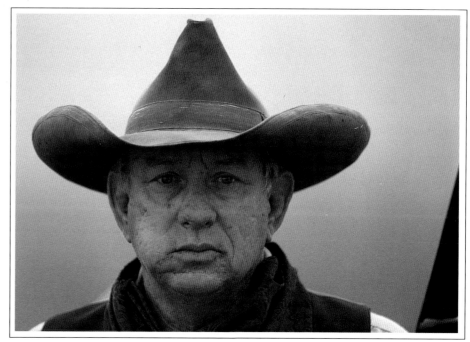

Top: Stetson's soft nutria fur hat, with a horsehair hatband

Bottom: Texas-style hat

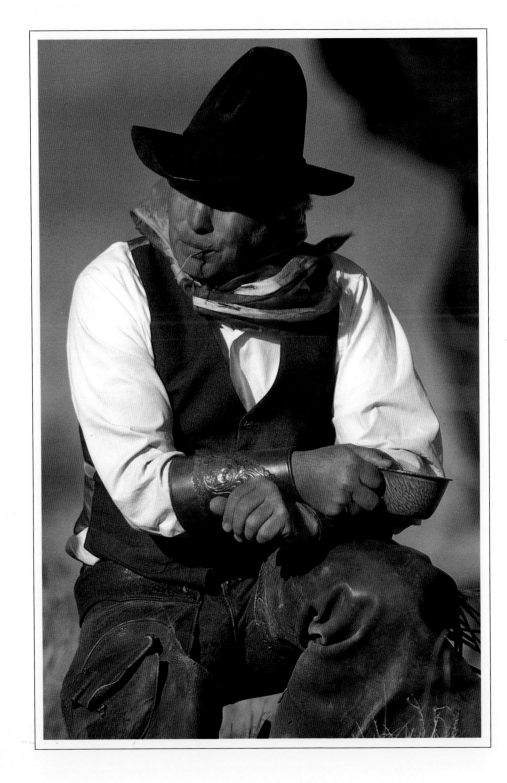

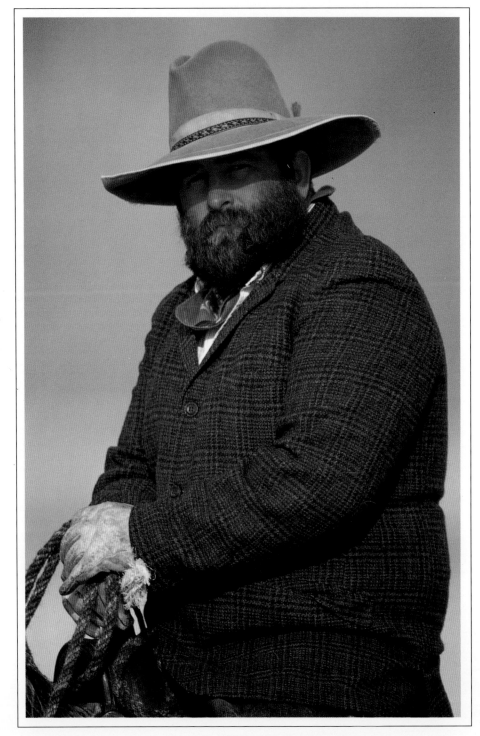

Soft roll hats like this one were easily shaped into any style.

This hat was made by Stetson and sold by Hamley, Pendleton, Oregon.

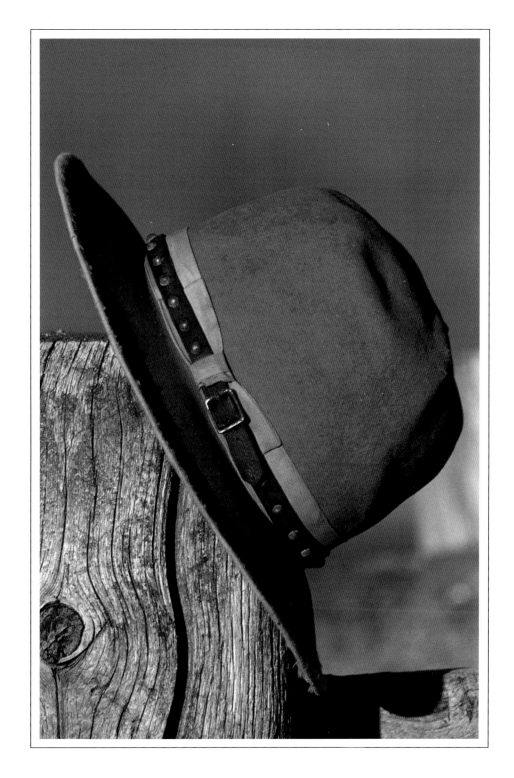

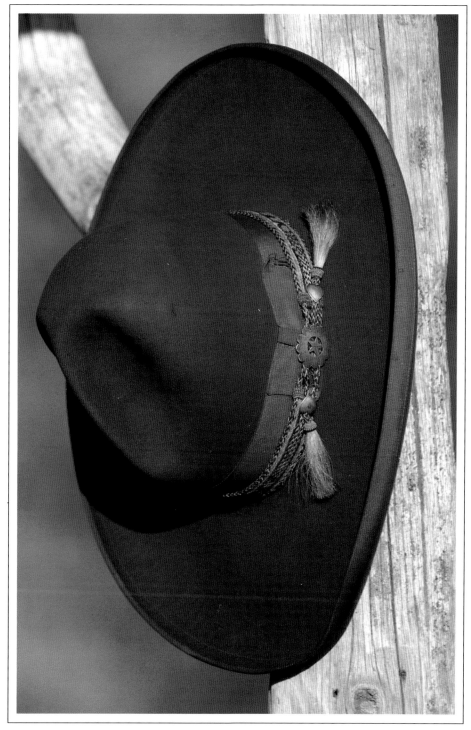

Sugar Loaf crowned hat with a studded leather hatband

An extraordinary Stetson: 7 $\frac{1}{2}$" crown, 5$\frac{1}{2}$" rolled bound brim,
and a silver-mounted horsehair hatband

"'Oh no!' young Charlotte cried, as she laughed like a gypsy queen / 'To ride in blankets muffled up, I never would be seen / My silken coat is quite enough, you know it is lined throughout / and here is my silken scarf to wrap my head and neck about.'"
—Young Charlotte

Scarves

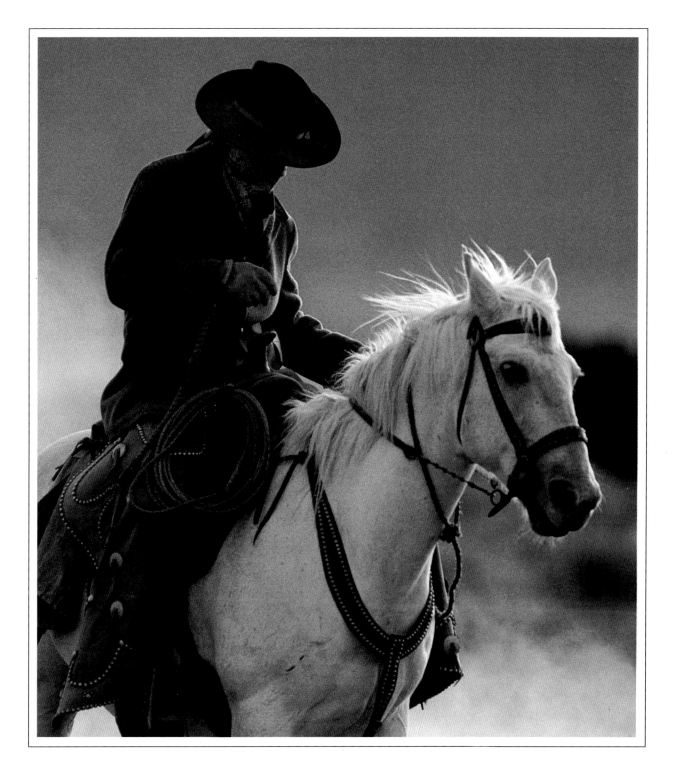

In a dust storm, a scarf was a necessity.

In a time when a cowboy often spent a month's wages on a single piece of equipment, one of his most versatile tools could be had for the price of a beer. The neckerchief, or bandana, measured about two feet square. It was usually red or blue, but sometimes white or black, although white found little favor because it was easily soiled and increased a puncher's visibility on the range—a characteristic many wished to avoid. They were most often cotton, but sometimes linen or silk. The kerchief was worn tied around the cowboy's neck, knotted at the back. It was often pulled over the nose and mouth to mitigate the choking effects of trail dust.

The neckerchief performed innumerable functions. It was often employed as a cover for a spooked horse's eyes, as a hobble, as a hat tiedown in windy weather, or as a washcloth and towel. Punchers used the bandana as a bandage, tourniquet, napkin, water filter, potholder, flag, and temporary repair for saddle or bridle.

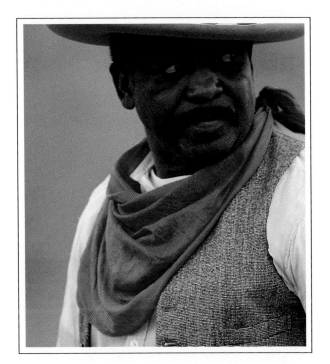

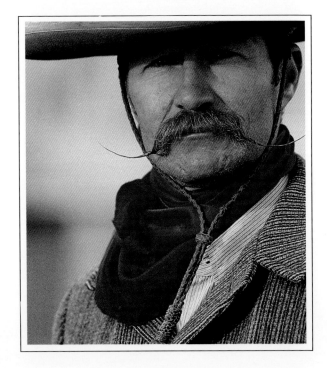

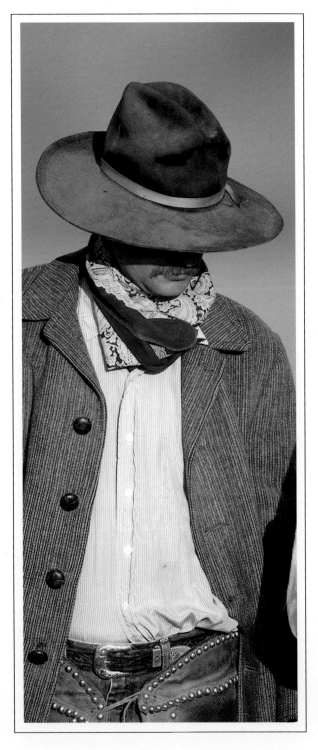

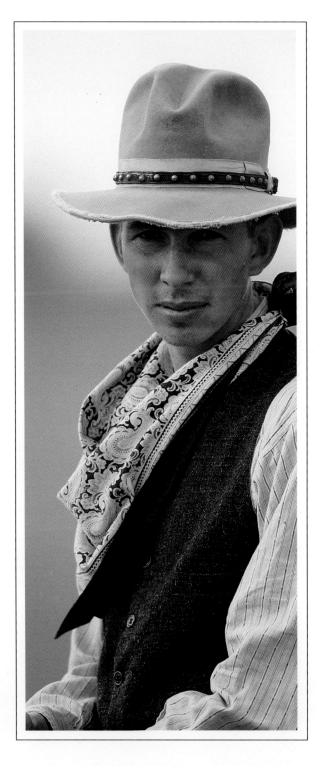

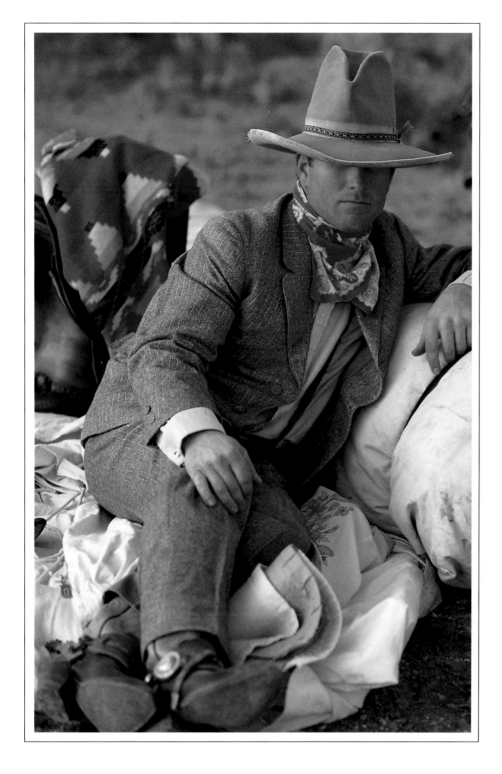

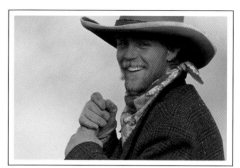

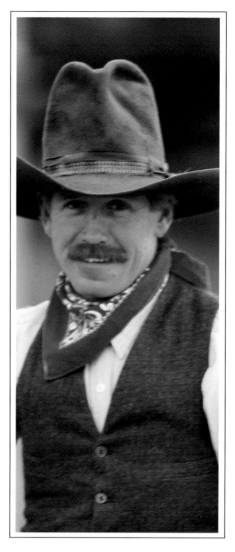

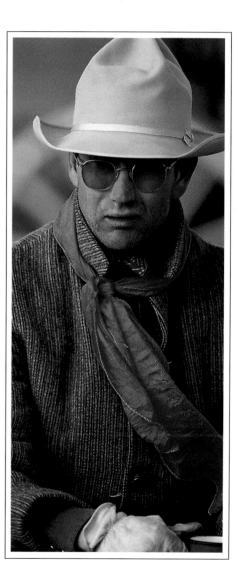

Scarves came in many styles, with as many ways to be worn.

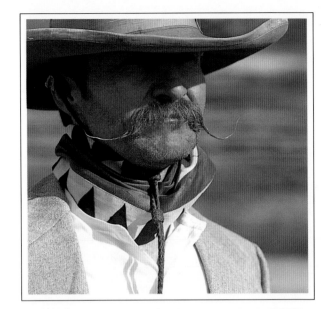

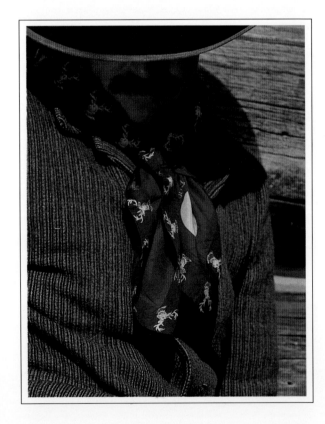

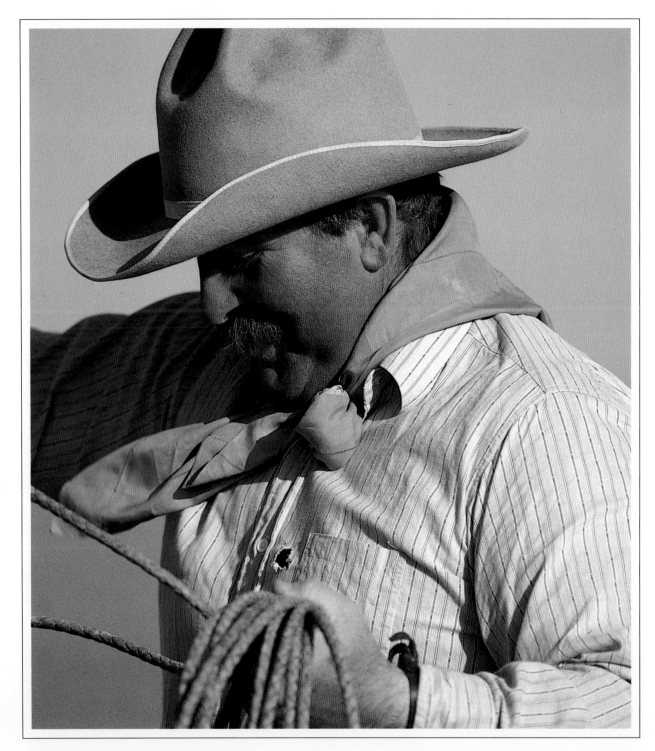

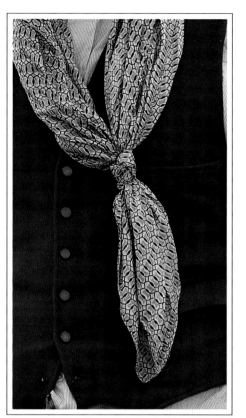

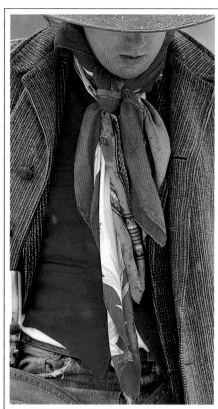

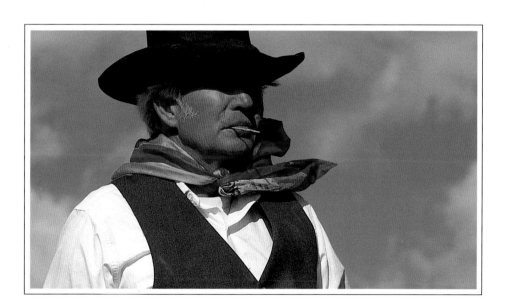

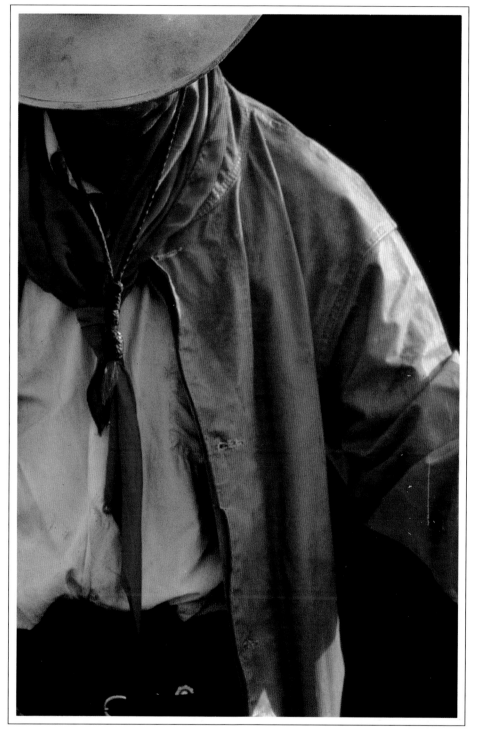

Like so much of the cowboy gear, the scarf served a multitude of purposes,
working as well for fashion as it did for function.

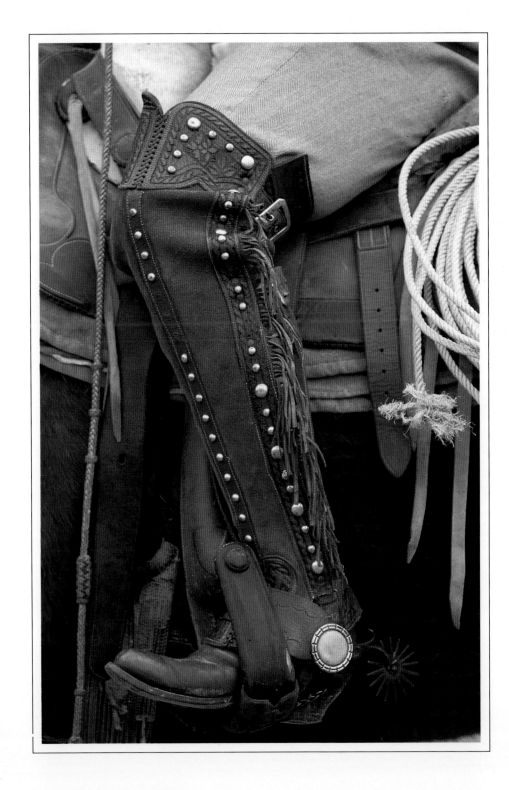

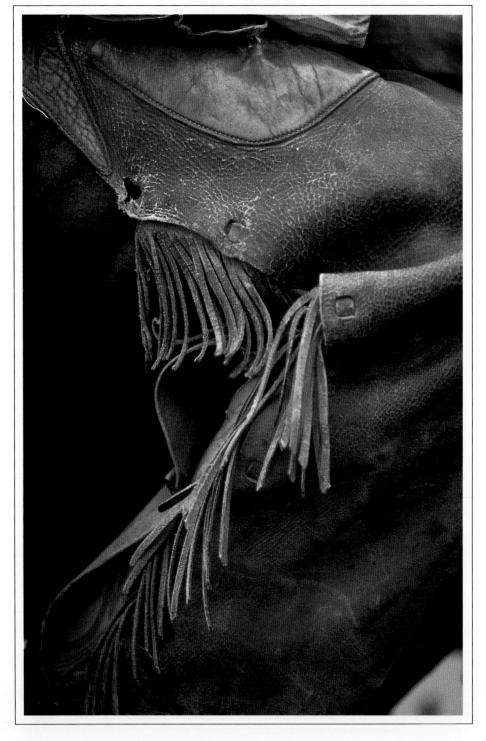

California leggings, circa 1890
One of the earliest styles of chaps

Leather fringe detail on shotgun chaps, circa 1910

Chaps

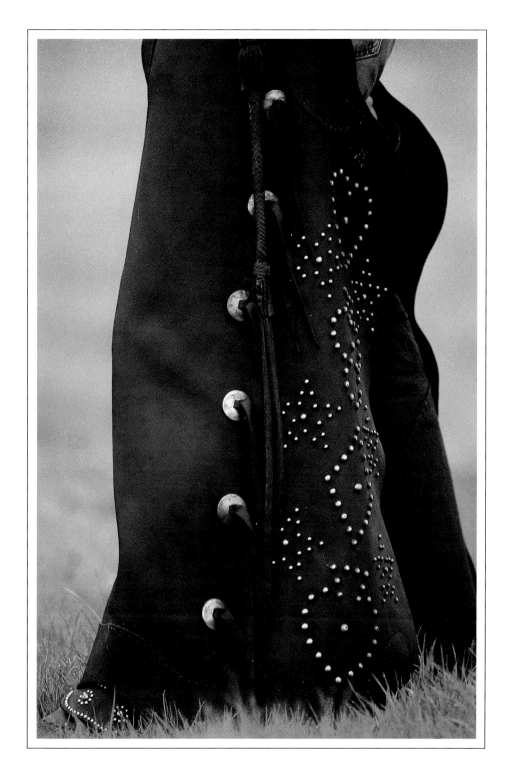

Heavily studded J. Quijaja chaps, circa 1910

Chaps, short for chaparajos, were seatless leg coverings used by cowboys as protection from heavy brush, rope burns, horse bites, and abrasions from corral poles.

Chaps descended from the Mexican vaqueros' "armas." These tough leather flaps fastened over the saddle and laid over the rider's lap like a blanket. While protective, "armas" were clumsy and required reattachment following each mount or dismount. About 1860, Texans developed "armitas," or "chinks," a leather apron tied to the puncher's waist and knees. Generally these were made of buckskin and featured fringe decoration on the sides and bottoms. Armitas led shortly to chaps, which covered both the fronts and backs of the legs.

American chaps fell into three general styles: shotgun, batwing, and woolies. Shotguns first appeared in the 1870s and cost the cowboy about $10 a pair. Their legs resembled the parallel barrels of a shotgun, hence the name. Shotguns were generally the plainest style of chaps, but some were trimmed with leather fringe, conchos, or fancy stitching. Batwings fastened at the back and could be snapped on without removing boots or spurs. They were also markedly fancier than shotguns, often decorated with fringe, silver conchos, and studs.

On cold Northern ranges, cowboys sought the warmth of "woolies." A long-haired variation of shotguns or batwings, woolies—or "hair pants"—were commonly made of Angora goat hides, with the wool worn on the outside. Bear, buffalo, dog, and horsehair were also used. Woolies, costing about $25 and generally black, white, gold, or occasionally orange, were initially popular in the Northwest and California, but by the 1890s had spread to Montana, Wyoming, and Canada. Wild West shows and rodeo riders also favored woolies for their flashy style and showy patterns.

Famous chap-makers included R.T Frazier, H.H. Heiser, and S.C. Gallup of Colorado; F.H. Meanea of Wyoming; Al Furstnow and the Miles City Saddlery of Montana; G.S. Garcia of Nevada; Hamley & Co., and G. Lawrence of Oregon; Visalia Stock Saddle Co., of California.

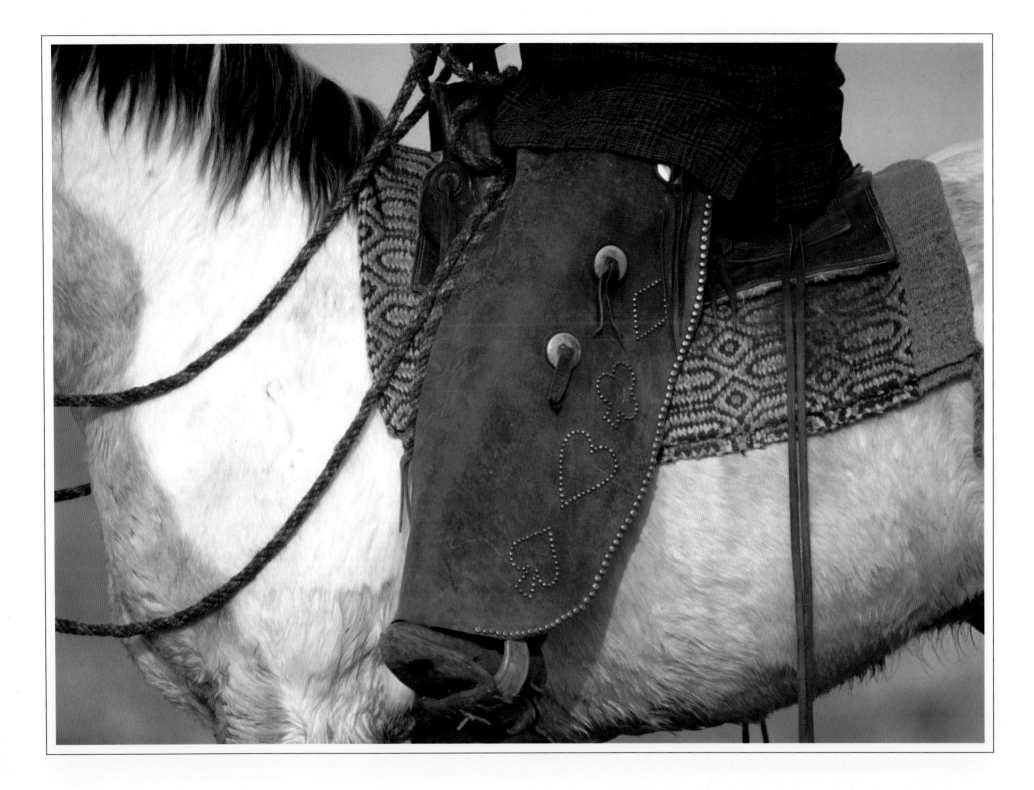

Sentinal Butte Saddlery batwing chaps studded with card suits, circa 1920

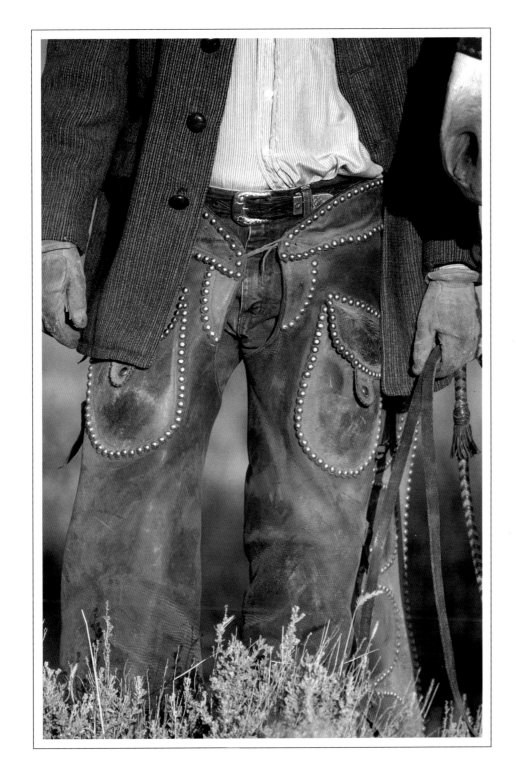

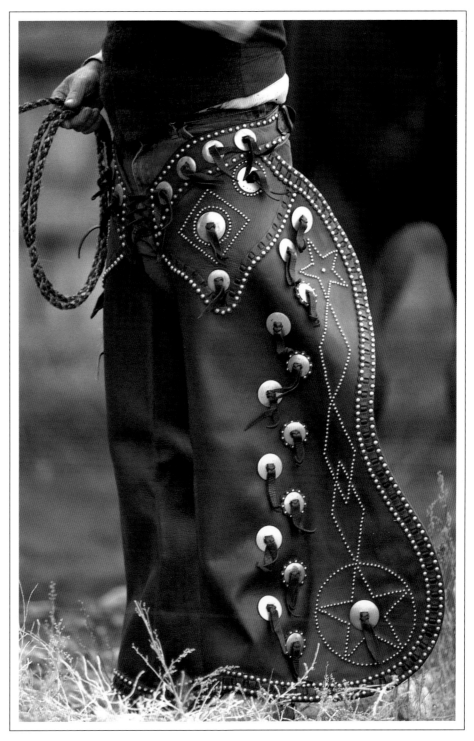

Visalia studded batwing chaps, circa 1930

Miles City 2,000-spots batwing chaps, circa 1910

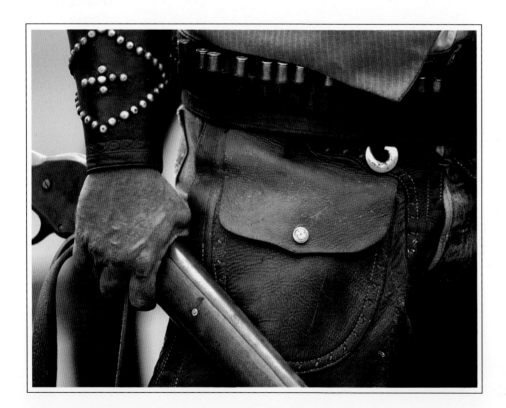

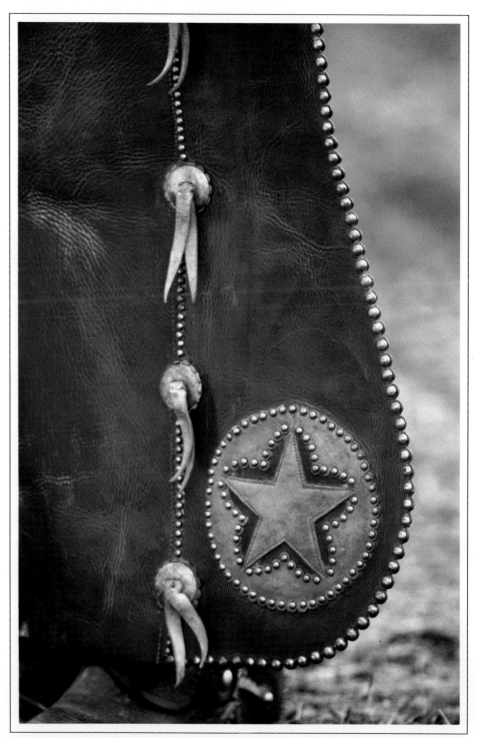

Top: Detail of maker's cartouche "mark," J.C. Read & Bros., Ogden, Utah; circa 1898

Bottom: Clark chap pocket detail—not all chaps have pockets.

Otto Ernest batwing chap detail, circa 1915

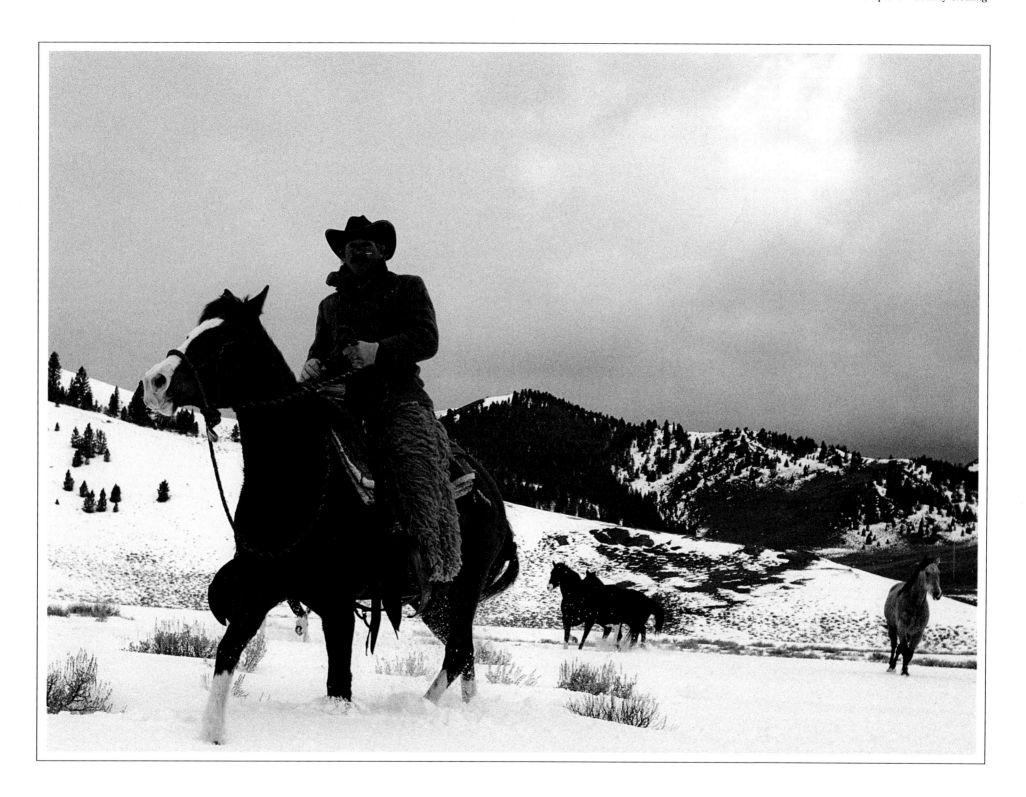

Orange angora chaps made by Hamley, Pendleton, Oregon; circa 1910

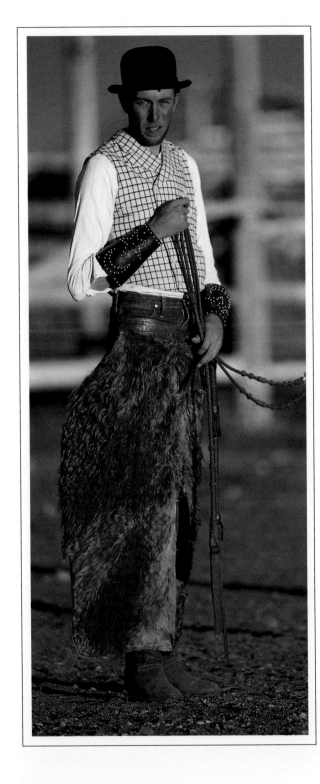

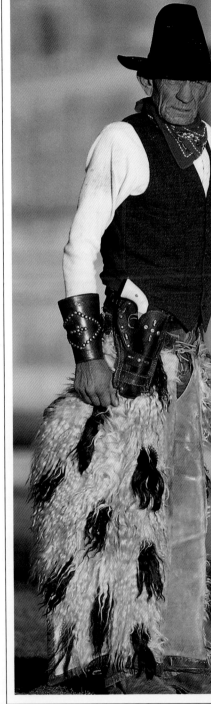

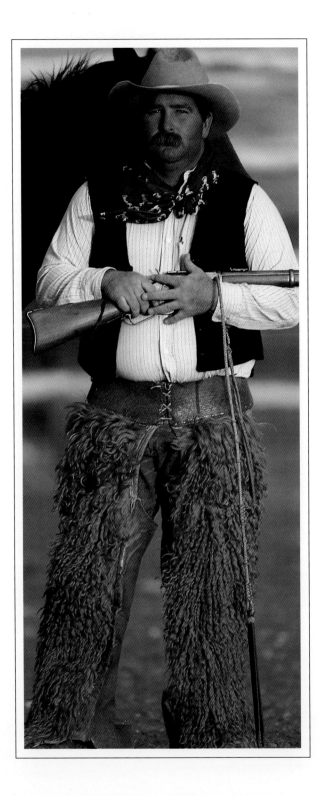

Red Nigger Boy brand chaps, Ogden, Utah; circa 1890
This brand of chaps was named after the famous
racehorse, Nigger Boy.

Batwing black-and-white spotted chaps
made by R.T. Fraizer, circa 1910

Gold angora chaps made by B. Gaffney,
Fossil, Oregon; circa 1890

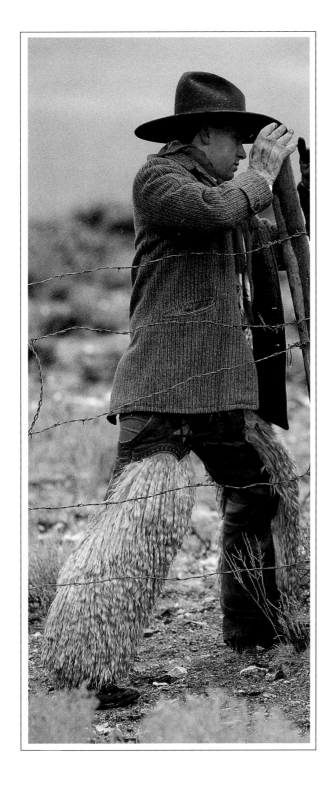

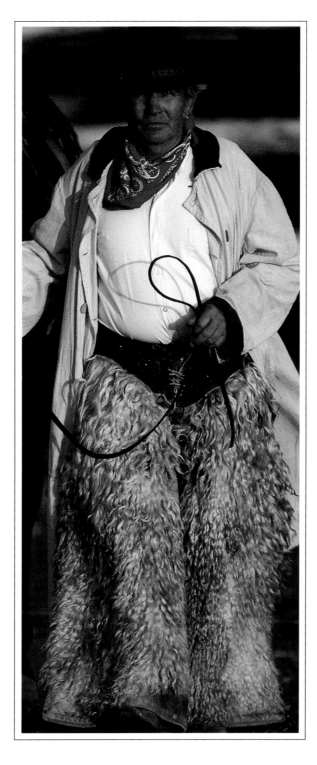

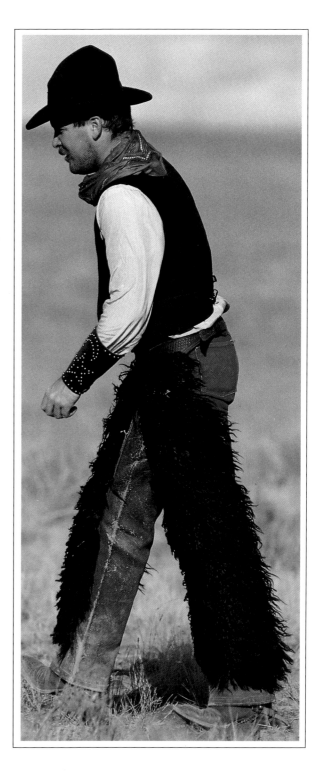

Canadian-made white woolie chaps, circa 1890

Batwing woolie chaps made by Hamley Saddlery,
Pendleton, Oregon; circa 1910

Lawrence shotgun woolie chaps, Portland, Oregon;
circa 1900

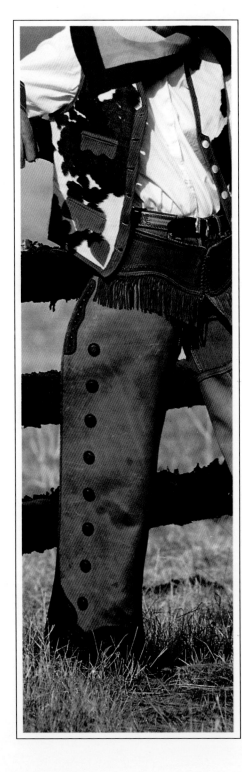

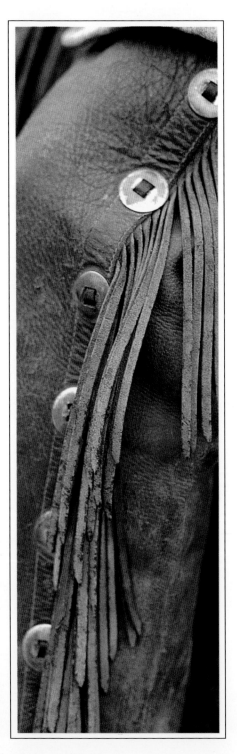

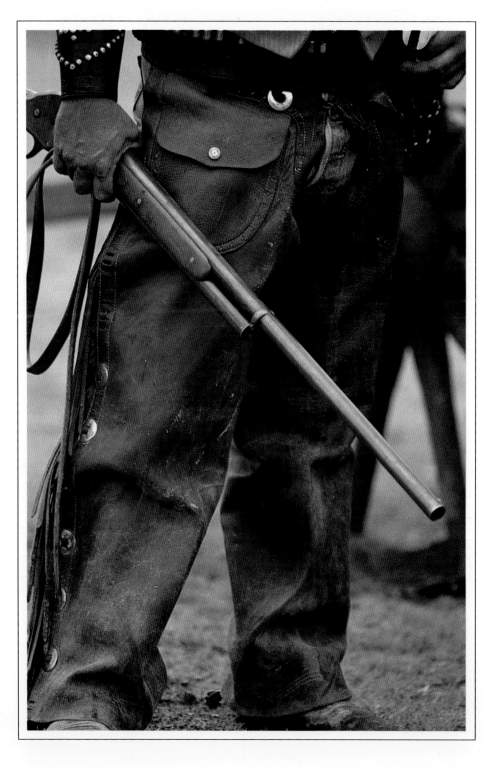

Early Californian chap detail, circa 1885 Clark shotgun chap detail, circa 1920 Clark shotgun chaps, circa 1920

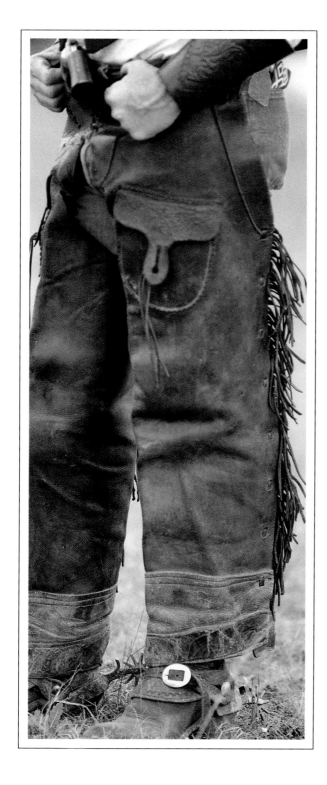

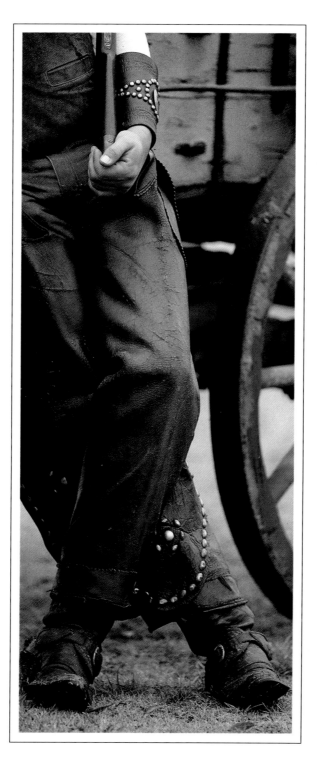

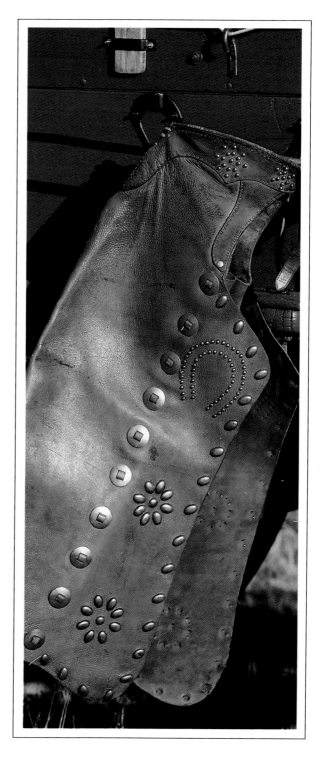

J.C. Read & Bros. shotgun chaps, Ogden, Utah; circa 1898

Main and Winchester shotgun chaps, circa 1890

R.T. Frazier batwing chaps, circa 1920

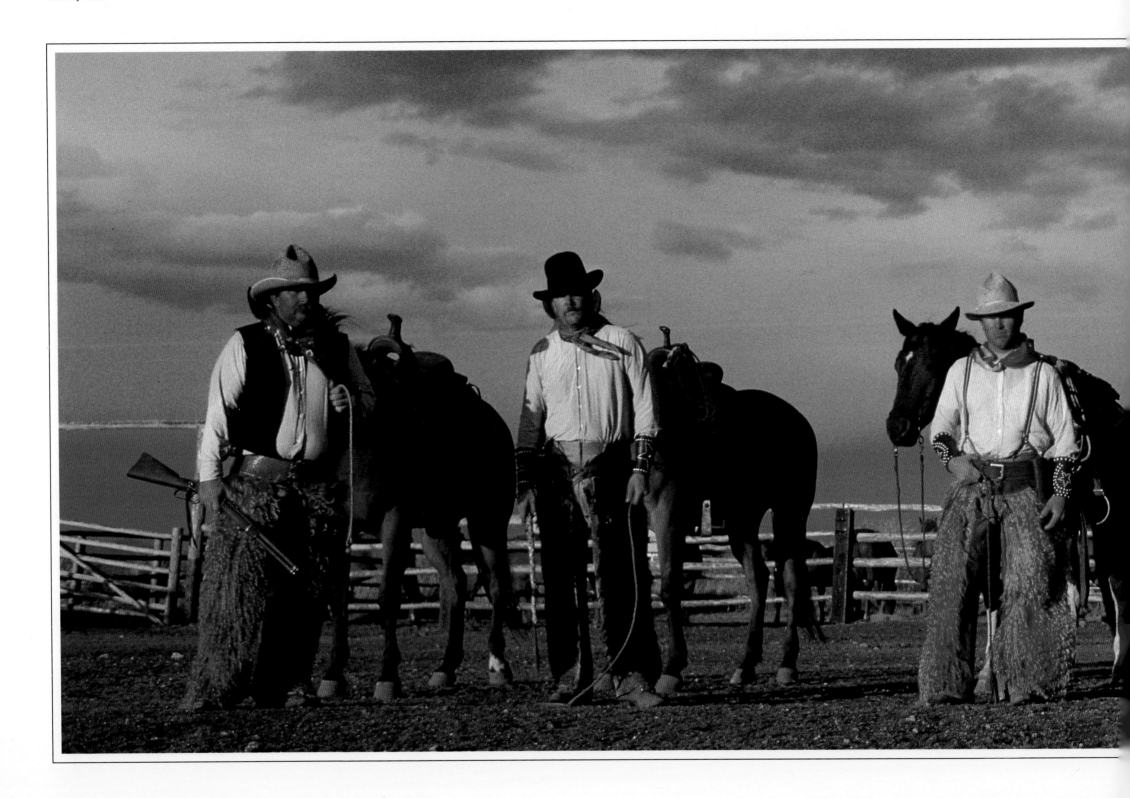

"When the boss ain't about he leaves his leggins in camp,

He swears a man who wears them is worse than a tramp."

—Top Hand ("Top Hand" was a parody of a bogus cowboy's attitudes.)

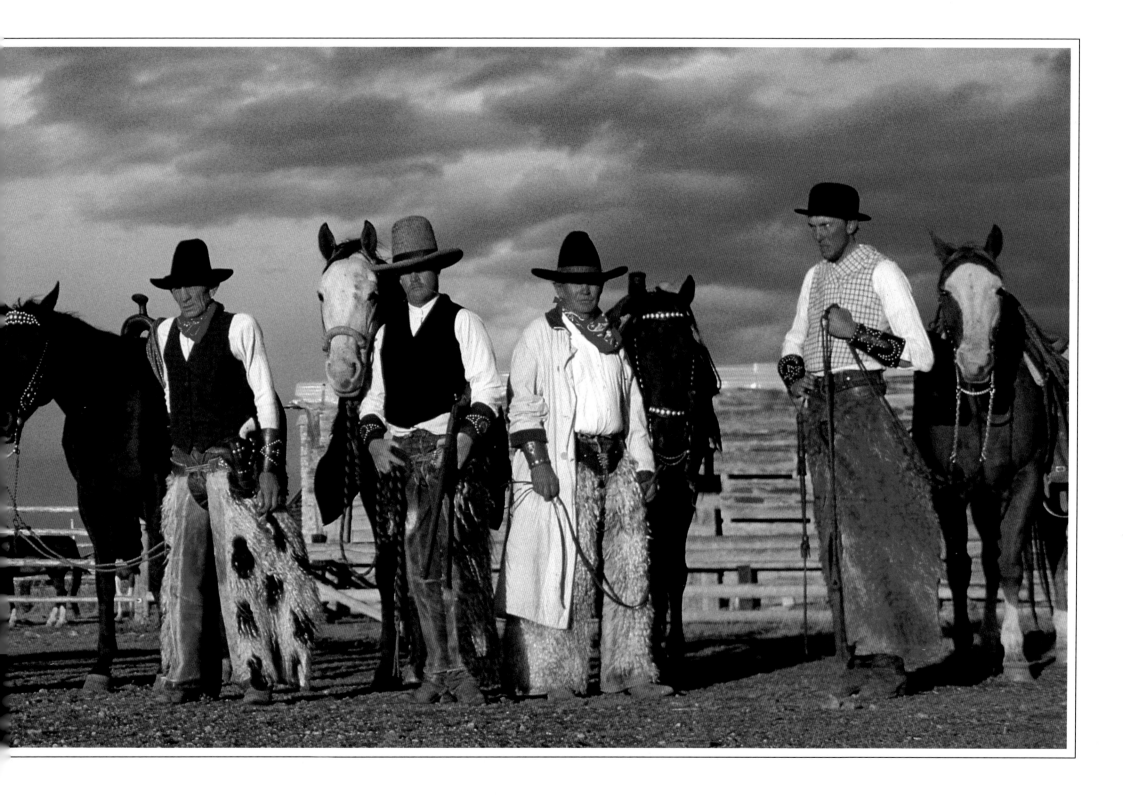

No single item in a working cowboy's gearbag was more important for his protection than his chaps.

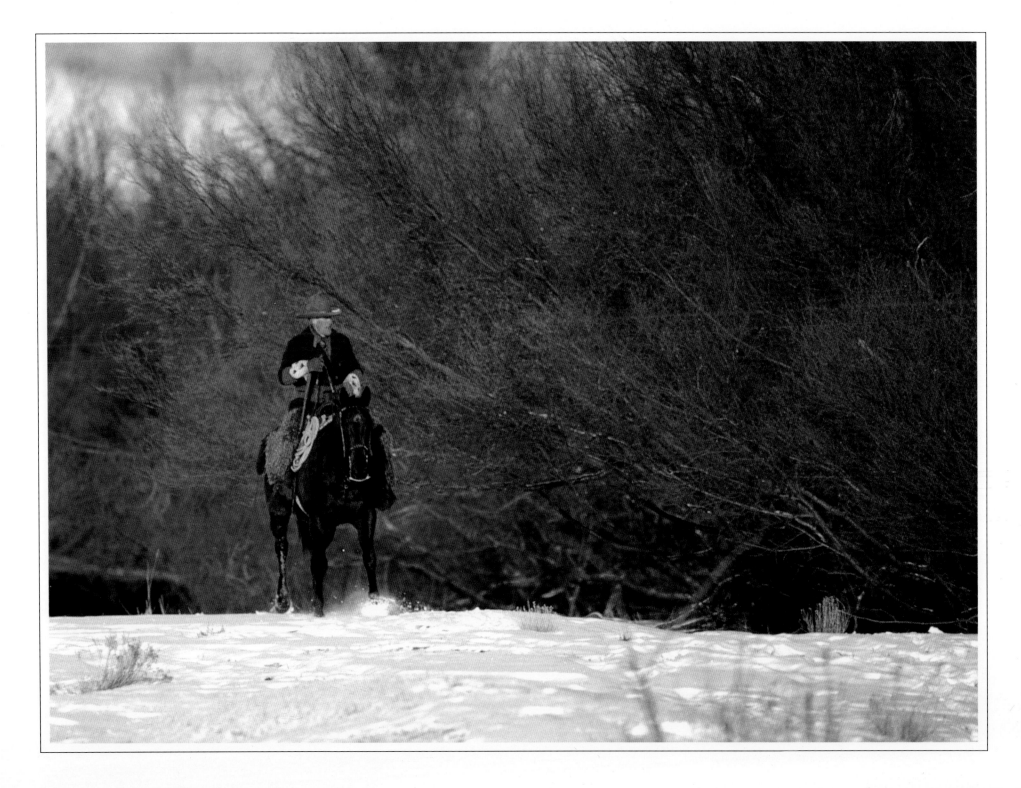

"I'm a wandering cowboy, from ranch to ranch I roam,

At every ranch when welcome, I make myself at home."

—The Wandering Cowboy

Coats, Vests & Jackets

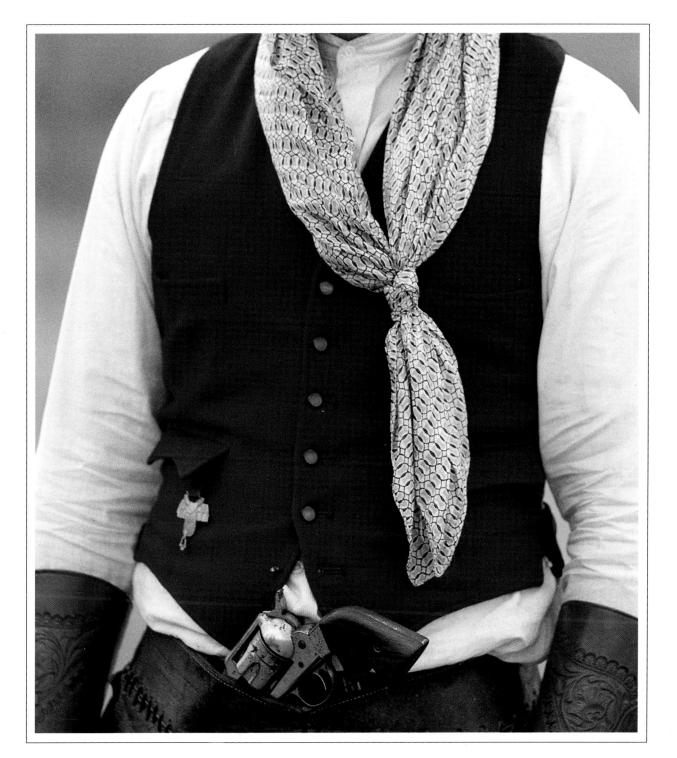

Typical wool vest

Cowboys mostly worked coatless, preferring the freedom of motion offered by their collarless shirts. Vests were common since they didn't hamper movement, and provided ventilation, and plenty of pockets for cigarette papers, matches, and tobacco.

When necessary, the cowboy wore a canvas overcoat. This was light brown in color and reached the knee in length. Lined with a wool blanket for warmth, it was often coated with paint for windproofing. Sometimes the owner's brand was marked on the paint.

In the coldest weather, cowboys wore fur overcoats. Initially made of buffalo hides, these changed to horsehair in the 1880s. On rainy days, most cowpokes preferred the pommel style, split-tail slicker, which fit over both man and saddle. The Fish brand was the most popular. Other popular styles included short, sleeveless waistcoats; blanket-lined jackets; brush jackets; and ponchos.

Favored suppliers included Gordon & Ferguson of St. Paul, Minnesota; Chicago Hide, Fur and Wool House in Douglas, Wyoming; and Globe Tanning Company from Des Moines, Iowa.

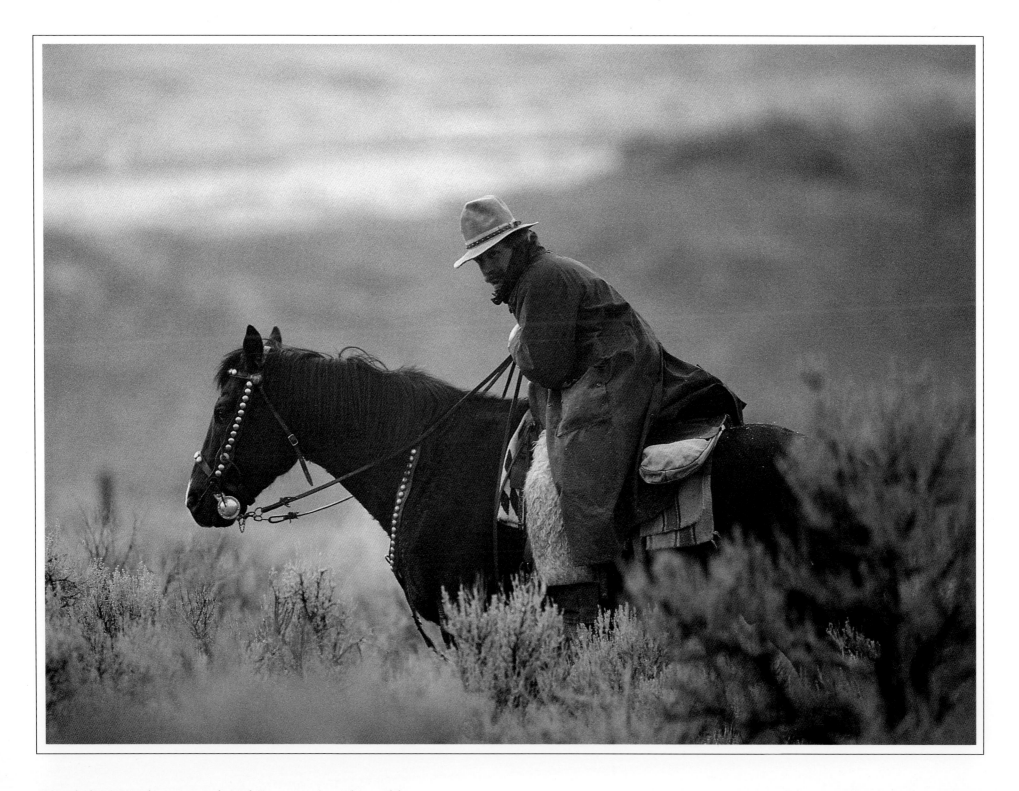

"My slicker's in the wagon / And I'm gettin' mighty cold,

And these longhorn sons-o-guns / Are gettin' hard to hold."

—The Old Chisholm Trail

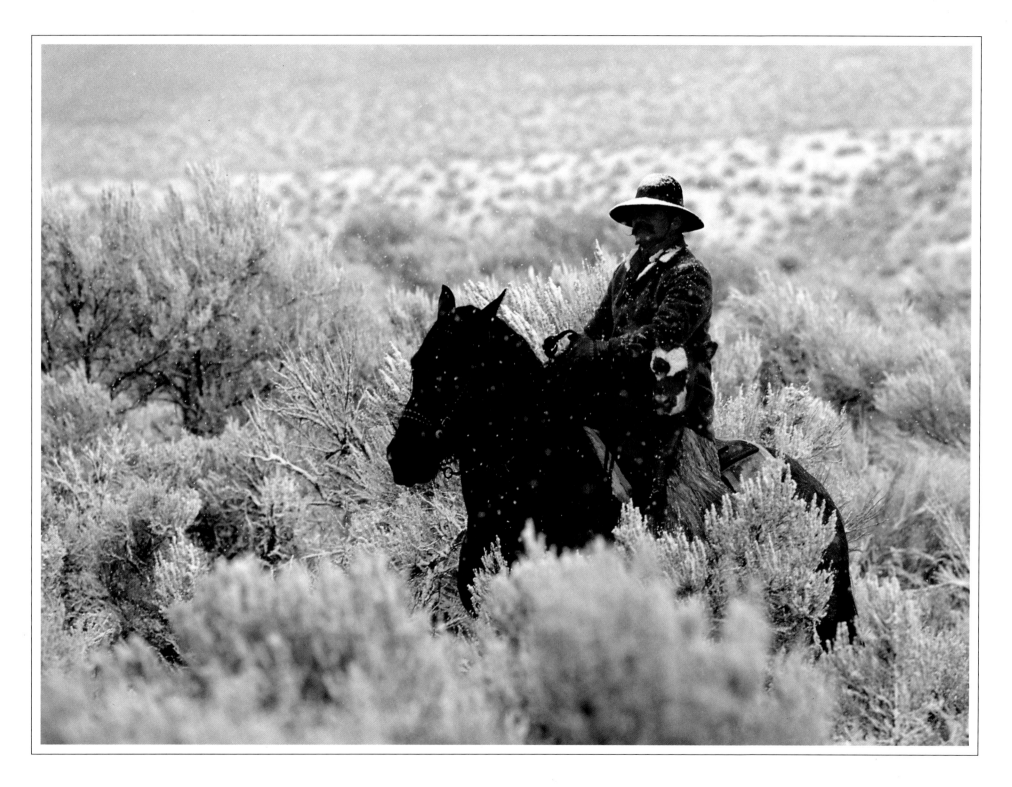

Sometimes a cowboy had to wear as many as three layers of wool coats to keep as warm as he would have in a modern coat.

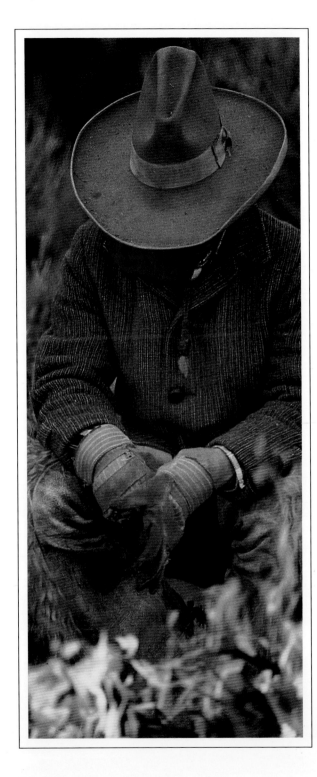 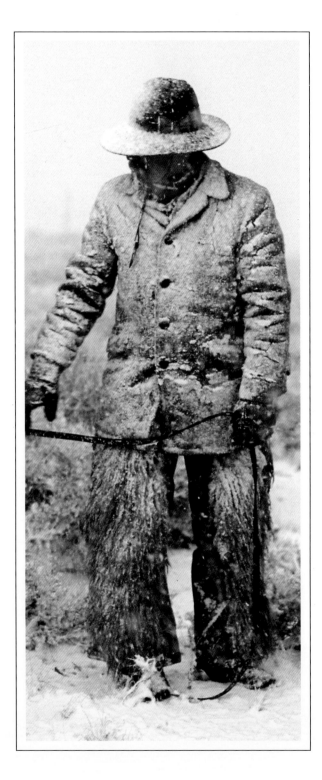

Cowboys had to work and live in the elements. They put on the back of the saddle what would work, and work well, in all conditions.

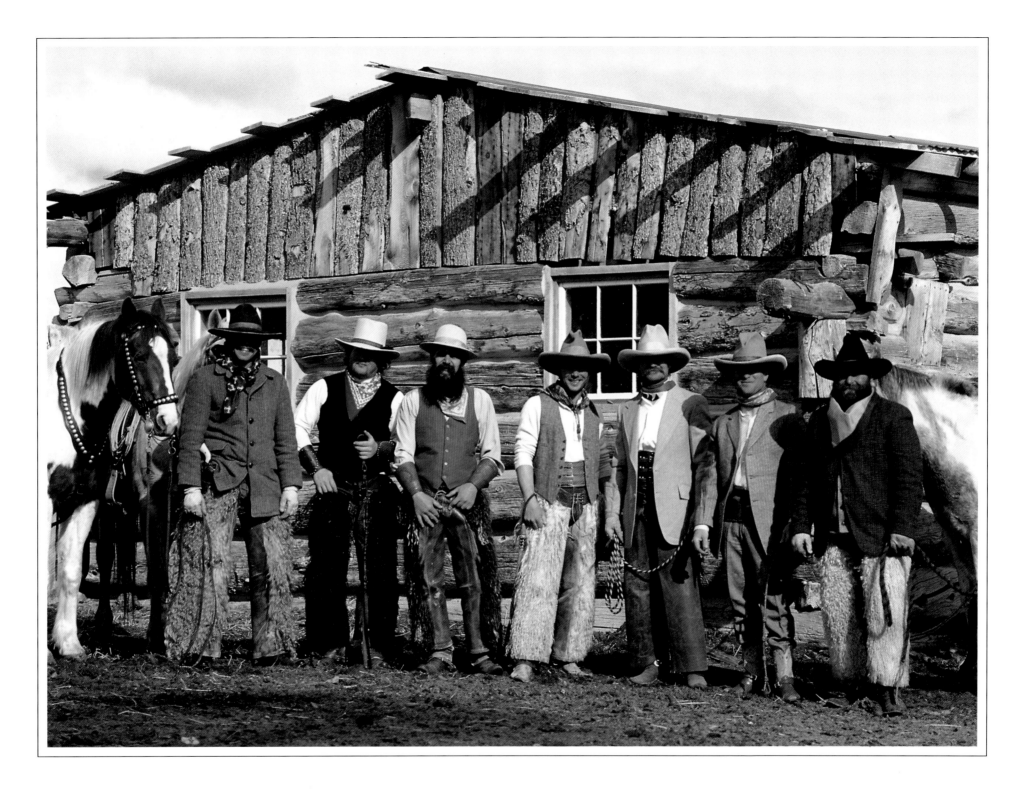

Typical dress for the 1890s
Next page: Warming up after a long day looking for strays.
These cowboys are dressed in heavy buffalo and bear coats.

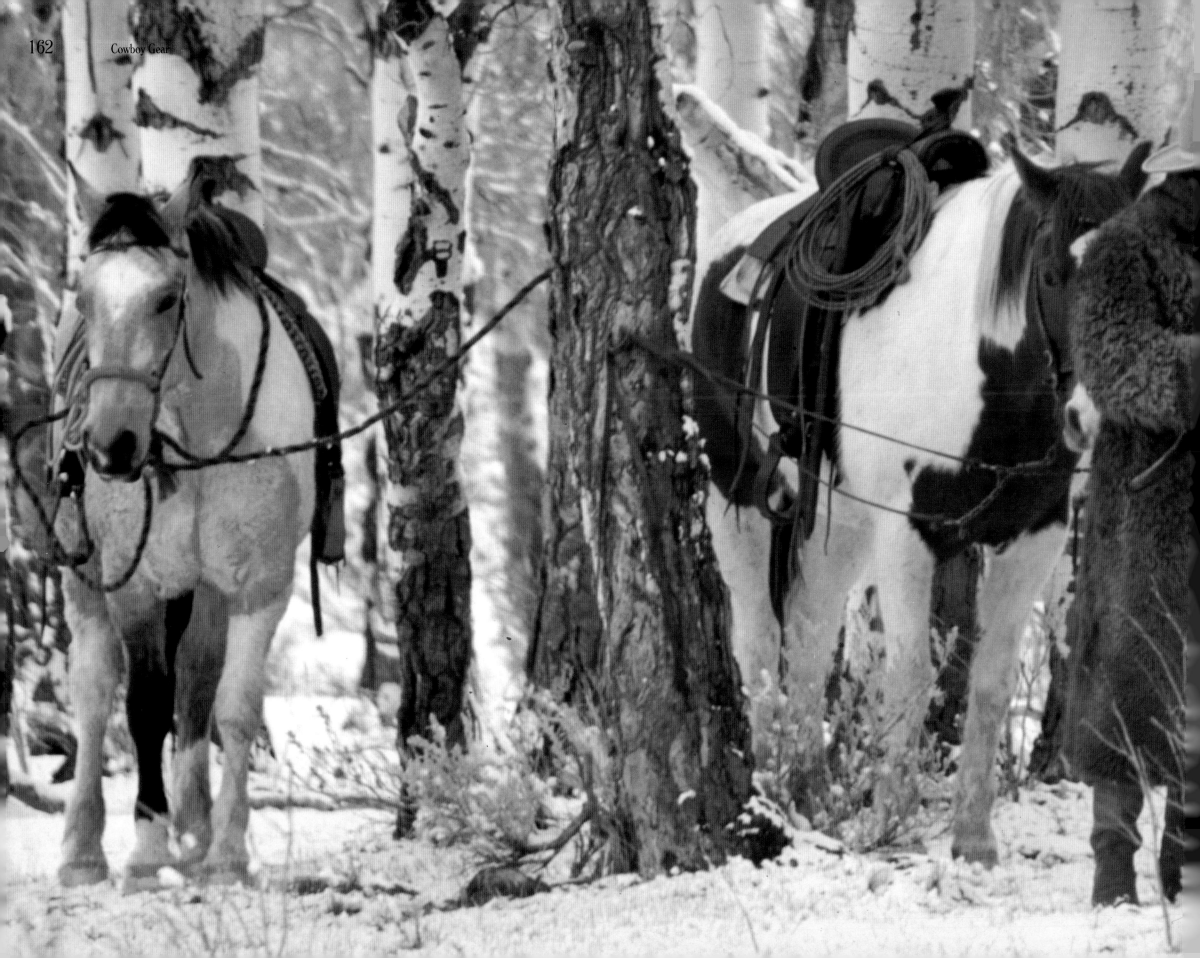

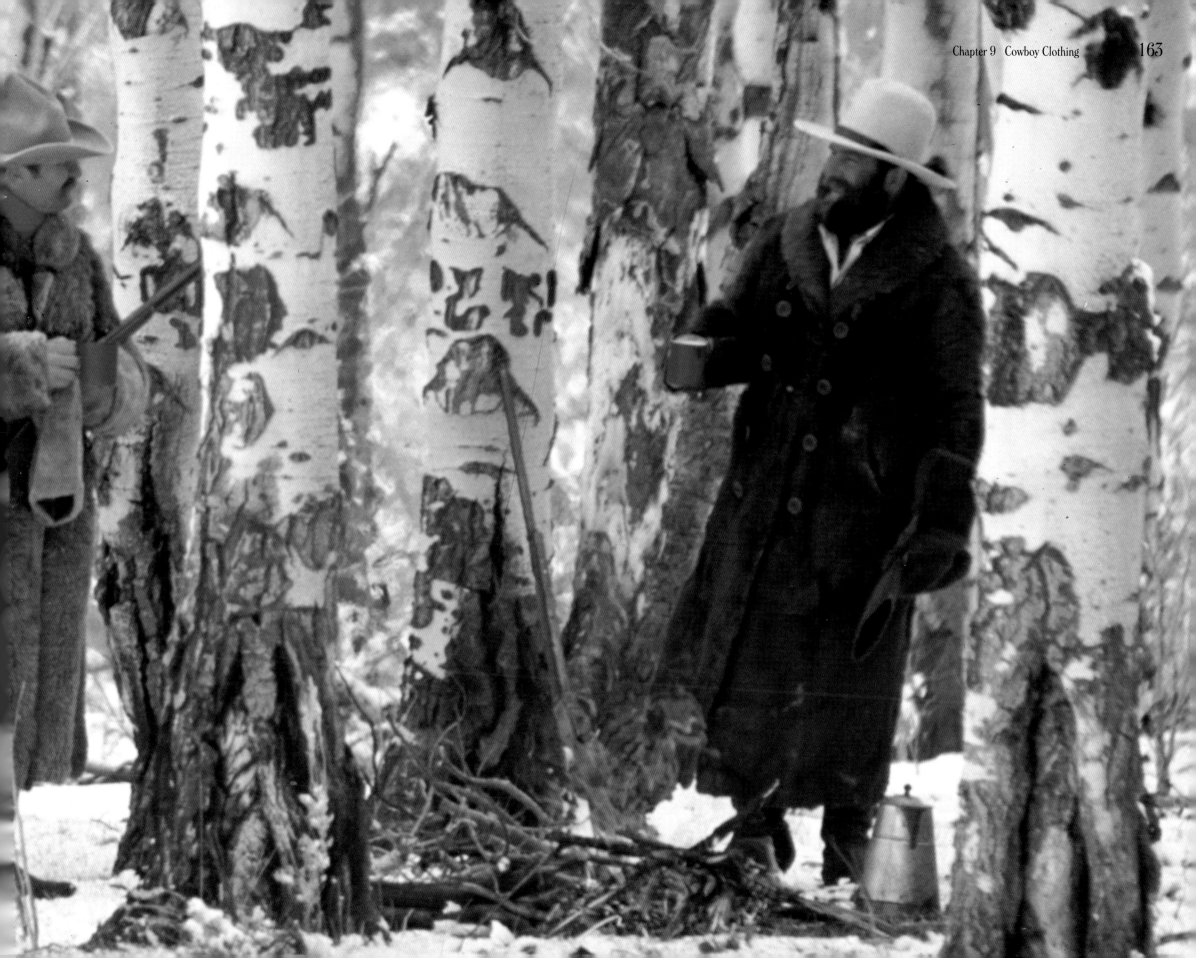

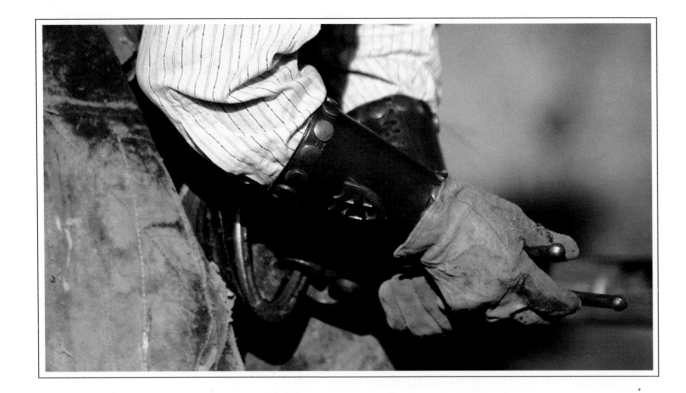

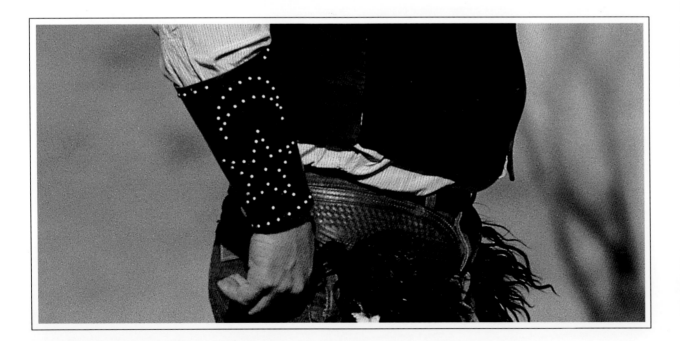

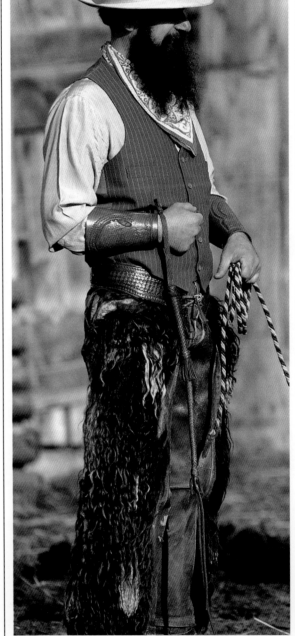

Top: Leather cuffs like these (circa 1920) were used for hard work like horseshoeing and branding in order to protect the wrist.

Bottom: Stars and horseshoes were the most widely used patterns for studding cuffs, circa 1900.

Engraved cuffs by Zenith, circa 1910

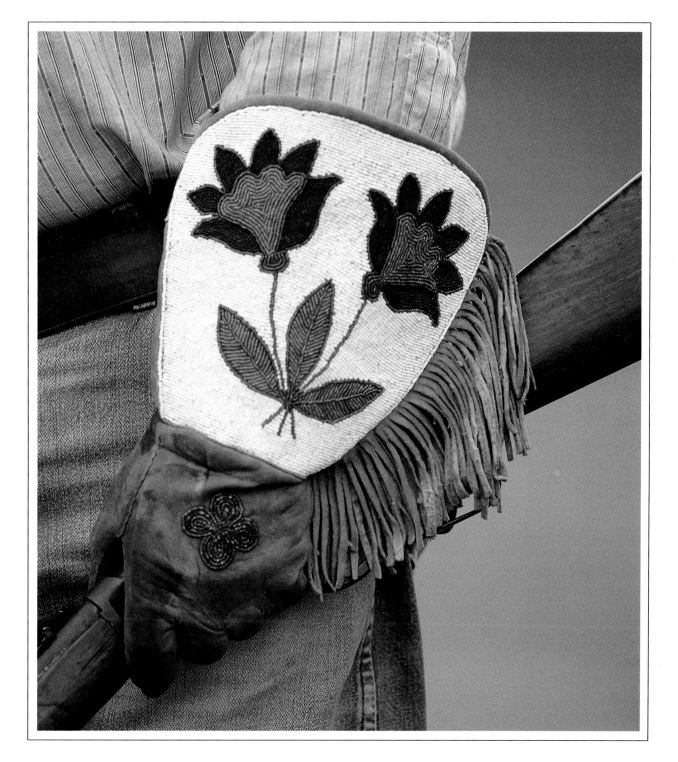

Cuffs, Gloves, Gauntlets & Kidney Belts

A cowboy's cuff was a leather gauntlet used to guard his wrist and shirt-sleeve from barbed wire, thorns, branding irons, and rope burns. Attached with laces or buckles, cuffs were also a decorative accessory, usually dressed up with conchos, carving, or embossed designs. A less obvious use for these leather cuffs was to cover dirty shirt cuffs. Combined with a neckerchief over the collar, a shirt worn for a month could pass inspection by anyone standing upwind.

Gloves were worn for protection from blisters, rope burns, and the winter cold. Usually made of buckskin, gloves were also made of horsehide or smooth leather. In the coldest weather, fur and wool gloves were used. Many early cowhands used gloves featuring flared and decorated gauntlets, often five to eight inches long. These gloves, modeled after U.S. Cavalry styles, were often made by Indian women and were highly decorated with beadwork, fancy stitching, and fringe.

The kidney belt offered protection to a cowboy riding hard-pitching or bucking stock. Sometimes called a bronc buster, the kidney belt was usually five to eight inches wide, and fastened with two or three buckles. Kidney belts were often highly decorated with elaborate carved designs. They became quite popular after cartridge belts disappeared from the range.

Buckskin beaded gloves, circa 1915
These gloves, often used by Indians throughout the West for trade, were also sold through catalogs.

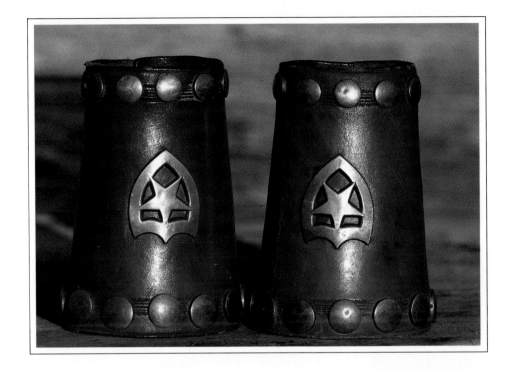

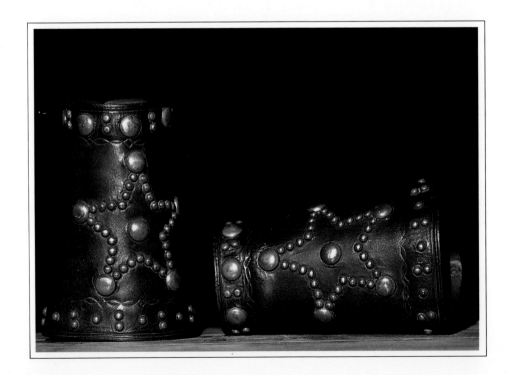

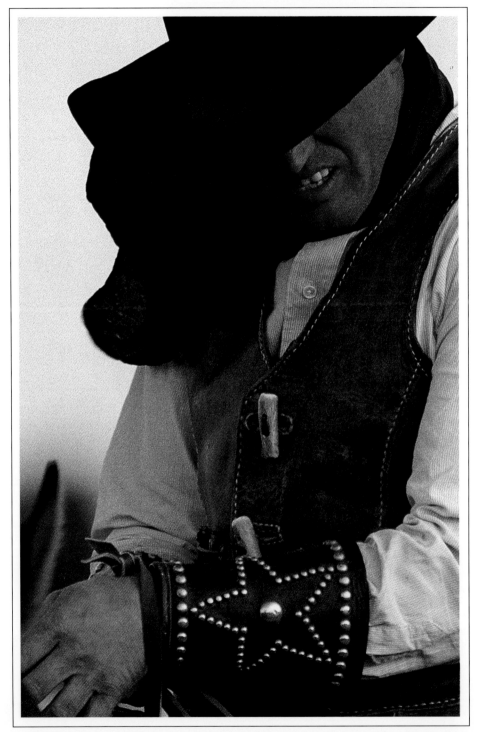

Harness studs and medallions were used for decoration on these cuffs, circa 1920s.

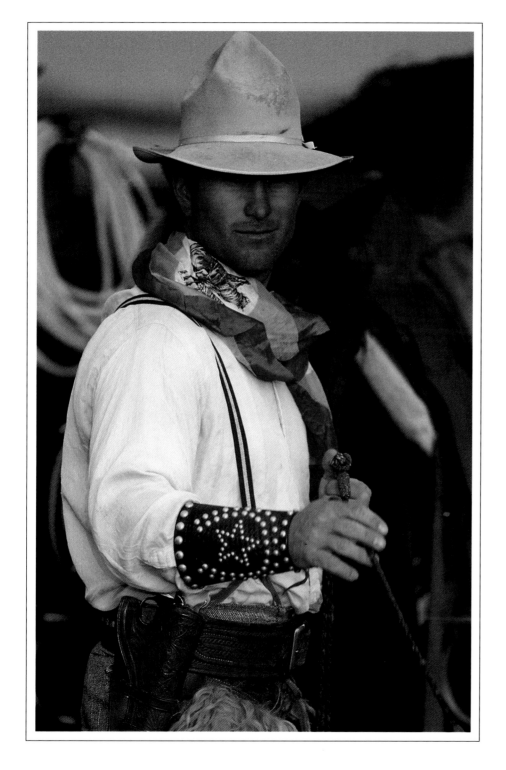

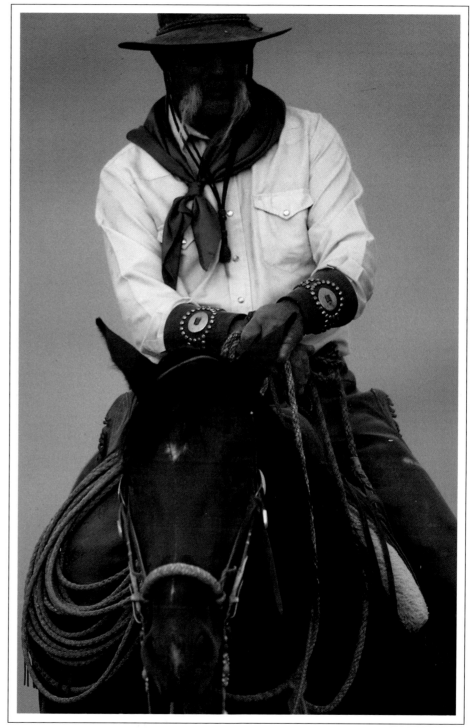

Cuff with silver conchos, circa 1900

Fancy studded leather cuffs, circa 1920

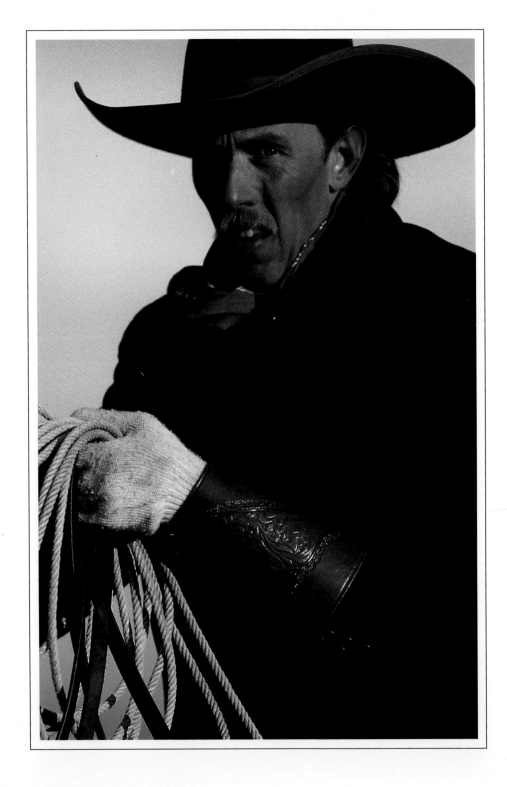

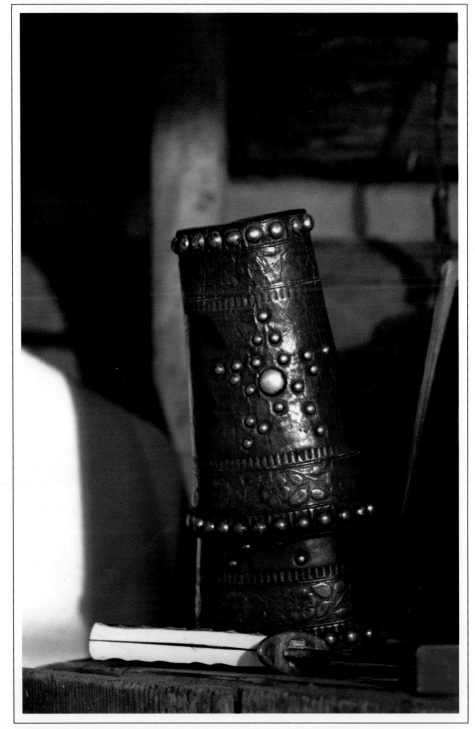

Tooled leather cuffs, circa 1900

Leather star-studded cuffs, circa 1890

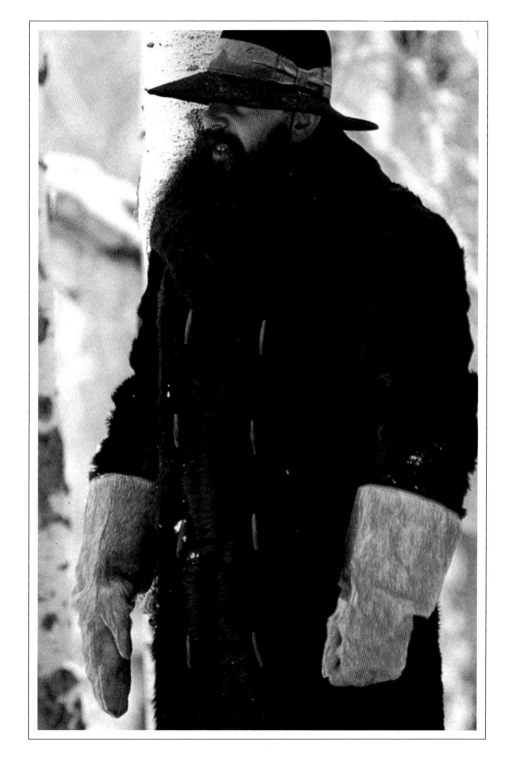

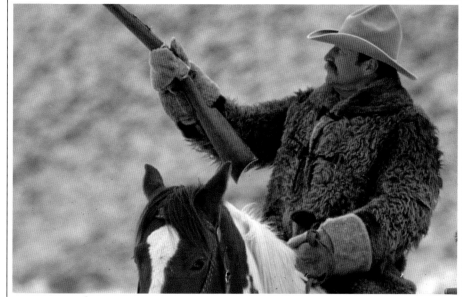

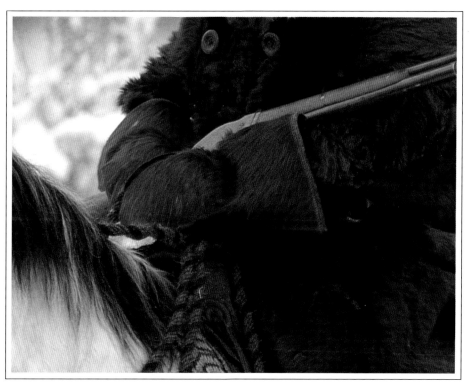

Horsehair gloves, circa 1890

Top and bottom: Beaver gloves, circa 1890

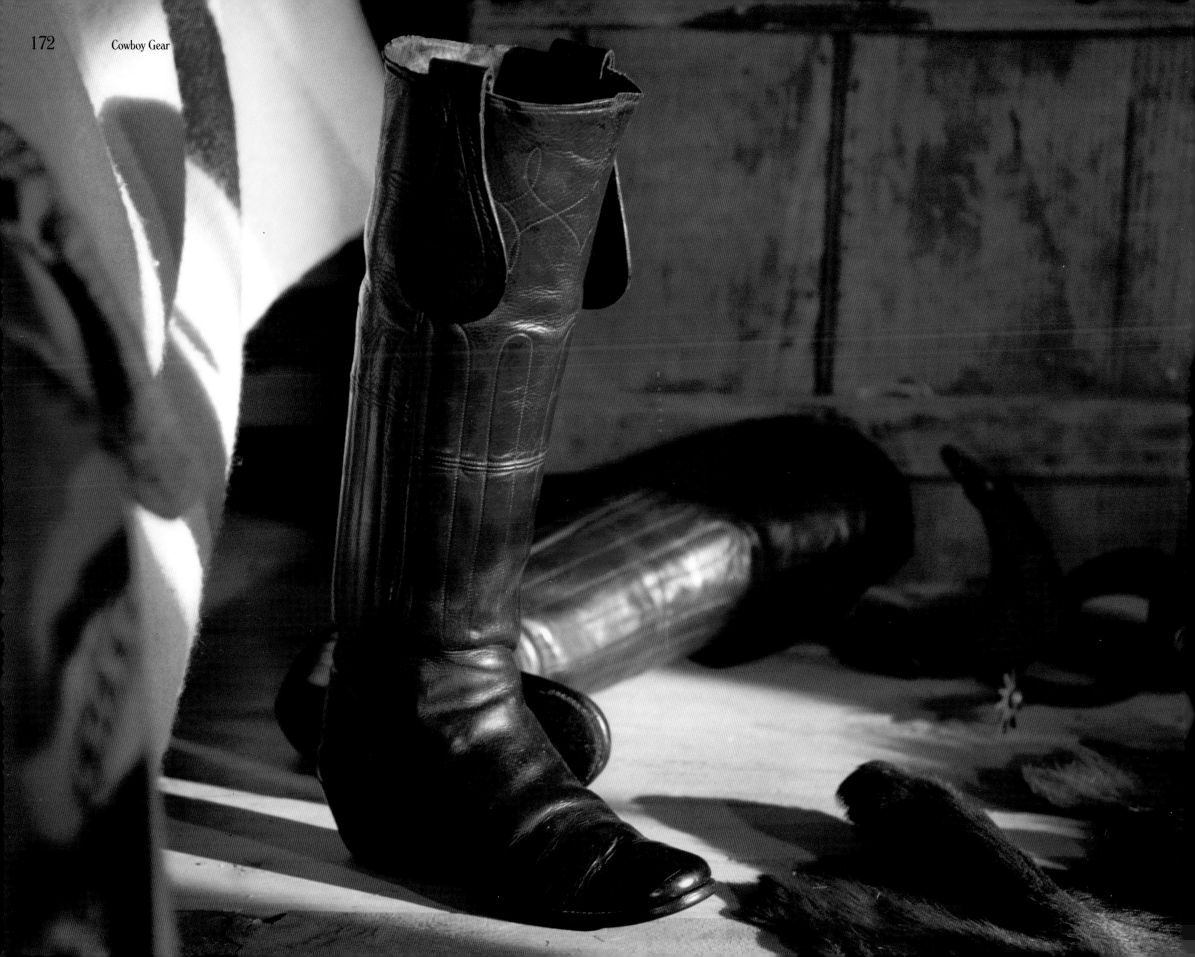

Cowboy Boots

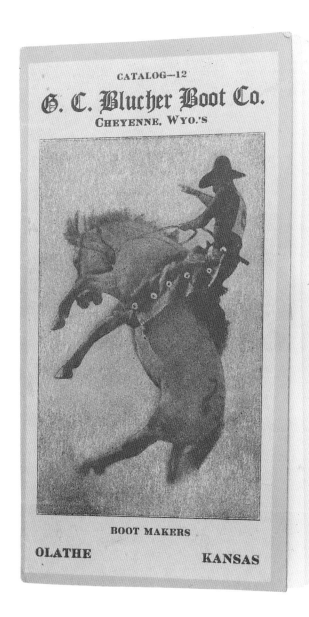

CATALOG—12

G. C. Blucher Boot Co.
CHEYENNE, WYO.'S

BOOT MAKERS

OLATHE KANSAS

Blucher Boot Catalog, circa 1917

"The puncher with vanity for his tight, thin boots, and with contempt for the heavily soled foot coverings of Easterners, 'put his feet into decent boots, and not into entire cows.'"

The Cowboy
Phillip Ashton Rollins;
Charles Scribner & Sons, 1922

The earliest cowboys, both in Texas and California, often wore soft buckskin leggings and moccasins. Slightly later came "bota-de-alas," the "winged," fringed, and often embroidered boot seen in many Frederick Remington illustrations. Following the Civil War, cowhands wore the round-toed, flat-heeled boots that had been issued in the army.

In the late 1860s, the earliest versions of the true cowboy boot appeared. The boot had a high, narrow, and underslung heel; a soft, tightfitting foot; soft, high tops; and thin soles. Cowboys felt the high heels provided more certain footing in the stirrups than did other types, and the thin soles provided a better "feel for the stirrup." Some said the high heel provided surer footing when roping afoot as well, because the heels could be dug in to give the cowpoke a solid stance. Others were not so quick to praise the boots, pointing out that the puncher who lost his mount and walked back to the ranch was usually a near-cripple upon arrival.

The first cowboy boots were made by craftsmen such as Justin and Hyer, who set up shop along the Texas trails. Later versions sported frills like the pointed toe and floppy grips called "mule ears," which made the boots easier to pull on. Early boot tops were often red or blue and featured a simple design like a horseshoe or a star. The fanciest boots were made after the 1880s and featured soft leather, appliqued designs, and decorative stitching. The stitching provided additional durability and supported the tall boots.

Boots were originally worn with the cowboys' pantlegs tucked inside to provide protection from brush. Later, though, boots were worn with the pants outside.

A cowboy could get a boot mail-order kit, which provided examples of styles the puncher could order, as well as instructions on measuring and tracing his own foot. The catalog saved the cowboy a long trip to town, but he often had to wait as long as six months for his new footwear to arrive.

Opposite page: 1880s mule-eared boots—classic early cowboy boots
These boots are so well preserved they must have been used only for dancing or church.

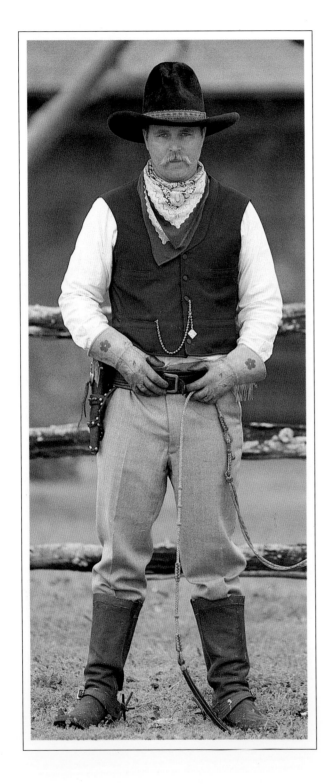

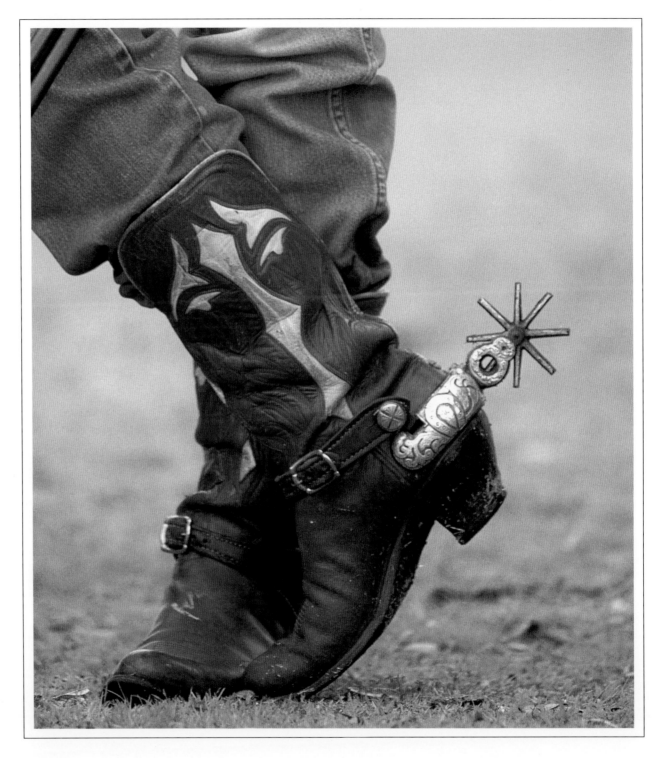

The earliest cowboy boots were Civil War surplus boots, circa 1860

These boots were made by Justin in Fort Worth, Texas, but sold by Visalia of California; circa 1920. The early cowboys tucked their pants into their boots.

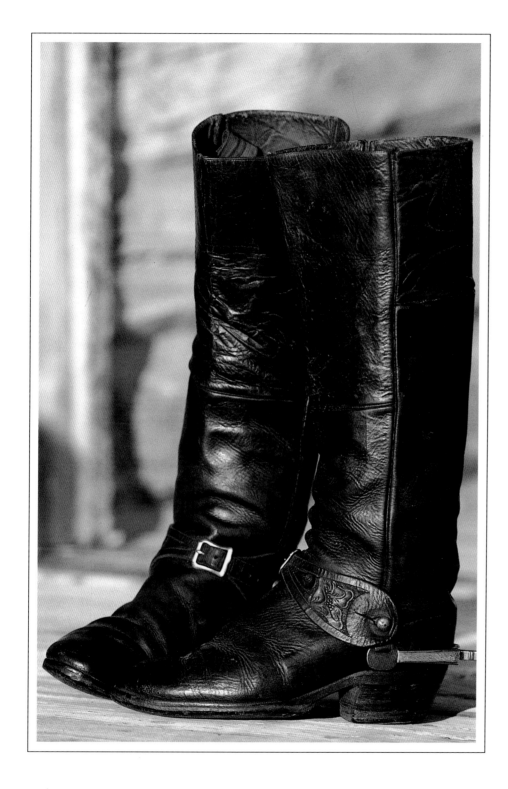

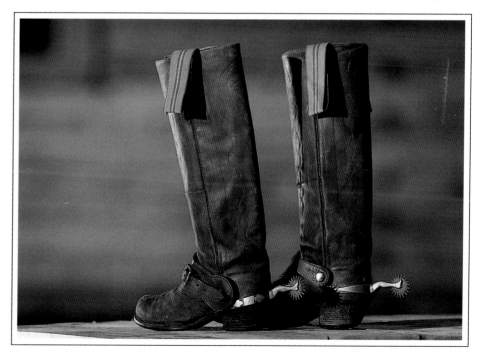

High vamp boots from the 1880s

Top: Undercut boot heel

Bottom: 1890 boots with cloth bootstraps and stove-pipe tops
By the 1890s scalloped boot tops began to be popular.

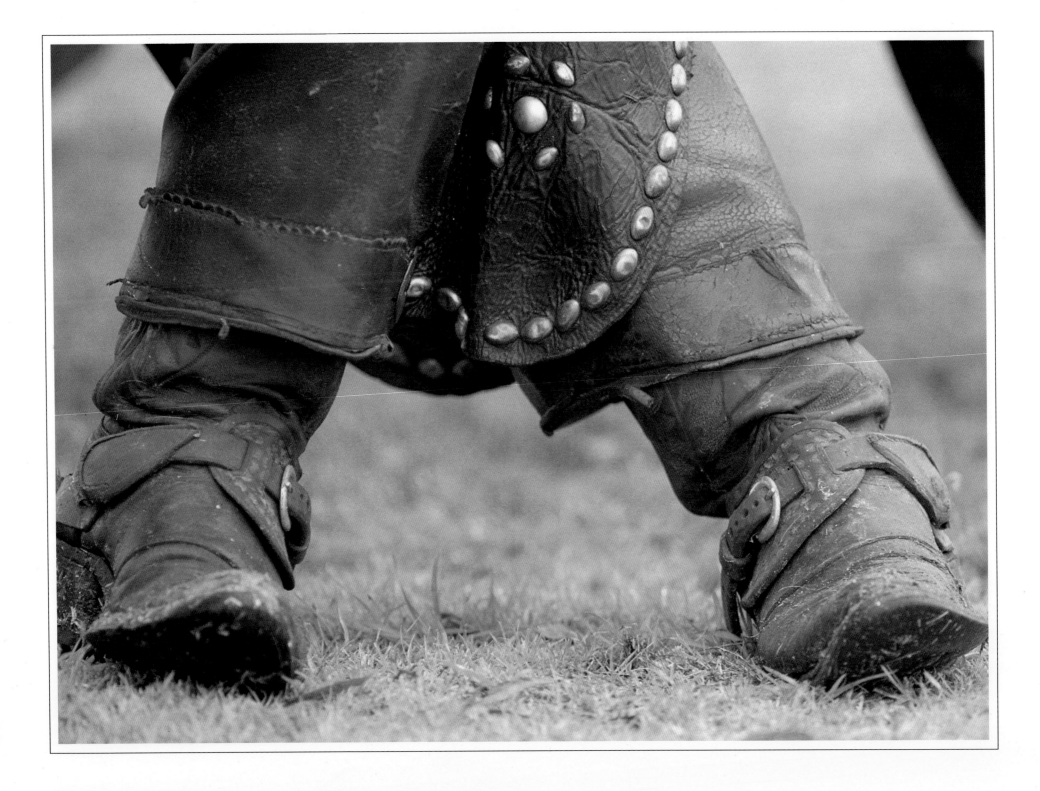

1900s well-worn cowboy boots

Opposite page: Fancy butterfly inlays on mule-ears of 1915 boots

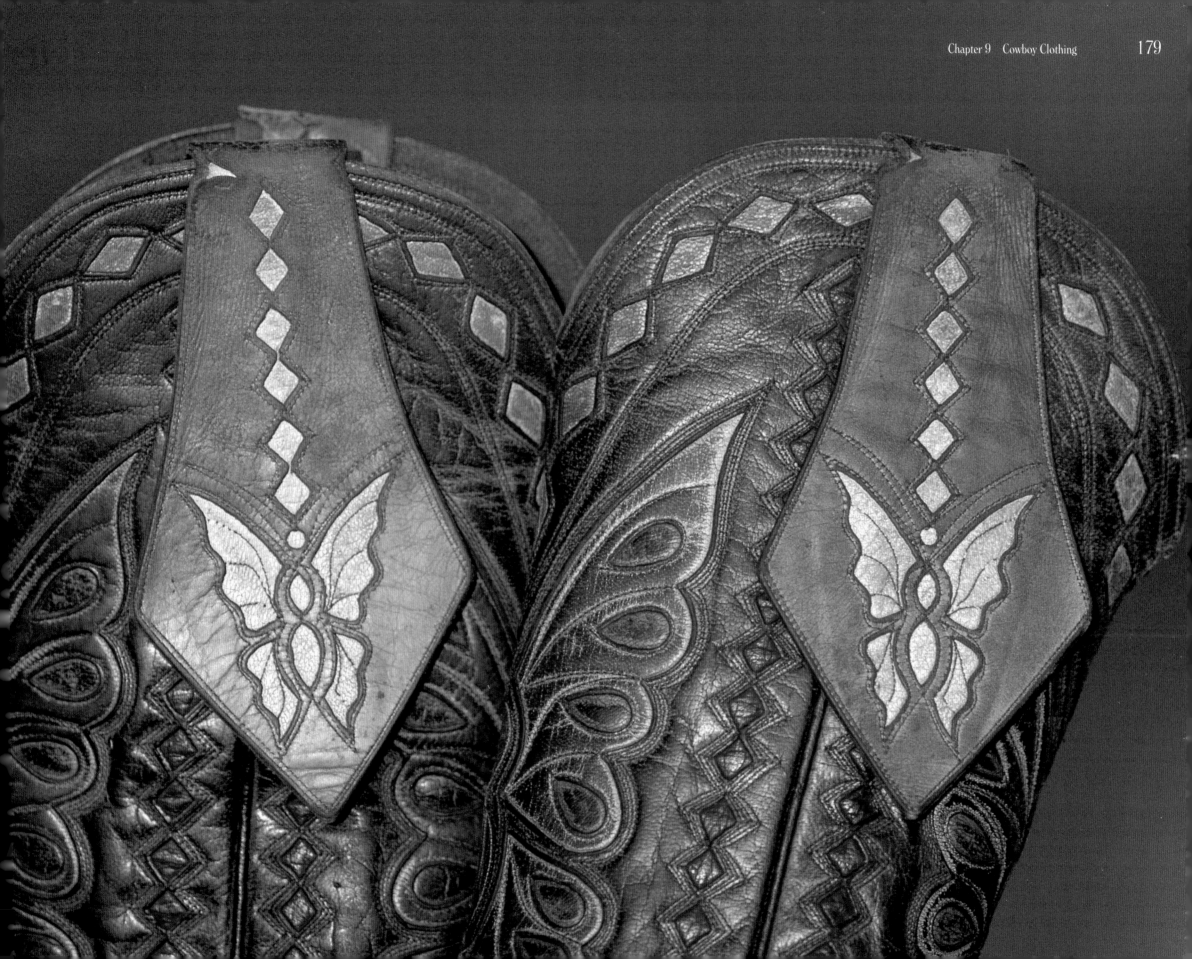

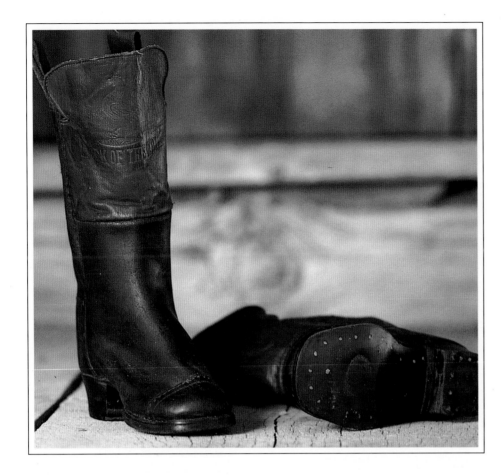

1880s Cock-of-the-Walk childrens' boots

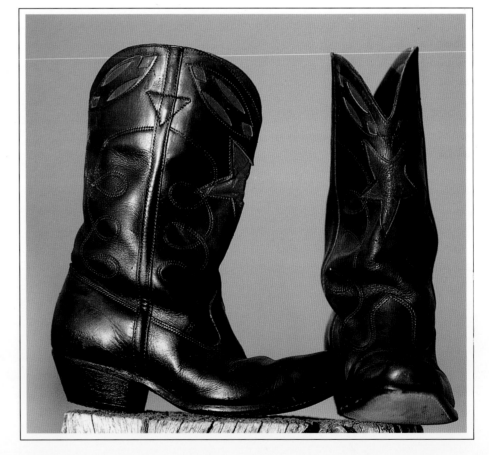

1920s childrens' Star Boots

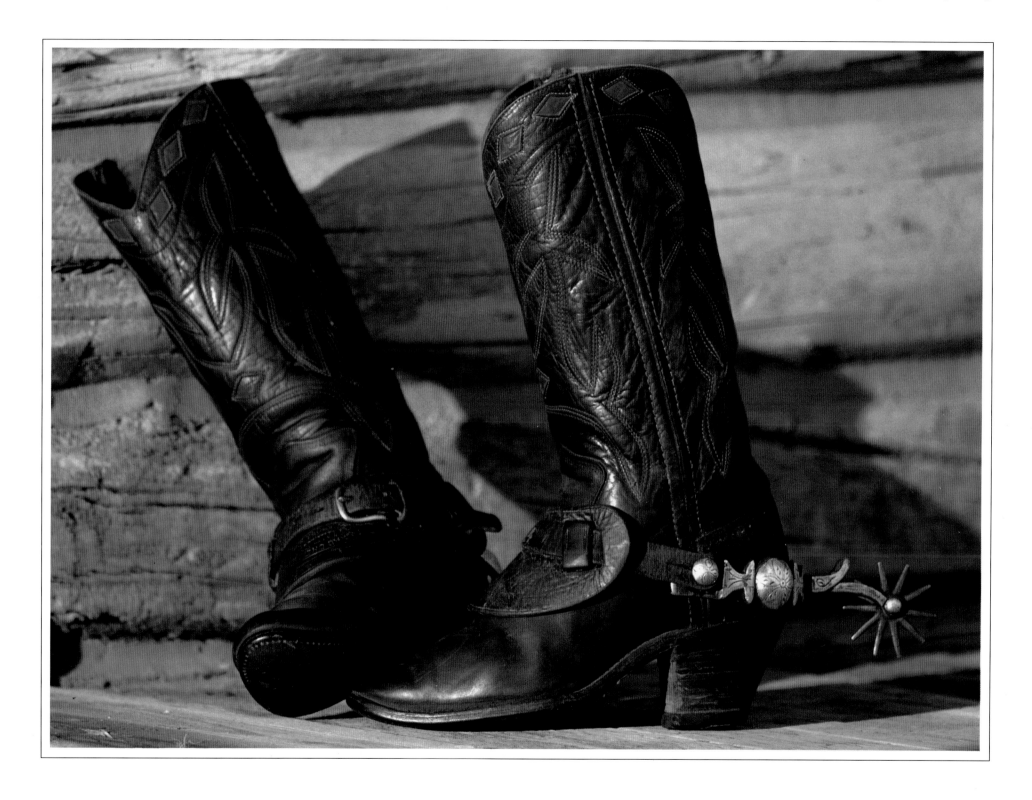

Heavily stitched 1890s boots with
California transitional spurs

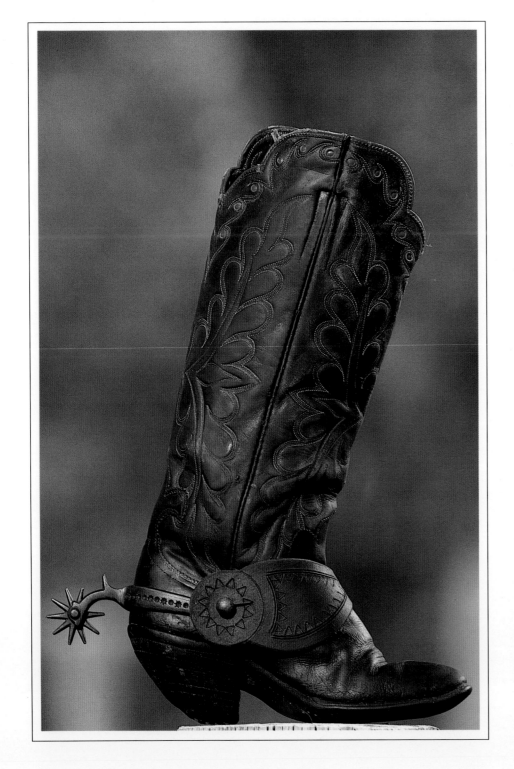

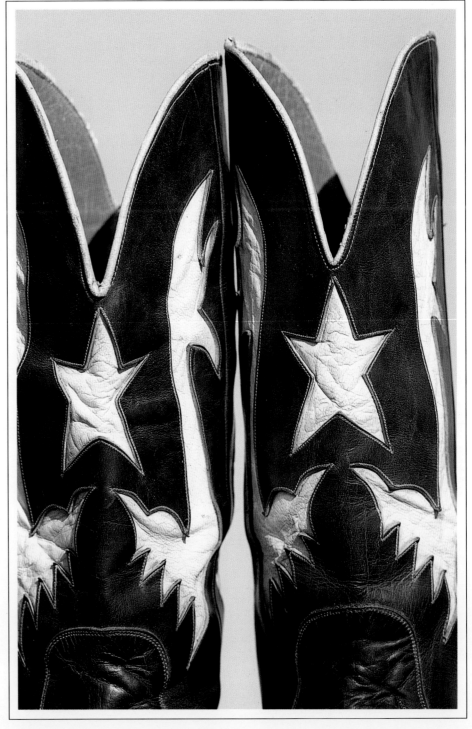

1915s double-scalloped top boot by Tuscon, Arizona maker
The spurs are early Buermann, circa 1890.

C.H. Hyer & Sons boots with inlaid stars on tops, circa 1915

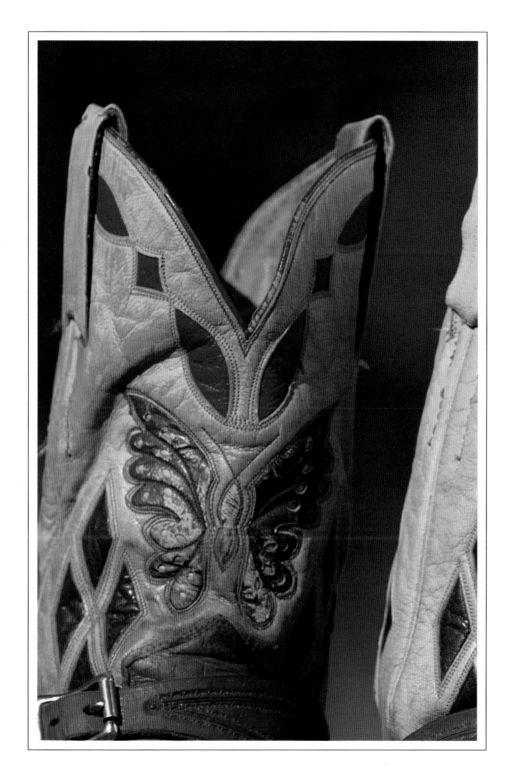

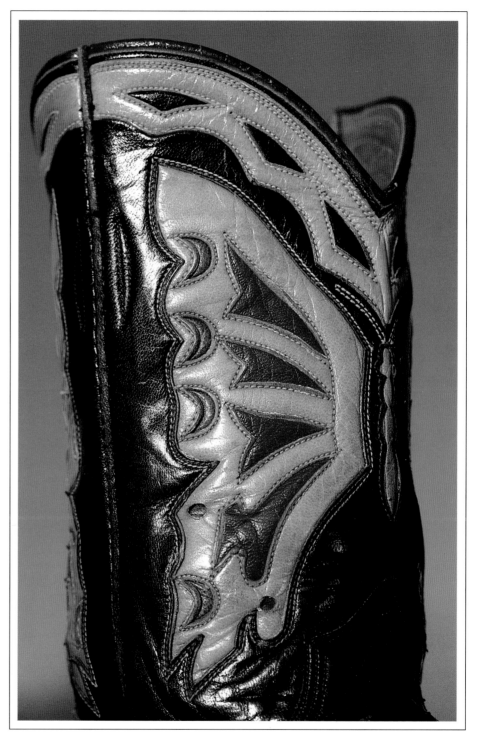

Men's Olathe yellow boots with butterfly inlay on tops, circa 1920s

Ladies' butterfly-inlay boot, circa 1930s

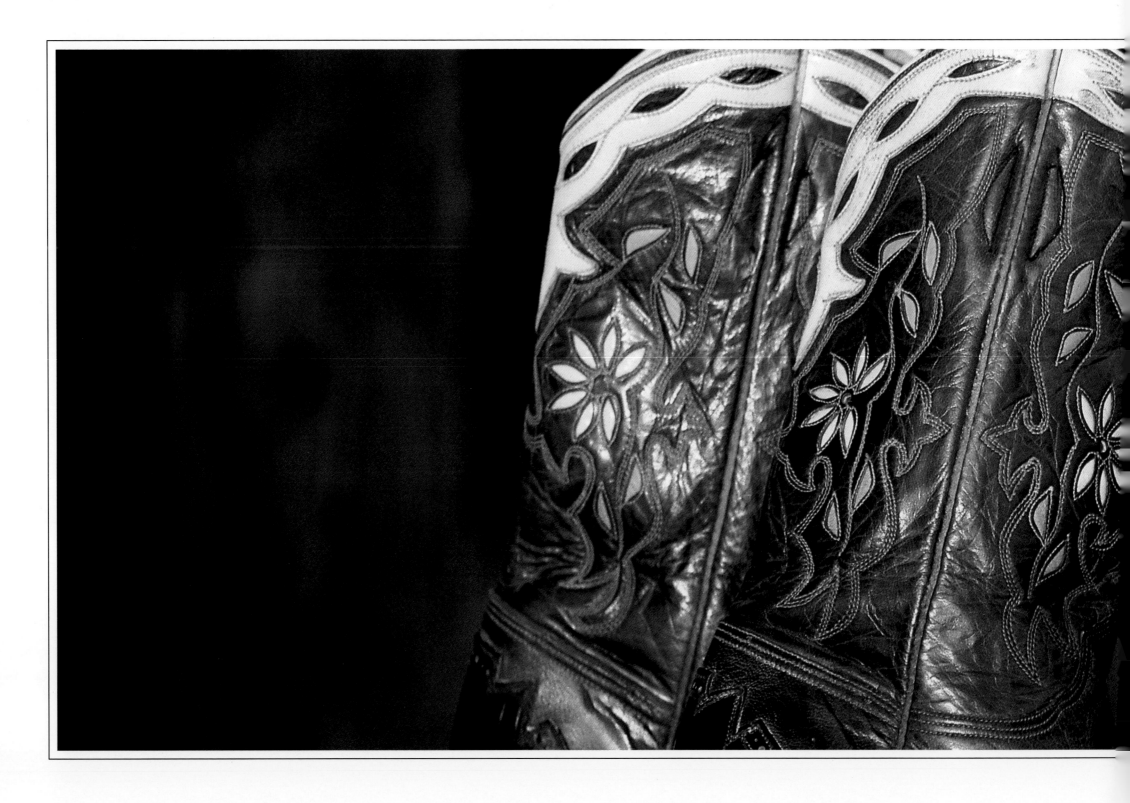

1940s Acme boots

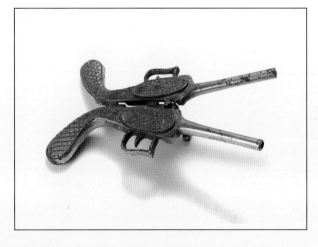

Top: Cricket
Middle: Mermaid
Bottom: Naughty Nellie

Top: Cut plug advertising
Middle: Beetle
Bottom: Folding pistol

Top: Carved wood
Middle: Black Naughty Nellie
Bottom: Bug

Bootjacks

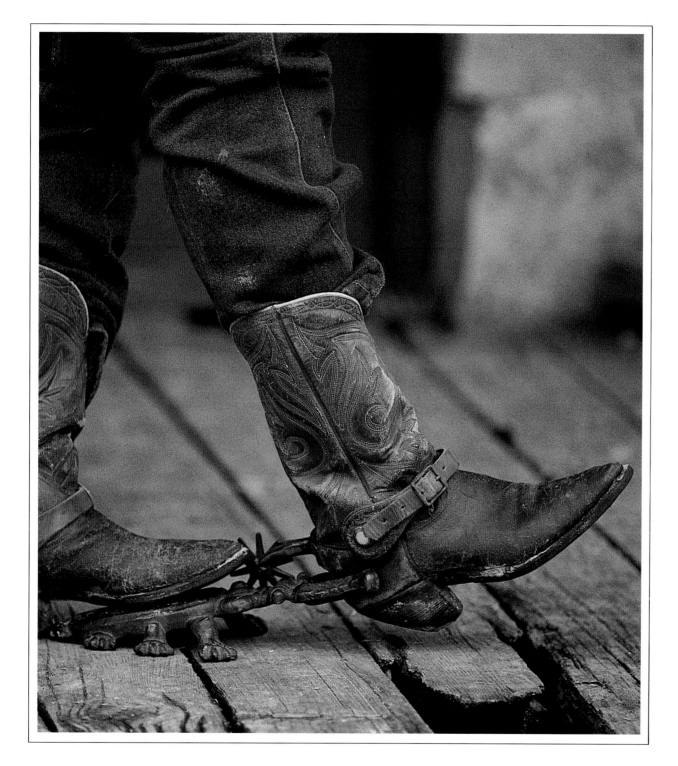

The bootjack was a tool commonly found on the floorboards of a ranch or bunkhouse just inside the door or on the porch. A simple, usually one-piece, device having a U-or V-shaped notch at one end, its function was to remove tightfitting cowboy boots. The wearer would place his boot heel in the notch and pull up, while pushing down on the other end with the other foot.

Many early examples are hand carved from wood. These made a good winter project.

Also very popular were whimsical bootjacks made of cast iron and hand painted in gaudy colors. Most widely made of these was the beetle (the boot heel fit between the antennae). Also popular was the infamous Naughty Nellie, which showed a woman lying on her back with legs spread to service the boot. It was necessary to step on Nellie's head to use the jack. These bootjacks would brighten what was often a bleak, dark ranch house.

This cowboy is taking off his Texas-style boots with a beetle bootjack.

Victorian cast-iron bootjack, patented 1869, Brown Bros., Chicago, Illinois

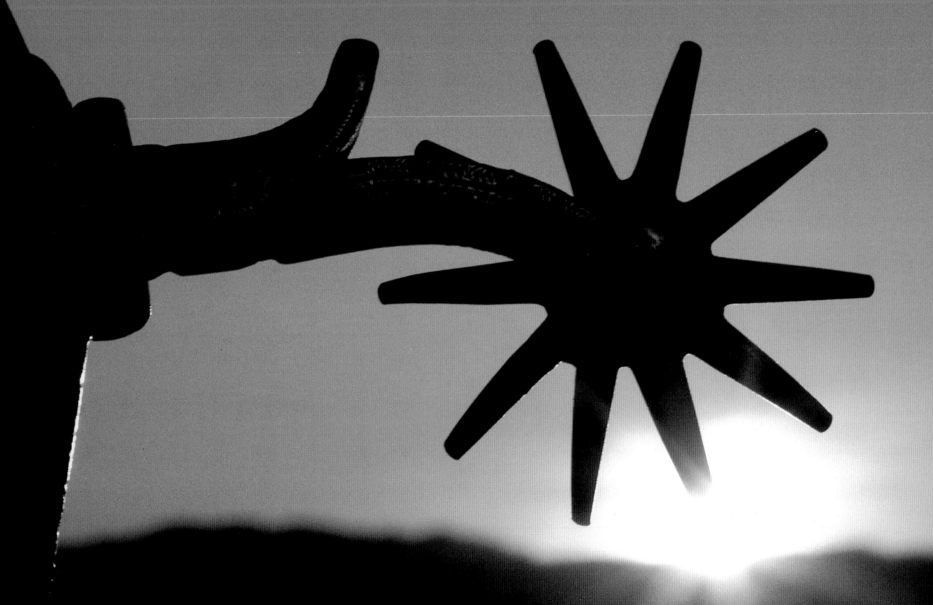

Spurs

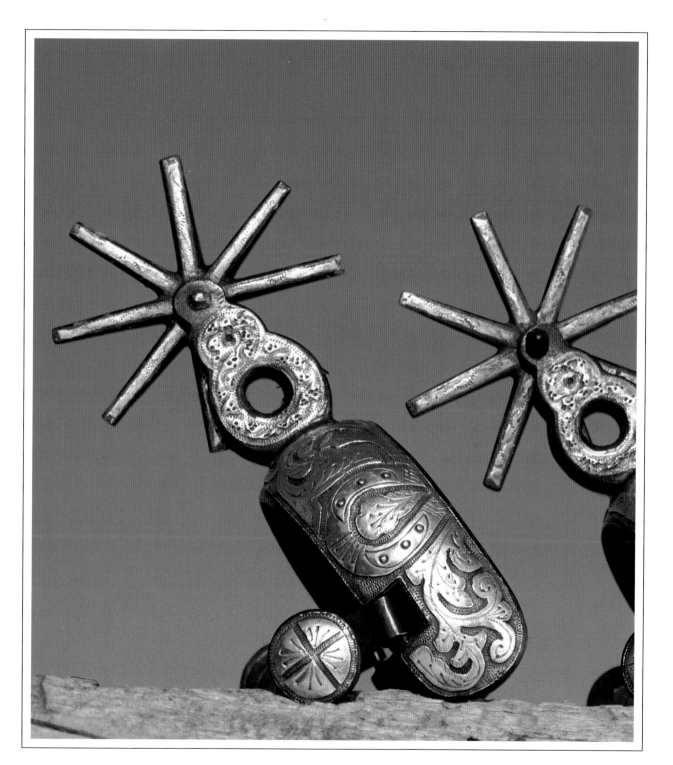

Spurs, used to guide horses and urge the animals onward, were an integral part of the cowboy's work day. But they were also part of his fashion image. Punchers rarely removed their spurs, prompting one writer to observe that a cowboy would as soon appear in public without his pants as without his spurs. Some punchers even left their spurs attached to their boots when they took the boots off at night.

Generally, the spur's heel band, which held the shank and rowel, fit over the back of the boot, while the spur strap fastened across the instep. A chain under the boot heel prevented the spur from riding up. Pear-shaped "jinglebobs" were often attached to the pins that held the rowels in place, and, combined with the heel chains, added a musical jingle-jangle to the cowboy's gait.

The California-style spur was reminiscent of those worn by the vaqueros. It was often decorated with silver, and had slightly larger rowels than its more utilitarian Texas cousin. The vaquero spur was full-mounted, and of two-piece construction. It usually had stationary buttons and double heel chains.

Texas-style spurs were forged of a single piece of metal and had swinging or stationary buttons and turned-up heel bands, often with overlaid decorations. Northern plains cowboys

These beautiful Charro spurs were made in the Amosac area of Mexico from 1900 through the 1920s

Opposite page: Early California transitional spur with drop-shank chap guard and 10-point rowel, circa 1890s

combined the Mexican and Texas styles, utilizing both one-piece construction and decorative silver conchos on the shank and heel band.

Most cowpunchers avoided the spiky-roweled Mexican spur, preferring models like the "O.K." brand, which had filed-down rowels that could not rip a pony's flanks. The work spur, with a gentle, star-shaped rowel, was the plainest design. Rowels varied widely, some having nearly 20 points, some as few as three. Nearly always, the points were blunted. There were many rowel diameters, but the largest rarely exceeded three inches.

Many cowboys also owned fancy spurs, often custom-made and accented with gold and silver. Spur makers offered a wide array of embellishments and decorations. The "gal-leg" and "gooseneck" styles evoked images of a woman's leg or the curved neck of a goose. Some spurs were decorated with crude geometric engravings, while others carried complex designs and fine inlays.

Before 1890, spurs were hard to find on the range. They were often brought from Mexico to the Santa Fe area, where traders obtained them and then carried them farther north for sale or barter. As the 19th Century closed, however, spur catalogs offered a wide variety of styles for purchase by mail. Garcia and his protegé, Morales, were noted spur makers. Both these men crafted premium spurs in the California style. Other famous makers included Gutierrez, McChesney, Kelly, Crockett, Bianchi, Hulbert, and North & Judd's "Anchor" brand.

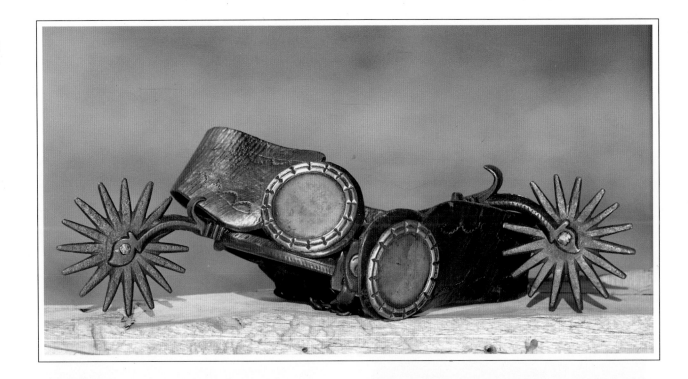

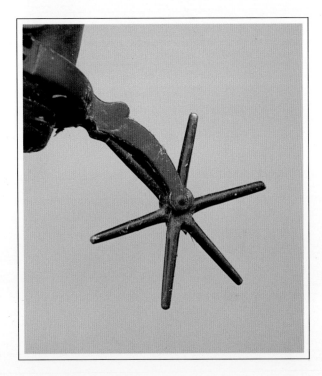

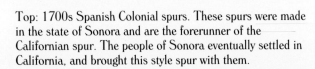

Top: 1700s Spanish Colonial spurs. These spurs were made in the state of Sonora and are the forerunner of the Californian spur. The people of Sonora eventually settled in California, and brought this style spur with them.

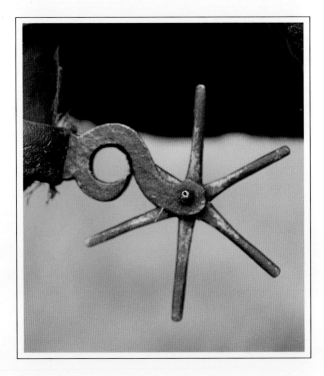

Bottom left and right: The large, pointed rowels on these spurs are indicative of the Mexican style. These spurs were made between 1870 and 1880 and are transitional-style spurs. The spurs on the left show the transition to California style, while the spurs on the right indicate a Texas transition.

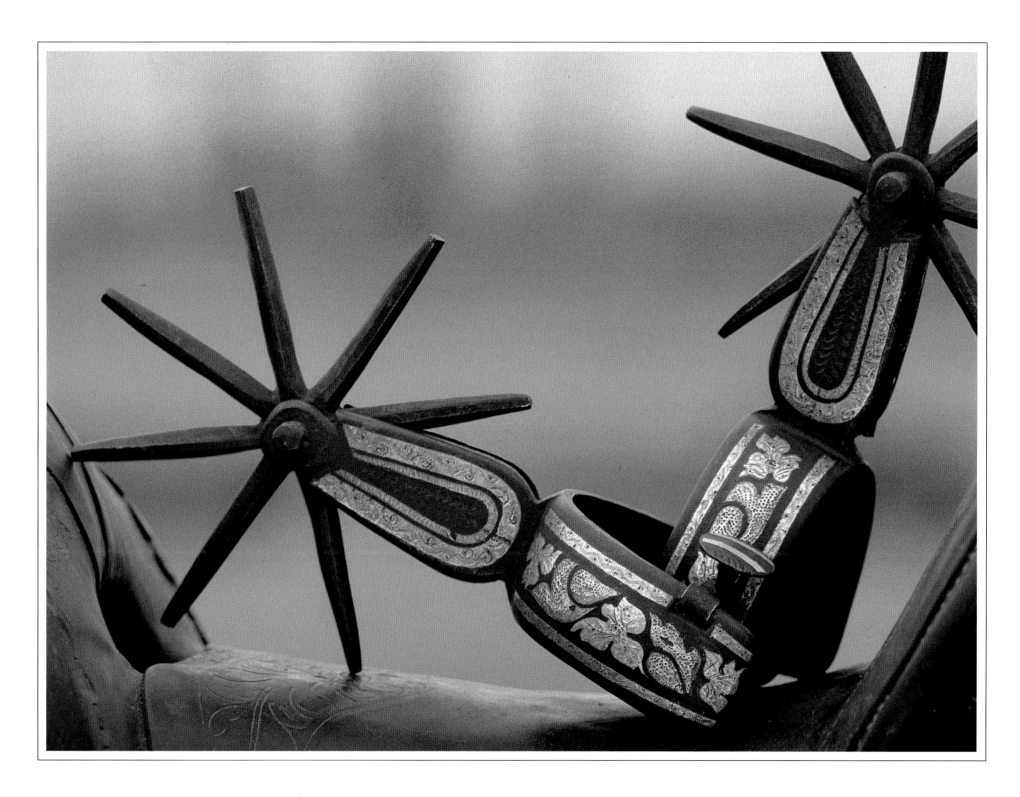

These massive Mexican spurs have seven-inch rowels and were actually
worn by vaqueros in Mexico and the Southwest in the early 1900s

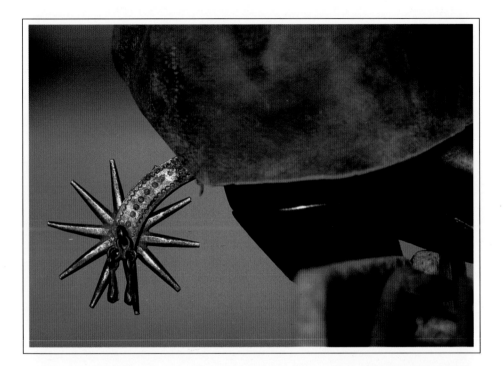

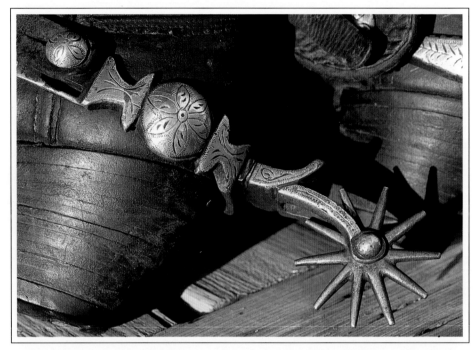

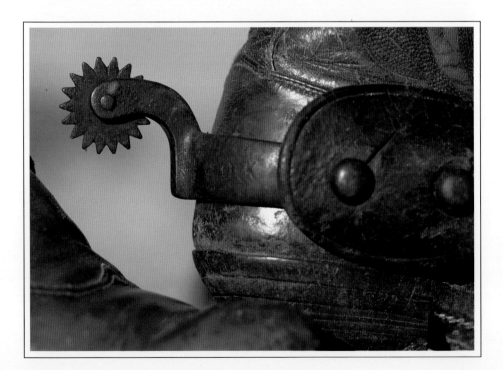

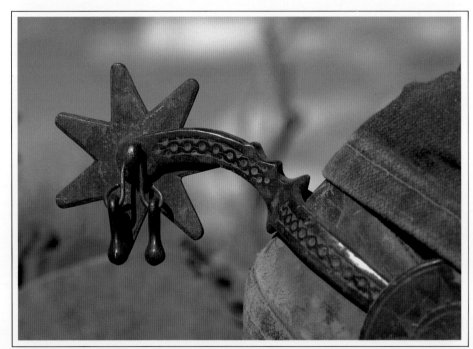

Top: Early transitional Southwestern-style iron spur, circa 1900

Bottom: O.K. spur by August Buermann, circa 1880—Inexpensive and very popular with the cowboys during the trail drive days.

Top: California transitional spur, circa 1890s

Bottom: Drop-shank, iron jinglebob spur with unusual seven-point rowel; circa 1890s

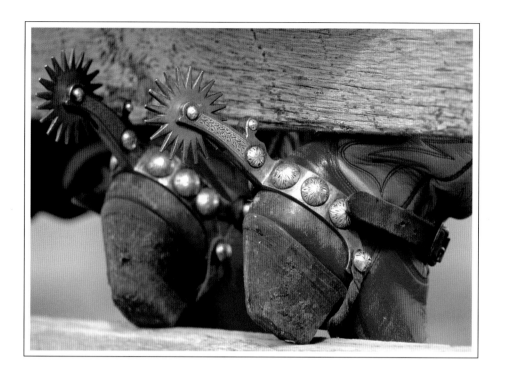

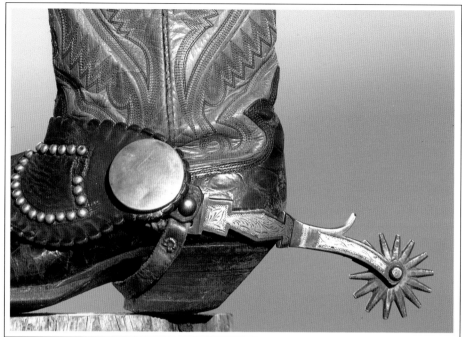

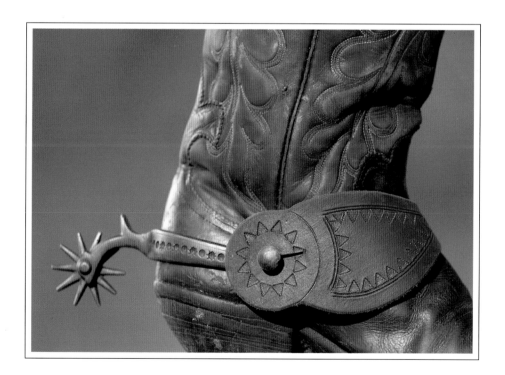

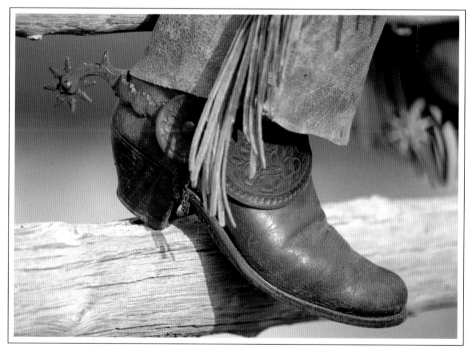

Top: Silver-inlaid Plains-style Gutierrez spurs, circa 1920

Bottom: Buermann Star-brand spur, circa 1890s

Top: Silver-inlaid Morales spur, circa 1920

Bottom: Old iron spurs with unusual Maltese cross and snowflake rowels, North & Judd; circa 1900

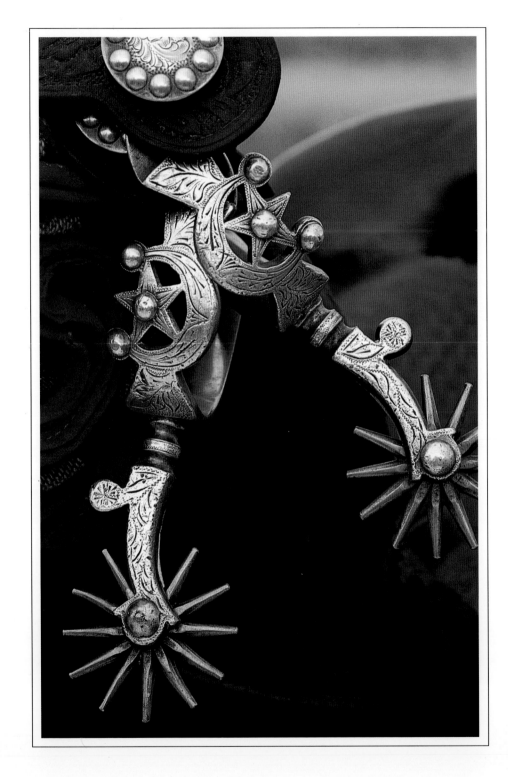

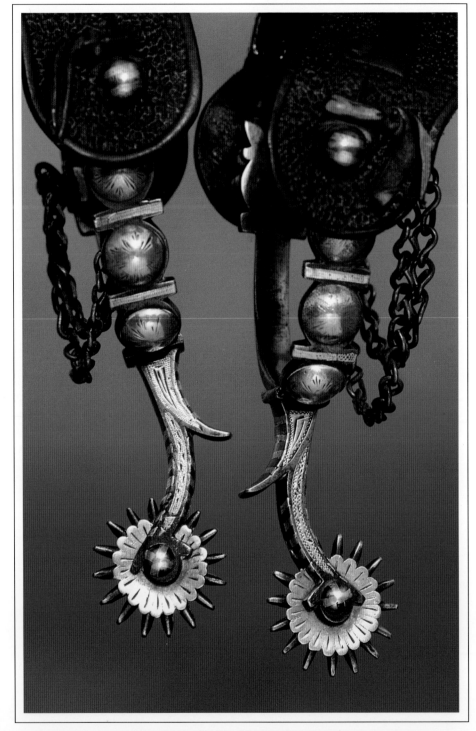

Very rare G.S. Garcia Elko Star spurs, circa 1905

Spurs by Mike Morales when he worked for the Hamley Co.
of Pendleton, Oregon; circa 1915

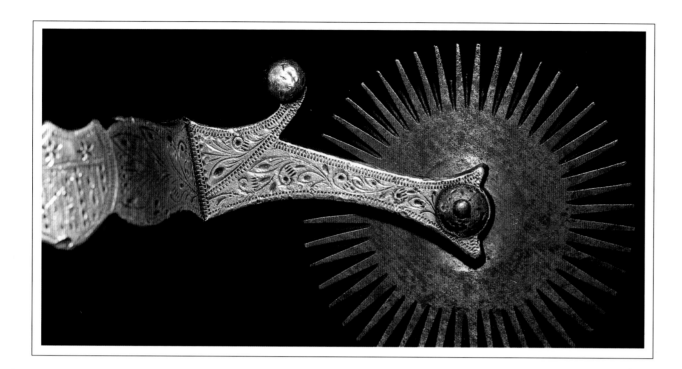

Qualey Bros. spur, Joseph, Idaho; circa 1925
This very unusual pair of spurs has 52 points on each rowel.

Qualey Bros. of Joseph, Idaho, were master spur makers. Using a hacksaw, hammer, and file, they made one-piece spurs out of Winchester gun barrels and the iron rims of old wooden wagon wheels. Many of their spurs were inlaid or overlaid in coin silver and had three-inch rowels with 52 points. Their workmanship and engraving was exquisite.

Tapia spur, California
These beautiful spurs have a very ornate brush guard on the rowel, which adds greatly to their value.

Fine early California makers included J. Figueroa and Jose Tapia of Los Angeles, and J.F. Echavarria of San Jose.

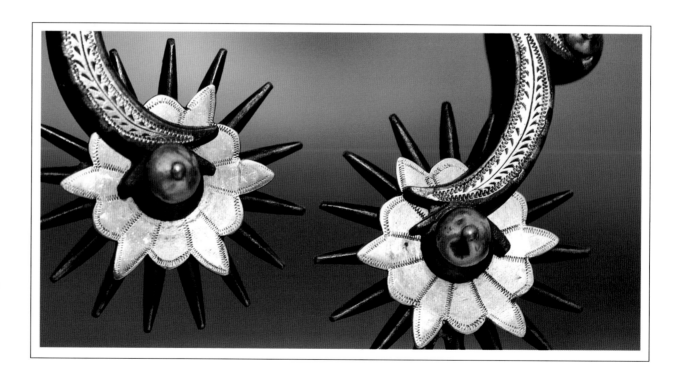

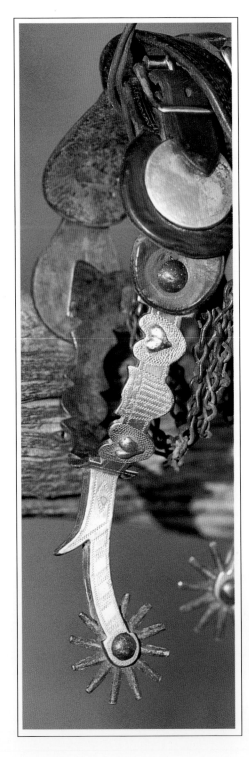

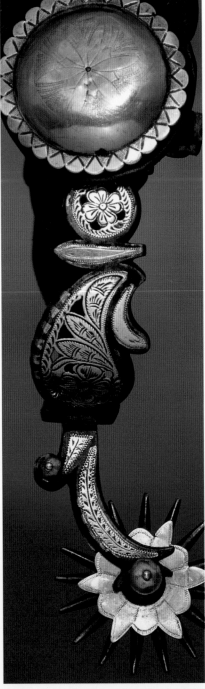

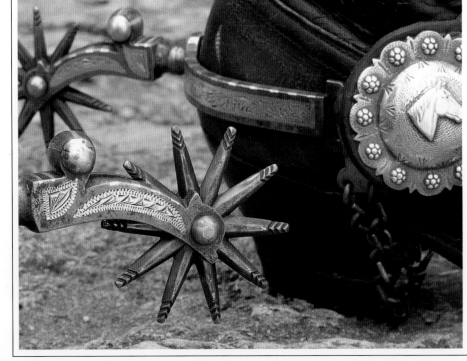

Prison-made nickel-silver overlaid spurs
These spurs have "1913"-etched shanks

Silver filagree Tapia spurs

Top: Morales silver-inlaid diamond pattern spur, circa 1915
These spurs have F.A. Meanea straps and large silver conchos.

Bottom: Visalia spurs with an unusual and beautiful chevron pattern on the rowels, circa 1920s

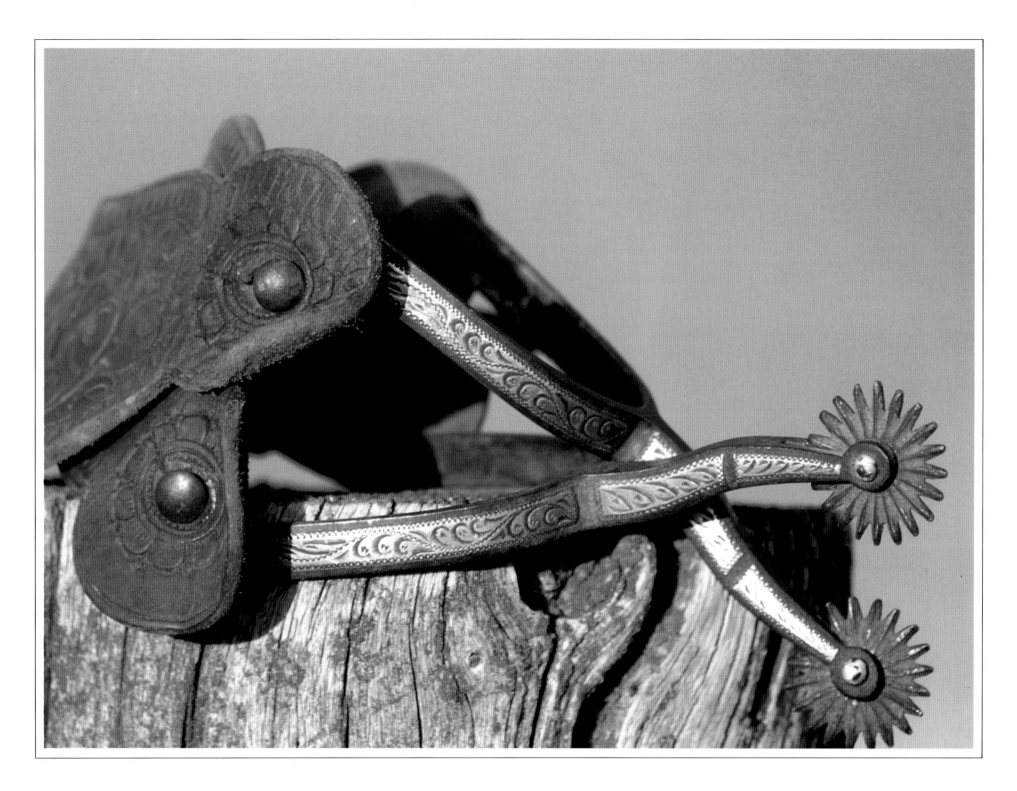

Buermann silver-inlaid spurs, circa 1890s

"Out upon the round-up / I'll ride the bucking horse,
and spur him in the shoulder / with my silver spurs, of course."

—Up the Trail

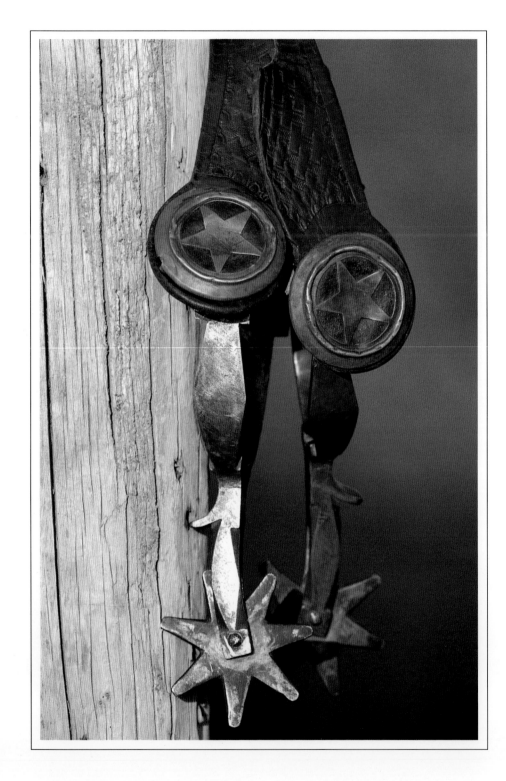

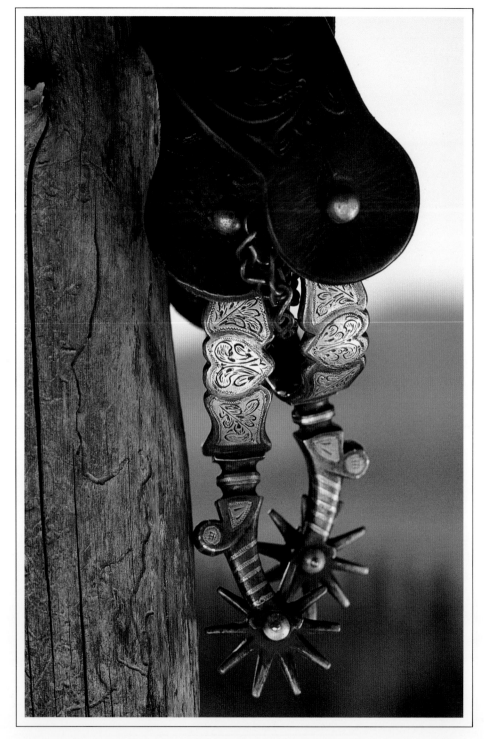

Probably Texan shop-made spurs, circa 1910

G.S. Garcia heart-pattern spurs, circa 1900

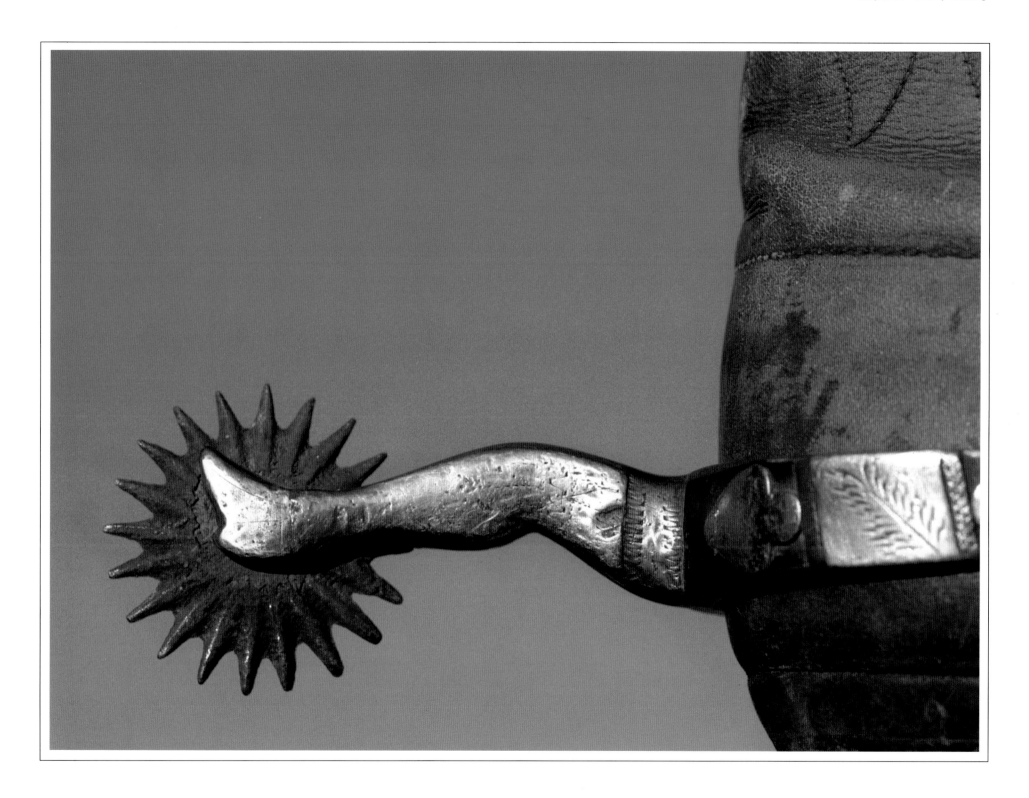

Texas-made McChesney gal-leg spur, circa 1910
(Matching bit, page 99)

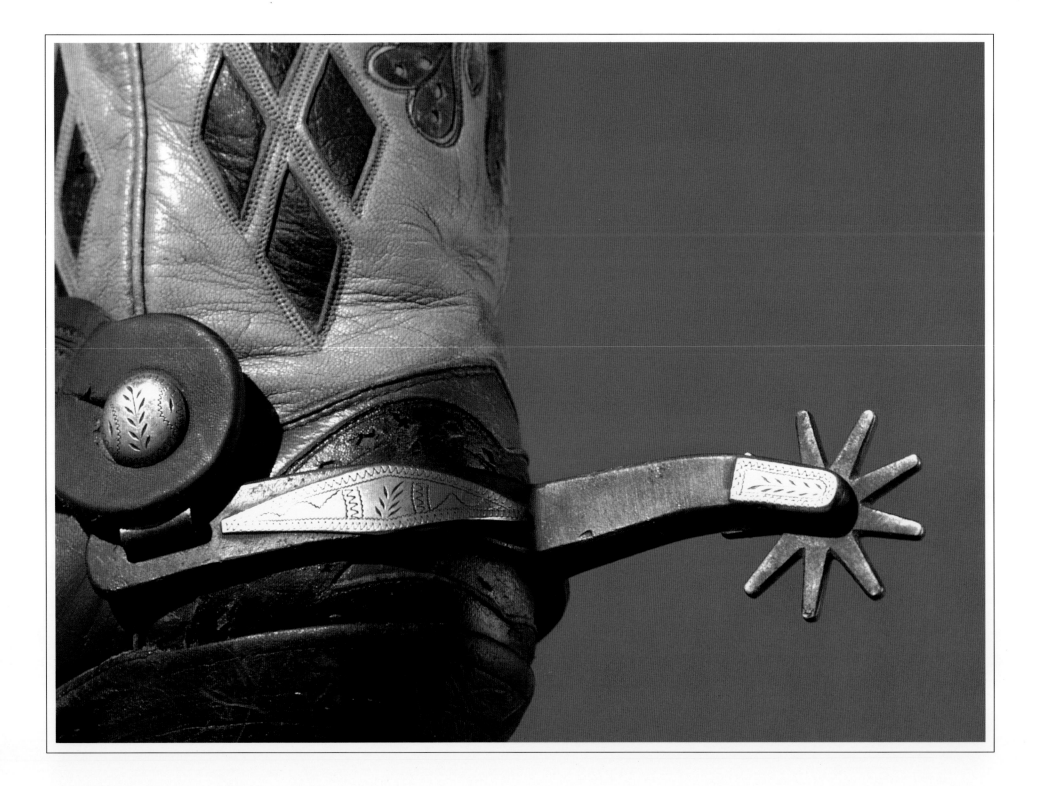

Texas-made Kelly Bros. spur, circa 1920s

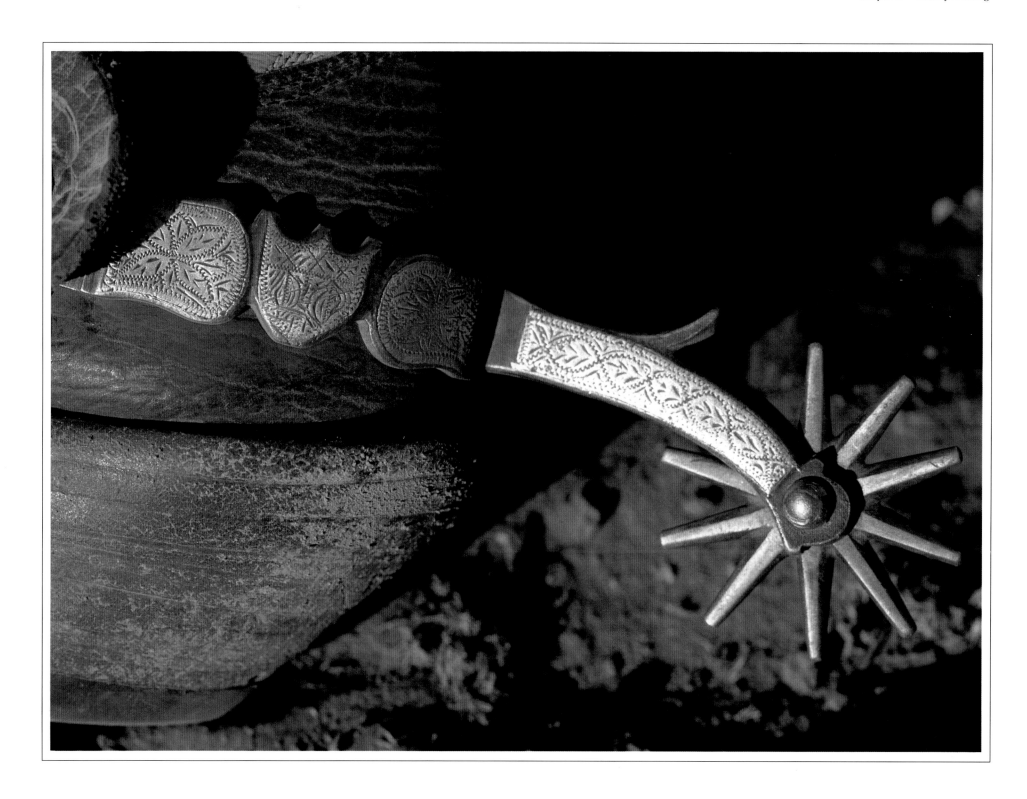

Unmarked spur probably made by August Buermann, circa 1905

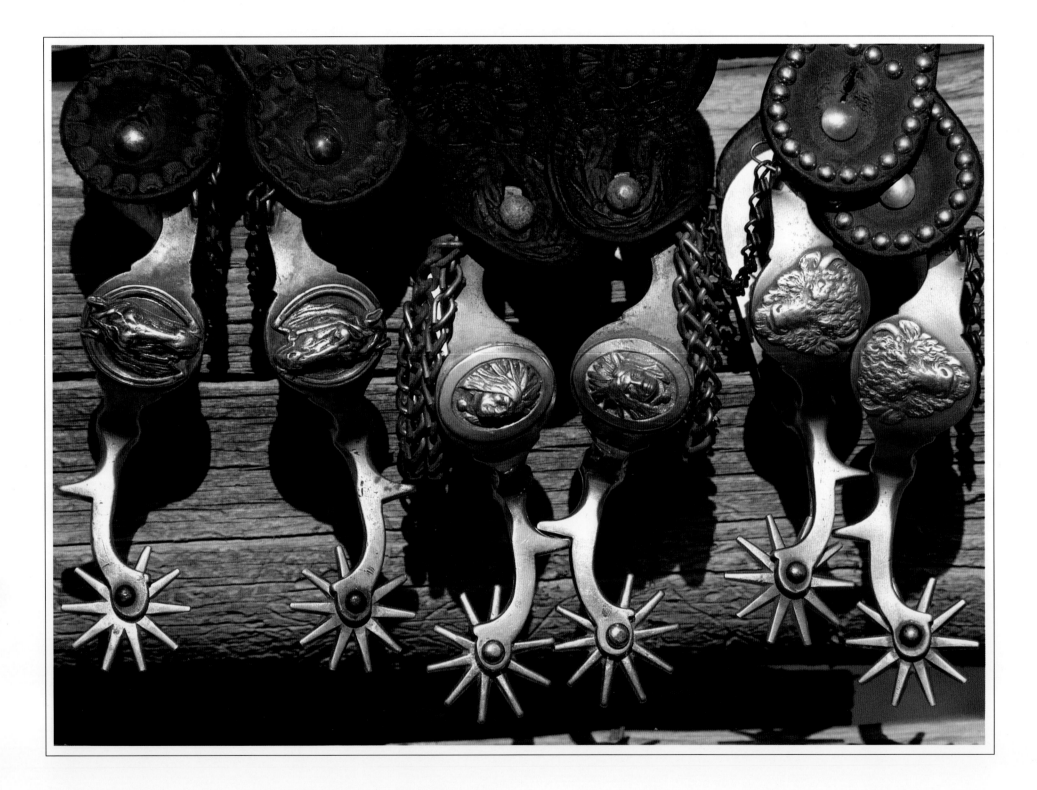

From left to right: Horsehead, Indian and buffalo spurs made by August Buermann; circa 1910
These spurs could be purchased with matching bits, as shown on page 100.

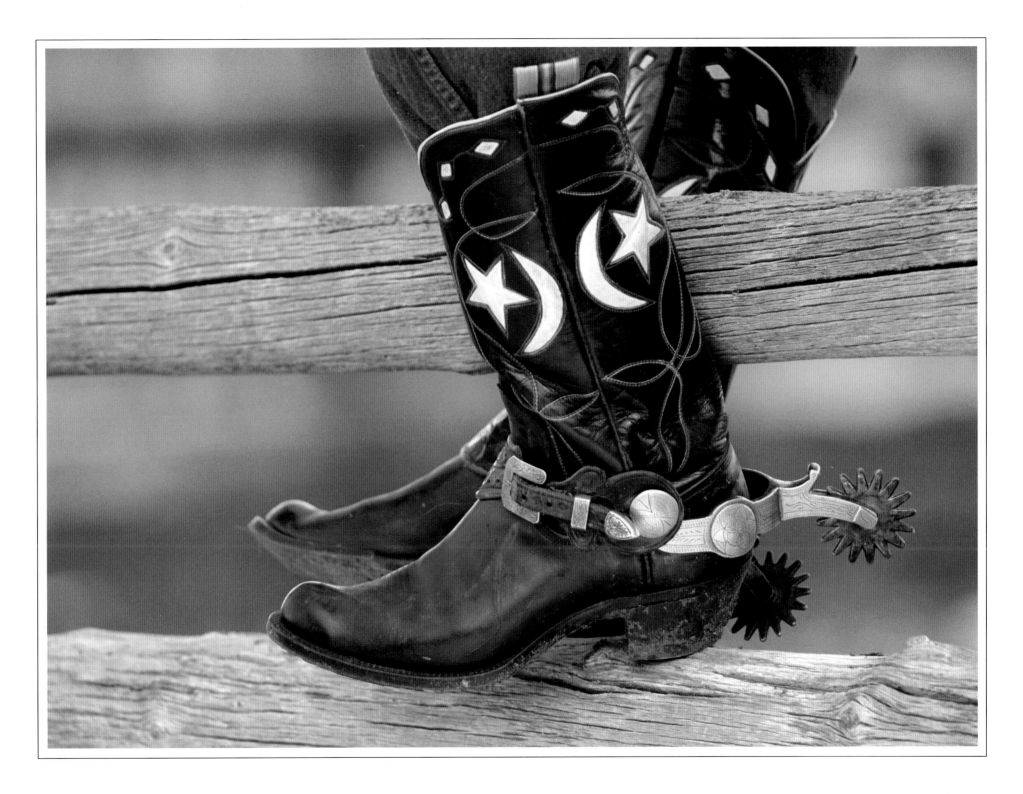

McChesney silver-overlaid spurs on C.H. Hyer & Sons
stars-and-moons boots, circa 1930

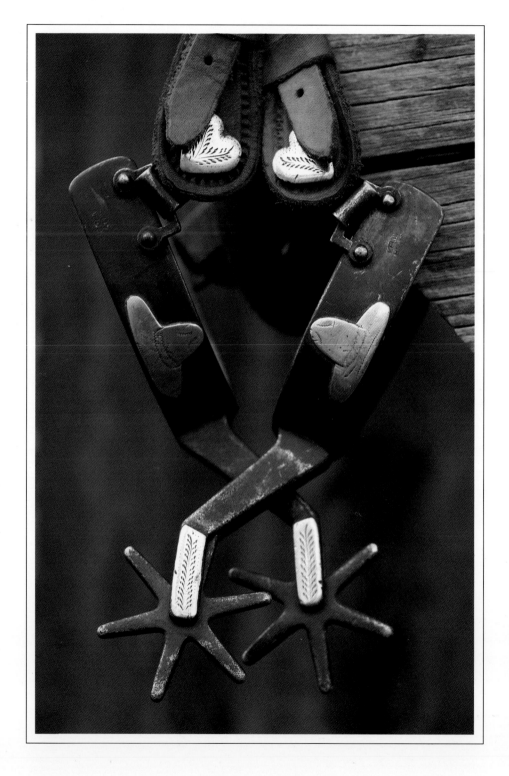

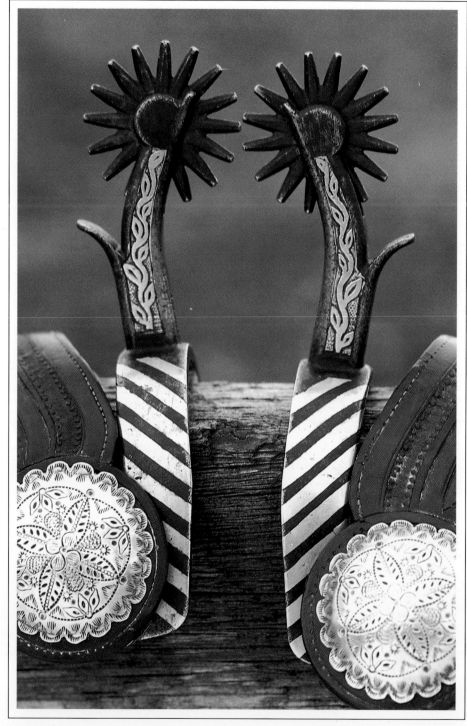

Kelly Bros. sombrero spurs, circa 1925-1930

Canyon City Prison silver-inlay spurs, circa 1920

Opposite page: Chap guard and rowel on Canyon City Prison spur, circa 1910. Canyon City Prison spurs were made by inmates in this Colorado prison. The spurs were sold at the prison store and also sold to the public. The spurs are usually double-mounted (silver on both sides) with nickel silver. The premier maker was John Cox, who marked the spurs with his prison number: 4307.

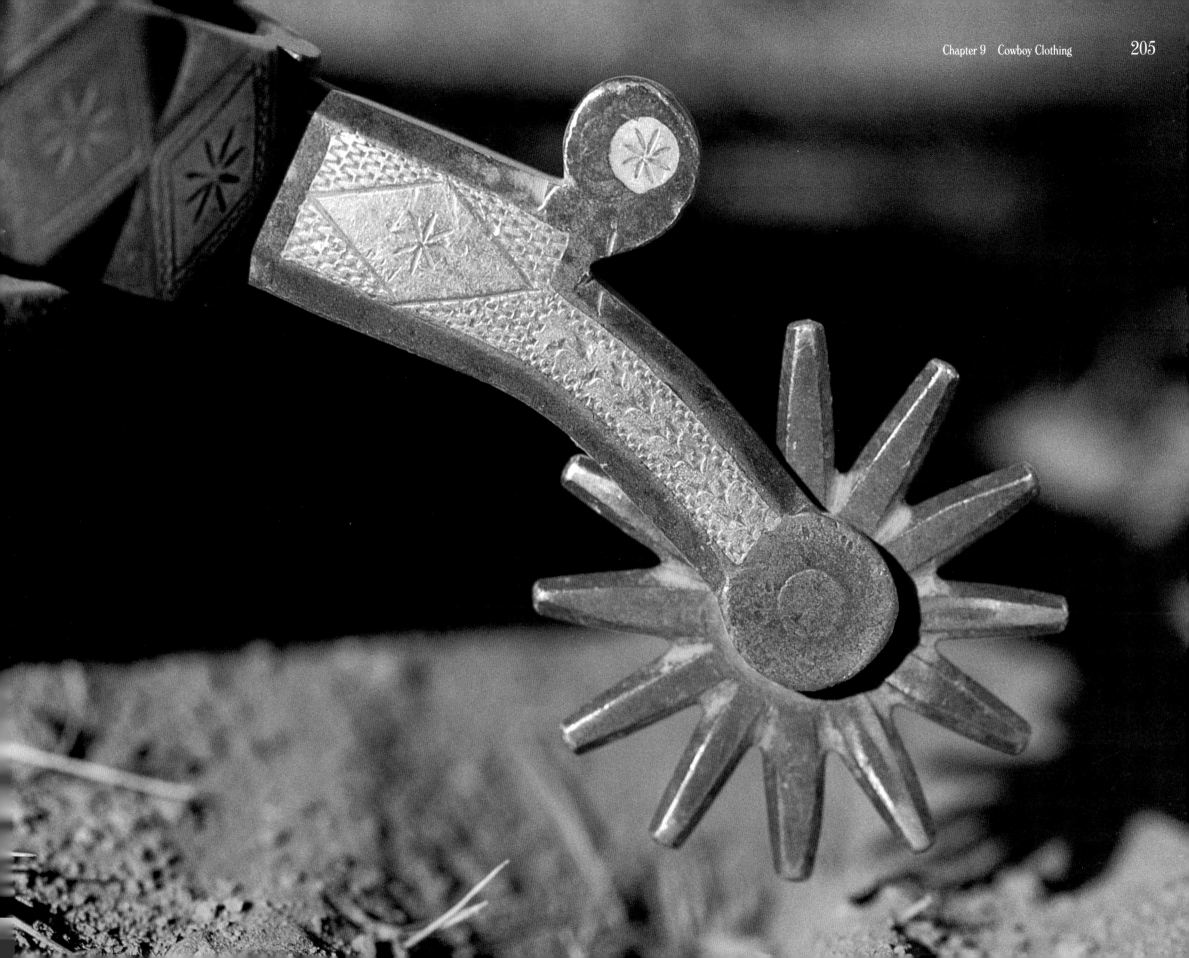

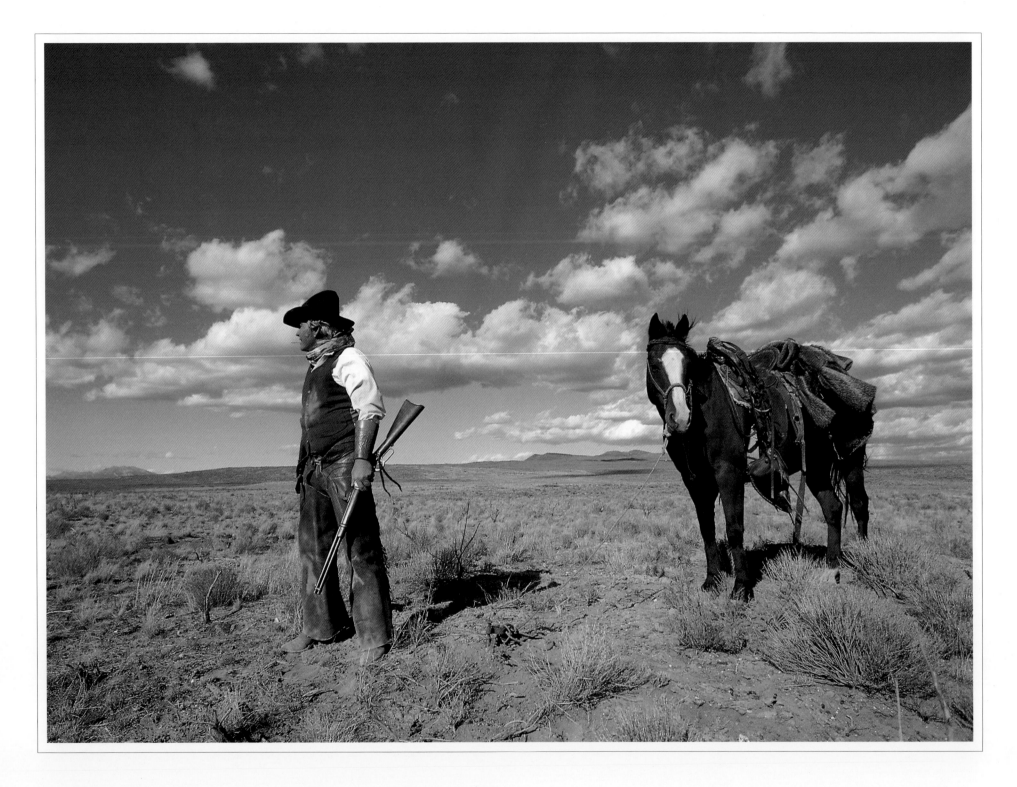

"A cowboy's life is a dreary, dreary life / Some say it's free from care—

Rounding up the cattle from morning 'til night / In the middle of the prairie so bare."

—The Kansas Line

Guns & Knives

Chapter 10

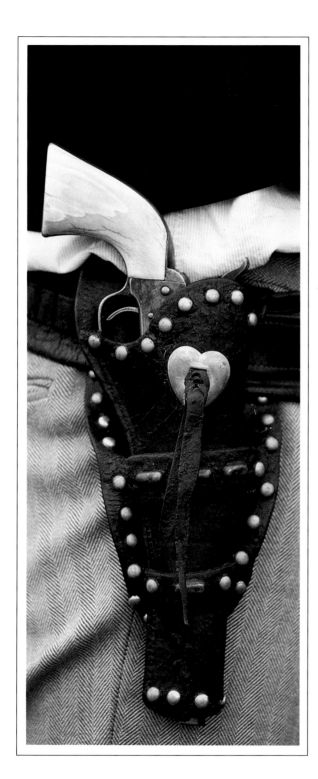

Colt .45 Peacemaker with ivory handles, circa 1881
The studded holster has no maker's mark.

"*Well, there's one thing to be said about packing a six-gun; it certainly showed up character in an individual, and made a young fellow feel plum full of importance and consequence. It showed one up as a reserved, not-to-be-trifled-with hombre, or a cocky, turbulent, dangerous pest. There was no half-way stuff with gun toters.*"

Trail Dust And Saddle Leather
Jo Mora; Charles Scribner & Sons, 1946

While gunplay was not as widespread on the range as movie lore and literature would suggest, firearms were a part of a cowboy's everyday life. Most cowboys carried a gun to use for defense against men and animals, to end the life of an injured horse, to turn a herd of stampeding cattle, or to signal other hands.

The choice of handgun was usually a Remington or Colt .44- or .45-caliber, six-shot, single-action model with an eight-inch barrel. Unloaded, the gun weighed more than two pounds. Cowboys usually packed five bullets in the cylinder, leaving the hammer over the empty chamber as a safety precaution.

Like the repeating rifle, the revolver changed the violent dynamic between the white man and the Indian. In the earliest days, the Indian had only to wait for the white man to reload his single-shot weapon in order to unleash a hail of arrows in relative safety. The revolver forever altered this tactical balance. Following an early Texas shootout, a surviving Comanche lamented, "I will never again fight Jack Hays, who has a shot for every finger on the hand."

When riding, cowboys usually carried their pistols in either a pommel holster or a saddlebag. When they wore them, they carried the weapons in open holsters attached to a loosely worn belt. The holster was often tied to the owner's thigh with a rawhide strap that reduced bouncing and facilitated rapid with-

withdrawal. Sometimes the holster's top was fastened with a strap in order to contain the pistol while the wearer was in the saddle. This strap was always undone when the cowboy found himself in a potentially dangerous situation.

The most popular type of holster appeared around 1870. Known as the Mexican Loop, this holster was made from a single piece of leather, with the pouch that held the revolver fitted through a series of slits cut in the leather. This formed the "loop" (or loops in the case of a long-barreled gun). Mexican Loop holsters also featured an "S"-curve top-pouch contour and were fastened with waxed linen thread or rivets.

Cartridge belts arrived with the advent of the cartridge revolver. One special type, known as the money belt, was made of leather doubled over itself and stitched together on top. On one end was a slit through which coins could be inserted. The belt's billet was then run through the slit, ensuring the coins would not fall out.

Cowboy etiquette required the removal of gunbelts while visiting another man's home. They were generally left hanging over a saddle horn. In later years, this unwritten rule became formalized, as firearms were banned in many cowtowns. Cowpokes were made to "skin themselves" upon entering the community, and re-arm as they made their exit.

Other customs included avoiding idly touching or feeling the pistol unless the cowboy was prepared to use it. Rollins recalled, "An absent-minded fingering of his weapon might occur at an inopportune moment, and thus give an armed enemy good reason for firing the first shot." Likewise, the hand was raised to the hat brim when greeting a stranger, removing it from the vicinity of the gun belt.

The most famous handgun of the time was Samuel Colt's Model 1873 Single Action Army .45-caliber revolver. Known as the "Peacemaker," by 1875 this model, which had several advantages over its predecessors, was widely identified with the cowboy. It accepted center-fire cartridges, was sturdily constructed and more powerful, and rarely misfired. In 1878, the Colt Company refitted the Peacemaker to accept the .44-.40 cartridge used in the popular 1873 Winchester repeating rifle. This allowed a cowpoke to carry both weapons and only one type of ammunition.

Ballistics aside, many revolvers, known as revolving pistols in Texas, were quite beautiful. Some bore ivory or mother-of-pearl grips, silver-inlaid details, and fancy engraving on the metal.

The most famous rifle in the West was Oliver Winchester's saddle-ring carbine, often called "the gun that won the West." This .44-caliber weapon was strong, durable, and powerful. It was the first good center-fire repeating rifle, and was overwhelmingly popular. More than 700,000 of them were made over a half-century span. Cowboys prized the Winchester for its flat shape and light weight. Farmers, outlaws, hunters, and Indians all liked it for the same reason.

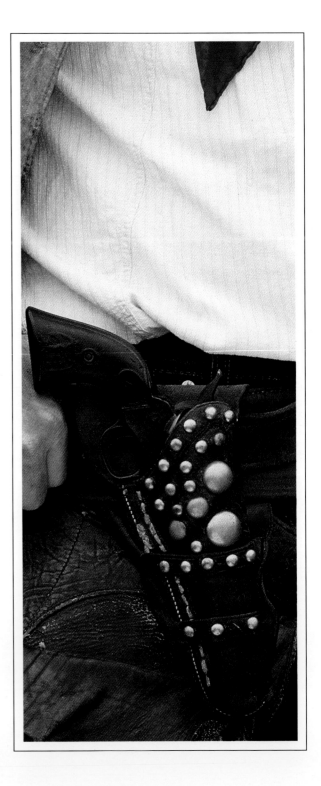

Studded holster, bunkhouse special

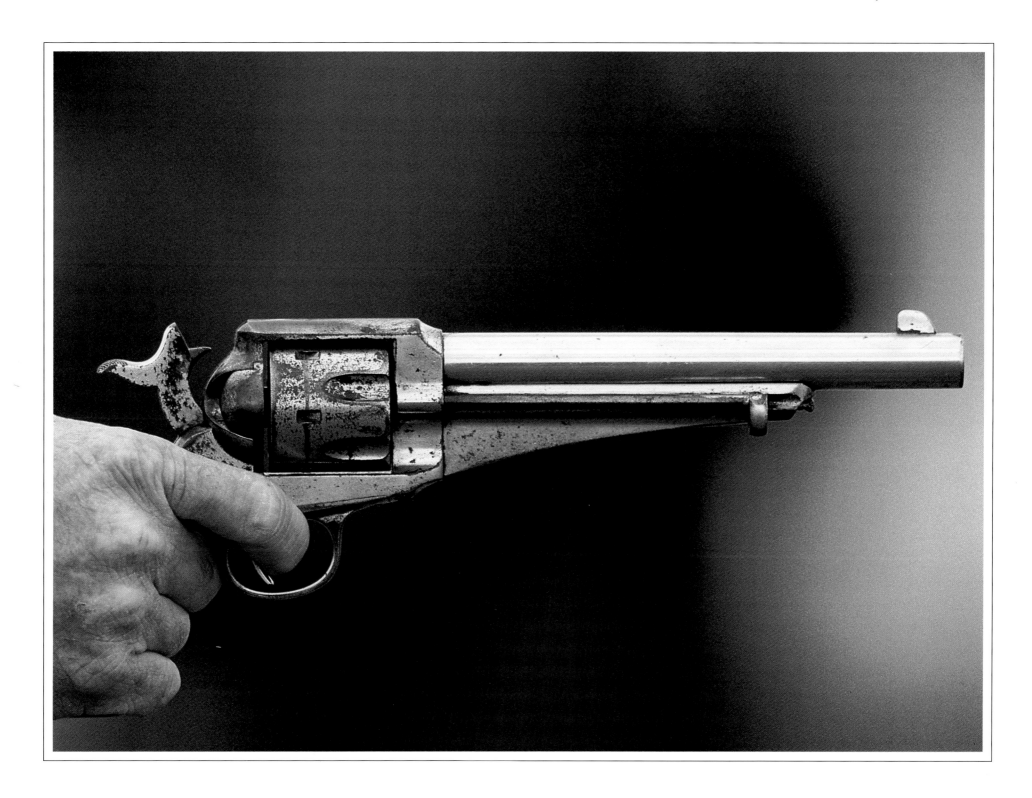

.44-.40-caliber Remington, early 1870s

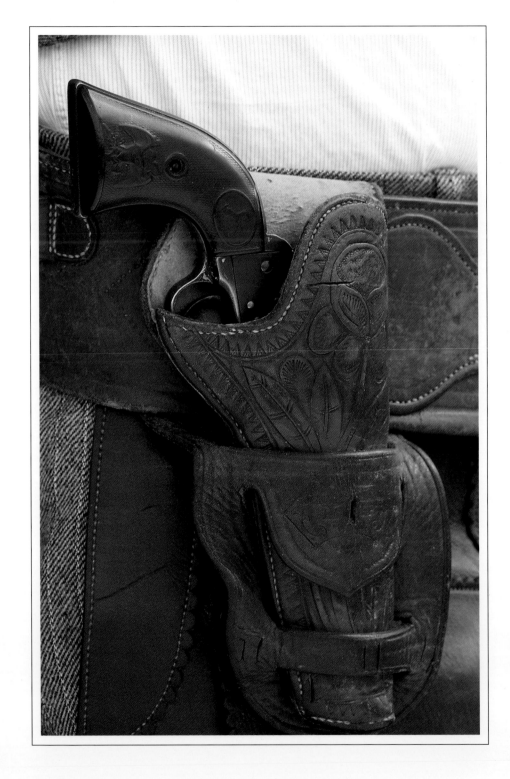

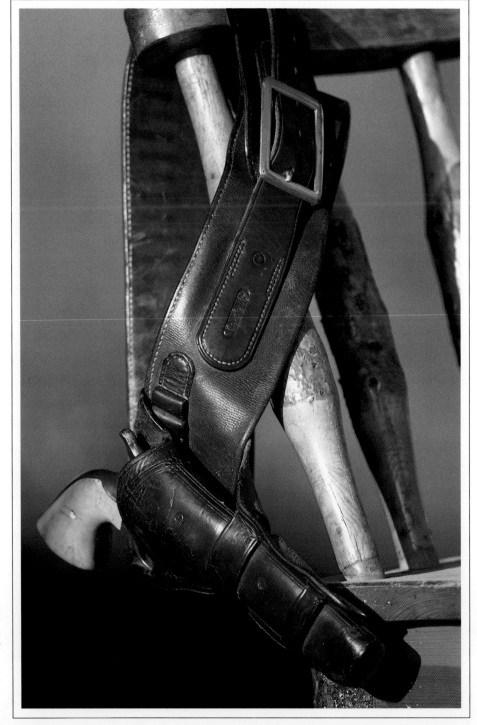

Colt .45-caliber pistol with rubber grips, in a tooled holster and
money belt by J.N. Farlow, Lander, Wyoming

F.A. Meanea holster and money belt with Colt single action .45-caliber pistol with ivory grips;
early 1900s

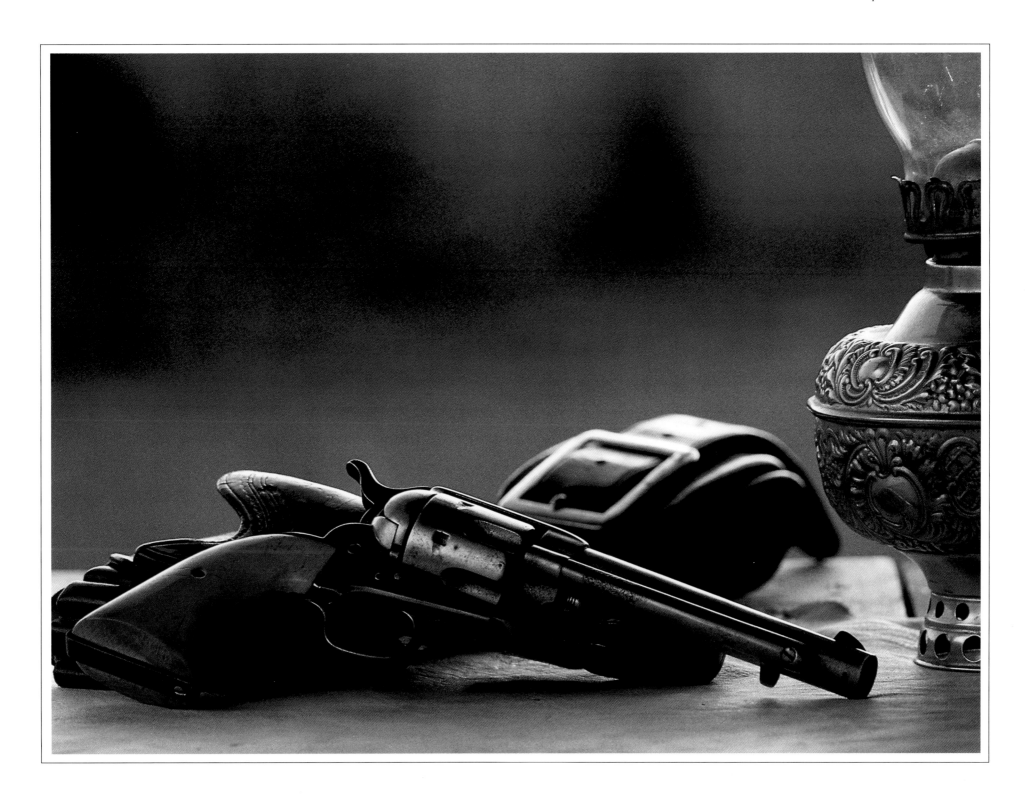

1880s Colt single-action .44-.40-caliber pistol

Winchester rifle, Model 1873 .44-caliber carbine

Winchester rifle, Model 1873 .38-caliber saddle carbine

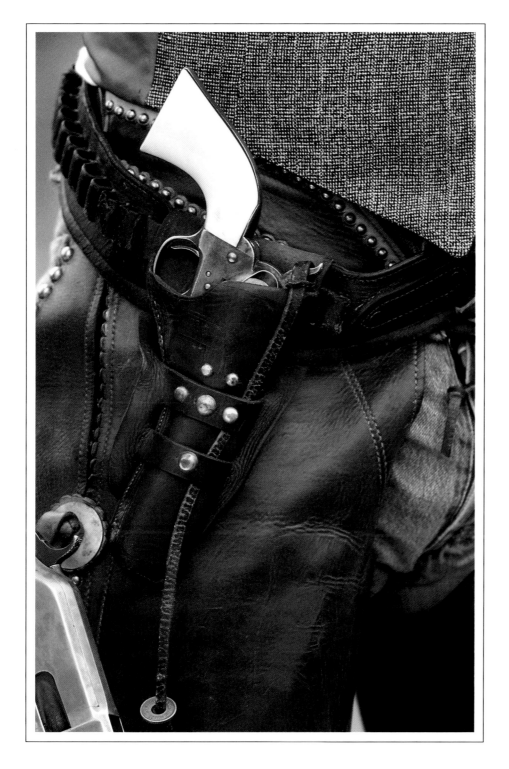

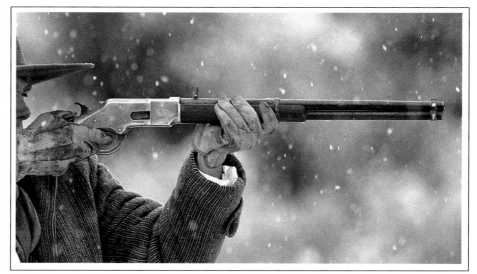

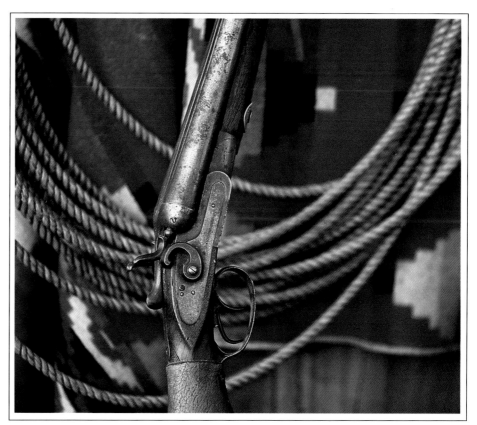

Colt .45-caliber pistol, holster marked Moran Bros.

Top: 1866 Winchester "Yellow Boy" saddle carbine

Bottom: Hammer-action shotgun detail

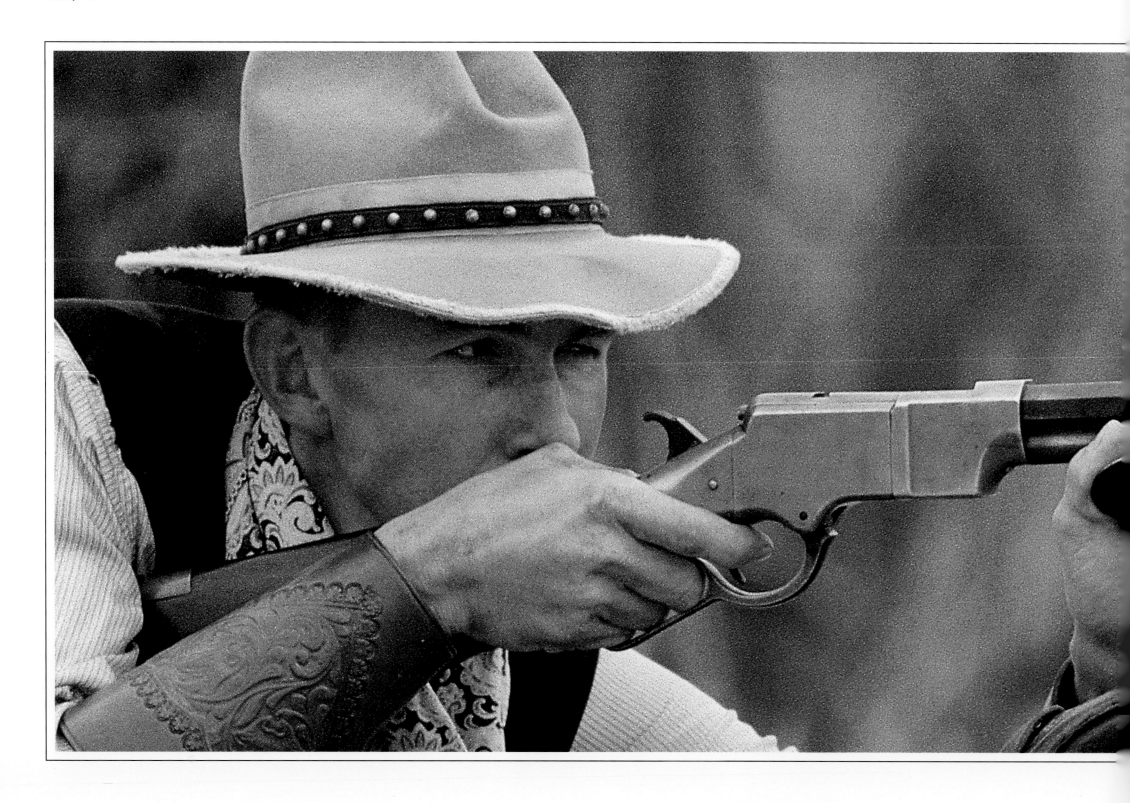

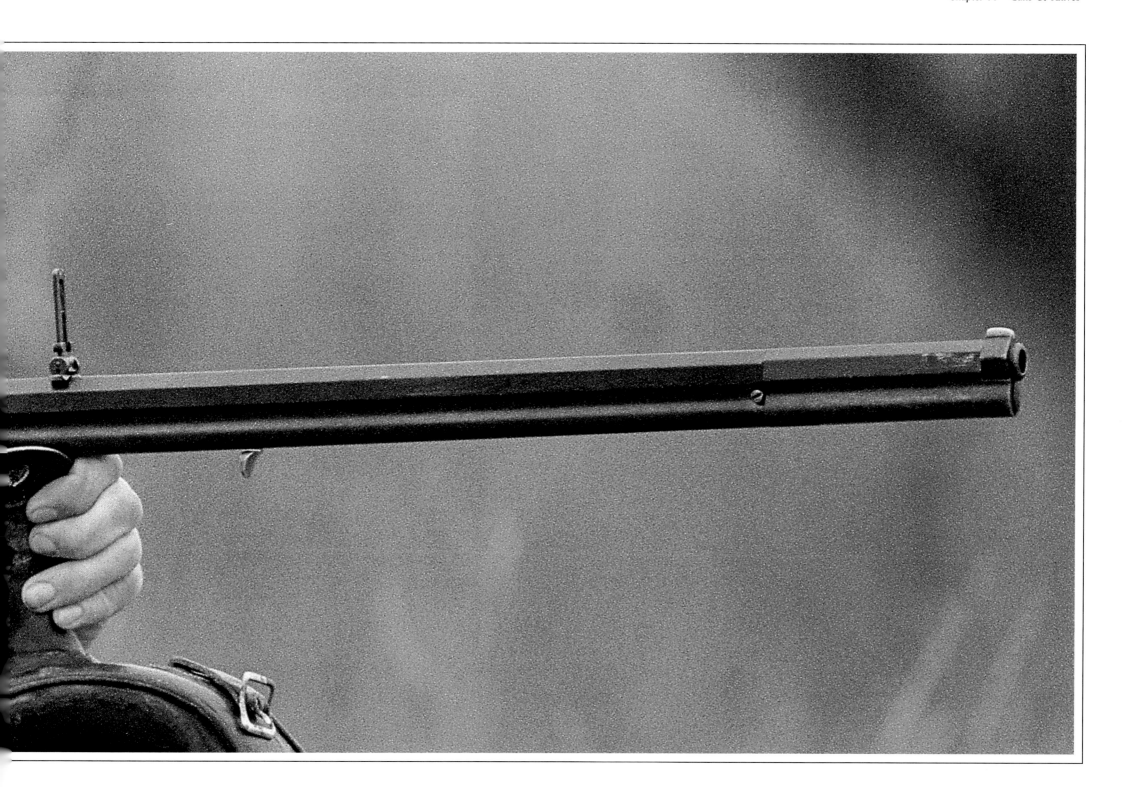

.44-caliber Henry with a 15-shot magazine
The Henry rifle came to fame during the Civil War and continued in heavy use into the era of the Old West, circa 1870

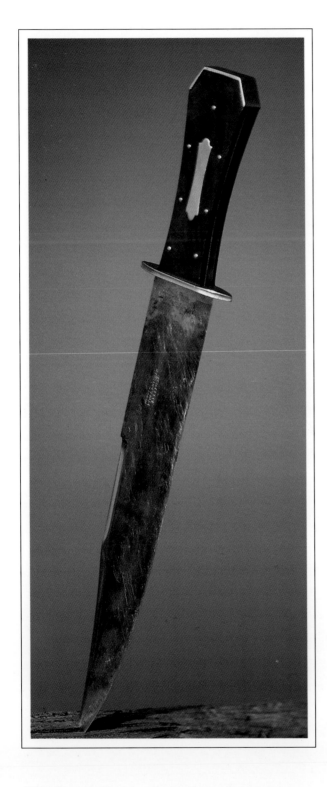

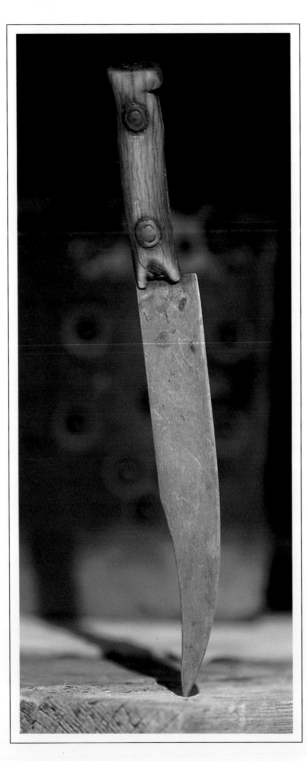

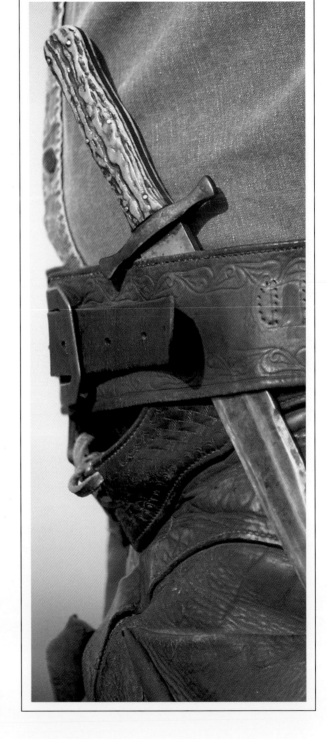

1830s Bowie knife with coffin handle, a collector's prize

Ranch-made bone-handled knife, circa 1886

Bone-handled knife
High-quality knives like this one were made in great
numbers in England, for use on the frontiers throughout
the 19th Century.

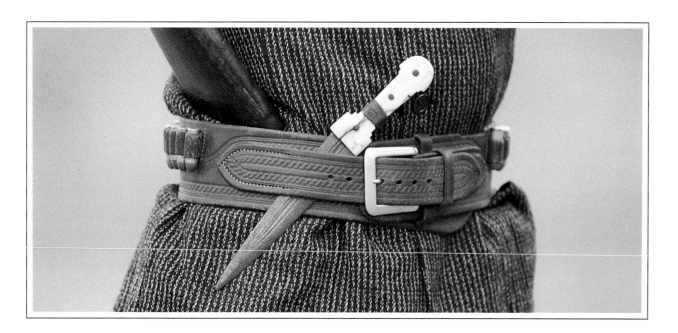

Knives

Most cowboys carried some type of knife, generally a jackknife or clasp knife. In the early days, many carried long knives, but this ended with the wane of Indian fighting.

The Bowie knife was the blade most identified with the American Cowboy. Named for gentlemanly killer and Alamo hero Jim Bowie, this knife was first fashioned by Bowie's brother, Rezin, in the early 1800s. Decades later, the "Arkansas toothpick" found wide acceptance on the Western range.

Many heavy knives were called Bowies, but the real thing had a 10- to 15-inch-long blade that broadened to nearly two inches along the spine before tapering to its double-edged tip. The knife's shape shifted its weight toward the point, allowing a cowboy to use the knife as an axe. Many Bowie knives were imported from England, but among the most widely favored was one made by J. Russell & Co., of Massachusetts.

The much-imitated Bowie knife was a clear favorite among mountain men, trappers, and Texas Rangers, as well as cowboys. At short distances, the knife was deadlier than a gun in competent hands. It could be thrown up to 30 feet with fatal accuracy, often more quickly than a six-gun could be drawn and fired.

Rollins quoted an old-timer: "The knife is a plumb ungentlemanly weapon, and it shore leaves a mussy-looking corpse."

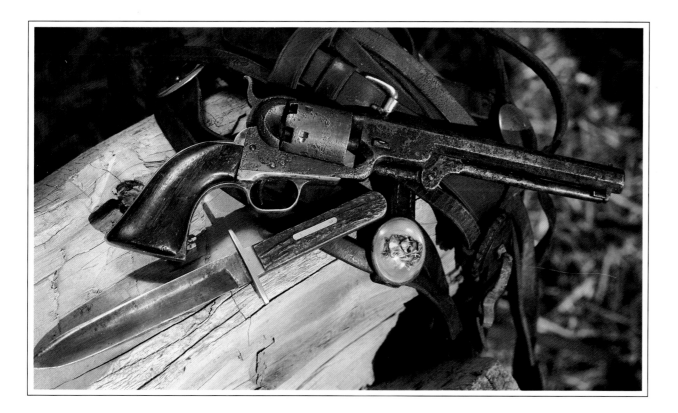

Top: Early ivory-handled knife
Bottom: 1851 Navy Colt with Harrison Bros. knife

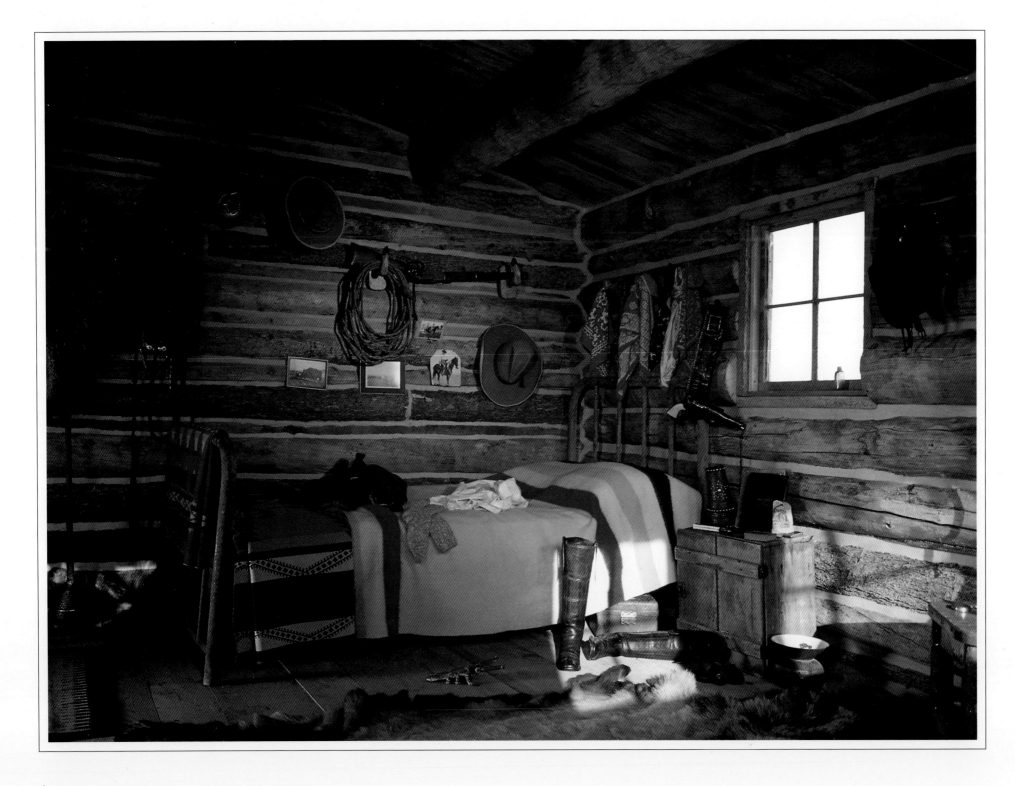

Back at the ranch, the bunkhouse was the place to rest
up, store your gear, and spin a yarn or two.

After the long dusty trail, a cowboy bathtub usually
had as much dirt as water.

End of the Trail

Chapter 11

The cowboy rode his horse onto the scene as the era of the pioneers was ending. Wearing the clothes he needed to endure the hostile environment of the range and packing gear created and perfected by the men who worked the wild, long-horned cattle of South Texas, he unknowingly became one of the most enduring symbols of our country.

But by 1925, the time of the trail-driving cowboy was long past. The great open ranges of the West had been bound in by barbwire. The huge herds of longhorns had been replaced by improved breeds of cattle that grazed on ranches covering tens of thousands of acres. While the cowboy was still a necessary component of these ranches, he never again took part in a legendary cattle drive.

The images you have seen on the pages of this book not only show the implements that were a daily part of life in the West, but also reflect the courage and fortitude of the early cowboys. From the tips of their pointed boots to the tops of their Stetsons, these men personified self-sufficiency and a way of life that will most likely never be seen again. But that way of life, the life of the cowboy, will forever be an integral part of the spirit of the American West.

Cowboy Talk

Afoot

Said of a man without a horse in the cattle country. A man afoot on the range is looked upon with suspicion by most ranchers and is not welcome when he stops for food or shelter, unless he can prove that he belongs to the country and that his being afoot is the result of some misfortune. It has always been the custom of the range country to regard a man as "a man and a horse"—never one without the other. Even cattle have no fear of a man on foot, and he is in danger of being attacked by them. One of the old sayings of the West is, "A man afoot is no man at all." He cannot do a man's work without a horse and is useless in cow work. Teddy Blue Abbott used to say, "There's only two things the old-time puncher was afraid of, a decent woman and bein' left afoot."

Ambush

To attack someone, especially from hidden position.

Amigo

Friend, good fellow, or companion; commonly used in the Southwest; from the Spanish.

Angoras

A frequently used slang name for chaps made of goat hide with the hair left on.

Appaloosa

A breed of horse whose distinguishing characteristics are the color spots on the rump, a lack of hair on the tail and inside the thigh, a good deal of white in the eye and pink on the nose. This particular breed was developed by the Nez Perce Indians in the Palouse, or Pelouse, River country. There are several explanations of the origin of the word appaloosa. Some writers contend that the word comes from the Spanish noun pelusa (an unlikely origin since this feminine noun means down that covers plants or fruits, and is certainly not applicable); others claim that the spelling is Appaluchi and, with vivid imagination, connect it with the Appalachian Mountains.

Apple-horn

The name given a style of saddle used in the eighties, named for the small horn whose top was round like an apple, compared to the broad, flat horns of the saddles it replaced.

Arbuckle

In ranching, a green hand. So called on the assumption that the boss sent off Arbuckle coffee premium stamps to pay for the hand's "extraordinary" services.

Arkansas toothpick

A large sheath knife; a dagger.

Armitas (arm-mee'tas)

From the Spanish armar, meaning to arm or to plate with anything that may add strength. Well-cut aprons, usually made of home-tanned or Indian buckskin and tied around the waist and knees with thongs. They protect the legs and clothes and are cooler to wear in summer than chaps. Their use mostly passed with old-time customs, although they are still used to some extent, especially in Southern California.

Association saddle

The saddle adopted by rodeo associations in 1920. Its use is now compulsory at all large contests. Built on a modified Ellenburg tree, medium in height, with a 14-inch swell and a 5-inch cantle, it has nothing about it to which the rider can anchor himself. As the cowboy says, "It gives the hoss all the best of it." The original Association saddle was made with small, round skirts, three-quarter-rigged, with a flank rig set farther back than on a regular-rigged saddle. It was full-basket-stamped and had stirrup leathers made to buckle for quick and easy adjustment. Also called Committee saddle and contest saddle.

Band

A group of horses. The word is used in referring to horses only; cattle or livestock are spoken of as a herd or bunch of cattle, or as a bunch of livestock.

Barbed brand

One made with a short projection from some part of it.

Bat-wings

Chaps made of heavy bull-hide with wide, flapping wings. They have become the most popular chaps on the range because they snap on. Every cowboy lives with a pair of spurs on his heels, and when wearing bat-wings, he does not have to pull his spurs off to shed his chaps, as he does with the "shotgun" style. These chaps are commonly decorated with nickel or silver conchas.

Bear trap

A cowboy's term for a certain style of saddle. A severe bit.

Bed ground

The place where cattle are held at night; also called herd ground. It is the duty of the day herders to have the cattle on the bed ground and bedded down before dusk. The bed ground is chosen in an open space when possible, away from ravines or timber, in order to avoid anything that might frighten the cattle.

Bedroll

The cowboy's bedding and other equipment, rolled up for carrying. It consists of a tarpaulin 7 by 18 feet, made of No. 8 white duck, weighing 18 ounces a square yard, and thoroughly waterproofed. Next to his horse and saddle, his bedroll is the cowboy's most valued possession. It serves as his safe-deposit box, and it is not healthy to be caught prowling through another man's bedroll.

Bedwagon

A wagon used to carry bedding, branding irons, war bags, hobbles, and corral ropes. It generally contained all that the cowboy truly valued, and was also used as a hospital to carry the injured or sick until they could be taken to town or to headquarters. Only the larger outfits provided a bed wagon, the smaller ones piling their beds into the chuck wagon.

Bell mare

A mare with a bell around her neck, used in some sections of the cattle country to keep the saddle horses together. Some cowmen contend that the bells warn them if the horses become frightened in the night and leave in a hurry. But most cowmen object to a bell in the remuda because it sounds too many false alarms and awakens a sleeping outfit needlessly.

Belly gun

A gun carried in the waistband of the pants instead of in a holster. The gun is naked and is drawn with a single motion similar to the regulation cross draw.

Biddy bridle

An old-fashioned bridle with blinders.

Big house

The cowboy's name for the home of the ranch owner.

Bit

A metal bar that fits into the horse's mouth. There are many kinds of bits, some of them extremely cruel when misused. Yet it is rare that a cowboy uses a bit for cruelty. His idea of a bit is that it is merely to hang in the horse's mouth. When turning to the right, for example, he does not pull the right rein; he merely moves his bridle hand a couple of inches to the right, bringing the left rein against the horse's neck. It is merely a signal. The well-trained horse turns himself; he does not have to be pulled around. Many cowboys do not use bits, but ride with a hackamore instead.

Blacksmithing

What the cowboy calls pimping or procuring for a woman of easy virtue; a polite way of giving information about such activity, as "Bill is blacksmithin' for Bertha."

Boot

The cowman's footwear; also a horseshoe with both heel and toe calked. The cowboy's boots are generally the most expensive part of his rigging, and he wants them high-heeled, thin-soled, and made of good leather. The tops are made of lightweight, high-grade leather, and all the stitching on them is not merely for decoration. It serves the purpose of stiffening them and keeping them from wrinkling too much at the ankles where they touch the stirrups. (John M. Hendrix, "Boots," *Cattleman*, XXXIII, No. 11 [April, 1937],5.)

The boots are handmade and made to order. The cowman has no use for hand-me-down, shop-made footgear, and no respect for a cowhand who will wear it, holding the opinion that ordinary shoes are made for furrow-flattened feet and not intended for stirrup work.

The high heels keep his foot from slipping through the stirrup and hanging; they let him dig in when he is roping on foot, and they give him sure footing in all other work on the ground. Then, too, the high heel is a tradition, a mark of distinction, the sign that the one wearing it is a riding man, and a riding man has always held himself above the man on foot.

A cowhand wants the toes of his boots more or less pointed to make it easier to pick up a stirrup on a wheeling horse. He wants a thin sole so that he has the feel of the stirrup. He wants the vamp soft and light and the tops wide and loose to allow air to circulate and prevent sweating.

When a man is seen wearing old boots "so frazzled he can't strike a match on 'em without burning his feet," he is considered worthless and without pride.

Boot Hill

A name given to the frontier cemetery because most of its early occupants died with their boots on. The name has had an appeal as part of the romantic side of the West and has become familiar as representing the violent end of a reckless life. But to the Westerner, Boot Hill was just a graveyard where there "wasn't nobody there to let 'em down easy with their hats off." Like the old sayings, "There ain't many tears shed at a Boot Hill buryin'," and it is "full of fellers that pulled their triggers before aimin'."

Bosal

From the Spanish "bozal" (bo-thahl'), meaning a muzzle. A leather, rawhide, or metal ring around the horse's head immediately above the mouth, used in place of a bit.

Brand

The mark of identity burned upon the hide of an animal (as noun); the act of burning this emblem (as verb). Also slangily used to mean the deed to a saddle horse. The origin of the brand dates back to antiquity, and there has never been anything to take its place as a permanent mark of ownership. As the cowman says, "A brand is somethin' that won't come off in the wash."

Brand artist

A rustler, one expert at changing brands.

Brand book

An official record of brands of a cattle association.

Brand you could read in the moonlight

Said of a large brand, or one covering a large area of hide.

Bridle

The headgear of the horse, composed of a crown-piece, brow-band, throat-latch, and, on each side, a check-piece. Most cowboys prefer a plain headstall, because there are no buckles or conchas down the checks to interfere with roping. When the cowboy ropes anything and holds it, he keeps his horse facing it so that the rope naturally runs out beside the head.

Bridle chain

A short piece of chain fastened to the bit ring on one end, and to the reins on the other end. Some riders like chains because the reins do not get wet when the horse drinks, and they also keep a tied horse from chewing the reins.

Bridle head

The headgear of the bridle.

Bridle ring

A metal ring at each end of the bit, to which the reins are fastened.

Bronc belt

A broad leather belt sometimes worn by a bronc fighter (q.v.) to support his back and stomach muscles.

Bronco

A wild or semi-wild horse, often shortened to bronc; from the Spanish. A horse usually retains this appellation until he has been sufficiently gentled to be considered reliable.

Bronc saddle

A specially built saddle used in breaking horses or riding bad horses, made with a wide, undercut fork, built-in swells and a deep-dished cantle. Also called bronc tree.

Brush popper

The most popular name for the brush hand. The brush popper knows he will never catch a cow by looking for a soft entrance into the brush; therefore, he hits the thicket center, hits it flat, hits it on the run, and tears a hole in it.

Buckaroo

A cowboy; a name used in the Northwest. The terms baquero, buckhara, and buckayro, corruptions of the Spanish vaquero or boyero (both meaning cowherd), are also used. (Phillip A. Rollins, *The Cowboy* [New York, Charles Scribner's Sons, 1936], 39.).

Buckboard

A light, four-wheeled vehicle in which elastic boards or slats, extending from axle to axle and upon which the seat rests, take the place of the ordinary springs. Instead of sides on the body, it has an iron rail, three or four inches in height, that holds in luggage or other packages carried on its floor.

Bucking rein

Usually a single rope attached to the hackamore of a

bucking horse. By gripping this, the rider has an aid in keeping his balance; but in contests he is not permitted to change hands.

Bucking roll

A roll of blankets tied across the saddle, just behind the fork, to help wedge the rider in the saddle and make it more difficult for the horse to throw him. Sometimes a leather pad, stuffed with hair, 3 or 4 inches high, and tied down on each side of the fork just behind the horn.

Bull whip

A long woven whip attached to a handle of hickory or white ash 3 feet long upon which the bullwhacker could firmly plant both hands. At the butt, each lash, which was attached to the stick by a soft strip of buckskin, formed a loop and was frequently more than 1 inch thick. The lashes were from 18 inches to more than 10 feet long and graduated in thickness to the tip, which was the thickness of a lead pencil. The number of strands in a bull whip were also graduated. At the butt there were as many strands as the maker—usually the bullwhacker—could weave, often fourteen. At the tip, this number was reduced to six. From the top down to six or eight feet from the end the whip was made of leather, often old boot tops. The rest was made of tough buckskin or elk skin.

Cabin fever

Restlessness and hostility among cowboys snowed in at a line camp and forced to spend too much time in each other's company.

Cahoots

Partnership. The cowman always went into cahoots or throwed in with another man when he entered a partnership.

Calf fries

The testicles removed from castrated bull calves and fried; in the Southwest considered as much a delicacy as sweetbreads.

Calico

A pinto horse. A cowboy's term for a woman, so called because of the dress material she commonly wore. It was said in the Old West that "calico on the range was as scarce as sunflowers on a Christmas tree."

Calico fever

The "ailment" of one who is crazy about girls, or lovesick.

Calico queen

The frontier name for a honky-tonk woman.

California reins

Reins made of one piece of leather, with no separation of each rein as with the open reins.

Cantina

A tavern. One of the pockets of the knapsack used by the pony-express rider. From the Spanish, originally meaning wine cellar and later, in Spanish America, tavern or knapsack.

Cantle

The raised back of a saddle.

Carrying the news to Mary

Said of a horse that is running off with a saddle on his back.

Carvin' scollops on his gun

Making credits, or notches, on a gun to commemorate a killing; done mostly in fiction.

Casa grande

To Spanish-American cowboys, a place where all the hands gathered for fun and frolic. The ranch owner's home; used only in the Southwest. From the Spanish, meaning large house.

Catalog woman

What the cowboy called a wife secured through a matrimonial bureau. Usually, as Alkali Allison said, "one of them widders that wants her weeds plowed under."

Cattle Kate

A general name for a woman connected with cattle rustling. "Cattle Kate Maxwell," whose real name was Ella Watson, was hanged with Jim Averill for cattle stealing in Wyoming in 1889, during the Rustler's War. Though history doesn't prove her to be a thief, her name has gone down as such.

Cat wagon

Name given to a wagon that carried women of easy virtue who plied their trade along the cattle trails or on the range.

Chain hobble

A short chain, about a foot long, fastened to the horse's foreleg and left loose at the other end. This method of hobbling is not commonly used, because the loose end strikes the horse's legs if he starts to run and, besides causing pain, often trips and injures him.

Chaps

An American abbreviation of the Spanish chaparejos (chah-par-ray'hose), meaning leather breeches or overalls. This word was too much of a mouthful for the American cowboy, so he "bit shallow" and said chaps, pronouncing it shaps.

They are skeleton overalls worn primarily to protect a rider's legs from injury when he is thrown or when a horse falls upon him, pushes him against a fence or another animal, carries him through brush, or other chaparral, or attempts to bite him; also they are proof against rain or cold. The word occurs in English dictionaries as chaparejos, but the Spanish word is chapareras (cha-par-ray'rahs).

In spite of the movies and popular fiction, the cowhand sheds his chaps when he dismounts for ground work, for they are hot and uncomfortable to walk in. Only the hand of the brush country keeps his on, because he never knows when he is going to have to tear a hole in the brush. When the cowboy rides to town, he leaves his chaps hanging on a nail in the bunkhouse. If he does wear them, he takes them off when he arrives, and either hangs them over his saddle horn, leaves them at the livery stable, or throws them behind the bar of some saloon where he is known.

Cheek-piece

The side part of the bridle.

Cheyenne cut

A type of wing chap developed in Wyoming, the wing being narrower and straight. The under part of the leg is cut back to the knee, with no snaps below that point.

Cheyenne roll

A saddle devised by Frank Meanea, a saddlemaker of Cheyenne, to create something different from the saddles of his day. The saddle was made with a leather flange extending over, to the rear, of the cantle board. The saddle was brought out about 1870 and became very popular throughout the seventies and eighties, especially east of the Rockies.

Chigaderos (chig-gah-day'ros)

Another name for riding aprons or armitas. See armitas.

Chuck wagon

The mess wagon of the cow country. Usually made by fitting at the back end of an ordinary farm wagon a large box that contains shelves and has at its rear a lid that, hinged at the bottom and armed with legs, makes, when lowered, a serviceable table.

In the open-range days the chuck wagon was the most widely known and most talked of institution in the cattle country. Nothing added more to the harmony of the cowboy's life than a well-appointed chuck wagon. It furnished a complete index to the good or bad management of the ranch.

Once a hand has thrown his bedroll into the wagon, he has pledged allegiance to the brand for which it stands, and he will fight for it until he leaves it. He may cuss the cook, the company, and everything connected with it, but he had better not hear an outsider say anything against it.

The life of the cowboy away from headquarters has always centered around the chuck wagon. It is his home, his bed and board; it is where he gets his fresh horses, and it means fire, dry clothes and companionship; it is his hospital and office, his playground and social center. At night it is his place of relaxation, where he spins his yarns, sings his songs, smokes his cigarettes at leisure, and spends the happiest years of his life.

Cinch

A broad, short band made of coarsely woven horsehair or sometimes of canvas or cordage, and terminating at each end with a metal ring. (Philip A. Rollins, *The Cowboy* [New York, Charles Scribner's Sons, 1936], 126.) Together with the latigo, it is used to fasten a saddle upon a horse's back. From the Spanish "cincha."

Cloud watcher

A horse that travels with his head too high to watch his cattle work.

Concha

A shell-shaped metal ornament; from the Spanish, meaning shell. In the language of the cowboy it means a small, semi-flat, circular metal disk, usually made of silver. It is used for decorative purposes, attached to chaps, belt, or hatband; or to the saddle skirt, or the browband of the bridle.

Cookhouse

The ranch building where food is prepared, also including the dining room.

Corral (cor-rahl')

Spanish, meaning yard or enclosure; commonly pronounced kr-rall' by the cowman. As a noun, it means an enclosure or circular pen built of stout, horizontal wooden rails that are supported by posts set firmly in the ground. The rails are lashed to the posts with green rawhide, which contracts when dry, thus making the entire structure as strong as iron. The corral is circular so that the animals cannot dodge into corners or injure themselves by crowding into them. Used as a verb, it means to drive stock into a corral.

Corriente (cor-re-en'tay)

To run. From the Spanish, literally it means current, and is adopted by the Southwestern cowboy to signify inferiority, when referring to the quality of cattle (Harold W. Bentley, *Dictionary of Spanish Terms in English* [New York, Columbia University Press, 1932], 129).

Cow

The cowboy's generic term for everything from a sucking calf to a ten-year-old bull.

Cowboy

This word seems to have originated in Revolutionary days when a group of Tory guerillas roamed the region between the lines in Westchester County, New York, and called themselves by this title. It's hard to say why they gave themselves this title, since they had nothing to do with cows.

The next men we find calling themselves by this name are a bunch of wild-riding, reckless Texans under the leadership of Ewen Cameron, who spent their time chasing longhorns and Mexicans soon after Texas became a republic. To the Mexicans they became the symbol of calamity.

Then came the real cowboy as we know him today—a man who followed the cows. Two generations ago the East knew him as a bloody demon of disaster, reckless and rowdy, weighted down with weapons, and ever ready to use them. Today he is known as the hero of a Wild West story, as the eternally hard-riding movie actor, as the "guitar pickin" yodeler, or the gayly bedecked rodeo follower.

The West, who knows him best, knows that he has always been "just a plain, everyday bow-legged human," carefree and courageous, fun-loving and loyal, uncomplaining and doing his best to live up to a tradition of which he is proud. He has been called everything from a cowpoke to a dude wrangler, but never a coward. He is still with us today and will always be as long as the West raises cows, changing, perhaps, with the times, but always witty, friendly, and fearless.

Cowpoke

A slang name for the cowboy.

Cow sense

Such sense as is needed for success in cattle raising. Common sense.

Cricket

A little roller inserted in the bit to make a chirping noise, giving the horse something with which to amuse himself. His tongue creates a music the cowboy loves to hear.

Crown piece

The top part of the bridle, a strap passing over the top of the horse's head.

Curb bit

A bit with an upward curve, or port, in the center of the mouthpiece; one of the most widely used bits in the cattle country.

Curb strap

A piece of adjustable leather under the horse's chin. Sometimes a curb chain is used on a hard-mouthed horse.

Cutting horse

A horse especially trained for cutting out cattle from a herd.

A good cutting horse is the top-ranking and most talked-of horse in cattle work. This coveted title comes only after years of training and experience, and the rider who can boast of such a horse is the envy of his comrades and the pride of the entire outfit.

When a good cutting horse begins his work, he is made to understand which animal is to be cut. He works quietly until the animal is urged to the edge of the herd. Naturally the cow tries to remain with her companions, and here is where the cutting horse proves his worth. A good cutter is mentally and physically alert, possesses speed and action, and knows how to use them. He must spin and turn faster than the cow; and it takes an expert rider to stay on, for he must anticipate the horse's turn to keep from getting spilled. All this must be done in such a manner as to excite the herd as little as possible.

While the horse needs no assistance from his rider, an unskilled rider will certainly hinder the work of the horse. The work of a good cutter under an equally good rider is a joy to watch.

Cutting out

The act of riding into a herd of cattle, selecting the animal to be cut, and keeping it on the move away from the herd and toward the cut being formed. It is hard and exciting work, but it gives both horse and rider the opportunity to prove their worth.

Dally

To take a half hitch around the saddle horn with a rope after a catch is made, the loose end being held in the roper's hand so he can shorten it or let it slip in case of an emergency. The expressions daled, vuelted, dale vuented, and dolly welter are also used, all from the Spanish phrase dar la vuelta, meaning to take a turn or twist with a rope.

The early American cowboy gave the expression the nearest English pronunciation, dolly welter, which brings to mind a story told by S. Omar Barker of a tenderfoot roper who made a lucky catch and was immediately advised from all sides to "take your dolly welter," whereupon he retorted that he "didn't even know the gal." Later the expression was shortened to dally, which is now the most common term.

Dead man's hand

In gambling, a term used throughout the West to describe a hand made up of aces and eights, considered to be bad luck. This superstition was handed down from the time Jack McCall killed Wild Bill Hickok in Deadwood, South Dakota, in 1876, while he sat in a poker game holding such a hand.

Decoy herd

A small herd of cattle used in snaring wilder animals or in starting a cut of cattle on a roundup.

Democrat wagon

A light spring wagon used on a great many ranches.

Derringer

A small, .41-caliber, short-barreled pistol with a large bore, using a blunt-nosed bullet, capable of delivering a heavy blow at short range. This weapon was popular, especially among gamblers and bunko men, as a hide-out gun from the early 1870s to the close of the century.

Drag

The rear of a column of cattle on the trail. It holds the footsore, the weak, the young calves, the weary, and the lazy; also called tail. The cattle themselves are called drags, and this term is also sometimes applied to lazy humans. The average cowhand has little use for a lazy person, and his descriptions of one are rather high-flavored. Hunk Bouden spoke of one with, "The hardest work he ever done was take a long squint at the sun and a quick squat in the shade." Wishbone Wilson spoke of a man being so lazy "he had to lean ag'in a buildin' to spit," and Curly Hicks said of another that he "didn't do nothin' but set 'round all day on his one-spot."

Drag rider

A cowboy whose duty it is to follow the drags. This is the most disagreeable job in cattle driving because the man has to ride in the dust kicked up by the entire herd and contend with the weak and lazy critters until his patience is sorely tried. While the other riders may be singing in the pure air up ahead, there is no music in the soul of the drag rider, and he is using his vocal powers to cuss beneath the neckerchief he keeps tied over his nose and mouth. Also often called tail rider.

Drive

The moving of cattle on foot from one location to another (as noun), the act of moving cattle (as verb).

Dry-gulch

To kill; to ambush.

Dude

What the cowboy calls a person who comes west for enjoyment, thrills, and rest.

Dude ranch

A ranch that has been converted into a place of recreation for Easterners.

Eagle bill

A slang name for a tapadero, a leather stirrup covering, so called because of its shape.

Ear down

To distract a horse's attention by holding his head down by the ears while the rider mounts. Sometimes the man doing the earing will catch the tip of the horse's ear with his teeth. This action causes the horse to stand very still to avoid pain.

Empty saddle

A danger signal on a ranch. A horse showing up at the ranch carrying an empty saddle has a great significance in the cattle country. There is much anxiety concerning the rider because he may be dead or hurt or maybe afoot, perhaps far from home, which in itself might mean tragedy. As Will James said, "To range folks, such a sight [a horse coming home with an empty saddle] hints to a serious happening." (Will James, *All in an Day's Riding* [New York, Charles Scribner's Sons, 1933], 216.)

Fence crawler

An animal that cannot be kept in a fenced pasture.

Fence cutter

One of the men who cut fences during the fence-cutting wars of the cattle country in the 1880s. Most of these men were farmers and cattlemen fighting the larger ranch owners who had begun fencing in the open range.

Fiador (fee-ah-dore')

From the Spanish verb fiar, meaning to answer for or go surety for. A looped cord ordinarily made of braided horsehair, passing from the front of the bosal upward over the top of the horse's head. Also theodore. (Philip A. Rollins, *The Cowboy* [New York, Charles Scribner's Sons, 1936], 151).

Figure eight

A loop thrown so as to catch the forelegs of an animal in the lower part of the 8 while his head is caught in the upper part. This is done by throwing the straight overhead loop at an animal passing to the left, so that the honda will hit him just behind the left ear, the loop going out in front and dropping over his head. The sudden stopping of the loop when it hits the animal at the honda causes the loop to fold across and it is then up to the animal to get his forefeet into the lower part of the loop. (W.M. French, "Ropes and Roping," *Cattleman*, Vol. XXVI, No. 12 [May, 1940], 17-3.)

Fish

The yellow oilskin slicker that all old-time cowboys keep neatly rolled and tied behind the cantle of their saddles, so called because of the slicker's trade-mark, a fish. The cowboy might carry it until he wore it out and never need it, or let him leave it at the wagon for half a day and he was certain to get soaked to the hide. According to cowman philosophy, "A wise cowhand'll have somethin' besides a slicker for a rainy day," but few of them did.

If the cowboy was riding a bronc that might pile him and he was riding a slickfork saddle, he would tie the slicker behind the fork of his saddle for a bucking roll to help wedge him in. Some riders, when riding a spooky horse they were interested in training, would tie the slicker behind the cantle so that it nearly touched the ground on the left side. Of course, the horse tried to kick it to ribbons, but he soon got

used to it and quit trying to stampede. Through this training the horse also learned not to spook at other harmless articles. (Will James, *All in a Day's Riding* [New York, Charles Scribner's Sons, 1933], 14.)

Fleabag
A cowboy's name for his sleeping bag.

Fool brand
A brand too complicated to be described a briefly.

Forefooting
Roping an animal by the forefeet. The roper approaches the animal from the left side, and a medium-sized loop is thrown over the animal's right shoulder and a little ahead, in a position to receive one or both feet as they reach the ground. The noose is given an inward twist as it is thrown, which causes the upper side of the noose to flip backward against the animal's knees, ready for the catch. The method is generally used on horses.

Form fitter
A saddle with a high horn and a cantle made to fit a man's form.

Front jockey
The leather on the top of the skirt of the saddle, fitting closely around the horn.

Gelding
A castrated horse.

Gentling
Breaking and taming unbroken horses.

Grass rope
A cowman's name for a rope of any fiber other than cotton; originally one made of bear grass, but now usually one made of sisal or Manila hemp.

Grazing bit
A small bit with a curb in the mouthpiece. It is a good all-round lightweight bit, does not punish a horse, and is used now in most states east of the Rockies.

Greenhorn
A cowboy's name for a tenderfoot; also called greener.

Green River
A trapper's hunting knife made at Green River, Wyoming, and bearing that trademark; also, to kill someone by thrusting the knife into him all the way to the trademark, far up the blade.

Grizzlies
The name sometimes given chaps made of bear skin with the hair left on.

Hackamore
A halter. Corrupted from the Spanish jaquima (hah'ke-mah). The American cowboy pronounces his Spanish "by car." When he first heard the word jaquima, he pronounced it hackamer, as it sounded. Gradually it became hackamore, as it is found in the dictionary today.) S. Omar Barker, "Sagebrush Spanish," *New Mexican Magazine*, XX, No. 12 [December, 1942], 19.)

It is usually an ordinary halter having reins instead of a leading rope. More commonly it consists of a headpiece something like a bridle with a bosal in place of a bit, and

a brow-band about three inches wide that can be slid down the cheeks to cover the horse's eyes, but it has no throat-latch.

Hair pants
A general classification of chaps with the hair on.

Headquarters
The house of a ranch owner; the business office of a ranch.

Headstall
The headgear of a horse; the part of the bridle that encompasses the head.

Heel
To rope an animal by the hind feet; the method is never used on horses.

Henry
A breech-loading, lever-action repeating rifle first used by the Union Army in the Civil War. This type of rifle never became popular as a military weapon, but was used to some extent upon the frontier.

Herd
A bunch of cattle (as noun); to bunch cattle or horses and keep them bunched (as verb).

Herd broke
Said of cattle when they become accustomed to traveling in a herd.

His cinch is gettin' frayed
Said of one who has worn out his welcome. An unwanted person might be described as being "welcome as a polecat at a picnic," "welcome as a rattler in a dog town," or "pop'lar as a tax collector." Of such a person it is said that "folks go 'round 'im like he was a swamp."

His saddle is slipping
Said of someone losing his efficiency. Said of someone telling a tall tale.

Hobble
A leather cuff to buckle about each of the forelegs of a horse above the pastern joints, the two cuffs being connected with a short swivel chain (as noun). Most men get the same result with a wide band of cowhide, or a diagonally cut half of gunnysack. The act of applying these cuffs to horses (as verb). They are only applied, however, at a camp, for at the ranch, if the horse is not placed in a corral, he is turned loose (Philip A. Rollins, *The Cowboy* [New York, Charles Scribner's Sons, 1936], 141-42). When a rider camps at night, he wants to be able to find his horse in the morning. With hobbles on, the horse can move about with a certain amount of freedom and find grazing, but he will be unable to get very far because he can travel only at a slow walk.

Hombre
A Southwestern cowboy's name for a man. Generally used by Americans to mean a man of low character, or used in conjunction with such adjectives as bad and tough.

Honda (on'dah)
A knotted or spliced eyelet at the business end of a rope for making a loop. Sometimes a metal ring is used, though

some men claim that metal objects might possibly blind an animal, and they will not "set" to keep the struggling brute from freeing itself. Hondas tied in the rope itself should be protected with a piece of slick leather sewed about the upper end of the loop so that the rope will not burn through it. (W.M. French, "Ropes and Roping," *Cattlemen*, Vol. XXVI No. 12 [May, 1940], 17-30.) The term is Spanish, meaning eye, and originally had reference to the receptacle in a sling for holding a stone or other article to be thrown.

Hoodlum wagon
A cowboy's name for the bed wagon.

Hoolihan
A cowboy's term meaning foul or dirty play.

Horn
That part of the saddle above the fork. Its technical name, pommel, is never used by the cowman.

Horse
To man, probably the most important animal of the equine family. A male horse, as distinguished from the female, called a mare.

Idaho brain storm
A cowboy's name for a tornado. A whirling sandstorm.

Indian side of a horse
The right side of a horse; so called because the Indian mounted from that side, whereas the white man mounts from the left.

John B.
Cowboy's hat, named thus after its maker, John B. Stetson. The cowman takes pride in the age of his Stetson. As one writer said, "A Stetson will take on weight with age and get to the point where you can smell it across the room, but you can't wear it out." The big Stetson is just as much a part of the cowboy as his hands and feet.

Kettle-bellied
Pot-gutted.

Ladinos (lah-dee'nos)
Outlaw cattle of the brush country. The Spanish word means crafty or sagacious. The term is often applied to any vicious animal.

Lasso
A long rope, usually made of hide, with a running noose. Though Mexicans introduced this name to the cow range, the word comes from the Portuguese laco, meaning snare. To rope by means of a lasso. Stockmen of the Pacific Coast are the only ones using "lasso" to any extent; the Southwestern cowmen prefer "rope."

Last roundup
A cowboy's reference to death.

Latigo
A long leather strap used to fasten a saddle on a horse. The strap is passed successively through the cinch ring and the rigging ring and tied much in the manner of a four-in-hand tie.

Lead steer
A steer who, by his aggressiveness and stamina, takes

his place at the head of the trail herd and retains his leadership to the end of the trail. He is invaluable to the drover and, as an individual, is always honored with a name. There have been many stories written about famous lead steers; for example, those written by J. Frank Dobie, J. Evetts Haley, Jack Potter, and others; and these stories always move the heart of a real cowman. To him these steers are more than mere bovines.

Leather pounder
A slang name for the cowboy.

Leavin' Cheyenne
A cowboy expression meaning going away. The expression was taken from the cowboy song "Goodbye, Old Paint, I'm Leavin' Cheyenne," a song usually used as a finale at a cowboy dance, much in the way that "Home, Sweet Home" was used in other sections of the country.

Leggin's
What a Southwest Texan calls chaps. He rarely uses the latter term.

Longhorn
A name given early cattle of Texas, because of the enormous spread of their horns; also the name for native men of Texas, the home of the longhorn cattle. The saga of the longhorn is interesting, and for a valuable, complete study of this historic bovine, see *The Longhorns*, by an able recorder of the West, J. Frank Dobie (Boston, Little, Brown, 1941).

Mail-order cowboy
A tenderfoot, devoid of range experience, dressed in custom-made cowboy regalia. The average mail-order cowboy "looks like he was raised on the Brooklyn Bridge."

Makin's
Cigarette material. The old-time cowboy never smoked any cigarettes other than the ones he rolled himself from his makin's. If he ran out of makin's when he was situated where he could not buy more, he asked another rider for them and they were never refused, unless the refusal was an intentional insult.

Martingale
A strap from bridle to girth, passing between the horse's forelegs. It is intended to hold the horse's head down and thus keep him from rearing.

Maverick
As a noun, it means an unbranded animal of unknown ownership; as a verb, it means to brand such an animal with one's own brand.

Many and varied stories are told concerning the origin of the use of this word. Some of the stories have even gone so far as to brand Mr. Maverick a thief, and nothing could be farther from the truth. He was a useful, prominent, and honorable citizen, a lawyer and one of the signers of the Texas Declaration of Independence. He never made any claims to being a cattleman. In fact, his ignorance regarding cattle was responsible for his leaving such a colorful addition to our language. Here is what is apparently the true story:

The term is derived from the name of Samuel A.

Maverick, who, as a lawyer, took over a bunch of cattle for a debt before the Civil War and failed to brand the increase of the herd and let them wander far and wide. In 1855 Maverick sold his entire outfit—brand, range, and all—to Toutant de Beauregard, a neighbor stockman. According to the terms of the deal, Beauregard, in addition to the number of cattle present and actually transferred in the trade, was to have all the others that he could find on Maverick's range, both branded and unbranded. Beauregard, being a thrifty man, instituted a systematic roundup, and whenever his riders found an unbranded animal, they claimed it to be a Maverick, put Beauregard's brand on it, and drove it in. These riders took in so much territory, at a time when the prairies were full of unbranded cattle, that the news began to spread. From these circumstances the term maverick was applied to unbranded range cattle. The term spread over the entire cattle country and gained such common usage that it found its way into the dictionary. (*Prose and Poetry of the Cattle Industry* [Denver, 1905]; George M. Maverick [son of Samuel A. Maverick], St. Louis Republic, November 16, 1889.)

The term is also now used in speaking of a human who does not mix with others, or one who holds himself aloof from a crowd.

Maverick brand

An unrecorded brand. A thief can easily hold an animal on the range with one of these unrecorded brands until he is able to drive it off. In case suspicion is aroused, there are no records to connect him with the theft.

Mavericker

A man who rode the ranges in the early days to hunt and brand mavericks. In the beginning this practice of roping and branding any calf that was not at the time following its mother was not considered stealing, but legitimate thriftiness. Calves of this kind were considered anyone's cattle. Many ranchers who would not condone theft in any form sent their cowboys out "to do a little mavericking" at so much per head.

Mochila

In the days of the pony express, a name for one of the mail pouches built into the skirt of the saddle. Later, a large piece of leather covering the saddle and put on after the saddle was cinched on the horse. It had a hole for the horn and a narrow slit to allow the cantle to slip through. The contraption is virtually obsolete now, but was frequently used in the early days, especially in California. From the Spanish, meaning knapsack.

Mossy-horn

A Texas longhorn steer, six or more years old, whose horns have become wrinkled and scaly; also called a moss horn. The term is sometimes slangily applied to old cowmen.

Mountain oyster

The testicle of a bull. Some find it a choice delicacy when roasted or fried.

Mule-ears

A cowboy's name for boots with pull-on straps at the top. Also, a name for tapaderos, so called because of their shape.

Muley saddle

A saddle without a horn.

Mustang

A wild horse, a term restricted to the unmixed variety. To catch wild horses. From the Spanish mesteno, meaning strays from the mesta. A mesta was a group of cattle and horse raisers; thus the early mustangs were horses that escaped from the mestas and ran wild.

Mustanger

A man engaged in catching mustangs for a livelihood; from the Spanish mestenero.

Nag

A cowboy's term for a horse of poor quality.

Necktie party

A hanging.

Nose paint

A cowboy's name for whisky. One cowhand spoke of another at a bar "paintin' his nose with cow swallows of that stuff that cures snake bites."

Ocean wave

A rope trick that consists of flipping a noose backward and forward in an undulating movement.

One-eared bridle

A bridle composed of a single broad strap with a slit in it, which fits over one ear to keep it in place.

One-horse outfit

A small ranch or outfit.

Open range

Range not fenced.

Open-range branding

The branding of calves or cattle on the open range away from corrals, a practice followed by the larger outfits in the early days. Open-range branding was also sometimes done by an owner when he came across a calf that had been overlooked during the roundup. It was more difficult to drive one or two head of cattle than a large herd, and a good cowman avoided driving his stock as much as possible. To avoid a long drive back to headquarters, the cowboy would rope the calf, tie it down, build a fire, and brand it where he found it. Open-range branding was also frequently practiced by the rustler, especially if he was where he was not likely to be seen by some range rider. For this reason the practice came to be looked upon with suspicion unless it was carried out in the presence of a regular roundup crew.

Open reins

Reins not tied together, each independent of the other. Most cowhands prefer open reins because if the horse falls or the rider is thrown, the reins will fall to the ground and the horse will step on them, giving the rider a chance to catch the horse.

Outlaw

A particularly vicious and untamable horse, a wild cow or steer, or a man who has committed deeds that have placed him on the wrong side of the law. A man who follows the Western philosophy of "the best health resorts are the places unknown." Some of the early

outlaws lived a life, as Charlie Russell said in *Trails Plowed Under*, "that'd make some o' them scary yellerbacked novels look like a primer."

Overhead loop

In roping, a throw made by starting the whirl across the front of the roper to the left, with two or three whirls around the head for momentum, and then casting at the target by whirling the loop out in front as it comes across the right shoulder. (W.M. French, "Ropes and Roping," *Cattleman*, Vol. XXVI, No. 12 [May, 1940], 17-30.)

Packsaddle

A saddle used to carry freight, camp equipment, and other materials on the back of a pack animal; an aparejo.

Paint

A horse with irregular patterns of white and colored areas. It is a favorite with fiction writers but fails to meet with much favor as a cow horse. Not being good for close, quick work, it does not develop into a cutting horse and is inclined to acquire the habit of fighting the bits.

Paint horses are very showy, and for this reason the cowboy does not object to having one in his string to use as his "gallin' horse"; but when it comes to real cow work, he prefers a solid-colored horse. Because of their colors, these horses were popular among the Indians. But an adage of the cow country is, "Color don't count if the colt don't trot."

Palomino

A dun-colored or golden horse with a white, silver, or ivory mane and tail; from the Spanish palomilla.

Panniers

In packing, pouches made of canvas or leather fitting over the forks of a packsaddle and strapped to the pack animal with cinch and tightening strap, or latigo. From the French panier, meaning basket.

Pasture

Grazing ground; ground covered with grass to be eaten by cattle or horses. Land appropriated for grazing. To feed on grass. To place cattle on grazing ground.

Peacemaker

The 1873-model Colt revolver, which became the most famous in the world and was the favorite of many noted gunmen. It was originally chambered for the .45-caliber, center-fire, black-powder cartridge, but almost immediately after its introduction was chambered for the .44 Winchester (.44-.40) center-fire cartridge, and was used as a companion arm to the equally famous Winchester 1873-model rifle.

Peewees

A cowboy's name for boots with short tops, the most popular style of boot found upon the range today.

Carl B. Livingston, of Santa Fe, New Mexico, tells the following story of the origin of the short-top boot: "Heroes could not come home with ragged boots. They simply whacked off the tops, and laced the edges together with string. When the crowd came stomping into Old Sol's Lone Wolf Saloon, in Carlsbad, they were shockingly asked by their comrades who had stayed at home, 'Where'd you git

such funny boots?' The adventurers reared back their shoulders, indignantly stuck out their chests, and replied simply, 'Them's the style!' And so they have become the customary height of boot from that day to this, for there boys who had roped all over North and South America were princes of the cowboy profession, and set the styles." (Carl B. Livingston, "Development of the Cattle Industry in New Mexico,"*Cattleman*, Vol. XXIV, No. 12 [May, 1938], 21-31.)

Pegging

Ramming one horn of a downed steer into the ground to hold him down. This is not allowed in contests.

Picket pin

A wooden or iron stake, driven into the ground, to which an animal is picketed. When it was the practice to stake night horses, picket pins were carried as part of the chuck-wagon equipment. If the horseman had no picket pin, he dug a hole in the ground, tied a knot in the end of his rope, buried it and then tamped the dirt closely around it. It is surprising how well it would hold.

Pinto chaps

Spotted hair chaps made by sewing in pieces of hair of another color.

Pistol

A cowboy's name for a young, inexperienced rider. A cowboy never called his gun a pistol.

Prairie butter

A cowman's name for the grease left from fried meat or bacon, which he sometimes poured over his head.

Prairie coal

A cowman's name for dried cow chips used for fuel.

Put on the nose bag

A cowboy's expression meaning to eat a meal.

Quarter horse

A saddle horse of the range country with great endurance; so called because of its ability to run a short distance (a quarter of a mile) at high speed; formerly called short horse.

Quirt

A flexible, woven-leather whip made with a short stock about a foot long and carrying a lash of three or four heavy, loose thongs. Its stock is usually filled with lead to strike down a rearing horse that threatens to fall backward, and it can also be effective as a blackjack. A loop extending from the head provides means of attachment to either the rider's wrist or the saddle horn. The word is derived from the Mexican cuarta, meaning whip; this, in turn, is from the Spanish cuerda, meaning cord. (Philip A. Rollins, *The Cowboy* [New York, Charles Scribner's Sons, 1936], 137.)

Ranch

Either an entire ranching establishment including buildings, lands, and livestock, or else the principal building, which usually is the owner's dwelling, or else the owner's dwelling together with other structures adjacent to it, or else the collective persons who operate the establishment. From the Spanish rancho,

meaning farm, particularly one devoted to the breeding and raising of livestock. Used both as a verb and as a noun.

Rancher

A man who operates a ranch. A title restricted to members of the proprietor class.

Ranchero (ran-chay'ro)

Spanish for rancher, though a ranchero is more commonly a Mexican, while a rancher may be either Mexican or American.

Range boss

A man who works mostly for company-owned outfits. His work is to secure and protect the company's range, run its business, keep the men at work, and see that the cattle are bred up. He sees that fences are kept in repair and that the water supply functions, and does everything within his ability to better the interests of his employers. To be successful, he has to be a leader of men and know horses, cattle, and the range. (John M. Hendrix, "Bosses," *Cattleman*, Vol. XXIII, No. 10 [March, 1937], 65-75.)

Range count

Counting each grazing bunch of cattle where it is found on the range and drifting it back so that it does not mix with the uncounted cattle.

Range pirate

In the open-range days this term meant a man who turned stock loose on the range without owning open water and range in proportion to the cattle turned loose.

Range rights

The right to the use of a certain range in consequence of priority of occupation and continuous possession.

Rawhide

The hide of a cow or steer (as noun)—It was one of the most useful products of the pioneer cattleman. From it he made ropes, hobbles, clotheslines, bedsprings, seats for chairs, overcoats, trousers, brogans, and shirts. It patched saddles and shoes, and strips of it bound loose wagon tires or lashed together pieces of broken wagon tongue, as well as substituting for nails and many other things. To tease (as verb).

Rear girth

A Texan's term for the hind cinch.

Rear jockey

The leather on top of the skirt of a saddle, fitting closely around the cantle.

Reata (ray-ah'tah)

A rope, particularly one made of braided leather or rawhide; from the Spanish, meaning rope to tie horses in single file.

Remuda (ray-moo'dah)

From the Spanish remudar, meaning to exchange, reexchange. Remuda de caballos means relay of horses. The cowman uses the word to mean the extra mounts of each cowboy herded together and not at the time under saddle; also called remontha, this latter word a corruption of the Spanish remonta. The word is pronounced remootha in the Southwest, but most Texas cowmen merely say hosses. The remuda is to the Southwest what the cavvy is to the Northwest, though the Northwestern cowboy usually called these horses the saddle band.

A horse usually goes into the remuda when he is four years old. By the time he is six, he is fairly trained for cow work, but doesn't reach his full period of usefulness until he is about ten years old. Each year the remuda is culled of horses too old for the best work. A good and faithful cow horse is pensioned for a life of ease and grass; otherwise, the horse is sold for farm work.

A good cowman knows that his outfit is no better than its horses, and he watches them closely. Every day he checks the horses and counts them out to the wrangler. Each cowboy is responsible for the condition of his string, and the man who abuses his horses doesn't last long with the outfit. No horse is overworked, no horse overlooked. Each man realizes that the horse is his motive power and that his work is handicapped unless these horses are in top condition.

A rule of all remudas is that all horses must be geldings. Mares are never a part of the remuda, because they are bunch quitters and failures as saddle horses. As Charlie Russell said, "Lady hosses are like their human sisters. They get notions of goin' home, and no gentleman cayuse would think of lettin' a lady go alone." Stallions, on the other hand, fight and otherwise disturb a peaceful remuda.

When the work is over in the fall, the remuda is turned out to run the range, rest, and heal their scars. A small portion of the horses are kept up to be grain fed and used by the men who remain to do what winter riding there is to be done. The average remuda holds from ninety to one hundred horses, a number necessary to mount a cow outfit of eight to ten men.

Renegade rider

A cowboy employed to visit ranches, sometimes as far as fifty or more miles away, and pick up any stock found anywhere branded with his employer's brand, taking it with him to the next ranch or range. He takes his gather to the home ranch as often as he can, changes horses, and goes again.

Rigging

The middle leathers attached to the tree of the saddle connecting with and supporting the cinch by latigos through the rigging ring.

Ring bit

A bit with a metal circle slipped over the lower jaw of the horse. A cruel bit devised by the Spanish, it is not looked upon with favor by American cowmen. It can be extremely severe unless handled carefully and is hardly a bit for a man who loses his temper.

Romal

A flexible whip made on the bridle reins when they are fastened together. In Spanish the word is spelled ramal and pronounced r-r-rah-mahl'. El ramal means literally a branch road, a division or a ramification. Thus, attached as it is by the loop to the bridle reins, the romal becomes but a ramification of the rein, a handy addition that may be used as a quirt and dropped from the hand without fear of its getting lost.

Rope

The most important tool of the cowman, made of many different materials and serving many purposes. It catches his horse, throws his cattle, drags his wood to camp, pulls cattle from bog holes, and helps pull his wagon across rivers and rough places. It ties his bed up, helps in fighting prairie fires, secures his packs, stakes his horses, serves as a corral, is useful as a cow-whip, and is a weapon for killing snakes. It also serves as a guide in snowstorms when tied from his bunkhouse door to the stable or the wood pile, and it was frequently used to mete out frontier justice. Without it the cowboy would be practically useless. It is said that he does everything with a rope except eat with it. There are truly many men who can do anything with a rope except throw it up and climb it.

Rope corral

A temporary corral at the cow camp, made by three or four cowhands holding ropes between them to form an obtuse U. Used to pen saddle horses until they could be caught for saddling.

Rowel

The wheel of a spur. There are many different kinds and shapes of rowels.

Running iron

A branding iron made in the form of a straight poker or a rod curved at the end and used much as one would write upon a blackboard with chalk. In the 1870s a law was passed in Texas forbidding the use of this iron in branding. This was a blow aimed at the brand blotter, whose innocent single iron would tell no tales if he was caught riding across the range. The law made the man found with the single running iron an object of suspicion, and he was sometimes obliged to explain to a very urgent jury.

Rustler

This word was first used as a synonym for hustle, becoming an established terms for any person who was active, pushing, and hustling in any enterprise; it was used as a name for the wrangler; and, as verb, meant to herd horses. Later the word became almost exclusively applied to a cattle thief, starting from the days of the maverick when cowboys were paid by their employers to "get out and rustle a few mavericks." These same cowboys soon became interested in putting their own brands upon motherless calves to get a start in the cattle business, and this practice was looked upon as thievery. Thus the word connoted a thief. Texans, however, prefer the blunter term cow thief.

Winter is open season on the rustler, as he is busiest then. Dodging range riders, he rides through the grazing cattle, picking up big calves that were missed during the summer and fall branding.

Sabino

A horse with a light-red, almost pink, roan-colored body and a pure-white belly; from the Spanish.

Sack

To flip a blanket or sack at a horse to get him used to it.

Sacking out

A cowboy's expression for tying up the hind leg of a horse and waving a saddle blanket about him to gentle him for saddling.

Saddle

A seat for a man on horseback. The stock saddle is built to fulfill the cowboy's requirements in cattle work, and the slight variations in shape cause special names to be given to these saddles according to the shape of their trees. Many changes and improvements have been made in saddles through the years.

Saddle blanket

The blanket placed upon the horse's back beneath the saddle; also a slang name for griddlecakes. One good blanket is all that is necessary for a horse. Too much padding under the saddle makes him sweat unduly, and an overheated back becomes tender. After the saddle is thrown on and before it is cinched up, a couple of fingers should be inserted under the blanket where it comes over the withers to work up a little slack.

Saddle ring

The metal ring fastened to the tree of a saddle from which the latigo straps hang.

Serape

A blanket or shawl worn as an outer garment by Mexicans; from the Spanish.

Sharps

A hunting rifle with a lever breechblock action; named for its inventor, Christian Sharps. Early models of the Sharps were made with a percussion cap, and all were breechloaders. It was a favorite rifle until the repeater took its place.

Shirttail outfit

A small ranch that employs only one or two men.

Shotgun chaps

So called because sewing the outside seam together all the way down the leg made them look like the twin barrels of a shotgun, with a choke at the muzzle. This style proved more comfortable on the windy northern ranges than the bat-wings.

Side jockey

The leather side extensions of the seat of a saddle.

Skirt

A cowman's name for the broad leathers of a saddle that go next to the horse.

Slick

A name for an unbranded animal, particularly a horse.

Slick fork

A saddle with a little bulge or roll at the fork.

Snubbing post

A vertical, round timber about five feet high, firmly set in the earth at the center of the corral and stout enough to stand the strains to which it is subjected.

Sonora reds
A nickname given by the northern cowboys to the red Mexican cattle that came up the trail.

Spanish bit
A very severe bit with a port about 2 1/4 inches high and a curb ring instead of a curb strap.

Spurs
The metal necessities worn upon the cowboy's heels. They are one of the most essential implements of the cowboy's equipment for controlling his horse. He does not wear them to punish a horse as many people think, nor are they on his heels for ornament. He uses them more than he does the reins, but mostly as reminders. They are necessary in helping a horse over rough places he does not want to cross, or in signaling him for turnings and quick starts and stops.

If a cowhand used his spurs to cut a horse up; he would not last long at most ranches; and if the outfit was so short-handed it was forced to keep him on, he would likely be given such a rough string, he would be kept so busy trying to hang on he wouldn't have time to use his spurs.

The real cowboy loves his horses, and being cruel to them is farthest from his mind. When he buys a new pair of spurs, the first thing he does is to file the points of the rowels until they are blunt. Sharp rowels keep him from doing good work because they keep the horse fighting nervous and shrinking from their touch. When he uses them, a mere touch is as far as he goes. Sometimes a slight motion of the leg is all that is necessary.

He does not buy a big spur because it looks scary, but because the big one is less cruel. The bigger the rowel and the more points it has, the less damage it does. It is the little spur with few points that sinks in. (Will James, *All in a Day's Riding* [New York, Charles Scribner's Sons, 1933], 54.)

The jingle of the spurs is sweet music to any cowhand. It keeps him from getting lonesome when he's riding the range, and as long as he hears the music of the spurs everything is rosy. He rarely takes them off when he is working, and in some sections he loses his social standing when he is caught without them. Many a pair of boots has been worn out without ever having had the spurs removed. Spurs are helpful at night, too, as a bootjack.

Stallion
A male horse, especially one used for breeding.

Stampede
The running wild of cattle or horses from fright, used both as a verb and a noun. From the Spanish estampida, meaning a general scamper of cattle; also a loud noise or crash. The term is also used to express the rush of humans to new localities.

A stampede is dangerous both to the running cattle and to the men herding them. The cattle will often run until exhausted, this is of course damaging to both their weight and their condition. The fact that the majority of stampeds occur on stormy nights makes them more difficult to bring under control and more dangerous for the riders. Many a cowboy has been left in a unmarked grave upon the prairie as the result of a stampede.

Nothing can happen so quickly as a stampede. It is difficult to realize how suddenly many cattle can rise to their feet and be gone. As the cowman says, "They jes' buy a through ticket to hell and gone, and try to ketch the first train." A stampede spoils cattle and makes them nervous and hard to hold for many days. Often many of them are killed or crippled, and others are so scattered they are never recovered.

Anything can cause a stampede. Thousands of causes have been listed by the cattlemen, some of them so simple that they sound ridiculous to the uninitiated. In the trail days the cattle were traveling a country strange to them and were naturally nervous and suspicious. Also at this time the country was full of thieves who often stampeded a herd in the hope of retrieving some of the scattered ones.

The old-time cowman called them "stompedes," and his description of one was, "It's one jump to their feet and another jump to hell." (J. Frank Dobie, *The Longhorns* [Boston, Little, Brown, 1941], 88.)

The riders make every effort to gain a position alongside the lead cattle and try to head them into a milling circle. Each rider keeps us his singing or some sort of noise, and if he can hear his partner, he knows he is safe. If he does not hear him, he might be down. Contrary to general belief and popular fiction, guns are rarely fired in front of cattle in an effort to turn them. This would only frighten them the more.

Steer
A castrated male bovine animal.

Stetson
A name the cowboy often gives his hat whether it is a "genuwine" Stetson or not. The big Stetson hat is the earmark of the cow country. It is the first thing the tenderfoot buys when he goes West, but he never seems to learn to wear it at just the "right jack-deuce angle over his off-eye." One cowman can tell what state another is from by the size and shape of his hat.

It is not altogether vanity that makes the cowboy pay a high price for his hat. He knows he has to have one of fine quality to stand the rough usage it receives. He may throw it on the floor and hang his spurs on a nail, for he knows a good hat can be tromped on without hurting it, while tromping on a spur does neither the tromper nor the spur any good.

You may be surprised to learn that the cowboy's hat has more different uses than any other garment he wears. Often his life depends upon a good hat, for a limber brim of a cheap hat might flop in his eyes at just the wrong time. When he is riding in the scorching sun, the wide brim is like the shade of a tree, and the high crown furnishes space to keep his head cool. The wide brim also shades his eyes so that he can see long distances without getting sun-blinded when a lot depends upon his vision. When the sun is at his back, he tilts his Stetson for neck protection. In the rain it serves as an umbrella and makes a good shelter when he is trying to snatch a little daylight sleep. (Will James, *All in a Day's Riding* [New York, Charles Scribner's Sons, 1933], 15-20.)

The crown makes a handy water bucket if his horse cannot get to water, and the brim serves as his own drinking cup. He starts his campfire with his hat by using it as a bellows to fan a sickly blaze, and he can use it again as a water bucket to put out that same fire when he breaks camp. In the winter he pulls the brim down and ties it over his ears to avoid frostbite.

His hat is the first thing a cowhand puts on when he gets up and the last thing he takes off when he goes to bed. But during the day there are many times when he may have to jerk it off to use as a handy implement. There are times when its sudden use saves a lot of hard work, a long ride, a nasty fall, or even sudden death. Perhaps he is penning a bunch of snaky critters when the wave of a big hat will turn a bunch quitter and save a long ride. It also comes in handy to turn a stampeding bronc from dangerous ground by fanning its head when reins would be useless. It is useful in splitting a bunch of horses in two when the cowboy is afoot in a horse corral.

A big hat in the hands of a bronc rider can be used like a balancing pole of a tight-wire walker. If the rider loses his hat, he loses a lot of his balancing power.

Perhaps the cowboy is afoot in a branding pen when some old mama cow hears the bellow of her offspring as he is being branded. She comes on the run and on the prod. (Being afoot in a pen with a cow in this mood is, in the language of the cowhand, "more dangerous than kickin' a loaded polecat.") The big hat now comes in handy to throw into her face when she gets too close, making her hesitate long enough to let the cowboy get to the fence.

Most riders decorate their hats with bands, both as ornaments and for the purpose of adjusting the fit to the head. What they use is mostly a matter of personal taste. Some like leather bands studded with silver conchas, some use strings of Indian beads, while others are satisfied with bands of rattlesnake skin or woven horsehair. Whatever is used will likely serve as a storage place to keep matches dry.

Stirrup leathers
The broad leathers that hang from the bar of the tree of the saddle and from which the stirrups hang.

Stirrups
Foot supports for the saddle, usually made of wood bound with iron, brass, or rawhide, but sometimes made entirely of iron or brass. There is nothing the cowboy fears more than having a foot caught in a stirrup and being dragged to death by a horse.

Straight bit
A bit made of a straight piece of metal.

Straw boss
A cowboy's title for the foreman under the general superintendent of a ranch.

Strays
A term applied to cattle visiting from other ranges; horses from other ranges are said to be stray horses, not merely strays.

Sunset rowel
A spur wheel with many points set close together; also called sunburst.

Swell fork
A saddle with leather swells, or projections, on each side of the fork below the horn. When riding a pitching horse, the rider can hook his knees under these projections to help him stay in the saddle.

Swimming horse
A horse, selected because of his ability to swim, used in crossing rivers. Not all horses are good or steady swimmers, and during the trail days, when there were many rivers to cross, much depended upon a good swimming horse.

Swing rider
One of the riders with a trail herd, riding about one-third of the way back from the point riders.

Tailing
Throwing an animal by the tail in lieu of a rope. When he is traveling rapidly, any animal can be sent heels over head by seizing his tail and giving it a pull to one side. This method was resorted to frequently with a wild longhorn, and a thorough tailing usually knocked the breath from him and so dazed him that he would behave for the rest of the day. The act requires both a swift horse and a daring rider. (J. Frank Dobie, *Vaquero of the Brush Country* [Dallas, Southwest Press, 1929], 15.)

Tapadero (tah-pah-day'ro)
From the Spanish tapaderas, which comes from the verb tapar, meaning to close or cover. It is a wedge-shaped piece of leather that covers the stirrup front and sides, but is open in the rear. Its literal meaning is toe-fender. The word is usually shortened to taps. Made from heavy cowhide and occasionally reinforced by a wooden frame, it is used mostly in the brush country to protect the rider's feet and stirrups from brush.

Tenderfoots
The name originally applied to imported cattle, but later attached to humans new to the country; both cattle and humans are also called pilgrims.

Three-quarter rig
A saddle with the cinch placed halfway between that of the center-fire and the rim-fire.

Three-quarter seat
The leather seat covering of a saddle that extends only to the rear edge of the stirrup groove.

Throat-latch
The leather strap fastening the bridle under the throat of the horse.

Tied reins
Bridle reins tied together at the ends.

Tobiano

A pinto horse with the white color originating at the back and rump and extending downward, with the borders of the markings generally smooth and regular. (George M. Glendenning, "Overos and Tobianos," *Western Horseman*, Vol. VII, No. 1 [January-February, 1942], 12.)

Trail herd

A bunch of cattle, guarded day and night, being trailed from one region to another. A trail herd usually traveled in single file, or in twos and threes, forming a long, sinuous line, which, if seen from above, would look like a huge serpent in slow motion.

Trap corral

A corral used for capturing wild horses or cattle. The gate opens inward easily and closes behind so that the animals cannot escape.

Tree

The wooden frame of a saddle, which is covered with leather. The saddle usually takes its name from the shape of the tree or its maker, such as California, Visalia, Frazier, and Ellenburg.

Turn-out time

Time in the spring to turn cattle out to grass.

Twist-horn

A nickname for the longhorns because of the many different twists and turns of their horns.

Vaca (vah'cah)

Spanish for cow.

Vamoose

A cowboy's word meaning go; an Americanized form of the Spanish vamos! The cowboy uses it to mean "Get to hell out of here."

Vaquero

In the Southwest, a common word for any cowboy, but more particularly for a Mexican cowboy; from the Spanish.

War bridle

A brutal hitch of rope in the mouth and around the lower jaw of the horse.

Wattle

A mark of ownership made on the neck or the jaw of an animal by pinching up a quantity of skin and cutting it down but not entirely off. When the wound heals, a hanging flap of skin is left.

Wet stock

Cattle or horses that had been smuggled from across the Rio Grande River after having been stolen from their rightful owners in Mexico or Texas. Later the term was used to refer to any stolen stock.

Wild mare's milk

A cowboy's term for whiskey.

Winchester

A breech-loading rifle, usually a lever-loading, tubular-magazine type, first made by Oliver F. Winchester and manufactured by the Winchester Arms Company.

Woolsey

Slang name for a cheap hat, usually made of wool. Ross Santee tells a good story of a cowhand named Shorty letting a cowtown merchant sell him a cheap hat so much too large for him that he had to stuff five lamp-wicks under the sweat band to make it fit:

"'It's pourin' rain when I leaves town, '[says Shorty]' and the old hat weighs a ton. I ain't any more than started when it's down over both ears, an' by the time I hit Seven Mile it's leakin' like a sieve. I'm ridin' a bronc that's pretty snuffy, an' every time I raises the lid enough to git a little light, I see him drop one ear. I finally decides to take the lamp-wicks out altogether. I'm tryin' to raise the lid enough to see somethin' besides the saddlehorn when the old bronc bogs his head. I make a grab for leather when he leaves the ground, but I might as well have a gunny-sack tied over my head, for I can't see nothin'. When he comes down the second time I'm way over on one side. When he hits the ground the third jump, I ain't with him. I'm sittin' in the middle of the wash with both hands full of sand. I finally lifts the lid enough to see the old bronc headin' for the ranch. He's wide open and kickin' at his paunch.'" (Ross Santee, *Men and Horses* [New York, The Century Company, 1921], 115.)

Wrangle

To herd horses.

Wrangler

A herder of the saddle horses. It is the duty of this man or boy to see that the horses are kept together and at hand when wanted for the work. The word is a corruption of the Mexican caverango, meaning hostler. His job is considered the most menial in cow work and he does not stand very high in a cow camp. He rides the sorriest horse in the outfit and is the butt of all the jokes of a dozen cowhands. Yet his job is a training school, and many good cowboys have gotten their start in a wrangler's job. By studying the characteristics of the various horses, he saves himself much work and grief. He knows which are apt to be bunch quitters, which are fighters, and which are afraid of their own shadows. The arrival of stray men with their strings adds to his cares, and he has more horses to get acquainted with. Although it can rarely be said, the greatest praise that can be bestowed upon a wrangler is that "he never lost a horse."

Zorrillas (thor-reel-lyahs)

Cattle of the early longhorn breed, called this in the border country from their color, which is black with a line back, white speckles frequently appearing on the sides and belly. The word is from the Spanish, meaning polecat. (J. Frank Dobie, *The Longhorns*, [Boston, Little, Brown, 1941], 24-25.)

Bibliography

Adams, Andy: *The Log of a Cowboy*, Houghton-Miffin & Company, 1903.

Adams, Bill, Moss, Terry, and Voyles, J. Bruce: *The Antique Bowie Knife Book*, Museum Publishing Company, 1990.

Adams, Ramon F.: *Western Words: A Dictionary of the American West*, University of Oklahoma Press, 1968.

Ball, Robert, and Vebell, Ed: *Cowboy Collectibles & Western Memorabilia*, Schiffer Publishing, 1991.

Beatie, Russel H.: *Saddles*, J. A. Allen & Co. Ltd., University of Oklahoma Press, 1981.

Botkin, B.A., Editor: *A Treasury of Western Folklore*, Bonanza Books, 1975.

Commager: *The West, an Illustrated History*, Promontory Press, N.Y., 1976.

Connell, Ed: *Reinsmen of the West, Volume II: Bridles and Bits*, Wilshire Book Company, 1964.

Dary, David: *Cowboy Culture: A Saga of Five Centuries*, Alfred A. Knopf, 1981.

Dobie, J. Frank: *The Longhorns*, Bramhall House, 1941.

Fehrenbach, T.R.: *Lonestar*, Collier Books, 1980.

Forbis, William H., and the Editors of Time-Life Books: *The Cowboys*, Time-Life Books, 1973.

Foster, Harris: *The Look of the Old West*, Viking Press, 1955.

Friedman, Michael: *Cowboy Culture: The Last Frontier of American Antiques*, Schiffler Publishing, 1992.

Gragg, Rod: *The Old West Quiz and Fact Book*, Harper & Row, 1986.

Grant, Bruce: *Famous American Trails*, Rand McNally & Company, 1971.

Grant, Bruce: *How to Make Cowboy Horse Gear*, Cornell Maritime Press, 1956.

Grant, Bruce: *The Cowboy Encyclopedia*, Rand McNally & Company, 1951.

Haskett, T.H., and Hoskins, J.E.: *The Veterinary Science*, The Veterinary Science Association, 1896.

Hassrick, Royal B.: *Cowboys: The Real Story of Cowboys and Cattlemen*, Octopus Books, 1975.

Holling, C.: *The Book of Cowboys*, Platt & Munk, 1936.

Kennedy, Michael, Senior editor: *Cowboys and Cattlemen*, Hastings House, 1964.

Ketchum, William, C. Jr.: *Western Memorabilia: Collectibles of the Old West*, Rutledge Books/Hammond, Inc., 1980.

Laird, James R.: *The Cheyenne Saddle*, James R. Laird, publisher, 1982.

Langmore, Bank, and Tyler, Ron: *The Cowboy*, Promontory Press.

Mackin, Bill: *Cowboy & Gunfighter Collectibles*, Mountain Press Publishing Company, 1989.

McCracken, Harold: *The American Cowboy*, Doubleday 8 Company, Inc., 1973.

Monaghan, Jay, Editor: *The Book of the American West*, Bonanza Books, 1963.

Mora, Jo: *Trail Dust and Saddle Leather*, Charles Scribners and Sons,1946.

Nathan, McGinn Mitchell: *Spur Marks*, Newfoto Publications, 1986.

Nelson, Mark: *Bibliography of Old Time Saddle Makers*, Mark Nelson, 1992.

Newark, Peter: *The Illustrated Encyclopedia of the Old West*, Gallery Books, 1980.

Pattie, Jane: *Cowboy Spurs and Their Makers*, Texas A&M University Press, 1991.

Paul, Virginia: *This Was Cattle Ranching*, Superior Publishing Company, 1971.

Potter, Edgar R.: *Cowboy Slang*, Superior Publishing Company, 1971.

Reedstrom, Ernest L.: *Scrapbook of the American West*, The Caxton Printers, 1991.

Rice, Lee M., and Vernon, Glenn: *They Saddled the West*, Cornell Maritime Press, Inc., 1975.

Richardson, M.T.: *The Practical Horseshoer* (Fascimile of the 1880 edition), Johnson Publishing, 1991.

Rollins, Phillip Ashton: *The Cowboy*, Charles Scribners and Sons,1922

Russell, Charles M.: *Trails Plowed Under*, Doubleday and Co., 1927

Technical Notes

Camera

All of the outdoor photographs were taken with Nikon 35mm cameras and lenses.

The studio shots on pages 56—63, 186—187 were taken by my trusty assistants, Jim Volkert and Bruce Kendall, and shot with 4x5 view cameras: a Wisner Technical Field, a Sinar "p", and a Cambo 45NX.

Film

For sharpness and the mood we were looking for in this project, we relied on both Kodachrome 64 Professional and Kodachrome 200 Professional films, ensuring the consistency we needed from the beginning of the first photo session. We really needed film that would exhibit a high degree of shadow detail as well as being able to work well in all types of weather and under all qualities of light—rain, snow, and the intense heat of summer. Kodachrome film gave us the range and qualities we were looking for. From start to finish, we were able to rely on the technical support of Eastman Kodak's Professional Imaging Division for assistance with any technical problems encountered.

All film was processed at BWC labs in Miami Beach, Florida. To ensure quality and consistency, every roll of film— from the first roll shot in the mountains of Idaho to the last roll shot in the thick mesquite brush country of Texas—was looked at individually by the technicians and staff at BWC. We all worked as a team from the beginning—Eastman Kodak, BWC, and my staff—to make this project a success. The team effort made this book what it is. I hope you've enjoyed it!

STOECKLEIN PUBLISHING

The following books and calendars have been published by either David R. Stoecklein Publishing or *Dober Hill Ltd.*, a division of Stoecklein Publishing. You may order any publication from your local bookstore or by contacting Dave's studio:

David R. Stoecklein Photography
P.O. Box 856
Ketchum, Idaho 83340

208/726-5191 800/727-5191 Fax: 208/726-9752

The Idaho Cowboy

A photographic portrayal of the life and times of cowboys at work and play on the beautiful ranges of Idaho. Each individual photograph opens the cowboy mystique to you in a unique and intimate way. David has collected these photos over several years of working and living in the rugged outdoors of Idaho.

(ISBN #0-922029-02-4) $39.95

Sun Valley Signatures III

Third in a popular series of scenic books on Idaho, this spectacular book illustrates the outstanding lifestyle Idahoans enjoy. You'll see a skier exploding through deep powder on Baldy, a fly fisherman releasing a feisty rainbow trout at Loving Creek, a kayaker shooting Class IV rapids on the Payette River, a neon sunset over the Snake River . . .

(ISBN #0-922029-00-8) $39.95

Stoecklein's 1994 Calendar Collection

Dave Stoecklein and *Dober Hill Ltd.* publish five calendars annually. **The Idaho Cowboy** calendar is a popular series that continues to document the life of the true Idaho cowboy. **The Cowboy Classic** and **The Cowgirl Classic** calendars depict real cowboys and cowgirls at work and play throughout the West. Two additional calendars that highlight other facets of Dave's photography are **The Skiing Classic** calendar—a photographic portrayal of skiers throughout North America—and **The Sportsman's Classic** calendar—a spectacular photographic essay of hunting and fishing around the world. ($10.95 each)

LEGEND

"EARLY RAILROAD LINES"

- ● UNION PACIFIC
- ● CENTRAL PACIFIC
- ● KANSAS PACIFIC
- ● ATCHISON TOPEKA & SANTA FE
- ● HANNIBAL & ST. JO
- ● MISSOURI PACIFIC

"HISTORIC CATTLE TRAILS"

- ● CHISHOLM TRAIL
- ● EASTERN TRAIL
- ● GOODNIGHT-LOVING TRAIL
- ● SANTA FE TRAIL
- ● WESTERN TRAIL
- ● SHAWNEE TRAIL
- ● SEDALIA TRAIL
- ● BOZEMAN TRAIL
- ● OLD SPANISH TRAIL
- ● BUTTERFIELD OVERLAND MAIL ROUTE
- ● OREGON TRAIL
- ● CALIFORNIA TRAIL
- ● TEXAS TRAIL
- ● MULLAN ROAD

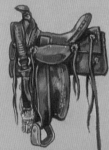

"COWBOY GEAR MAKERS"
The towns listed are most representative of each maker or the town he is most noted for.

- **1** J.O. BASS
 Tulia, Texas
- **2** JOE BIANCHI
 Victoria, Texas
- **3** ALLEN BONA
 Buford, Georgia
- **4** AUGUST BUERMANN
 Newark, New Jersey
- **5** C.E. COGGSHELL
 Miles City, Montana
- **6** BOB CAUSEY
 Carlsbad, New Mexico
- **7** COLLINS BROS.
 Cheyenne, Wyoming

- **8** TOM FLYNN
 Pueblo, Colorado
- **9** R.T. FRAZIER
 Pueblo, Colorado
- **10** AL FURSTOW
 Miles City, Montana
- **11** E.L. GALLATIN
 Denver, Colorado
- **12** S.C. GALLUP
 Pueblo, Colorado
- **13** G.S. GARCIA
 Elko, Nevada
- **14** E. GOETTLICH
 Miles City, Montana
- **15** HAMLEY AND CO.
 Pendleton, Oregon
- **16** H.H. HEISER
 Denver, Colorado

- **17** KELLY BROS.
 El Paso, Texas
- **18** KEYSTONE BROS.
 San Francisco, California
- **19** GEORGE LAWRENCE
 Portland, Oregon
- **20** MAIN & WINCHESTER
 San Francisco, California
- **21** J.R. McCHESNEY
 Pauls Valley, Oklahoma
- **22** F.A. MEANEA
 Cheyenne, Wyoming
- **23** MIKE MORALES
 Portland, Oregon
- **24** HUGH MORAN
 Miles City, Montana
- **25** FRED MUELLER
 Denver, Colorado

- **26** S.D. MYERS
 El Paso, Texas
- **27** NORTH & JUDD
 New Britain, Connecticut
- **28** PHILIPS & GUTIERREZ
 Cheyenne, Wyoming
- **29** JOSEPH PETMECKY
 Austin, Texas
- **30** N. PORTER
 Phoenix, Arizona
- **31** CHARLES SHIPLEY
 Kansas City, Missouri
- **32** J.B. SICKLES
 St. Louis, Missouri
- **33** VISALIA STOCK SADDLE CO.
 San Francisco, California
- **34** WYETH SADDLERY & HARDWARE
 St. Joseph, Missouri

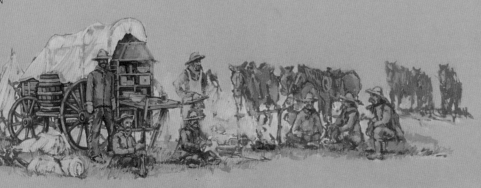

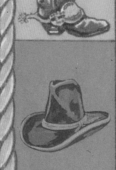
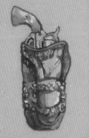
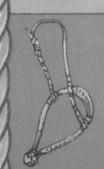
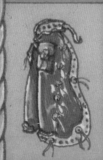

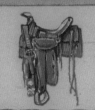

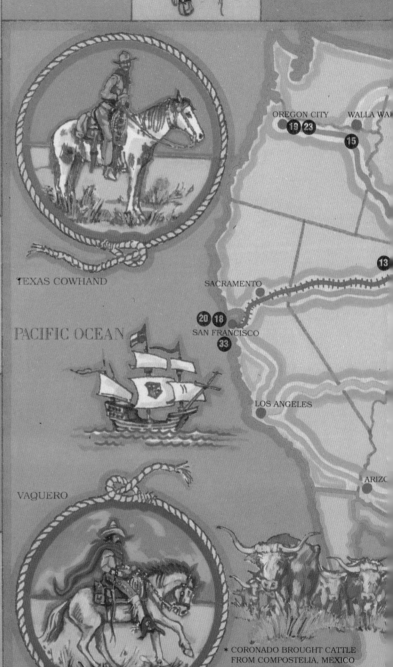

TEXAS COWHAND

VAQUERO

PACIFIC OCEAN

OREGON CITY WALLA WALLA

19 23 **15**

SACRAMENTO **13**

20 18
SAN FRANCISCO
33

LOS ANGELES

ARIZO

★ CORONADO BROUGHT CATTLE
FROM COMPOSTELIA, MEXICO
NORTHWARD INTO ARIZONA
IN THE 1540s. THEY WERE
THE FIRST SUCH ANIMALS
IN THE AMERICAN
SOUTHWEST.